# Gavin's

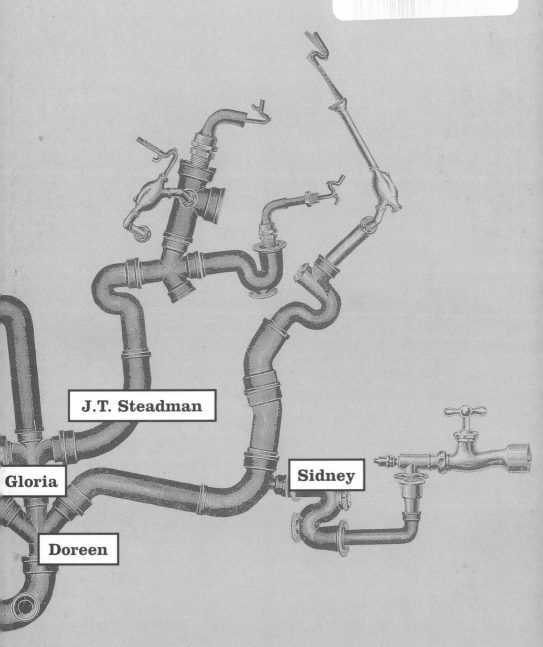

# DOODAAA

# DOODAAA

The Balletic Art of Gavin Twinge

*A Triography by*
Ralph Steadman

BLOOMSBURY

Published by Bloomsbury, New York and London
Distributed to the trade by Holtzbrinck Publishers

Cataloging-in-Publication Data is available from the Library of Congress

ISBN 1–58234–265–2

First U.S. Edition 2002

10 9 8 7 6 5 4 3 2 1

Typeset by Hewer Text Ltd, Edinburgh
Printed in Great Britain by Clays Limited, St Ives plc

STEAM PRESS

For Lawrence Brough
(1947–2002)
Anytime

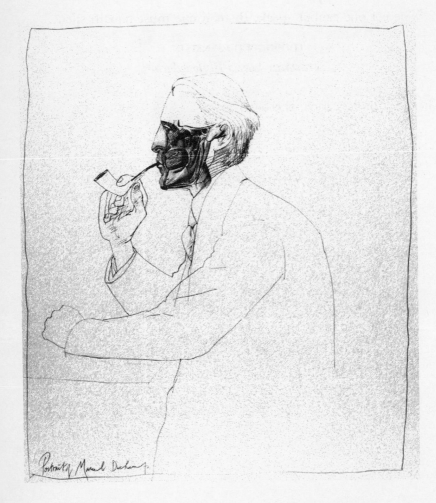

Portrait of Marcel Duchamp by Gavin Twinge

Whereof one cannot speak, thereon one must remain silent.

LUDWIG WITTGENSTEIN,
*Tractatus Logico-Philosophicus*

The head understands, the heart cannot speak — follow the river.

INDIAN SAYING

There is no solution because there is no problem.

MARCEL DUCHAMP

# CONTENTS

PART III

# ACKNOWLEDGMENTS:
# HONORARY DOODAAAISTS

Roy Ackerman. Noel Acherson. Oscar Acosta. Fleur Adcock. Casey Affleck. Michael Agnew. Damon Albarn. Tariq Ali. Mahmoud Al-Udhari. Brian Aldiss. Paul Allen. Malcolm Andrews. Martin Andrews. Danny Antonucci. Anunciata Asquith. Michael Aminian. James Allen. Enzo Apicella. Marshall Arisman. Susan Arosteguy. Jessamine Ashford. Tim Atkin. Patricia Atkinson. Guy Badot. John Bagley. Alan Bagwell. Beryl Bainbridge. David Baird. Tom Baker. Ian Ballantine. Helen Bamber. Lyn Bamber. Archie Baron. Walt Bartholomew. Michael Bateman. Denise Bates. Martin Bax. John Bayley. Kevin Bayliss. Jim Beale. The bell boys at the Oxford Hotel, Denver. Samuel Beckett. John Belushi. Steve Bell. Susan Benn. Alan Bennett. Anita Bejmuk. Peter Bide. Nick Blacknell. Cherie Blair. Peter Blake. Quentin Blake. Bob Bleckman. Anna Bliss. Frank Bloom. Valerie Bloom. Louis Boillot. Peter Bonev. Galina Boneva. Edward Booth Clibborn. Michael Bolton. Peter Boyle. Henry Boxer. Heather Bradley. Percy V. Bradshaw. Melvyn Bragg. Richard Branson. Bob Braudis. Doug Brinkley. Harold Bronson. Ralph Brown. Bill Buford. Keith and Joan Burns. Humphrey Burton. William Burroughs. Kate Bush and Dan. The Bus Stop Girls. Adam Buxton. Jean Pierre Cagnat. Sally Connell. Liz Calder. Mel Calman. Roy Calne. Ben Cameron. Neil Cameron. Aziz Cami. Jeff Canin. Humphrey Carpenter. Ruth Caird. Donald Carroll. Mike Chalmers. Ian Carr. Jimmy and Rosalind Carter. David Cash. Cinzia and Franco (Forte dei Marmi, 19th Premio Satira Politica). Robert and Emma Chalmers. Chelsea Arts Club. Caroline Cassidy. Alain and Françoise Cirot. Judith Cook. Kevin Crossley-Holland. Noel Channon. Andrew Chapman. Chris Churchill. John Clancy. Ann Clarke. Kenneth Clarke. Nick Clarke. John Cleese. Graham and Wendy Clarke. Peter Conradi. Piers and Sophie Russell-Cobb. Peter Cook. Wendy Cope. Ian Craig. Quentin Crisp. Barry Cryer. Dennis Conyon. Jay Cowan. Rita and Philip Crofton. Chris Curry. Matt Curtis. Joan Cusack. John Cusack. Liccy Dahl. Matt Damon. Harvey and Judy Daniels. Steve Daniel. Carole Davis. Jack Davis and Dena. The Daure Family. Richard Dawkins. John and Mo Dean. Mr. Delbanco. Don Delise. Demetri Demetriou. Felix Dennis. Judi Dench. Johnny Depp. Michael Dibb. Frank Dickens. Ron Diggins. John Dinsmore. Robin Dinwiddie. Stuart Dodd. Alan Doick. Amanda Jane Doran. The Doust Family. Robert Doutre. Ronnie and Deirdra Drew. Sarah Derrick. Martin Drew. Carol Ann Duffy. John Dunne. Lawrence Durrell. Sappho Durrell. Dusty. Robert Edwards. Gary Day-Ellison. Penny Ely. Robert Epstone. David Eskanazi. Kyle Etzkorn. Harold Evans. Marianne Faithfull. Barry Fantoni. John Farmer. Colin Farrell. Wally Fawkes. Dan Fern. Jose Ferez. Penelope Fitzgerald. Alan Fletcher. FLOP. Klaus and Joelle Flugge. Dawn Lambert. F. X. Flynn. Glenn Ford. Harrison Ford. Michael Foreman. Andrew Franklin. Antonia Fraser. Leo de Freitus. Deborah Fuller. Patrick Flynn. Jean Frapat. Christopher Frayling. James Gardner. Art Garfunkel. Patrick Garland. Jamila Gavin. David Gibbon. Gavin (barman at the King Cole bar, NY). Terry Gilliam. Peter Glassman. Jim Gleason. Don and Natalie Goddard. Gerry and Chris Goldstein. Selwyn Goodacre. John Gill. Alan Ginsberg. David Glean. Juliette Goddard. David Gollins. Jim Goode and Harry. Randall Grahm. Craig and Pat Graham. Margaret Grade. Richard E. Grant. Sue Grant. Adam Grater. James Grauerholz. Simon and Mo Green. Germaine Greer. Richard Gregson Williams. Richard Griffiths. Murray Grigor. Oscar Grillo. Gaby Gunst. Romesh Gunesekera. Steve Haber. Judith Vidal Hall. Anthony and Arabella Hamilton Russell. Terry Hands. Peter Hall. Maggie Hambling. Ian and Adele Hargreaves. Robert Harris. George Harrison. Gerry and Ellie Harrison. David Harsent. Jane Hartwell. Richard Harvey. Nigel Hawthorne. Susan Haynes. Steve Heller. Bill and Carole Havu. David Hayman. Lisa Haywood. Denis Healey. Adrian Henri. Michael and Penny Henshaw. Pip Hills. Charlie Hines. Warren Hinckle III. Susan Hill. David Hillman. Christopher Hitchens. Derek Hoad. Anthony Holden. David Hockney. Alan Hodgkin. Nicky Holford. Eleanor and Casy Hollack. Jools Holland. Merlin Holland. Cas Holms. Ian Holm. John Hooper. Wendy Horowitz. Taska Houseago. John Hughes. Sean Hughes. Shirley Hughes. Ted Hughes. Rod Hull. John Hurt. Brad Holland. Roy Hood. Paul Hogarth. Ian Hunter. Zoe Huston. Angela Huth. Cillandrella Hyams. Eric Idle. Michael Ignatieff.

Paddy and Catharine Imhof. Richard Ingrams. David and Margaret Izatt. Sarah Jackson. Howard Jacobson. Benoit Jacques. Mick Jagger. Andrew Jefford. Nicolas Joli. Glyn Jones. Lola Jones. Terry Jones. Martin and Cordelia Lambie-Nairn. Robin and Jessica Lough. Russ Karel. Don and Leslie Katz. P. J. Kavanagh. Simon Kelner. Bob Kingdom. Michael and Orna Kustow. Francis King. Rosamund Julius. Ellen Kent. Nicholas Kent. Andy Kershaw. Gordon and Diane Kerr. Rosalind Kidman-Cox. Lissie Kihl. Norma Kitson. Lionel Koffler. John Korpics. Jerelle Kraus. Dean Kuipers. Roland Laboye. Andrew Lambirth. David Langsam. Penny Lauerman. Glen and Isobel Lawes. Sue Lawley. Margaret Layman. Sarah Lazin. Timothy Leary. John Lent. Liberace. Eddie Linden. Art and Lily Linson. Martin Lock. Nils and Amy Lofgren. Christopher Logue. John Lord. Mary Louden. Robin Lough. Edward Lucy Smith. David Low. Jo Lynch. John and Catita Lumley. John Lloyd. Katie MacAulay. Dennis and Sylvia Main Wilson. Richard Macadam. Jim MacEwan. Gloria MacGowran. Avril MacRory. David Macsweeney. Derek Mahone. Pamela Manson. Nouritza Matossian. Ken Mahood. Marcello and Barbara Mannarini. Guy Masterson. Felicity Marsh. Jan Marsh. Jean Martin. Ian Mayes. Steve Martin. Simon Mason. Tom Maschler. Beryl McAlhone. John McCarthy. Ed and Hildeke McClanahan. Paul McCartney. Don McCullin. Ian McEwan. Linda McFadyen. Paul McGann. Roger McGough. George McGovern. David McKee. John McKee. Ian McKellan. Ian McKenzie Smith. Ailsa McWilliam. Stephen Medcalf. Sonny Mehta. George Melly. David Melville. Patrice and Dominique Mentha. Rosalind Miles. Spike Milligan. Trevor Mills. Melvyn Minnour. Michael Minas. Barry Miles. Adrian and Celia Mitchell. Aurelio Montes. Henry Moore and Mary. Simon and Alison Mostyn. Kate Moss. Andrew Motion. Alex and Anne Murawski. Douglas Murray. Harvey Myman. Martin Myrone. Laila Nabulsi. Sandy Nairne. Keith Newstead. Iris Murdoch. Jimmy Murikami. Philip Murphy. Bill Murray. Stephen Nemeth. Jane Newman. David Newmann. Keith Newstead. Barry Nicholson. Nick and Carly. Ciara Nolan. Laura Nolan. Chris and Gay Nutbeam. Jim O'Halloran. P. J. O'Rourke. Mitch Omer and Cynthia Gerdes. Lisa Orapallo. Deborah Orr. Our lovely postmen. Jane Owen. Suat Ozyurek. Marsha Palanci. Harry Peccinotti. Ken Pottle. John and Elspeth Quarrie. David Morris. Tim Page. Michael Palin. Anita Pallenberg. Tony Palmer. Eduardo Paolozzi. Jill Paton Walsh. Pascal. Brian Patten. Charlie Paul. Jean Pauli. Richard and Anna Pawelko. Sebastian Peake. Ann Penfold. David Perry. Trevor Petch. Willy Poole. Jonathan Porritt. Alan Pentecost. Tobias Perse. Joe Petro II. Joe Petro III. Nancy Pfister. Jonathan Piddock. Harold Pinter. Abbie Phillips. Owen Phillips. George Plimpton. George Plumptre. Phillip Poole. Jonathon Pope. Bob Priest. Tony Prior. Libby Purvis. Steve Pyke. Dougal Rae. Raj. Dan Rattiner. Robert and Margaret Ray. Lila Rawlings. Zandra Rhodes. Vicky Richardson. Des Ryan. Paul Pappiate. Summer Phoenix. Elunid Price. Howard Price. Jack Price. John and Binnie Price. Nate and Nancy Price. David Puttnam. Mike Quinn. John Ratcliffe. Lila Rawlings. Corin Redgrave. Roland Rees. David Remnick. Leslie Richardson. Anthony Rhodes. Andy Roberts. Barry Robinson. Bill Rock. John Rogers. Richard Rogers. Sheila Rogers. Anthony Rooley. John Ross. Tony and Zoe Ross. Victor Ross. Alain and Mireille Roux. Dorothy Rowe. Royce Rogers. Bruce Robinson. Jonathan Routh. Izel Ro zental. Gina Rozner. Robert Runcie. Tony Rushton. Mike Shackleton. Rachel Sadinsky. Laura Sandys. Lois and Lee Sarkisian. Paul Sauerteig. John Sauvage. Peter Sayers. Paul Scanlon. Gerald Scarfe. Jim Schoff. Paul Schofield. Richard Schofield. Helen Scott. Simon Scott. Max Schubert. Will Self. Bob Sharp. Barry Shaw. Carl and Liz Sherriff. Ned Sherrin. John Shuttleworth. Brian Sibley. Dimitri Sidjanski. Jim Silberman. Pearl Silver. Simeh. Paul Simon. Ted Simon. Posy Simmonds. Mathew Singh-Toor. Peter Smart. Ken Smith. Karuna Springer. Sean Street. Lou Stein. Saul Steinberg. Roy Strong. Bernard Stone. Nat and Judith Sobel. Terry Southern. Albert Spevak. Tim Stanley Clarke. Ringo Starr. Jonathan Stedall. Dave and Val Stockwell. Stephen and Ann Stockwell. George and Patti Stranahan. J. C. Suares. Stuart Sutherland. Alan Sillitoe and Ruth Fainlight. Michelle Somers. Abner Stein. Stephen Spender. Maggie Steed. Bill Swainson. Massoud Tabatabai. Alan Taylor. Brian and Michelle Taylor. Laurie Taylor. Jo Tizard. Jake Thackray. Davison Thompson. Hunter S. Thompson. Juan and Jennifer Thompson. Maureen Thompson. Virginia Thompson. David Thomas. Alan Tomkins. Sue Townsend. Barbara Trapido. Renato Trestini. Joanna Trollope. William Tuckett. Tomi Ungerer. Derek Ungless. Sally Vincent. Sal Viscuso. Tess Viscuso. David Vivian. Ernst Volland. Kurt Vonnegut. Tom Wakefield. Mac Wallace. Arthur Watson. Marina Warner. Marilyn Warnink. Auberon Waugh. Steve Way. Will Webb. Laurie Webster. Michael Weight. Jack Weir. Wendy at Felix's office. Jann and Janie Wenner. Arnold Wesker. Alan Wherry. Cliff White. Grahame White. Tony White. Tim Whitehead. Brian Whittaker. Roger and Camille Whittaker. Frere Wright. Nina and Graham Williams. Heathcote Williams. John Williams. Nigel Williams. Nike Williams. Mars Williams. Richard Williams. Trevor Willoughby. Fred Woodward. Patrick Wright. Barney Wyckoff. John Wilbur. Drenka Willen. Hal Willner. Penelope Wilton. Dan Wirt. Octavia Wiseman. Martin and Ba Woodcock. Jan Woolf. Keith Wright. Keith Wyncoll. Paula Yates. Yoshida. Alan Young. Tom Zito. Bill Zorn.

# Doodaaaism –
## Gastronomic Tutu 3000

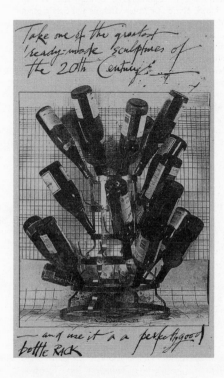

*Take one of the greatest 'ready-made' sculptures of the 20th Century' ... and use it a a perfectly good bottle RACK*

A maligned exhibition has been snatched from the jaws of oblivion by wine writers and weekend review editors in their relentless quest to keep alive a thirst for inspiration and chic in the blurred world between art and wine.

'They can't do this to me!' declared carping Doodaaaist and wine colossus Gavin Twinge (pronounced Twarnge) as mayhem erupted around his controversial new exhibition of booze-related themes entitled *Gastronomic Tutu 3000*, which was due to open simultaneously in London, Paris, Rome and New York but now has no venue. The director of Millbank's Tite Gallery, Norbert Xanadu, and Musée des Booze Arts of Paris commissionaire, Flaubert de Fluckingeaux, gasped at the audacity of the works, which contain lewd reference to empty bottles once full of some of the world's finest wines. They had been transformed into thought-provoking master-works and not a drop was spared.

'I drank the bloody lot,' slurred Twinge in his characteristically *soigné* fashion. 'I can't lift a pencil until I'm ripped.' Some of the greatest wines of the century went down his throat as he attempted to control the savage thirst which drives his inspiration. Quoting Nietzsche he burped, 'We possess art lest we perish from the troof!'

The truth is Twinge has reached his nadir, but Twinge disagrees. He confesses that he didn't know what a nadir was anyway.

'It's the pits, Gavin, they're getting at you, mate,' said a hanger-on who was busy emptying a Lafite '72 from the actual bottle that is now part of art history.

In essence Twinge has grasped the bottle of the New Age by the neck, L'Époque de la Bouteille of Dodo-Doodaaaism, by halting the ageing process of the last great wines of the twentieth century simply by drinking them. But it would be too simplistic to say that he

merely drank them, or even drunk them. In Twinge's own words, 'I drinked them. I treated the liquid as the formaldehyde of art and its mysterious relevance to a form's inebriate qualities and, in my case, quantities. By drinking the finest wines, the process of maturation is atrophied. I made the choice to stop the process and I stopped it with the best of everything, stone-dead. I drank it and that's my statement. I flogged the idea to extinction. I owe it all to Doodaaa. There isn't an artist alive or pickled who doesn't.'

Quoting himself Twinge gargled, 'If wine is my inspiration, then my art is my squits!' thus lending a whole new dimension to the phrase 'passing the bottle'.

Apparently all was well and everyone was in awe of Twinge's brutal act of daring until Cardinale Welli Donatelli Sellatanicosta of the Pristine Chapel Art Tomb and Souvenir Crypt on Rome's Pietro Pizza (*sic*) happened to mention 'bowel movements'. Bowel movements? Why bowel movements? The art world was in disarray. 'Simply,' he said, 'because the process does not stop with Twinge's artistic and biological functions. It goes further and generates a new and precise form of its own.' Asked to elucidate on his profound observation, the cardinale declined for what he described as religious considerations and his impending nomination for the post of Mayor of Rome which was looming in the New Age of Transparency. 'I am the true vine,' he uttered mysteriously and left it at that.

Floyd Positiona, curator of the Gluggenheim Museum of Modern Movements in New York, agreed with the cardinale.'Signor Sellatanicosta is right. What appears on the surface to be a perfectly innocent act of human existence is in fact a subversive motion created in the privacy of one's own home to create a sensation! It is not the function of our bodies to promulgate these acts as sacred icons in Temples of Art. We had no alternative but to reject Twinge's movement.'

When consulted, a retired lavatory attendant, Reg Doowin, from Leicester Square's hallowed Public Convenience Art Cellar, replied, 'I dunno, mate. I've seen 'em all come and go in 'ere. I've seen toffs in 'ere. I've seen scribblers. Weirdos. Primitives. You name it. They do their art and leave. The marks on these walls and down the pan are a part of my life. They are sacred to me; as sacred as the cave paintings in Lascaux are to the Incas.'

We shall have to await the outcome of the enigmatic Twinge's struggle to determine whether art is for the people or whether people do the art and leave rubbish to the professionals. 'I intend to build a full-size version of my Time Machine,' he breathed, 'and travel to the year three thousand to prove that my Bottle Art and my Theory of Random Orbits will be remembered like them Egyptian blokes and stuff.'

Meanwhile internet wine merchants have salvaged the situation and cashed in on Twinge's insatiable appetites and dubious output. His inspiration, the raw material for the art of Gavin Twinge, can be bought in bulk from just about anywhere from Cardiff to Bangkok.

*Grauniad*, 4 April 2002

# PREFACE

'Being exposed to Twinge's work for the first time jerked my glossopharyngeal, pneumogastric pinal accessory nerves into an emotional G force – a torn-back flesh flap of raw recognition – as his work plunged its perceptive prong into the bread pudding of my brain. The shock of life entered my body as an alien and I was born again.'

Glossopharyngeal, pneumogastric,
and pinal accessory nerves[3]

'Go easy on the big words,' I said to Ralphael Steed, whose services I had engaged to observe and scrutinise Twinge, with a view to writing a biography of this intriguing creative child of our times. 'We don't want to paralyse our readers before they have wrestled off any natural resistance to supine provocation. Seduction is an art in itself and calls for a certain *je ne sais quoi.*'

I needn't have worried, although it's true it took him more than twenty years to get down to it. Steed has proved to be the voice within the voice needed to achieve what ultimately drew me in as a third person to render the work a triumvirate *tour de force*. What was needed was a soul so simple that prejudgment was an impossible task, an unthinkable travesty. Steed proved to be a paragon of gullibility. He took Gavin Twinge at face value. Effectively, Steed reduced Twinge's natural outgoing honesty in his own work to an open book, to be picked at like the carcass of a gazelle languishing in its last moment of protestation, a natural right, to its own place in the sun. Like a Lammergeier vulture, Steed devoured Twinge's organs first, his eyes next and then, with leisurely finesse, picked every last morsel of meat and muscle from his bones, leaving little enough of even the marrowbone to the skulking hyenas and sparrow rats truculently awaiting their turn at the scrofulous feast.

Biographies are suspect compilations, a mixture of fact, hearsay and guesswork. Triographies, on the other hand, lend themselves to checking and verification. Honesty, scholarly investigation and candour are paramount weapons in the triographer's armoury, but, as with any scholarly work, imagination lends dimension to discovery, truth to uncertainty and power to expression. Ralphael Steed took such a leap of faith into the dark cavern of life's hanging bats that he landed on his feet – and maybe somebody else's as well. It would have been a failed opportunity to act otherwise.

I believe this book to be a testament to the triumph of the creative spirit in a world of bruised values and tiresome cant.

*Ralph Steadman, Kent, England, spring 2002*

# INTRODUCTION:
# AN ENCOUNTER WITH GAVIN TWINGE

I had work to do: a suite of leg portraits: people I could only remember by the shape of their pins – those awful memories of varicose veins bulging blue on bodies that at first had looked pretty fabulous if you were looking their owners straight between the eyes. That and legs in stockings which mask the terrible truth that most shop girls have the condition to a greater or lesser degree depending on how long they have had the jobs and how many hours a day they are compelled to stand, by order of the management. The portraits were going to be a kind of satirical tribute to a shop girl's lot. They make great models and always fall for the intriguing pitch that reclining for art is such a romantic thing to do.

Today I just couldn't face it. The gallery that had shown my previous work, Armpit Close-ups, had folded and taken with it the six sales I had made at the time. Times were bad and nobody was buying art anyway. The owner at my new gallery was enticing potential customers with big discounts. I had said I didn't like the idea, cheapening my art, especially since the discounts were coming off my slice, leaving his 50 per cent intact. He had big overheads, he explained, an image to maintain, which reflected on his stable of artists, don't forget. The creepy little bastard was screwing us all rotten and his 'stable' was going along with it.

I decided the Hell with it. I didn't do decoration. My line was moral indignation. So I took off from my chic *pied-à-terre* near the North End Road in Fulham's market district. I kicked aside the wooden fruit boxes and discarded cabbage leaves that for some reason accumulated outside my door on the other side of Eel Brook Common in Parthenia Road. At that time of day the barrowloads

of perishable goods got flogged as fast as their fast-talking owners could shift them; and always from the back of the barrow, behind the freshly polished façades of prime unblemished apples and oranges where the bruised stuff is shifted first. You dare not touch the beautiful examples of God's produce up front. 'Lovely ripe oranges!' barked a barrow boy at me once, to which I replied, 'Yeah, and well boiled too!' His retort was faster than a cobra's strike. 'Well, ya can't eat 'em raw, can ya, mate?' Touché! I had no reply to that, except to buy from someone further down the street, just to teach him a lesson. A futile gesture but what else can you do?

At that time – the mid-seventies – you could drive your car right into town and always be sure of a space, especially if it were a London taxicab, like mine. Of course you got the odd hail from some old dear. 'Can you take me to East Ham town hall, young man?' 'Sorry, lady,' I would reply in my best cockney, 'on'y goin' as far as Nottin' 'ill Gite,' which was true. I would park the cab down one of the backstreets in Holland Park, then wander around the area, day-dreaming the real estate along every little backwater down as far as the Gore.

There used to be a weird wooden structure in Kensington Church Walk, set back behind a row of small shops that had an old-world feel to it. It may have been a Rosicrucian Secret Brotherhood Church once. There was no plaque to commemorate the possibility. Too secret to advertise. Anyway, they have magical knowledge. There one day, gone the next. They know a mean landlord when they see one. It was cavernous inside, but as a Greek café it served the best meat and two veg anywhere around at two shillings and ninepence, and that included a cup of tea, or rhubarb tart and custard. It was thruppence extra if you wanted both.

A few doors down was a very small shop, chock-a-block full of antiquarian books, old magazines and cheap, second-hand paper-backs spilling out on to the small forecourt. A small bespectacled man was preoccupied inside, always submerged, it appeared, beneath this avalanche, which was his shop. He was always friendly whether I bought anything or not.

One day the shop wasn't there, so I walked up to the Greek café and that had gone too. In its place was the little bookshop, which seemed as full as ever, as though it had been transplanted and had grown organically to fill its new space – a demonstration of the exponential power of the intellect that cannot be contained. And there was the little man, looking smaller than ever in his emporium, huddled behind a makeshift cash counter and tapping away on an antiquated Underwood mechanical typewriter, which seemed a part of him too. Each lettered key was encased in chrome as though each letter was sacred. The machine was shiny black, black as a Model T Ford. Each key had to be slammed down like a steam hammer. Each letter was meant to transfer intention to the sheet of paper fed into the rollers, together with a sheet of carbon paper. A carbon copy was essential to fulfil any transaction. The little man was not a writer, not all of the time, anyway. Most days he typed out invoices for limited editions of his poetic friends' own broadsheets. Mail order fulfilled the greater part of his regular income, particularly original writers' manuscripts. Universities pay small fortunes for significant ephemera and the little man was always able to find these treasures, because a lot of writers were his friends. His shop was a watering hole for passing thirsty poets and writers in town. There was magic here, a whole new world, a backwater that thrummed, not with physical activity but with ideas. This was like a home for discarded literature, from Plato's *Republic* to the expiring late works of Lawrence Durrell, and for the likes of J. G. Ballard and Anthony Burgess, who were just getting into their stride. And of course there were poets, huddled masses of them, unknowns, unread, and great ones like Robert Frost, e. e. cummings, Dylan Thomas, John Berryman and Sylvia Plath. The plays of Harold Pinter, Samuel Beckett, Arnold Wesker, John Osborne and others formed a large section to themselves. Posters of lost causes hung on drawing pins, posters by Christopher Logue about electric chairs, political statements that would never be realised, and poetry broadsheets that were as far from jam-making as Tintern Abbey is from Las Vegas. The hastily erected shelving sagged beneath the weight of these works of the imagination, which

appeared to be cowering beneath the freshest dust and the scattered obscure broadsheets, which were tossed on to any space that would support them. The little man, I learned later, never turned down anyone trying to find an outlet for their new publication.

I bought a grubby little broadsheet called *New Departures* – grubby at that time, anyway – which had obviously been produced on an equally grubby Gestetner printing machine that only squeezed ink on to paper if you caressed it with curses and oil. It was the cutting edge of desktop publishing, produced by a passionate devotee of both powerful and legless poetry: Michael Horovitz. I was about to leave when a scream rent the premises. The *Aralia sieboldii* house-plant curling its way up to the skylit roof like a rehabilitated triffid shuddered visibly at the sound . . .

A figure, with wild, unfashionable hair, as white as a Hampton Court swan, leaped out of a small room at the back of the building. 'Fuck me, Bernard! It works! That little flatbed printing press works like a dream. A tad more packing and it will be perfect. Every letter is as clean as a whistle. I can read it!' I took a step backwards and pretended to be looking at my purchase as I moved towards the exit beyond a stack of equally unsaleable book bargains. 'No, don't go,' he warbled, 'this calls for a celebration. Bernard, have you got any more of that awful red plonk? Let's launch Broadsheet No. 1 in style. Steam Press has just published its first item. STEAM PRESS! D'you like the name?'

I nodded. ''S'OK. Whose idea was that?'

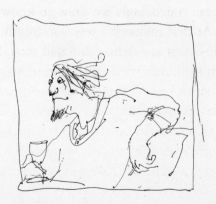

'Well, we had a sort of pissypoo evening inventing names, like Balls and Rollers, a printing term, The Iced Nun, Trembling Embers, Bollick Rolics, Sad Reflections, er – Poet's Noets, The Garbled Slump (which sounded more like something that Edward Gorey would have used for a book title). Bernard came up with Book Shook Press. Eleanor, who works here as Bernard's mentor, thought of Birds Who Do Words, long before Virago Press, and Wrichted Leterature. Then there was Poo Press, Gone Song Press, Long Gone, Get Lost, Stricken Letter, Poised Press, Insert Press, er – Pull Press, and King Ludd Press (the mythical king who hated newfangled machinery, like printing presses). Then I produced this old colophon photo engraving block of an old steam traction engine, with a big flywheel, made for driving all machinery, including printing presses, so somehow it stuck, because I could print an actual image. That was it. Let's drink to it! STEAM PRESS!'

The little man, Bernard, stooped beneath his complex, sculpted desk, which I learned later had been a gift from Henry Moore, and brought out a bottle of what most people buy to take to a party, in the hope of finding something superior, leaving the gut-strip for someone else, who would be too drunk to notice. That was a trick that always worked, and forged a generation of dribble-swillers, the like of which has never been seen before or since. For beyond the seventies lay a whole new élite whose palates were about to be educated by end-of-bin vintages, brought over from obscure French and Italian masters of the art of winemaking, who had banished for ever the anti-freeze concoctions we grew to know and crave.

Never mind. At that moment I was standing in the presence of a man whose enthusiasms so patently drove all thoughts of scoured and burning stomach linings beyond them, through the lower intestine, and out of a glistening sphincter so fast it hardly mattered. The drink was merely a token of an electric moment, and I circumnavigated the rim of the glass that was handed to me. I teased the liquid across my tongue in milligram droplets while I observed a creature whose idiosyncratic body movements collectively resembled an ostrich on Ecstasy.

'Take a look at that!' he gargled, and a dribble of the nitro-glycerine *vin de la maison* emerged over his bottom lip, forming a fractal arc of red on the tip of his chin. 'Our first printed broadsheet. Number One! And look what I printed it on. A brown paper bag from the tobacconist next door. It's a haiku. I set it all in the solid linotype I found in an old font tray. Not all the same typeface or point size, mind, but just as it comes out of the font. You don't get much more radical than that. All different shapes and sizes, pure natural graphics. It can never happen twice. Here, you can be the first to have one. I only printed six. That's the edition. Signed, sealed and delivered!' He rushed outside to stop a strolling passer-by. 'Scuse me, madam! Take one of these. No, please, it's very rare, only six printed and you've been chosen. Go on, it's a haiku!' The woman looked alarmed but gingerly accepted the bag with the message on it. 'You'll never regret it. Thirty years from now you'll wish you'd asked me for another.'

I looked down at this precious *objet d'art* and read what it said to myself. It went:

> HAIKU
> I have always Known
> That at last I Would
> TaKe this road. But yesterDaY
> I did not KnoW that it WoulD be today h
>      steam press

I counted the syllables – twenty-seven. Ten too many. I could just make out his scrawled signature as he came back into the shop. Gavin – Gavin Winge.*

I offered my hand warmly to congratulate him on what appeared to me to be a natural piece of design – simple and unaffected, like a child almost. 'Well done, Mr Winge,' I said. 'Twinge!' he replied with a huff. 'It's Twinge. Well, *Twarnge*, actually. Since I have been

---

* For this and other works by Gavin Twinge referred to in the text see the illustration sections, and also the additional information and original texts given in the list of Exhibitions and Collections (pp. 312–13) and the Bibliography (pp. 314–24). RS

going to France these past couple of years, I am known to the locals around Languedoc as M'sieur Twarnge, the Artiste Blagueur. They think I'm mad. I am trying to establish an artists' colony down there. It's cheap as old boots. You can get a place of your own for an old slag's tip. But it'll need everything doing to it, mind. No toilet, but that runs in the family. I can fit all that stuff myself. Interested? Are you an artist?'

I nodded, and looked at Bernard, who was shuffling papers and taking the cash out of his till for the night's boozing.

'Anyway, you're blooded now, mate. You've got one of my works. Ever thought of it? If you can raise five hundred quid you can live like a lord, high on the hog and wine is only a franc a litre, out of a petrol pump.' He rattled on. 'I've tried to get Bernard to join me down there, but he's stuck in his books.'

Bernard winced, and smiled at the ceiling. 'What shall we do with him? He never stops.' 'Take him for a drink,' I suggested. 'At least we have something to celebrate. Six paper bags. Each one a masterpiece!' I wondered to myself if that wasn't going a bridge too far, but at least it was different. I had nothing to lose but the paper bag.

'Come along, young man. Our friend here has got the right idea,' said Bernard to Gavin, and he started bringing in the old books on rickety shelves from the front of the shop; something he must have done on a thousand other nights like this one . . .

We strolled across to the Elephant and Castle in Holland Street, an inviting little pub.

'There he goes,' said Bernard, as Gavin ran on ahead. 'He'll have it all set up by the time we get there. He'll be drinking the best red wine they've got, but I always go for a vodka and tonic, so you'll be sharing with him, unless you prefer another tipple.'

'Yeah. I'll probably have a pint and a whisky chaser. A bit early for wine. Maybe later, and perhaps you will join me for supper. I'll pay.'

'Can't refuse,' replied Bernard, and I followed him into the small, smoky bar, full to bursting with habitués, who obviously held the place up, or maybe it was the other way around. A local pub is more than the sum of its parts, more than just bricks and mortar; it doubles up as a social services centre, a labour exchange, a moneylender, and

stage-set for every type you would ever want to see in one play at any one time. The Elephant and Castle could well be the Fitzrovia watering hole of the Kensington set.

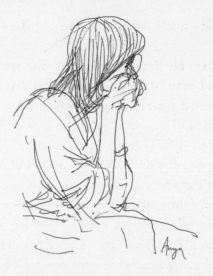

Gavin was deep in conversation with a lovely young girl, with soft brown eyes, an appealing, lopsided smile, and a fierce intelligence, belied by a gentle submissive nature.

'Darling! You waited for me!' was Bernard's amorous greeting to the woman, who hugged him with mock-thespian affection, as though he was the cuckolded husband in a farce by Georges Feydeau.

'I'll always wait for you,' she replied, flinging her arms upwards in a gesture of total obeisance.

'I don't know what she sees in him,' Bernard turned and addressed me, as he gestured a dismissive wave towards Gavin, who was studying one of the brown paper bags as though it were an old and precious document he had just uncovered in an Egyptian tomb. 'Gavin, why don't you introduce our friend to Anya? You promised him a drink. Let me do it. What'll it be?' Bernard scattered some of the day's takings on to the bar. I got my beer and whisky chaser and Bernard had a vodka and tonic placed in front of him by the landlord, who obviously knew his regulars.

'Look at this, Anya.' She turned to scrutinise the bag. 'I just

printed it, and it declares the founding of Steam Press. Four complete strangers have just walked off with four of them, and we have two left. One for Bernard and one for you, *cariad*. What d'you think. Set it all myself.'

'You are sweet, thank you,' and Anya plants a warm kiss on Gavin's cheek.

'Ah! Young love. He doesn't deserve it. She won't run away with me, even though I have been down on my bended knees. She is hard and ruthless.' Bernard takes an untipped Senior Service out of a packet and lights up.

'So what do you do?' Gavin turned to me. I made light of my gallery disappointments, and he nodded thoughtfully, looking off into the middle distance. 'Sounds familiar,' he said. 'I have just had cancellations from four galleries worldwide. Someone put the word about that *Gastronomic Tutu* was nothing more than a booze-related indulgence, an insult to fine wine, and the drunken outburst of a registered alcoholic. I was amazed how perceptive they were. It was spot-on and the result of an empty cellar. But because it was going to be exhibited in Rome at the Pristine Chapel Art Tomb, Cardinale Welli Donatelli Sellatanicosta reckoned my mention of bowels, biological body functions and art was the green light for a subversive new underground movement, and of course he was right. My interest in plumbing and its relevance to art is in my blood. And none of us can escape the connection. Some of my best inspirations were conceived in the loo, and that's not to discredit the loo by associating it with the current crop of artistic mavericks.'

'Is that the reason you've been rejected?' I asked. Gavin had paused to refill his glass.

'Not entirely,' he replied. 'It has more to do with the fact that Cardinale Welli is short-listed for Pope, and he thought my description of the exhibition was misleading.'

'What did you say?'

'Oh, I made reference to God as the receptacle of all our sins, priests as the carriers of the sacred rolls of wisdom that wipe away our misdemeanours, and the flushing waters of Babylon washing our

souls clean to find eternal life in the hereafter, or the "next meal", as I put it. He thought I was being profane. I was being serious.'

'Perhaps it does sound ambiguous, to a holy man, and what was he doing in the art world anyway?'

'His father was a painter and about as holy as an automatic weapon. The cardinale turned to the Church to absolve his father's sins, and tried to save him through Catholicism. There is always one in the family, believe me. His father said of himself that the only Catholic thing about him were his tastes, which ranged from defrocked nuns to grappa, the only spirit he was prepared to worship.

'Cardinale Welli Donatelli Sellatanicosta picked up on the spiritual side of his father's being, bought him the odd bottle and found him the odd nun. He realised he had a persuasive way with words, convinced his father that he was not a total bastard, and that he would find his own way to Hell. Then he preached using his father's pictures as a spiritual framework, and made the paintings sound fantastic: visions of the next life, the life we are all able to enjoy, if we believe. Saving whores was what the pictures were about, he preached, but what he meant was, he was really saving them for himself.'

'Brilliant!' I gulped, through the whisky, and a slurp of warm beer. The stuff was really beginning to do the trick, and I felt like a thousand yards. 'Religion always comes to the rescue when you are really in need,' I said, stumbling forward.

'Cardinale Welli is a master of the right phrase. The crypt was loaned to him as a religious art centre and souvenir shop, and that is how it began. Half his congregation wanted to buy the work his father produced. The Pope bought one for the Vatican Archive, for their special "Works of Satan" section, which includes everyone of any worth from the seventh century onwards, including the mass-murdering German priest-painter Urs Gras. Gras's work personifies the height of Sado-Masochistic Spiritualism. He could only work after a night of murderous self-indulgence, then he would go to the basilica and conduct Mass. Anyway, the cardinale was corrupted when he got into local politics, and one thing led to another. Now

he is in line for Pope – when the time comes. He is very choosy
about subject matter, so I am one of his rejects. I'm too honest, and
he is toeing the party line of acceptable art. Steer clear of human
waste, or anything associated with bodily functions, other than
physical pain. That's acceptable, particularly if it expresses domina-
tion and the manipulation of will.'

'Is your work always about human functions?'

'Good God, no! What do you think I am – some kind of grubby
sensationalist? I concern myself with whatever makes the heart tick,
whatever engages the human spirit, whatever intrigues the curiosity
of the mind in whatever capacity. That is the nature of life, and
everyone is involved. That is the secret and, I would have thought,
the purpose of art. Motivation is what moves a soul to act a certain
way. Movement is energy and energy is life. That is all that signifies
our driving force, otherwise we would wither and die.'

'Have you ever thought of doing a book?'

'Nah! Fucking books! The poor man's attempt to feel part of real
life.'

'What have you read?'

'Nothin'!' His manner was truculent and shifty.

'You mean you can't remember, like I can't remember, just like a
shopping list.'

'No. Like I can't remember because I never read a book. Any idea I
ever had is MY idea. I don't like second-hand knowledge. I don't like
people of my lifetime telling me things as though they are some new
kind of wisdom. They learned it all from a book. They simply pass it
on like goofy disciples. Unfortunately, there aren't just twelve of
them. There are legions of them, breathless salivating articulates who
can express someone else's ideas better than the next postulator. Is
that why we're here? Are we just here to repeat endless atrophied
wisdom? The first man says UG! The second man says UGH! The
third man says UGHU! and so on. They piss me off. Not because
they do that – that is their choice – but because they do it to sound
superior. They do it to exercise a power of knowledge over the next
man. That to me is not knowledge. That is manipulation. Then they

invent prizes for it, and award them to each other like "pass the parcel". They deliberately exclude those who just live their lives, have experiences and tell others about it in conversation. It is that simple. Some have a natural aptitude and tell riveting stories. Then there are those who simply converse, have a pleasant time performing a natural physiological discourse, engaging the intellect in a relaxing hammock of memories; a good time is had by all. Then there are those who think to themselves, if I augment this situation, and if I twist this tragic happening, and if I pervert this man's motives to transform him into a villain, and bring in a murder, for which he becomes the suspect, then I've got a story, and I can publish it. People will want to read it, out of curiosity, and an industry is born.'

'So?'

'So, what's your question?'

'My question is, what if I wrote a book about YOU?'

Anya sneaked up on Gavin and lifted his arm around her shoulder. 'I think it's a great idea,' she said. 'It's time you tried to get down what it is you are trying to say.'

'It'll come out all wrong.' Gavin reacted like an animal under attack. 'I don't know you from Adam! You could be one of those writers I have just described. Take my thoughts and twist them to suit your own devices.'

'Exactly!' I said. 'I would turn you into a victim. I would twist every word you said and make it my own. You would be putty in my hands. Your life wouldn't be worth living, but you would be famous!'

'I like it!' he said. 'When do we start?'

'We already have,' I replied. 'Let's drink to it. I will buy you a bottle, a bloody Mary for Anya, a beer and whisky for me and a vodka and tonic for Bernard. And something for this immediate circle. There is a thirsty look about the place.'

'You're perceptive, I'll say that for you, but don't miss out the one in the corner with the handlebar moustache – Eric de Wett. Look at that stained waistcoat. He usually makes his own booze,

in the sink, but he seems quite lucid tonight. He must have run out of sugar. He'll want treble sambuca. They'll serve him up with whatever dregs they have from empty bottles. It won't kill him, but what he makes himself will. He is Pure Ethanol Man, sugar in water, distilled into a cracked cup through a copper worm, swill it around like the dregs of a cup of tea, and straight down the gullet. Poison! But to Eric, poetry for the moment.'

'OK. Sounds fair to me. Where shall we eat? I'm buying.'

'How about that new hole-in-the-wall bistro on Kensington Church Street, opposite the Bus Stop Boutique. The Bus Stop girls say it's fab.'

Too drunk to make a value judgment, we finally stumbled off towards the venue, practically in single file, like a herd of thirsty elephants. It was hardly one hundred yards away, but by the time we got there we had a small army of hungry conscripts, and I think I paid for the Bus Stop girls as well. It was that kind of a night. Young things were sitting on our table, eating whatever was put in front of them. I don't know where they had come from, but they knew a free meal when they saw one.

By the time we got to the black coffees and the brandies, I think I had a book on the boil, and the advance was all but shot. What the Hell, I thought. I'll have a word with my publisher in the morning – or shall I wait a day? This weird man isn't going to disappear, and I'm shagged out.

<p style="text-align:center">*     *     *</p>

That was twenty years ago.

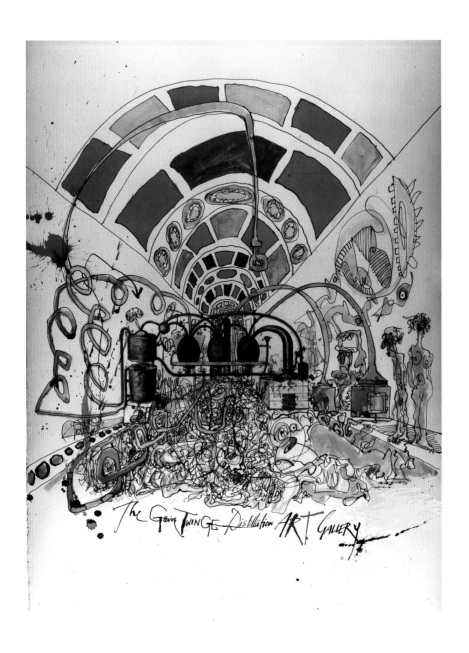

Distillation Art Gallery

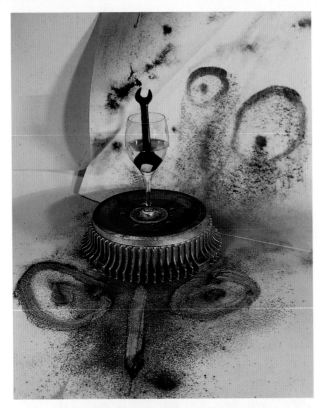

Palate

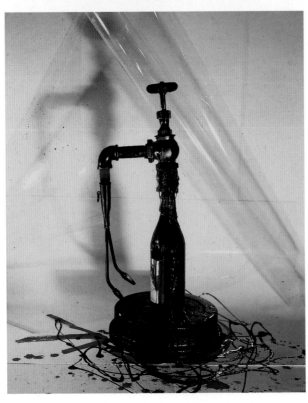

Wine Diviner

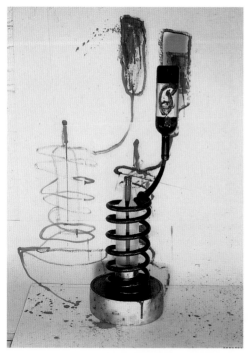

Aftertaste

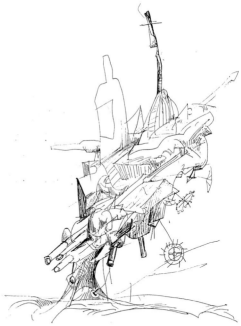

Bottle Art Mobile (line drawing)

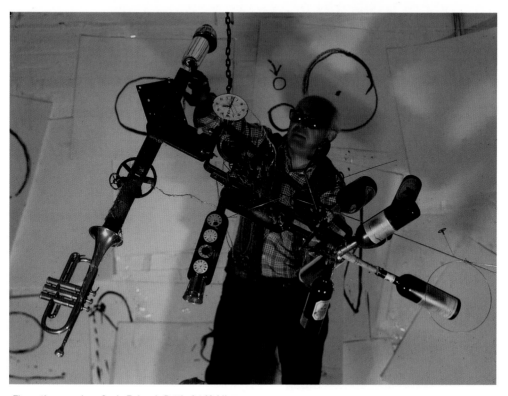

The author examines Gavin Twinge's Bottle Art Mobile

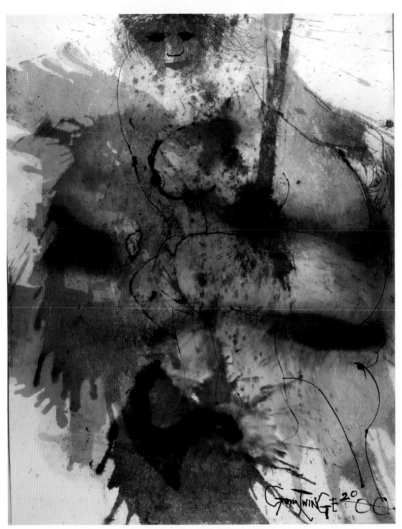

Anya Aqua Nude
(beer can
explosion art)

Aphrodite at Last (etching on steel drain cover)

Male Nude no. 3

Gavinoid 1: Athletic Ménage

Gavinoid 2: Job's Lot

Gavinoid 3: Brutal Taxi

Gavinoid 4: Rib Cage Torso

Gavinoid 5: Sexual Gymnast

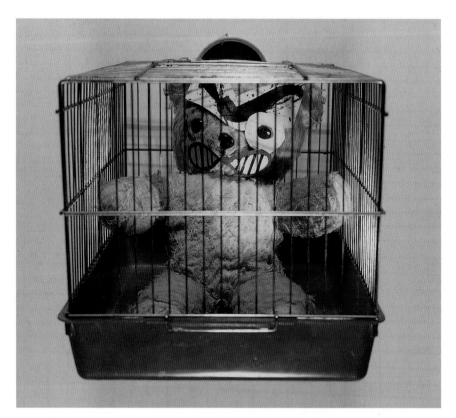

Captive Teddy (sculpture)

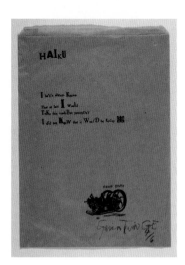

Paperbag Haiku

Cubist Chair (*Dancing to Paint*)

*above:* Architectural Model for Turner Art Centre, Margate

*left:* Appetite (driftwood and cutlery)

Battersea Power Station (upturned table)

Passing Cloud (found objects)

Weather Vane (found objects)

5 000143 520002

Liquorice (barcode art)

Blue Symphony (barcode art)

Grand Piano (barcode art)

Ice Mirage (barcode art)

Lost Horizon (barcode art)

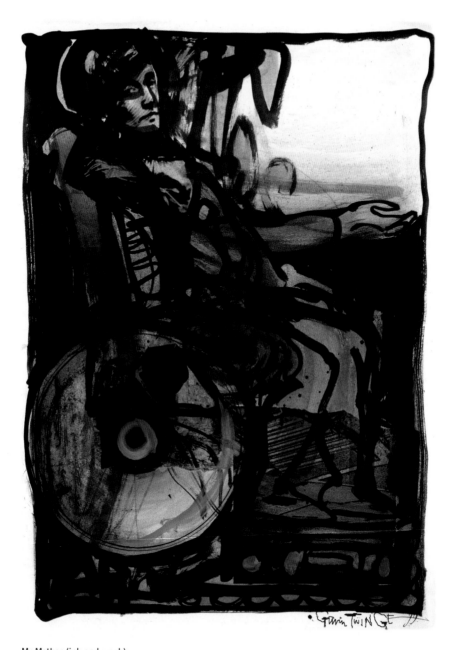

My Mother (ink and wash)

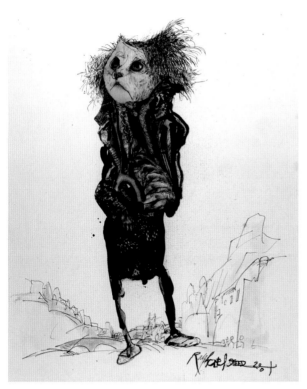

Beggar Girls: by Ralphael Steed (ink and collage)

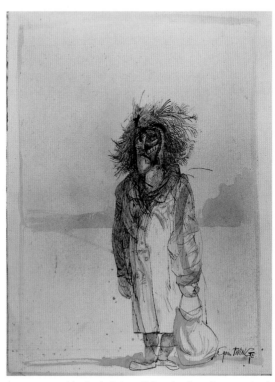

and by Gavin Twinge (ink and collage Daguerreotype)

Drive Chains in Red.

Basic drive system
(Not to scale.)

Planets on
revolving platform.

Fashion
Show
here!

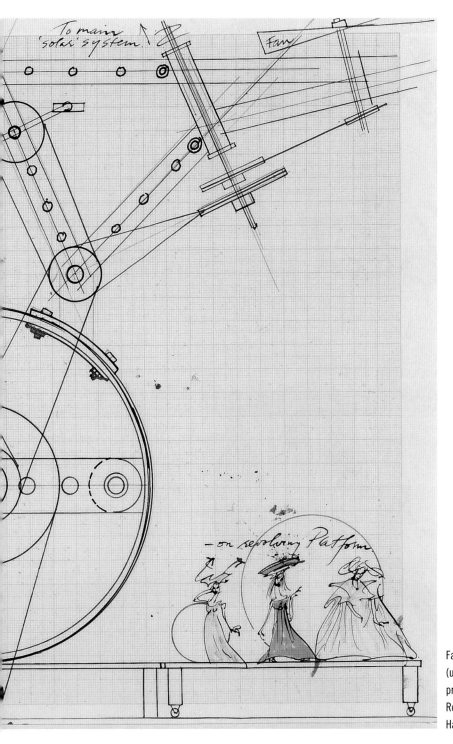

To main 'solar' system.

Fan

– on revolving Platform

Fashion Orrery (unrealised project for the Royal Albert Hall, London)

Château Château
(silkscreen print)

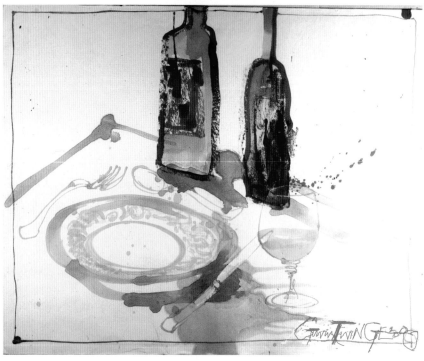

Still Life 'I took one sip of the Sauvignon Blanc, got up and walked away'
(watercolour on linen)

# PART I

# CHAPTER 1

# BRITISH ART: WORLD'S END

WHEN I RANG the bell on the door of Gavin's London house, which looked out over Eel Brook Common in Fulham, known to estate agents generally as the 'desirable outer reaches of Chelsea', the first thing I heard was the sound of a dog barking its way towards the source of the ring, followed by a yelp, a blood-curdling screech and then a whimper of utter, abject capitulation. My God, I thought, I wonder if the RSPCA knows about this? When I rang him yesterday to make an appointment to see him he hadn't mentioned a dog. I thought he hated them. Maybe I should walk away. I didn't like the sound of it, and, more important, did I want to be involved in an animal rights bust? It was too late anyway. The door swung open and there stood Gavin wearing an afghan towelling dressing gown with mirror insets and a fur collar. He was sporting a single-horned mask sprouting out on the right side of his head. 'Taraaa!' he said, and bowed like an old lovey intent on making his dramatic entrance noticed by what may turn out to be the same old audience, but he never gives up. He growled forward in a menacing posture, tongue hanging out of the side of his slobbering mouth, his right eye wide open staring into space and his other half-closed and quivering like Quasimodo who has just heard the bell ring.

'AAARRRINGHH! Yuuurgoomaaaaaa-RING! AaHHH! It's Es-meraldaaaaaaa! Come in, my dear. I am just belting the dog, or was that Bill Sikes, Jim, lad? Come in, m'hearty.'

'It's me again, Ralphael. We met at Bernard Stone's bookshop twenty or more years ago. You were printing limited and unrepeatable classic masterpieces by timeless poets with your own art adorning them. Then one thing led to another, and I got this hangover from Hell. We swore to meet again, like blood brothers, so here I am.'

'Woof! Woof! WOOF! Aaaargh! Oooaaeergh, nneeuurrgh, neeeeeuiii, burrhurr, naaaaaaaaiou-sniff!' Gavin whimpered away along the hall and down into a basement kitchen with a low ceiling. He looked as though he had been up all night and was having his breakfast.

'Champagne?' He stood by the gas stove proffering an uncorked bottle of sparkling wine from Romania. In his glass were the dregs of something pink. 'Early morning tipple,' he said, 'the cheap and the cheerful hold no dominion over me. Hair of the Afghan hound. Want some?' As he proffered an inch in a coffee cup I was looking over his shoulder towards a sealed pipkin of beer which he was 'cooking' on the stove.

I pointed to it nervously and said, 'Don't you think you should turn that off? It might explode, and it must be warm enough now as English beers go, if that's what you're after.'

'No, no,' he reassured me, 'it's an experiment. That's what the canvas is for, standing right in front. I need to see what kind of a mess it will make for me to work with as a concept. Step around the doorway there if you're nervous. It should explode at any minute. If my hunch is correct it will simply blow out at its weakest point and hit the canvas in a way that you could never achieve by hand.'

It did just that, miraculously as he was about to pour himself another pink thing, and, more miraculously still, the contents shot forward like a steam geyser, hit the canvas, shot upwards, hit the ceiling and ricocheted back towards the exposed brick wall where rivulets of Watney's Brown Ale ran down the pointing and on to the kitchen top. Gavin moved forward, switched off the gas stove and then picked up small bottles of coloured ink that he must have arranged earlier, in rows, and threw them in turn on to the dribbling canvas. 'Oh, boy!' he screamed, 'look at those marvellous nuances. Nature is having a field day. I will set it down horizontally in a mo and leave it to dry. Then when Anya gets back from the market I've got the basis of a new picture called *Anya Aqua Nude*. I can already see the flesh beginning to form, in subtle gradations of pinkish brown masses, which you can't get by other means. And look at that beer can! Pure natural sculpture! Two holes in one.'

*mital Beer Sculpture.*

He was right. On the stove sat a bottom half of the large tin can still intact but supporting the twisted remains of the rest of itself that followed the patterns of whatever natural forces blew it apart.

'I'll call that *Doorbell*,' he said, 'in honour of you. I may not have had the guts to see it through on my own. The bloody thing might have gone off before I was ready.'

He took the canvas off the easel and laid it flat on the floor to do its own thing, and poured himself another glass of pink and topped me up. Then he went to the fridge, opened it with another flourish and looked inside. 'Yes,' he said, 'thought as much. *Coq au vin* left over from a couple of nights ago, want some?' I shrugged a no. 'Good!' he said and he poured what was left into a soup bowl, hitched himself on to the counter and started to eat with the ladle. The canvas was settling down into all sorts of strange and wonderful possibilities and a kettle was boiling at the end of its wire. 'Coffee?' he said and cocked his head quizzically, then went into his Quasimodo mode again. 'One lump or two?' I followed him up three flights of stairs to his

rooftop studio. I wanted to explore his opinions of other artists and British art in general, but first I asked him how long the roof had been a studio. It looked like a recent conversion.

'It leaked,' he said, 'so I decided to do two jobs at once. I can see into our neighbours' back garden from up here. They're homosexuals, y'know. Best neighbours you could have. They make good models too. Love posing in the nude. But to be honest, I photograph them 'cos if you look at them intensely, as I do, you get nervous with yourself. It's too inhibiting and body language can be misleading. Have you ever heard the expression, "pouting your private parts"? They sort of do that, like smiling, I suppose. So I photograph them with an old nineteenth-century plate camera – that one there. It was left here when we moved in – then I work from the prints. Went to one of their New Year's Eve parties, last year, heaving with gorgeous women. Tried some exotic dancing, drunk I was, until one of my partners said to me, "You dance like a tank!" It was a man's voice. It was only then that I realised that everyone in the room was a bloke, except for Anya, so she was having a marvellous time. I think she knew but wasn't letting on. Dancing the light fantastic she had the best cover in the world! I still enjoyed it though, saw the New Year in with a 747 pilot from Hounslow, and Anya, of course, but she had got one of them in tow looking after her handbag. Women are crafty. What did you just ask me? Hmmm, what do I think of British art? It's a struggling runt most of the time, overburdened by the English obsession with convention, their overriding need to make it official so that it can be taken seriously. If it's wild it falls into another category which in its way is no longer art but a kind of fodder for media hype. Call it Hype Art if you like. That's OK because it gives the media-fed public somewhere to pigeonhole it, and in a way learn to accept the most outrageous of its hybrids as a digestible commodity. Once they have swallowed it they no longer fear it, and look for another meal, even though it's pigeon shit. Then they quite enjoy it as a huge joke. It's too embarrassing otherwise.'

'Some of it is serious, surely?'

Gavin picked up a didgeridoo, leaned on it like a pilgrim and adopted a wheezing style of voice.

'Er – being masters of trivia and island parochialism, the English don't like art, I reckon. Thinking back over my years with mud on my boots and a begging bowl, I realise now that art schools and art institutions of any kind are still thought of generally as places to stuff wasters and malingerers who can't get a proper job. Art was never an integral part of the fabric of our way of life. Anyone with serious artistic intentions has to be an embattled warrior, a suicidal stayer, a bit of a lad or lass, and weird. Sure, we are familiar with our Reynoldses, our Turners, Palmers, Gainsboroughs, Constables, Hogarths, Romneys, Coxes, Cromes, Gillrays, Rowlandsons, Fuselis, Epsteins, Lewises, Whistlers, Sickerts, Pasmores, Spencers, Sutherlands, Bombergs, Freuds and Moores, Nevinsons, Nicholsons, Blakes and Bacon, of course, but they too had to fight their way through privet hedges to ask if they could cut your lawn. A personal preference for me is Paul Nash, simply because I first encountered his work on a rubbish tip. Bit like finding a poem in the gutter.'

He tried to blow a raspberry into the didgeridoo, gave up and continued, this time speaking like Sir Cedric Hardwicke in *A Connecticut Yankee in King Arthur's Court*.

'When I was a student I salvaged from a rubbish tip in East Ham a rotogravure print of one of Nash's painted landscapes, photographically reproduced, I think, directly from the original on to colour-separated printing cylinders in the same way that wallpaper and other decorative printed textures are produced. It was torn, tattered and bent, as was myself, and had pieces missing, like me. Last year I decided to restore it. I soaked it in a home-made size and laid it on to a stretched canvas. Ironing out its wrinkles, I waited for it to dry. I painted in the missing segments. I restored it shamelessly through guesswork and it pleased me. As a lithograph it still makes me think of paint and, more crucially, it is what it is. I'd say it is a very personal statement of an English landscape. Within the austerity of the artist's natural reserve there beat a heart that craved the exotic. Yet this picture captures something of what we claim is so precious, the personification of our Englishness.

Well, I don't give a rat's arse for that, otherwise I would be cast in the same quaint role, if I am cast at all.

'What made Nash different was that he distinguished himself by expressing the landscapes of two world wars though he doubted that such power of expression was possible. He believed that the pain and personal predicament he had witnessed as a war artist in France belonged to those who had suffered it. I suspect that his doubts were assuaged by his ability to absorb and express the twisted wartorn landscapes as human agony. He must have been aware of, and receptive to, the fact that art too was in the throes of a cataclysmic upheaval. A traditionalist at heart, Nash would have found it a struggle to accept the thrust of a European experience of war. But he knew that the only way to meet the New World Order was to bend to its reality and let the flow of events impregnate his way of painting. "In the struggle lies the freshness. In the doubt lies the art." I said that, y'know. One of my very own. Twingean prose! Nevinson tried to express it. Wyndham Lewis tried as a Vorticist. But the Germans did it best, through Max Beckmann, Otto Dix and Georg Grosz. Those three particularly seemed to have accepted responsibility for the human condition head-on, and they worked to nail the culprits from Hell and vindicate the victims who survived, choosing art not as an escape but as a weapon. A confrontation without forgiveness. In Nash, however, I can sense the echoes of the conflict after a battle, an unspoken personal sadness, and in that reflective way lies its greatness, and of course its English reserve.

'The painting I found comes from a more lyrical time, and yet something happened there and is masked by the veil of nature reclaiming its own. Through the influence of Surrealism Paul Nash was able to filter his unease and offer up the fragments of a dream and maybe a nightmare.

' "British Art" is a misnomer. To celebrate it seems a contradiction. An aberration. If it is any good it has to be devoid of national priorities. It must be universal. I think the work of Paul Nash withstands that judgment. What he did he paid for. What he achieved he gave us.'

Gavin fumbled among some papers lying across bottles of ink by his drawing board.

'Addenda!' he declared. 'I have located and identified the painting. 'Its title is *Landscape of the Vernal Equinox*. It was painted during 1943 and 1944. Its inspiration comes from an actual garden on Boar's Hill, Oxford. Wittenham Clumps are in the background, which he used field-glasses to observe. He was also reading about equinox lore, myths and rituals at the time. Symbolism relating to sun and moon and especially the spring equinox preoccupied him. He was suffering from severe asthma and he was creating a dream world in a series of paintings that turned out to be his last works. The painting is said to measure 36 inches by 28 but the print in my possession measures 34.5 inches by 26 which I suspect is correct as it appears to be a facsimile copy from the original which is in the collection of our own dear Queen Mother! How's that?'

'Yeah,' I responded. 'Surreal!'

'Exactly, Ralphael, you old bugger. Nash is our only true surrealist. Can you imagine anything more surreal than the Queen Mother with a large gin in one hand and a paint-brush in the other dancing through one of Nash's war-torn landscapes lit only by the glow of a vernal equinox moon. He would have won the Turner Prize hands down at an age when he would still have been eligible – and he would have made it a prize worth winning ever after, provided they resisted the temptation to award it every year like a national lottery.'

I heard the sound of a key fumbling in the lock downstairs.

'Ah!' proclaimed Gavin. 'If I am not very much mistaken, here comes my Madonna Lisa now!'

He was off down the stairs like a dog whose mistress has just summoned him to heel. I wondered if I should wait upstairs or follow him down to introduce myself. I started down the stairs. Anya had hardly changed at all and still had that long black-hair. I was introduced, yet again, as Ralphael Steed, artist-biographer and bill-payer.

'We met so long ago you probably don't remember me,' I said, kissing her on both cheeks. 'We talked for ages about the stifling of

artistic expression in children. You wanted children to be left to develop naturally. "The exploration is part of the learning process. Their natural freedom is their strongest ally."'

'Oh, yes, I did bang on a bit. I do tend to after a few bloody Marys.'

'Not at all,' I said. 'Fascinating stuff, and you're still right. Schools just want to beat it out of kids. They don't stand a chance. Are you still teaching?'

'I do remedial teaching here at the house. Got a pupil coming along later, as a matter of fact. His name's Jimmy. A blitz of a boy. His father's been in jail. Jimmy loves coming here. Takes Gavin a cuppa up to the studio, just to look around. I often wonder if he's casing the joint for his dad. But that's unkind. I don't really mean it. Aren't you two going out for lunch to talk about things?' she said.

'Oh, shit! That's right,' said Gavin, slapping his forehead. 'I plumb forgot. I promised a return match. Why not now, if you're up for it? Didn't I say something about the Tite Restaurant?'

'You did. You even said you'd pay.'

'Oh, did I? I must have been well away. OK. Let's go now then. Fancy joining us, *cariad*?' She had preparation to do for her student, so she declined. 'Ah, sweetie. There's a bit of a mess in the kitchen. An experiment. It's the picture of you, not finished, but my approach required a kind of dynamite technique. I can clean it up before we go . . .'

Anya was shaking her head slowly from side to side, a kind of resigned but emphatic 'NO'. 'Why don't you two just go. I can manage.'

We went.

## CHAPTER 2

## GAVIN TWINGE: TITE CIRCUMSTANCES

S INCE THAT first meeting with Gavin Twinge, followed by the gargantuan drunken 'eat-in' at some hole-in-the-wall in Kensington, at my expense, the world had moved on and the original publisher had gone to the wall too.

Gavin had also moved on, but he was still having problems with galleries. His oeuvre was no longer just egg-shaped. World domination bored him. Art, for Gavin, was not about earthly (chickenshit) scratchings. Since our first meeting the muesli priorities of most had moved on to become their reason for living, but Gavin had kept alive a memory of art in flux, fractured by two world wars, shot senseless in a post-war miasma of rationed optimism and left for dead on a floor smeared with childish ideals of freedom, self-fulfilment and bright futility. Art to us was a mess. If we were honest, it no longer related to that part of us that privately demands some dignity for the human spirit. Art, like nature, drives its own juggernaut, and doesn't pay its own bills. Those who do don't have names.

I knew he still felt bad about laying half of Kensington's nightlife on my tab all that time ago and I bear a long grudge. He had made the booking for the extended lunch at the Tite Britain Restaurant, and there we were, surrounded by the 'Rex' Whistler Landscape Mural, which gives the place its rural theatricality and bygone ambience. His mother had known Whistler, he said. A Chelsea Arts Club habitué; the first, as a matter of fact, though not the Whistler who actually lived there. With the help of some lucrative English and Scottish commissions, Whistler became very fashionable and sociably easy, and was very much a crony of the art set between the wars, when art was still trapped in a circle of conservatism, with

few exceptions. The European and American movements had hardly troubled our island complacency. The public was blissfully ignorant, and 'modern' meant 'foreign' and, somehow, irrelevant. Walter Sickert was 'understood' because his Impressionism was of a local kind, accepted because it was about the good old music hall of the East End. The Camden Town Group flourished, and he was their leading figure. Augustus John forged on as a 'Rembrandtian Master' of the twentieth century, perpetuating the myth that proper drawing was 'wot 'e done'. His sister Gwen John, a victim of the French sculptor Rodin, was an infinitely superior painter to Augustus, and not such an insufferable Bohemian.

But 'Modernism' was knocking on the door of William Blake's New Jerusalem, and isms like Vorticism, Futurism and, particularly, Cubism were giving the art set cause to build new barriers to harrumph behind. The Royal Academy was still strong enough to withstand the enticements of the frivolous new wild beasts from abroad. Their ingrown Englishness and respectability held back the avalanche of 'daubs' that were building up on the steps of their hallowed portals. It was a fine arts country mansion in the heart of Piccadilly, Picasso was their *bête noire*, and Chelsea served as the starving artist's garret ghetto, 'out of town'. London's answer to Montmartre, but not too many Paul Gauguins or Claude Monets to the square mile, though I tell a lie: Monet spent quite a bit of time painting along the Thames, and Van Gogh did a stint in a fine art gallery, just a stone's throw from the Academy, trying to dissuade potential clients from buying the rubbish he was hired to sell.

This atmosphere of snobbery, and exclusivity, thinks Gavin, stifled the genuine revolutionary spirit of Wyndham Lewis, Stanley Spencer, Henry Moore, Paul Nash, David Bomberg, Gaudier-Brzeska, Epstein, Ben Nicholson, William Scott, Victor Pasmore and, of course, Francis Bacon, a fierce, figurative vengeance, as much against abstraction as any specific feelings about the English. In fact Bacon wallowed in his 'Englishness', probably because he was Irish, like Oscar Wilde. There were so many others, for years, before the dam broke and gave English art a newish voice, and the evidence that we

were in fact in the middle of the shining new Machine Age after all. The esoteric struggles between Abstraction and Form, Utility chic, Mass-production and Constructivism, Social Revolution, World Wars and the vexing question, 'Whatever happened to the Industrial Revolution here in England?' The Poor, the Irish problem and rickets left English art with a hesitant, nervous twitch. Overpowered by social change, it turned inwards and appealed to the Élitists and the Rich Leftovers of a once-great Victorian Age, during which the Pre-Raphaelites and the Symbolists reigned like Greek gods.

In the wake of the Oscar Wilde scandal and his appeal for a new Aesthetic Movement, of William Morris and John Ruskin, there was a powerful surge of book illustrators like Heath Robinson, Edmund Dulac and Aubrey Beardsley, but the world of 'fine art' remained steadfastly academic.

'It became quaint,' said Gavin, 'in a newer, more desperate world of Communist Upheaval and Fascist Insurrection. It was no longer "cricket" (or even rickets! Ha! Ha!) and Empire was swept away. Ninety per cent of English art was self-aggrandisement of Empire anyway, and so had no role on the new world stage. Political invective was at its most virulent in France and Germany, where new art was thriving, through Karl Kraus in Vienna, with his satirical magazine, *Die Fackel*, Georg Grosz, Otto Dix and Max Beckmann, the Blaue Reiter group, the Fauves, Alfred Jarry and Brechtian Theatre, in the rich mulch of Anti-Semitism and Fascist insanity. The Dada movement and Surrealism, held together in Cubism, and in Zurich of all places, was proving to be the most insane show in town, and in Berlin too, the only real threat to mind-numbing ideologies of the new state. It was beginning to grab the Americans, who were coaxing all the best talent to go over and live the Dream, though it has to be said, fear of annihilation played a great part in that hasty exodus, particularly after Hitler's *Degenerate Art* show in 1937, and the burning of books. It took two world wars to shake the English out of their rural charm, but that is when England is at its best. When the rest of the world is pissing up the wall, the English have got their backs to it, and then they are second to none.'

Was he telling me this, or was I telling him? A bit of both, I think. Our lunch conversation seemed to float along against this nostalgic rococo backdrop. Gavin loved it that artists were still wanting to paint, but he realised, pretty early on, that painting had relinquished its dominant role in the arts, and taken its place next to basketwork, weaving, pottery and home-made jam. The advance in photography, and particularly film, dismayed the English, who were making 'cuppa tea' comedies (Gavin's phrase), and wet street murderlogues (Gavin's word!). In France and Russia – and America, it has to be admitted – real artists like Salvador Dali and Luis Buñuel were experimenting with surreal films like *L'Âge d'Or* and *Un Chien Andalou*, and D.W. Griffith was making spectaculars like *The Birth of a Nation*, Fritz Lang was making *Metropolis*, and Eisenstein in Russia, in revolutionary fervour of the best kind, was forging *The Battleship Potemkin*. Abel Gance was using complex dissolves in his five-hour *Napoleon* epic. 'And don't forget the French cinematographer and illusionist Georges Méliès,' said Gavin, 'who invented, single-handedly, all the special effects which are still used today.'

But no, not here. It took ages to realise that film was art. Film over here was mainly propaganda about rationing and getting the Royal Mail up to Edinburgh, though it did give some paid work to one of our greatest poets, W.H. Auden. After that, and in spite of Alfred Hitchcock, tripping up *The Thirty-Nine Steps* to Hollywood, it was films to help the war effort and pipe lagging and Anderson shelters. But it wasn't for art. After all, art was still Art, dammit, wasn't it? No. Somebody had pulled the carpet, and left figures in a landscape staggering to stay upright, like honest, failed folks in a Lowry landscape, wallowing in self-denigration, and perky comedy institutions on the wireless, to keep the chin up, while they fought the most heroic battle of self-defence in the history of the world. But somehow, art took a back seat, or joined the military, to make it meaningful. Artists like Stanley Spencer drew the throbbing shipyards on the Clyde, Henry Moore caught the unifying mood of the blitz with reclining figures sleeping in makeshift dormitories down

the Underground, and Paul Nash painted haunting images of desolate battlefields, and later a crashed Messerschmitt in Hyde Park, a worthy work of Surrealism, but prized more as a morale-boosting image to put Gerry in his place; though nobody really wanted the poor bastard in that particular place, if you don't mind! 'The English don't like art,' said Gavin, and he reiterated that belief on several other occasions. At first I suspected that the statement may be masking a case of sour grapes, but as I thought about it, I realised that while the English love their proven 'eccentrics', whom they can safely categorise, artists make them feel uncomfortable and inadequate, because they feel that there is something they have to understand, but they don't. They don't understand, and they don't have to. They won't allow their irrational instincts out of the bag, in case they are being taken for a ride. That would never do, so they coat themselves in thick, treacly Philistinism; the only ism with which they feel completely at home; that, and worthy institutions, full of our past proven achievements; something to boast about rather than understand.

Gavin wasn't begging to tell me much about himself, at all, but he seemed eager to see that I had everything I needed, and plenty of good wine. Wine seemed to play a major role in his life, and he went out of his way to make himself an authority on the subject, more by physical involvement with the hallowed nectar than by the intellectual *modus operandi* preferred by a true Master of Wine. And he spoke a lot about failure; failure as a subject of interest. He told me more about his early failures than present projects, and I think he was going to make me dig for those.

'Writers and scribblers – not a lot of difference really,' quoth Gavin.

Gavin displayed an irrational admiration for writers, which I suspect was not only unwarranted but based on fear. Fear of the fact that he himself is dyslexic, writes also, but only to mask what he thinks is his 'landscape of ignorance', and because of a severely curtailed education, brought on by his hatred of authority and institutionalised teaching methods, sadism in the classroom, dullness

in the teachers, who, though well-meaning, transmitted that dullness through their own inadequate attempts to create for themselves.

'Teachers pass along dullness as "wisdom",' said Gavin. 'That is their weapon – the approved means to an end for defeated combatants, still fighting but only to maintain their superiority in the classroom, left behind by a world that has time only for the exceptional and, perversely, an appetite for drivel.

'I have always assumed that they know everything,' he continued, 'and have massive intellects, if not grandiose scholarship, to reinforce their status.'

'Teachers?' I pressed him on that contradiction.

'Good god, no! Fuck teachers! Much as I respect them for having to deal with gangs of wilfully energised thugs whose only ambition is to jerk off in French and fart in Latin, they belong in the Common Room.'

'Well, who then?'

'Writers, of course. They have always had more experience, too, more experience than anyone I have ever met, according to their books; and their names open doors to the great and the good. They seem to know everything: best wines, hotels, a deep knowledge of lemurs, and appear to have managed to survive enough sexual exploits to shame a stallion on a stud farm.

'They are sensitive, wise, perceptive, and they always project a ready wit at precise moments that takes a reader's breath away. Sophisticated? Wow! They know it all, and even if they didn't, they sure as hell do by the time a chapter is proofread. They know about art too and drop the occasional name just to flick off any lingering doubt a reader might nurse. Of course they know about art when they are writing about it. Everybody does, even those who don't know about art but know what they like, have an opinion about it, and express it with the certainty of a barstool lawyer. But can they DO it? Can these writers DO what they so flamboyantly KNOW in words? And another thing, they are as nice as pie when they need a drawing to illuminate their deathless prose, and their editors too, nice as pie, until they get what they want. Then writers strut and

preen themselves like cockerels with shot silk feathers. "What about a Goya on the cover? It will give my book classic authenticity. What I say has never been expressed before. I need to personify the main thrust of my book – man's constant inhumanity to man – or, human, all too human. That's it! Something like that. How about Hieronymus Bosch? He displays everything my book needs, and there's no copyright fee, is there? So you're home and dry. I can wallow in that, but put my name above the title. Not gold though. Gold looks cheap on a cover, unless you think it sells a book. Oh, it does? How many copies, on average, does Danielle Steele sell? Oh, really? Many as that? OK, use gold. I just need everybody to know that my book is precious, and has depth and irony."

'And keep designers away from an image. Or they will grind anything you do into a hamburger, and take credit for it like a TV master chef.

'Pisses me off! So if you need any favours, ask before you give a writer anything. They'll be far too busy later, swanning around on book promotion tours, and so will their editors. Stroking the lamentably insecure, the "first novel"-ists, and gushing out PR like tape recorders on the blink.

'OK! Writers are special. Let's agree on that. Language is the acknowledged superstructure of all culture. But can writers *do* art?'

'Well, there are a few, but I can't think of many, I admit.'

'Tom Wolfe reckons he can, but you can tell he is a writer. He draws like he is composing a handwritten note to a fan.'

'Er – how about William Burroughs? He was pretty good, dabbled better than most. His unfettered spirit dared his impulses to perform, and he wasn't bad as long as he could shoot his way out of an inanimate object at two metres.'

'Yeah! As long as he made sure he had killed the thing he loved, he was ecstatic. That kept alive the idea that he was an artist after all – 'cos he just destroyed the evidence! – which is the enigma, and therefore the art. Like Hunter S. Thompson. His attempts to create a certain perceptive elegance give his work sophistication. I always noticed that. He blasts bottles of colour on to two-dimensional

surfaces with a small-bore shotgun, which energises what's left of the image – and the bottle – and it is probably the only way that it can be done. Pure expression. That's art. Kurt Vonnegut, another great writer, loves to draw, not because he is good at it, mind, but he applies his imagination to an activity that mystifies him, and satisfies something in his primaeval spirit that would not be touched in any other way. That's art. Now, Victor Hugo was different. He was brilliant in a way that shone with an obvious draughtsman's ability, like Honoré Daumier. That is the difference. It is still art. Lewis Carroll was amateur but interesting. Max Beerbohm was on the cusp, both a writer and artist in equal measure. But as a general rule I can say without qualification and no qualms at all that artists can write better than writers can draw. It has something to do with controlling imagery, in the single frame. An image is like a cauldron, a self-contained statement, loaded with glaring ineptitude, but nevertheless captured, then spewed from the pot and ready to eat. Don't change a thing. It is speaking for itself, and the punctuation has dissolved and is within it. It has form, texture, ambience, intention, plot, mystery, taste, and inscrutable silence. It cannot be read, but conveys a world of meaning, without explanation. No writer would acknowledge such a claim. It is too awe-inspiring a concept – and belittling too.

'Asked to collaborate with me, the great writers William Burroughs and Hunter S. Thompson responded with characteristic malevolence. What did they contribute to the creative partnership? They shot my work to bits, that's what they did. Bullet holes everywhere and a jealous whim in every one. It is terrible to watch an embittered writer who knows when he is out of his depth.

'Think of the writers all twisted and gnarled inside with a crippled desire to be artists. Poor devils. Ugh! It doesn't bear thinking about, all frothing at the mouth realising what could be done if only they had connections. But that is the twist of fate, and it is probably better they stick to their paltry pursuits and panting editors and leave art to the professionals.

'That is a truth that will never be acknowledged, otherwise it

would render the writer inadequate, and – frankly – redundant. It would leave one-tenth of the world's population without a job or, worse, devoid of any meaning in life whatsoever. Industries would die on the spot; drawing, and imagining, our thoughts are quicker; reading is unnecessary and, what's more, a fucking waste of time. How's that for devil's advocate? Drawing was how we communicated before there was language. Now, has language helped us to understand each other, or has it just been an ugly obstacle, used by most as a blunt instrument to abuse and control?'

'Yes, but –'

'But, but – the truth stares us in the face every time we see early signs of pictorial representation, no matter how crude. It speaks to us across time, silently, and we imagine our personal interpretations, which are received pure and unadulterated.'

'Then the Egyptians got it just right when they developed hieroglyphs. That seems like the kind of balance you are talking about. But they spoke too.'

'Ah, maybe. But they would have used metaphor inventively, and been in touch with a visual vocabulary, which may even have been sacred. It was carved in stone. Or maybe, silence really was golden, and the only sounds one heard were the screams of slaves in distress. There was nobody taking notes, as far as we know. What we know about the Egyptians, the Assyro-Babylonians, the Hittites, who incidentally used to bury their architects and wise men in the foundations of their sacred monuments, and the Greeks, of course, in fetishism, through trees and animals. Stone worship, and the cult of pillars and axes. Word of mouth. Phoenicians, phonetics. But, that's where the trouble started. Socrates began to write things down, and written language became a new divisive weapon. Those who could write, and those who couldn't. Have you ever thought that written language was a form of élitism, even a secret; a form of passing on information to a chosen few, the few who could read in the rarefied realms of academe? And down the centuries that élitism has survived in the hotbeds of learning for those few, who still wield knowledge in writing, to control and exclude. Literacy as snobbery.

Caxton was the Devil incarnate! Ooooh, I love to go down that route and rile the writer. Pictures were never exclusive, well, not until gallery owners, anyway, but that's a whole other story.'

'True. I know you were referring to the essence of these activities, and your theory about a preferred method of communication, which it essentially was, rather than art.'

'The times we are talking about wouldn't have the concept of art like us. Most was for adornment, which is interesting, because man has always liked to decorate in order to intimidate or intrigue, but it wasn't art. Practical too. The tribe's artist would draw the beast the tribe was about to hunt. They would exorcise their fears before they did, as a kind of ceremony. The animals are always personified in profile. Have you noticed? Which is how they would attack – from the side. Only a suicidal daft bugger would tackle a bison head-on as it thundered right at him. So that would have been its purpose – identification. No good going out to hunt if you don't know what your prey looks like. It might be standing right next to you. And bingo! You are history. It's like Marcel Duchamp's theory – that it depends what you mean by art, if art must be defined at all. Each age has its own idea of that, which is often expressed as good or bad taste. But that is something other than art. Art means "to make". Something is made, but is it art as we wish to define it? We seem to crave a definition, which Duchamp saw as a trap, which makes him probably the most important artist of the twentieth century. His question – 'What is art?' – was left unanswered, of course, which gave the artist licence to create his own art – something made. Something entirely his own.'

'You make it sound so simple and clear-cut.'

'It is simple! Apart from the endless catacombs of human reason. There is no reason! Man invented "reason". Man is the consummate asshole who needed "reason" before he could move his middle finger to stimulate an erogenous zone. What a different world it would have been if man hadn't attempted to improve himself. We might still have had air to breathe, rivers to drink, and places to go that were still wilderness.'

'But that's not a writer's fault. Artists would have moved things on much quicker, if it's true that one picture is worth a thousand words.'

'Oh yes it is their fault! On one picture alone, millions of words have been written, by thousands of writers, and each one with a different interpretation. Interpretations which, most probably, had absolutely nothing to do with what the artist was trying to say. There is a catacomb, right there. The artist meant something else, perhaps, but he was considered not qualified to say. To do that, learning is required, scholarship, a privileged position of authority, and a widely read arsenal of wisdom. The artist most probably couldn't read, so he remained silent witness to his own creation – just like God! Ever heard a word from Him? Never! The less He says, the wiser we deem Him to be. Smart move. He is probably an artist too, did the best sunsets we have ever seen, created the humming bird, the butterfly's wing, and the Heavens, but He can't speak, can't read, never got a degree in philosophy, and wets Himself during the rainy season – but Man has found more ways to worship Him than mock Him. Come to think of it, the way religion manifests itself, we might just be doing that too. I've had enough of this. We'll carry on, but at Tite Modern next time. Your turn.'

He picked up the last of my rolling tobacco and papers, and was gone in a wisp. The waiter bore down on me holding out an unpaid bill on a silver saucer.

'I thought Mr Twinge had already paid on the last bottle.'

'That's not his style, sir. I think this is your department. Thank you, sir. The toilet? Right ahead the way you came in, sir. There are bars on the window. A Plumbing Sculpture, you might say. Gavin Twinge designed it himself. The significance escapes me, but it has something to do with his ancestors, so he says. Have a nice day.'

## THE NINETEENTH-CENTURY ANCESTORS: THE COLONIC LEGACY

I F I HAD asked Gavin once, I had asked him a thousand times: 'What are your plans now?' He rarely answered directly, as though there were no answer. He would rush off down one burrow or another in his studio, like a ferret, shuffling through reams of crudely written notes reminding him to do something, a brief outline of a new concept like shorthand, a scribbled sketch, in case he forgot, and he often did. Then filing cabinets would be opened, full of what I suspect was his 'archive', and he would riffle through file after file as he talked, addressing anything but the direct question.

On one occasion we were talking about heredity – had there been anyone in the family before him who might have been artistic? How far back can you go, and is it genes or experience that shapes the person? Is one born gifted, or is that learned also through bloody-minded effort? Is genius, as Leonardo da Vinci postulated, the capacity for taking pains, or are things just so easy for some that they hardly have to try? But doesn't that bring with it its own kind of pain, its own brand of loneliness? Something in what I was asking made him go silent, then he was off once more, shuffle, shuffle, shuffle. He dragged out from beneath other files a typewritten manuscript, crumpled and faded.

'Funny you should mention heredity. I tried constructing a potted history as the beginning of some fanciful idea to write a book. It was a swine to get into at first, and then it seemed to take on a life of its own, another voice, as though I recognised it. It's all true-ish! It was almost as if I had been there, eavesdropping on intimate lives in another time. Here, take a look while I go and do a couple of things. I've got a little experiment I want

to try, spraying nitric acid on to steel plates and letting it bite the metal in its own way.'

Gavin handed the typescript to me and I sat down on his drawing stool and read.

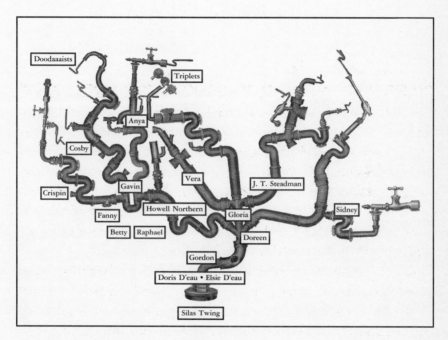

'Nowt wrong wi' 'ole int ground, lad!' A rotund, bellicose man, an arch-nineteenth-century industrialist by the look of him, with a mobile nose resembling a large articulated prune, was advising a stiff-collared young man standing before him. They were in a gaunt panelled office, which had a large studio window looking out over the industrial hangars below, the source of all the wealth pouring into the coffers of this self-made captain of industry. 'Ah knoo when they started putting up all them grid-iron terrace 'ouses ft'cotton workers in towns like Burnley and Blackburn every one of 'em was goint ter need place to shit int back yard, ant where's t'muck there's brass, lad.'

The big man was Silas Twing, a rough opportunist who claimed to be Lancastrian, but had a strong Yorkshire twang in his crude talk as he explained the facts of life to his 'nephew', who was actually his bastard

son, Gordon, about to begin work for his father. Urban development
had brought with it new problems. Social institutions evolved to deal
with new pressures. Measures to regulate public health and provide
basic sanitary and housing amenities had to be implemented if
widespread disease and pestilence were to be avoided. Twing was
in there like a shot, or 'like a rat up a drain' as the phrase was coined at
the time to describe Twing's meteoric rise to wealth and public esteem.
Twing knew nowt about cotton but he knew that sooner or later
everyone was going to wear it somehow, the Industrial Revolution had
seen to that, and Lancashire was bursting with new cotton mills and
cheap labour. As far as Twing was concerned, that labour force was
going to have to succumb 't' call of nature' sooner rather than later and
he would be there to provide a workable system. Twing had had
enough of petty theft around Leeds, where he was born, and as luck
would have it he had just raided the new town hall to test its security.
The wealthy new city had seen fit to install a posh library for the new
gentry of the mining fraternity. Apart from Gibbon's *History of the
Decline and Fall of the Roman Empire* they had accumulated a fine set of
the relatively recent phenomenon *Encyclopaedia Britannica*, compiled
by a 'society of gentlemen' in Edinburgh who wished to engage the
new rich in a pastime of self-enlightenment, whether they could read or
not. There was a broad concern growing that the new wealth would
engender sloth in their class if 'the Devil got hold of their idle minds'.
They must be seen to be busy and worthy of their strange new status.

   Twing stole the lot – 'wished 'e 'adn't, glad 'e did', as he put it –
and took them home. He reckoned that someone would pay a pretty
penny for such ' 'andsome furniture'. Curious as well as energetic,
Twing looked through the massive tomes. He had learned to read
when he first saw a notice which read PRIVATE PROPERTY, and went on
to KEEP OUT, then DANGER. FLOODWATER; PUBLIC HANGING, THIS THURS-
DAY; TRESPASSERS WILL BE PROSECUTED; BANK OF ENGLAND, on currency,
followed by 'Promise to Pay the Bearer on Demand, the Sum of One
Pound'. By the time he was sent to Botany Bay for five years for affray
– grievous bodily harm against a 'Peeler' while resisting arrest, and
fouling his cell – he could read his own rights.

Twing pored over the huge books. In Gibbon's *Decline and Fall* he read that ancient Romans had been far in advance of the moderns in respect of sanitary regulations, for they took especial pains to secure these two great necessaries of urban life, an abundant supply of water and efficient drainage. He read that covered drains of great magnitude and of solid construction still exist beneath the streets of some Roman cities, and the cloacae or sewers of Rome are of such vast size that some have supposed them to be the remains of a city more ancient than Rome. He read that the drainage of a large town which is then poured to waste into the river which passes through it, poisoning the waters and rendering the air pestilential, would, if properly distributed over its banks, bestow upon them unbounded fertility. But when Twing read that the excrementitious matters produced by each individual may amount to an annual quantity equal to one ton in weight, and that the other matters included under house sewage may amount to a similar quantity, and amount in total thus of two tons per annum, for every individual of the population, he knew he was on to a winner. 'Shift that lot, mate!' was the persistent voice whispering in his ear. Knowledge was a wonderful thing, he thought, as long as you knew how to exploit it. Twing had already established his formula for success. Knowhow + Need = Exploitation × How Many divided by no one but Himself = RICH.

*Encyclopaedia Britannica* was an altogether more generous fount of knowledge. It was defined as a Dictionary of Arts and Sciences compiled upon a new plan in which: 'The different Sciences and Arts are digefted into diftinct Treatifes or Syftems, which are explained as they occur in the order of the Alphabet'. Twing embraced the new system and within twelve months he became a self-educated man. The first editor of *EB* had been a local Edinburgh printer, William Smellie (1740–1795), who unwittingly became the sticking mast upon which Twing fixed his destiny. He dutifully returned all the fine books to the town hall and was handsomely rewarded for finding them. He bought a stout pair of boots, a suit, top hat and silver-topped stick. He took the Roman Road, walked to Lancashire and never read another word.

His bastard son, Gordon, on the other hand, had received a gentleman's education, absorbed much current wisdom and was already pestering his father for funds to help him to develop a system which filled his nocturnal thoughts – a water-closet.

Gordon had been a sickly lad; shy, but with an intense interest in practical things. He had been brought up by his mother's sisters, Elsie and Doris, while his mother Elspeth got to know the colour of every doorstep in Burnley. She had scrubbed and pumiced her way up from scullery maid until she reached the doorstep of Silas Twing. He saw her backside from his drawing-room window, saw it as an omen of rare beauty. She never had to work again but preferred working to sitting indoors listening to Twing eulogise about his empire of drains. Without rancour she put Gordon into the care of her sisters and went back to scrubbing to maintain her self-respect and keep her hand in. She became known as 'finest scrubber int' Weavers' Triangle' and had been known to scrub as far as Rochdale. Twing never made an honest woman of her but made sure that the lad was provided for. From an early age Gordon was fascinated by his own bowel movements and devised an overhead bucket on a fulcrum and lever principle which instantly washed away every scrap of evidence after inspection. While being effective in that respect it also soaked everything in the near-vicinity. It was an improvement on the quick bucket carried from the nearest stack pipe but only just. He began to work on a system of water containment for a more exit-efficient transport of solid substances in liquid form. He realised that there's nowt so bacterial as blocked drains. Stuck and stagnant excrement and even innocent waste products are the mothers of typhus fever, the contagion of the masses. Most, if not all, of the new housing specially erected for the shelter of a new and abundant workforce, refugees from other kinds of poverty and exploitation, still suffered mainly from dark, damp conditions which harboured the procreation of the deadly bacillus.

Silas Twing, in his fervour to make a fortune, overlooked the main fault inherent in his system of drains. He had forgotten in his reading of the *Decline and Fall* that while drains were an essential exit for all

unwanted matter, in as discreet a manner as possible, a vehicle to speed that action was crucial. The essential ingredient for all forms of life is water and without that ingredient life is futile. Equally, the need for water to flush away the results of the most menial of appetites was vital. The predicament visited upon populations was essentially a fever of the poor, known as putrid, hospital, ship and jail fever for obvious reasons. Gordon Twing realised this only too well and set about his experiments in earnest. Water, which had been introduced into housing complexes, was being shared at stack pipes between several families. Its use did not extend to utilities such as the Twing Shithole (patents pending) int' back yard. Silas Twing relied on the piss and washup water principle: folks have to drink, they have to eat, and someone has to fetch water from stack pipe in bucket to swill off the remains from crude utensils, after which they hurl the scum-topped liquid down th'ole and piss on it. No one was allowed to piss ont' yard. The labour force was dying like flies. With his father's influence and his own ambition, Gordon Twing convinced the doubtful group of respectable industrial city elders that they would lose less people, their main natural resource, if Gordon was allowed to try out his piped water supply. He would have it contained in his newly developed water-closet until needed on site for the necessary finale to a day's activities. That, and his own observation that women loved to gossip, were the key to his own fortune. Multi-seat water-closets were his great breakthrough and women would sit for hours and discuss their filthiest fantasies, whether at the mills or in the home. There are some things that can only be said in certain circumstances and the water-closet was the place . . .

With the advent of the brickbuilt shelter to house these receptacles and an aerial system of continuous venting, Gordon preoccupied himself with the advantages of different forms of base receptacles. His first important design, the pan-closet, was considered a most efficient fixture. The pan-closet consisted chiefly of the bowl, the receiver of the waste, the pan beneath, and a system of levers for operating the pan. The waste entering the bowl fell into

this pan which contained just enough water for containment until the occupant had finished. Then a system of levers was used to upset the pan and throw its contents into the receiver. The problem was, that large areas of the pan were left unwashed and, consequently, a cause of likely contamination ensued, the mainspring and provocation for all of Gordon's endeavours. He tried valves and plungers for directing jets of water. These became cumbersome and especially indiscreet for those in communal water-closets who were preoccupied with more pressing pursuits of the day.

Then Gordon Twing experimented with 'long hoppers' in an attempt to distance a user from the appliance, depending for its 'trap' on his revolutionary S-bend located directly below. This system was dependent on space available to accommodate its contraption and was not popular. The 'splash' factor was considered the biggest drawback and so Gordon tried and tested the 'short hopper' with augmented S-bend integrated into what he considered to be his 'porcelain masterpiece'. Queen Victoria is rumoured to have availed herself of such an appliance at the Great Exhibition of 1851 at Crystal Palace but complained about the excessive ornamentation displayed around the rim of the convenience at her disposal.

It was back to the drawing board for Gordon Twing if he was ever to overcome what was obviously the lowpoint, the *cri du bas*, of his pipe dream. He decided to concentrate on speedier water disposal, for therein lay the secret of substance evacuation. Feel low – think high. He turned his attention to a specific constant – gravity. Even though space was still a factor in his calculations, nature was the spur. 'What the Hell!' he reasoned. 'Perhaps one day he would be invited to serve the 'big houses', which were springing up all over Burnley and the north-west of England as new wealth grew like fungus on wet manure.

The process of evolution continued for Gordon and his next development was the Washout Water-Closet. The water is contained high above the user, and a simple ball-valve, operated by pulling a chain, released the waterload in a great gush which swirled over the waste matter, sweeping it off the bowl and around a bend into the

trap. However, the Washout method was seen to have certain serious defects. Without a flushing rim, water and contents shot out of the pan with disastrous results. Gordon fitted a flushing rim, a trap within itself, and the water plus the contents would be pressure-fed under it, causing many of the solids to remain around the rim while the water would simply disappear around the trap and down the drain. A more direct method was needed, and Gordon's next idea was to retain the flushing rim but direct the water around it first before it lost momentum, which then went straight down the pan and away round the bend taking all solid matter with it. It worked like the twinkle of a fairy's wand and the Gordon Twing Washdown Water-Closet was born and patented. Although that had been Gordon's first idea, he had rejected it as being too simple to work, but conceded that simplicity must be his first consideration in all things. Gordon prospered and, for the next ten years until 1870, served every new factory village from Giggleswick in the north to Oldham in the south. Wherever his dad laid drains, Gordon laid pipes.

It was about now that Silas suggested Gordon should find a comely wench to share his interests, nowt too fussy, but a lass who

could provide him with a son and heir to 'perpetuate the flow', as Silas put it. A couple of daughters to demonstrate any new developments in his refinement department would also be a bonus. His aunties, Elsie and Doris, were consulted and they set about listening at all the known conveniences around Burnley, most of which had been designed and built by Gordon Twing himself, but life is full of such ironies and thereby hangs the tale of how he met his grand passion, the femme fatale of all his patent dreams . . .

Once a week Gordon paid a visit to his two aunties for tea, and they filled him in about the young ladies they had heard talking and gossiping in their haunts. Curiosity had indeed filtered down among the teeming groups of lasses, who speculated about the identity of the one whose name was upon just about every convenience any of them used. Some thought that he must be a lord by now, or at least a privy councillor, certainly rich, and probably married.

None of these things applied. Gordon remained desperately impoverished in comparison to the speculation about his love life. There was not even a sniff of it and Gordon was already forty-two. But all was not lost and the gist of romance was all but upon him.

His experiments with ballcocks and siphon plungers necessitated a trip to Ramsbottom & Son, a chandlers and hardware store, one of many that had opened up in the wake of the Twing sanitation revolution. He pushed against the door. There was a gong-like sound above his head which he himself had activated as he entered. He recognised one of his own long hopper designs hanging there surmounted by a levered frying pan, the signal of entry. Behind a long wooden counter was a range of drawers reaching to the ceiling, with an item of the plumbing trade fixed to the front of each drawer, as a ready means of identification. The shop was deep and dark and Gordon could just make out stable sections, which contained samples of every one of his hopper designs. The ceiling was a catacomb of earthenware drains, strung up with a system of wires to display the variety of drainage applications, every one of which was eerily

familiar to Gordon Twing. Drum traps, Y-joints, flushing valves, loop vents, overflow exit standbys, S-bends, tray wastes, suction rams and Fuller faucet balls.

A polite cough startled him out of his reverie. Gordon peered towards the counter behind which stood an expectant Mr Ramsbottom senior. At least Gordon thought it must be Ramsbottom senior, on account of the flushed blue features of a man in his late fifties who had obviously imbibed his fair share of Slaithwaite's Brown Ale in his time.

'Good day, sir, and how can I help you? We rarely see the likes of a gent in our humble establishment, unless we were looking, were we, for William Morlings, the hatters, five doors down on the left. He fitted me up with a topper fit for a toff. I think my late dear wife would have been appreciative of the generous workmanship lavished upon such an august crown.'

'I am looking for ballcocks, specifically ballcocks in copper, polished copper. Do you keep them in stock?'

'We have ballcocks of every dimension, sir, every diphthong and every plunge tolerance. We have them in brass. We have them in copper. And, if you will believe, sir, we have them in alabaster, for those of a discerning proclivity. Many good people have seen fit to accommodate the er – Aphrodite range of sanitary appliances in their commodious abodes, and a more handsome sight would be hard to equal. In fact, sir, we have installed an Aphrodite Suite at the back of this very establishment, for the purposes of demonstration. I perceive that you are a gentleman of refined tastes and perspicacious with it. If you will allow me to er –'

'But I am in need of a certain ballcock for a plumbing ordinance of great import and do not have the time to –'

'Indulge me, sir. You will be the first outside our own respected family circle to gaze upon the "pee-ace duh raysistance" of the plumbing fraternity – Bath of Aphrodite! Follow me, sir, if you would,' and without further ado he rushed into the blackness at the back of the shop, stopping only at the base of a crude curtained stairway to shout up, 'Doreen! Customer!'

Gordon was, if somewhat alarmed, curious to see for himself what on earth the trade was beginning to steal from Greek mythology in the name of sanitation and, worse, in the name of household elegance.

Gordon caught up with Mr Ramsbottom, whose neck was glistening with beads of sweat, the viscous evacuations from last night's Slaith-waite's Brown, brought on by the excited exertion of showing the very first member of the public whatever it was that he had been at pains to dream up. The premises seemed to go on for ever until quite suddenly a heavy damask curtain was drawn back revealing another world and one that took Gordon Twing quite by surprise.

Everything Gordon looked at was alabaster, a plunging vision of plumbing excellence, the likes of which Gordon had not seen before, except for an exact replica of his own latest Siphon Washdown Water-Closet, all made in alabaster – all, that is, except for the copper pipework which had been polished like golden sunrays. And he could not help but notice his own name upon an oval brass nameplate shining like a kitten's eye.

'Well! What do you think, sir?'

'It's er – well – I am overwhelmed and er – perhaps I ought to reveal to you just who I er –' He stopped, for his gaze had fallen upon a vision, pulchritudinous, ample and inviting. A young lady lay in languished insolence, swaddled in ruby-red velvet, which had been thrown as a drape into the alabaster bathtub, an artefact in itself, of great beauty . . .

'This is my daughter Doreen, the epple of my eye, sir, who aids me in my endeavours, to convince the gentry of this most efficacious sweep of elegance. We are at pains to demonstrate the benefits of

such a contraption, compared to, say, the under-bed commode, and tiresome maid, who is never there when you most have need of her. That such elegance can be displayed as an interior feature, let alone a utility convenience, for the most extravagant premises known of our favoured population, can only excite transportation to a new level of luxury. Ee – I-eh – are you all right, sir?'

Gordon's mouth had dropped below his high stiff collar as his mind tried to grapple with what it was his eyes were absorbing. His mouth indeed resembled the very latest washdown closet of his own itinerary . . . Doreen, it has to be said, was doing her level best to preserve her modesty, while at the same time allowing a hint of petticoat to protrude outside the red velvet drape, though, had there been time, she no doubt would have had on show a teensy-weensy flash of her *tour de force*, northern buttock. This was not necessary, however, under the circumstances. Gordon was immediately cast beneath her spell. The ballcock was all but forgotten amid the soft yielding promise offered up by the ample forms of a bathtub crafted to smooth perfection out of one block of alabaster, the choice of the gods. To be displayed with such Byronic opulence and abandon all around him, was as though he himself were a figure inside a painting, possessed by sirens, which left him speechless.

'Doreen, love, cover yourself up. I think you have amply demonstrated the practical dimensions offered by our new range of de luxe installations fit for the Queen of Sheba. Mr – er, Mr aaah may I er – you were about to give me your name, sir.'

Gordon took his gaze off Doreen for a moment and turned his head towards Mr Ramsbottom and, as though in a trance, murmured, 'How much, Mr Ramsbottom?'

'Well, bless me, sir! Which item were you referring to, sir? The Aphrodite Bath? The vanity basin, with integrated taps and overflow connections, or the famous Twing Washdown Water-Closet with carved walnut seat, in two sizes? We can offer favourable terms, complete with installation. We can arrange transport within a twenty mile ra –'

Gordon had turned back to the bath and pointed towards Doreen, who was struggling to clamber out of it, and hanging on to the beige rubber curtain which came as an optional extra. She had gathered the velvet drape around her form, but was having difficulty getting her leg over the side. 'For her, Mr Ramsbottom, how much for her?'

'Doreen is not for sale, sir. Er – were you thinking of buying the whole suite?'

Gordon turned again to Mr Ramsbottom, and fixed him with the steady stare of one who has seen Jerusalem. Then he spoke very slowly and deliberately. 'The whole suite, Mr Ramsbottom, the whole suite – and the whole establishment, and if your daughter comes within the confines of those parameters, Doreen too. I would like to ask you for your daughter's hand in marriage – I –'

'But we hardly know you, sir, your prospects, your name. This is most unexpected. I –'

'Well, sir, you are the architect, the catalyst, of my destiny. It was you who insisted on my entering the world of your installation. It was you who drew me into your fantasy. You already detect, I think, that I have an interest in plumbing, and I would presume to add that I have an interest in plumbing second to none. Let me introduce myself. I am Gordon Twing, Inventor and Washdown Closeteur. You yourself are indeed trading on my closet. Your techniques of enticement, I might add, are second to none also. They hold me entranced, Mr Ramsbottom, and I compliment you on your con-siderable enterprise. However, sir, I hold your daughter Doreen in even greater esteem. I would go so far as to say, there is no receptacle, no hopper, long or short, no self-closing faucet, no pan, no siphonage inducer, no S-bend, no elegant sweep of the plumber's art, no – er –

flat backwater trap, ferrules or nipples, or, indeed, plumber's wipe to compare with the feelings welling up inside me as I speak. I have found my Aphrodite, my Aphrodite at last! Your Doreen. I implore you, sir, you must have been in love yourself. You mentioned your own dear wife as I came into these premises.'

'Aye, now you come to mention it, dear Hilda, rest her soul. I met her at fun fair. I was worse for wear at time and she were the prize, as it were, at side show. She were posing, not unlike Doreen, gets it from her mother, does Doreen, and I were a bit of a lad. I saw more than one bull's eye. I'll tell yer that. But when I threw that wooden ball I got a hole in one. It must have been a lucky shot. It dropped her straight into the tub of water below. It got me into plumbing, did that. I don't remember what happened next, I were too far gone, but we were married within year. St Mary's Church in Whalley. Lovely church. Used to sing in choir. I remember the carvings on one choir seat where I sat. It were of a wife hitting her husband with frying pan. Made me laugh, did that. Though she never hit me, nor me her. You might have noticed my contraption as you came in. I contrived it as a token of our love – humorous, of course. Hilda used to go in and out of shop just to hear it go bong. Had her in fits did that. In fact that's how she died. In a fit of coughing. I blame myself but I would never remove it. It reminds me of her.'

'Please consider my offer, sir. I am deadly serious. Anything less than a yes would plunge me into depths of the darkest drain. I would be condemned to a fate of rimless despair. My life would be a useless washout for evermore.'

'I'll have to ask Doreen. Buy the whole suite you say, and business an' all? And Mr Twing, no less?' Mr Ramsbottom went to the foot of the stairs. 'DOREEN! Make yourself decent and come here, lass!' Doreen re-entered and, still clothed in the ruby-red drape, stood demurely before the two men. 'Young Mr Twing here wants to marry you. How does June fourth sound? It were your mam's and my wedding anniversary. Good girl! Hilda would have been proud of you.'

And so it was. Gordon and Doreen were married on 4 June 1870

in the same church of St Mary's in Whalley. Silas Twing threw the biggest wedding reception ever held in Burnley. Gordon's mam was there. Doreen wore a ruby-red wedding dress, and the ring was of especial significance: it was made of copper to signify a proud marriage in the sanitation department, though in years to come Doreen's third finger of the left hand was permanently green. A proud sign she were a plumber's mate. Silas Twing had a whole row of drains fitted around the Weavers' Triangle and Gordon inaugurated the longest row of continuous closets that anyone had ever seen. It became known as the Twing Thunder Tunnel. All the young lady guests spent hours in there, gossiping about the throng of elegant people at the ceremony.

The Twings honeymooned in Southport and settled down to a life of sanitary bliss. Over the next ten years five children were born to them. Each new child coincided with a new and more efficient toilet system. The word 'toilet' had entered the language as a suitable euphemism to describe the water-closet. When young ladies went to the 'toilet' in polite society, they could simply be going to powder their noses. A new sophistication was born to suit a brave new age, La Belle Époque, or La Belle Ballcock, as Gordon was apt to call it, when the new century gushed into their lives, carrying with it the new enlightenment of hygiene that concerned a new generation.

The last two decades in a century of monumental energy ebbed away in colonial wars, on a tide of social reform and revolutionary ideas, seeping over the landscape like a weeping pipe joint across a soiled floor of broken tiles. British imperial expansion was in full flood, covering the cracks, and Bismarck sought to build a solid European power structure, together with Austria, Russia and Italy, while introducing sickness benefits at home in an attempt to stem the growing attractions of Socialism.

Working men were beginning to flex their muscle. They had had enough. The Industrial Revolution had been used to do its worst, and human misery, augmented by an unfeeling aristocracy and a new breed of self-made captains of industry, strengthened the resolve of

social reformers to demand rights for workers and their kin. Textile manufacture began to decline after 1880, but luckily for an ageing Silas Twing and his ever-inventive son, Gordon, Silas had been doing some thinking.

Queen Victoria sat on her throne and Silas spent more time on his – or Gordon's, to be precise – where he was obliged to take refuge due to the inevitable onset of incontinence, which was not such a hardship for the old 'benefactor', who got some of his best ideas on the magnificent washdown closet, the very one submitted to the Paris Exhibition of 1879 and the very one that won a Grand Prix Medal for efficiency and convenience. It set a new standard in modern design, introducing Gordon's revolutionary siphon-jet water-closet with low-down tank. It was necessary, too, with this new style of tank to increase the diameter of the flush pipe in order to induce siphonage in the closet. With this increased opening a large quantity of water is thrown into the closet, which is sufficient to make the siphon operate.

'You see,' explained Gordon, 'the old washdown closet is far from being an ideal sanitary fixture. It is of course an improvement over the hopper style of closet, yet its principle is not correct because it does not wash out.'

'Ee, lad, yer never satisfied. It never bothered me.'

'Oh, Dad! You'd 'ave been 'appy wi' ole in t'ground, but your intentions were always grand, and that I learned from you.'

'Aye, we come a long way from them good ole days, eh, lad?'

'My objection to the washdown closet, Dad, is that its bowl becomes jammed wi' muck in a short time, and without having a local vent attached to it, the bad odours from the bowl become unbearable. Doreen first pointed it out to me during one of your early attacks. In the bowl there is too much dry surface. The muck clings to it and cannot be washed off with the flow of water as it falls from the tank and it looks a bloody mess. So, I thought, science marches on, hence my siphon-jet water-closet wi' low-down tank. They've not 'ad complaints from prison job at Strangeways. The self-closing faucet connected to a siphon jet connected to the flushing rim saw to that – and nowt's escaped down 'em neither! Ha! Ha!'

The particular Grand Prix model that won the medal, the pride and joy of Gordon's proud father, was adorned with beautifully

carved walnut and mahogany legs and seat cover, and a joy to behold. The legs had been Silas's suggestion, his artistic impulses realised once only, through the skills of a craftsman from Leeds, J.T. Steadman, who not only carved nubile forms on the prows of barges but also built them and decorated them in enamel paints, with beautiful scenes of cows in the meadow and other delightful decorative motifs. Love later blossomed between Gordon and Doreen's eldest daughter, Gloria, and an artist joined the Twing family.

God knows, the twentieth century wasn't easy, especially in Europe, and many wretched people were uprooted, stuffed in ships and shuffled off to the New World. Young blood of all kinds, and many no hopers, weary of cavalry crowd control and whips, joined the tidal flood, economic and religious refugees, the huddled masses, took off in steerage conditions to chance their luck in a country, still young and unformed, where they could simply pick up the gold off the streets, or maybe make a fortune out of a humble skill. Silas Twing lived right though the nineteenth century, and died in 1901, along with Queen Victoria. He was one hundred and one. He put it all down 't' good honest muck'.

A year earlier, J.T. had persuaded Gloria that their future lay in America so they set sail and Vera was conceived in transit.

<p style="text-align:center">*　　*　　*</p>

'Read it?' Gavin had just come back in, shaking water off his hands. 'It works!' he said. 'Fabulous effects like marbling, and it burns, too, if you're not careful. Finding out that bit about me having a silent starlet in the family, my great Auntie Vera. What do you make of that? Sort of inspired me to bring her into my work.'

'It's fascinating,' I said. 'Are you going to finish it?'

'Nah! Doubt it. You can have it if you want. It may be useful. Toilet paper. Ha! Ha!'

'I'll put it in the book,' I said. 'An interesting backdrop to the rest. Explains a lot.'

'Wow! *The Forsyte Saga* meets *The Twing Saga*. OK by me. It's your book.'

# CHAPTER 4

# EARLY YEARS: ARTIST'S BLOCK

'ARTIST'S BLOCK' attacked Gavin when he had hardly begun on his massive conundrum work, *Who? Me? No!! Why??* He was still in his teens. Self-doubt poured into his life like rain through the roof of his first digs. The grasping landlady, Veronica Herongate, admonished him daily for attempting to cook bacon and porridge on a single gas ring while Gavin did his damnest to protect her wallpaper from the spitting culinary assemblage with the precious few sheets of drawing paper he possessed. Old newspapers from skips served as floor covering, which saved him from her wrath and weekly menaces of eviction when the porridge boiled over. His mother had always urged him to start the day with porridge. 'Whatever else,' she would advise, as gently as she was able, 'it will keep you regular, and regularity in all walks of life is shit-driven, believe me, son.'

It didn't seem fair to Gavin to be provided with a gas ring and not be able to use it. Was this just for show when Mrs Herongate let the room? She had proudly told Gavin at the time that her late husband had used it in the outhouse scullery to boil bone glue. He had fancied himself as a bit of a do-it-yourselfer and every fortnight did a spot of repair work on the mortice-tenon joints of their distressed kitchen chairs and anything else that Mr Herongate thought 'could do with a spot of sticko'. The electric kettle that she had placed in the room as an 'extra' was there strictly to boil water for tea, but only, she said, if the spout was pointed out of an open side-window of the huge old peeling bay that dominated the room. It was a toss-up for Gavin whether to freeze to death or risk it and warm his insides for a minute. If he left it boiling until it was almost dry he could work up a damp warmth like a Turkish bath in Istanbul. That was all right until wallpaper began to drop down noticeably from the picture rail

corners. Mrs Herongate removed the kettle. The gas fire in the room had long since given up the ghost and displayed its broken bone-brittle elements as a defiant statement of fact, which Gavin interpreted as a near-perfect expression of mortality. The only heating was in Mrs Herongate's kitchen, which steamed with the optimism of a Devil's cauldron. If she wasn't boiling sheets for the local youth hostel she was reducing cabbage to its lowest common denominator as a substitute for food for her tenants' evening meal, which, it has to be said, was optional. Gavin only remembers the cabbage. He preferred the remains of the cold porridge he made each morning. Occasionally Gavin surrendered to the warmth and the need for a cup of tea, but knew when he tapped on her door that he would be obliged to listen to her tales of experience and woe. He tried not to doze off, which was dangerous, but managed most times to stagger back to his own room and his own sheetless bed.

MRS HERONGATE .

This predicament was the subject of the work causing the block. He was young enough to worry about such things but old enough to realise that years from now when he was rich and famous this episode would pale into insignificant trivia. Right now, though, he was

dealing with his own kind of suffering mankind and he could hardly hold a ballpoint pen, let alone a brush.

'Would you say that that period was during your formative years? We are all very impressionable then, and some of us exaggerate.'

'No, bugger it,' he replied. 'Time usually lays those sad experiences to rest, but sometimes the smell of boiled cabbage, the forbidden kettle and the gas ring add up to a powerful recipe for cautious behaviour. In my case, it was a perverted desire to be looked after, by a jailer if necessary. I still felt too young to be entirely alone, and I was missing that closeness I might have got if my folks had been like, well, professional mum and dad. They were too wrapped up in nursing their own problems. I actually thought that there was some kind of strict world order that compelled all family units to play the allotted part. Then again, I may be so self-centred that their particular worries seem no concern of mine, even though they may be screaming with psychological pain themselves.'

'You're selfish then?'

'Hell, yes. I think you have to be pig selfish to be an artist. You are dealing with something that cares not a jot for you. You are acting as a conduit to something that merely emerges, if you are that conduit. What satisfaction you may get is self-generated; part of your own egocentric response to the reaction of others. The art doesn't care. So grab the buzz while it's going. The world just passes on.'

'What, if anything, came out of that period? Were there any significant signs that made you say, I'm going forward, no matter what?'

'Like I said, I had artist's block. You can't even shit yourself, unless you can find a bloody good reason to do it. If you do, it's out of spite or dysentery. I got a lot of that with Mrs Herongate. She had two awful fucking dogs. Poodles, I think. I can't exactly remember. They weren't, y'know, clipped like poodles, and I doubt if they ever got a bath. Her kitchen smelled of them, and don't forget the boiled cabbage. It's a smell like no other. Not a good farmyard smell, like some wonderful white burgundy. And she made this terrible angel cake in pink, yellow and white; always put a huge slice in my room

for when I got home from life classes. Drawing from the nude. At least six times a week. I was so determined to draw like it was second nature. I needed to learn it so I could forget it. Drawing wasn't a gift for me, at first, but familiarity and practice are good bedfellows. It has something to do with rhythm, and that marvellous moment when you realise that you are actually feeling the space on a two-dimensional surface. There is no sensation like it. It clicks, like realising you can actually float when you are learning to swim. Then all you want to do is wallow in it. You forget about doing a so-called finished drawing. There is no such thing. It's finished when someone tears it away from you. Then you draw to see how many ways you can express a particular form, a shoulder in relation to the neck; the solar plexus and the wonderful change of direction of a leg coming towards you but not bending; describing space as it will. When I speak of form, I don't mean light and shade. Form is the dynamic surface tension of a figure. Shading is theatrical and superficial. That's what you do when you have learned to forget the sheer underpinning of everything. But for me the idea has become the reason to proceed. Filling the void. Putting something there that wasn't there before. But the vocabulary is in place, so you speak as though it were a language, and ideas are born in the friction of conversation between you and it. Understand?'

'Brilliant!' I said. 'No one explained it to me like that before. The way you speak of it is almost with humility.'

'Listen, when I am speaking of the most awe-inspiring activity of man, I feel nothing but humility. The arrogance is nothing but a front. I use it in order to be a free spirit. I am warding off the things in life I know may hurt me. Artists are allowed to be actors too, you know. What was I talking about?'

'Dogs?'

'Ah, yes. Those awful little mobilised shit factories. I would get back from work with a rolled bunch of drawings under my arm, pass the kitchen, go up the stairs and straight into my room. The first thing I would see would be angel cake on the flap-table top, like a Balinese peace offering to a god. On my bed – IN my bed! – would

be these flea-bitten curs just lying there on my pillows. I had two pillows. Whatever was on those little bastards was now on my bed, and the stink from their kitchen would be there with them. That place represented all the worst aspects of living in rooms. Never mind the damp. That is natural osmosis. No, it's that bloody look on the faces of those dogs, the innocence, the "who, me?" gaze, and their unassailable right to be there – she never told them to get out. And they would look at me as though this was their place and I just happened by. They weren't paying the fucking rent; the thought never crossed their stupid minds – until I picked up a tightly rolled rug, which I kept rolled and tight for this moment. I would casually wander over to it, turn away, grasp it, like a baseball bat, swing up and round, and smash it down on my pillows. God! They moved, but they never learned, and neither did Mrs Herongate admit that she knew they had been there all afternoon. "Thought they were in the garden," she would say. "I've made you some angel cake. I've put home-made greengage jam in it. Thought it would make a change." A change from what? Christ! What was this woman's motive? Can you imagine, pink, yellow and white, now separated by a layer of green pond slime?

'Anyway, it didn't go on much longer. I murdered the little fuckers with Paraquat, a fashionable all-purpose weedkiller that I heard about on *Gardeners' Question Time*. It was one of those early cure-all patent toxins that eliminated everything, including deadly nightshade and poison ivy. If someone in the audience came up with a question about a weed problem in their living-room carpet, the name Paraquat always got bandied about as the miracle cure. Streets of terrace-house gardens got wiped out quicker than you can say "organic", as people applied the stuff on anything that might harbour just so much as a single ant. It was germ warfare for the middle classes, and the rise of the hanging garden centres of suburbia. "If you can't control it, kill it!" Mrs Herongate's sworn remedy for weeds. So I used it too.'

'You killed the dogs?'

'Sure. I mixed it in with their tinned dog food, and they couldn't

tell the difference. It took a month. The vet suggested a change of diet, but it was too late. The dogs' eyes were going green, and their fur fell out like dead undergrowth. I hadn't realised until then, my deep hatred for—'

'Dogs?'

'No! Landladies! Particularly her. I did a series of hideous drawings of creatures with no eyebrows, pink, yellow and white skin, greengage eyeballs, rent books stuffed down beige–pink reinforced brassières, and poodles strapped to their legs like batwing woolly chaps. I tried to interest my first gallery with these things as a theme, called *Black Widows*, but according to the gallery owner, Cardiac Frenelli, they looked too much like her customers, so the show would flop by default. Customers would have to know for sure these were pictures of them, and so they would need their names on them, no matter how hideous. People who buy art have got strange preferences. Especially rich widows. If it is not a reflection of them, and enigmatic, even deformed, then they would rather buy an umbrella stand made for Kaiser Wilhelm in 1913, as a conversation piece, and pay a small fortune. If there is a picture which is remotely a resemblance, but it isn't supposed to be them, they feel put down, and leave early. Cardiac couldn't stand that. Bad for business, she said. If I had been prepared to rename the show *Femme Fatale*, she said they would be a sell-out.'

'What happened?'

'I said that would be dishonest, and, anyway, I had begun my series of *Dog Collars*, rather like a tribute to Kees van Dongen in fashionable Kensington, of rich old bags with dogs as fur wraps, worn as decorative mortality. She went for that and so did the customers. My first small triumph really, but I wasn't chasing markets. I knew instinctively this was schlock art, and I was really trying to make art divorced from market forces. It has to live on its own terms.'

'How did you solve that one?'

'I never did. I went back to college, got sucked into experimental provocation, and met other like-minded wanderers who didn't know what they wanted to do, which was the germ of Doodaaa.'

'Doodaaa? What's Doodaaa?'

'Well, that's just it. If you have to ask, like "what is jazz?", then you ain't got it. I just knew that all these experiences, awful as they may sound, were leading me on. I had to follow, so that is what I do. It's a longer journey, but hey! There's time, and I have come a long way from those days. If you are up for it, I'm having a show in Paris next month, in a bookshop cellar. Why don't you come along, if you are serious about this book thing? Otherwise, we can talk for ever and you will still not understand.'

'Great! Give me dates and venue, and I'll be there. Is it Doodaaa?'

'Who knows?' said Gavin. 'Everything is Doodaaa, and nothing. One more Pichon-Longueville, and we'll call it a day.'

# CHAPTER 5

## ARRONDISSEMENTS:
## BODILY PARTS OF PARIS

GAVIN WAS off to Paris for his mini one-man show and I just caught him before he left. He was wearing a black velvet fedora, a pale puce-green jacket with black sleeves and brown leather buttons flashing down the front, denim flares and cowboy boots. I would see him in Paris anyway, but he had a bit of time, so I switched the tape on over a coffee and asked him about his birth . . .

'I don't know if I can do this. Talk about my most intimate and personal details. How do you talk about your innards?' he said, removing his hat and dropping it over a wooden sculpture of an owl, standing on a pinewood kitchen cupboard. 'It can never be pretty – physical or psychological. But, hey! It can also be beautiful. The beauty of my family is probably what everyone else aspires to, and all that wisdom pouring out of one Fallopian tube. I think it was Fallopian. I know I'm not pure English.

'When I was born, I never expected anything except what I got, and, let's face it, I didn't even expect that. What you get is everybody's idea of birth, I guess. The idea of birth should be reassessed. Here we are, thrust out into light, but the light is not necessarily the light of warmth and reassurance. The light is more likely to be the light of blinding reality, clinical confusion, and blood. In the midst of a fuck, no one is saying, hey! This could be a new human being with all those sensibilities that I myself embody. Do I care that much that I want to see lots more of the same type as me and this lovely partner of mine? Are there enough human beings in the world, or do we need some more? All that you are thinking at the time – as is, probably, your partner – are the biological sensations

of pleasure. That is nature's way of ensuring the species will continue. That is nature's way of producing the best and the worst. How it turns out is not nature's concern. She has a job to do and, boy! she does it faultlessly.

'I am only an artist trying desperately to ensure that there is something worthwhile in human kind that screams categorically that what I am is not a waste of space but a reaffirmation of an age-old belief that it is only as an aesthetic phenomenon that existence and the world are permanently justified. Nietzsche said that, and I am unequivocally with Nietzsche. Thoughtless fucks will not tell you that, any more than thoughtless fucks will tell you who your father is. In the many erotic relationships of my life, I can tell you only that the erotic is dominant, the entanglement is for that moment, and nothing in the world is more important than that moment. If you think otherwise, you are a complete charlatan, a poseur who pretends that the body is not a part of you, but a conduit through which you watch, and experience, the neurological electricity which goes through the ecstatic, coruscating tremors of an orgasm. If you think that is not at the very core of our existence then you are a fool, and not only a fool but a eunuch, male or female. Take your pick.'

I switched the tape off. I had been listening to the playback of our brief meeting as I travelled in the back of a Paris taxi. I can use that bit somewhere in the book, I thought.

I had just arrived at the exhibition of Gavin Twinge installations in Le Marais district, an expensively run-down part of Paris. It was a bookshop. My taxi driver knew to bring me here because it was the only show opening in town that evening. To have a show of any kind in Paris, you don't need to know where it is. Particularly if what you have to offer is undesirable, offensive and downright wretched. But I was here to witness yet another débâcle in the ongoing, unstoppable sideshow of the gut-twisting, gall-rumbling schmeck of writhing paint whorls slithering off surfaces that had been, only hours before, inoffensive rips of cheap hardboard and shuttering thieved from building sites in and around Paris. What do I want? I thought.

Piranesi? I only wanted what Gavin Twinge had to offer, which, by now, had become a desperate descent into the bowels of the worst excesses of Dante's lowest level. Even Dante had his limits, but what I was confronted with exceeded – was that the word? No, not exceeded, exacerbated? – exacerbated, and negated, the last vestiges of human experience and decency on our map. What I saw, I can only refer to, in what I feel is becoming the pathetic inadequacy of language. How do you describe the mind-yawing horror of blasphemy cradled inside the soft palm of an internal organ's pulsating will to live, as it attempts to comfort the victim, us, the newborn onlookers, whose only crime is to be here? What on earth was Gavin trying to say?

I managed to pull him aside, and only a few saw me take him off down the road to a quieter spot, a bar where I could ask him why he did this to an innocent public.

'How ya doin'?' he said from inside a slug of pure spirit and a *bière pression*.

'I'm worried,' I said. 'I'm worried by my response, my disquiet. How do you live with that torment, that detritus of our natural condition?'

'Hey!' he replied. 'Don't blame me for lousy humanity. What do y'want, cows in the meadow? My great uncle did cows in the meadow and he became a barge builder. Accepted? Sure, by a soporific multitude who wanted cows in the meadow, or barges. Was that what they wanted? Was that what they hoped for in some future which all of them felt lay ahead, like the meadow they graze in, or stooge through in a barge? Maybe. But what they had hoped for was anything but that. What they hoped for, unless they had already died, was the fear that only comes in the dark, unbidden, but nevertheless arrives. No point otherwise and art is dead. They may not want it now, but the hunger hangs in their subconscious like a cave of bats. My art may be anathema to some right now, but I just planted a seed, a seed of doubt or, hopefully, a seed of reassurance that art is not DEAD. It will never be decided now, because the seed will take time to grow, and I hardly know if I will be its father or not. I

was only involved in the passion of it, and the selfishness. Let's have the same again,' and he pointed to the back of the bar.

We took a seat against the wall and watched the customers who came in and ordered their particular tipple.

'Watch him,' said Gavin pointing at a dishevelled character in blue denim overalls, a trowel which he laid on the bar, and a backside that hung over the edge of a barstool like snow on a pitched roof. 'I'll bet he orders a pastis with grenadine, then a double brandy which he will pour into a beer and swig back in one, leaving the froth on his moustache, then pick up his trowel and leave, tripping on the step ledge as he goes through the door. Never fails.' Sure enough he did just that but this time he wiped his mouth with the back of his hand. 'Oh, that's new. He must have a date tonight. I like sitting here watching the behaviour patterns of people coming and going. That one over there, with the floppy beret and sandals. Looks like an old hippie. He's a photographer, but with a difference. Doesn't like modern equipment, uses a wooden plate camera – a new one, mind – they still make them. He has a studio across the street there, down that little side road. Great studio. Took my picture once, to accompany my last show, and I wore a black polythene bag for a hat. A whole plate picture, almost looks like it was taken a hundred years ago, if it wasn't for the bag. I love it – like a daguerreotype. The show was an old image collage, so it suited a treat.'

'What was that show called?'

'Er – *Cracked Mirror. Fragments of a Broken Life*. It got slated. Critics saw it as a pastiche of Max Ernst, which of course it was. The real

difference was that I had taken the pictures in New York, on Skid Row. They were photographs of derelicts taken on a Minox camera. Pocketful of quarters, camera at waist height, never up to the eye. They stumble towards you, clutch at your arm with beaten, dirt-purple hands, untreated open cuts. "Gis a dime, buddy. Dis is a tough city to get started in." Whip out a quarter, and hand it over, click, bingo. Another picture always shot from the hip, as I used to say. Nearly always tragic. You would see the same guy an hour later, lying in the doorway of an empty shop, among broken glass, gone on forty cents' worth of cheap ruck some bastard makes specially for them, behind the steam of a Chinese laundry in the neighborhood. The irony is Wall Street is just at the lower end. Downtown. Huh! What a description! The contrast is the startling truth of it. Polarised living, blind preoccupation. So it works – sort of. About ten winters ago they pulled down the railway bridge over the East River, which was where most of them went to keep warm. Thousands died of cold that winter; some say by design. A kind of final solution for the bums, courtesy of the City Corporation. That was the rumour anyway. I never told you my little story about being panhandled by a beggar girl, right here in Paris, did I? My "Esmeralda".'

I had not heard about the beggar girl, though Gavin had often talked of his love of old Paris, the characters, and the daguerreotype gloom he sees in his mind's eye. That gloom grew out of his sense of isolation from any kind of artistic vanguard after his futile efforts to stage a one-man show at Galérie Enghien-Montmorency on the left bank just a block away from the Pont Neuf in the sixth arrondissement. As he walked the streets, daguerreotypes were very much on his mind after a visit to the Carnavalet museum, and Gavin coined a phrase, or rather a definition of the word, which described a kind of artist and therefore the germ of a new movement. A 'Daguerreotype' would be an aggressive artist type let loose among the skin and bones of Paris long-gone, Paris now, and Paris as it disappears into the twilight zone of a twenty-first century.

Living between the night and the day – the light and the shade – neither twilight nor dawn – an undefined place only for those who

would see just enough to imagine that in the cracks and the crevices of all the dirty old walls and buttresses another life thrives and thieves – a theatrical style in a luminous gloom.

Leonardo da Vinci saw battles and beggars in the stains on the walls of every edifice and every posturing elevation. The wire wool images scuffed through time hover inside Gavin's mind as though a greater God was keeping the real Paris for itself and leaving instead these glimpses bathed in plague-tint blue – 'a beggar's reach from a rich man's dream', as Gavin loved to quote out loud over a bottle of Château Marquis d'Alesme Becker, a simple one-dimensional wine that tempered his enthusiasms perfectly. That is always Paris to him, Paris as it should be. Not everyone should be allowed to enjoy the Paris of opium dreams. The crowd can have the Paris of a thousand million cameras – the snaps of oblivion that languished in stuffed drawers in a thousand million front rooms of forgotten holidays. Wandering the six miles of skull-lined catacombs beneath its streets, Gavin willed the heads alive to tell him what he wanted to know about the Paris that only lives in dreams and nightmares. Some would be armies beaten and laid to rest after a Napoleonic defeat, or sometimes after a victory. These heads peopled the world of his daguerreotype mind and as he mused over the trials and strife of the six million who lay there amid the ruins of a wretched and a victorious past, he began to see the bare bones of a new idea take shape in his imagination.

As we watched the bar types come and go, Gavin told me the story about the beggar girl, his daguerreotype memory . . .

'Spare a franc, please?'

Gavin was jolted out of his reverie as he strolled aimlessly along the boulevard Saint-Germain. There was a girl keeping pace with him holding out an unwashed hand. In the other she carried a polythene bag. Her bag of belongings, he figured. She was wearing a shapeless navy-blue long coat about three sizes too big and her general appearance reminded Gavin of a wartime evacuee he had seen in an old black-and-white movie. Around her he could almost see the

fleck marks of distressed film which had been through the projector too many times for its own good. In his mind he saw the stream of other evacuees stretching back across a landscape of desolate bomb craters and broken buildings, blitzed trucks and dead trees.

(The author was later to draw the girl in an attempt to capture Gavin's description of a pathetic derelict on the streets of Paris without her old coat on. Gavin is said to have taken one look at it and said, 'For God's sake, Ralphael, you're a bloody Romantic. That's been your problem all along. Get real. I said she was destitute and that's what she was. You've made her look like a homeless kitten with ambition. She wouldn't be homeless for long looking like that!' Gavin did his own version and captured her exactly.)

'Why a franc? Why only a franc? What can you do with a franc? Go to the toilet, maybe?'

Gavin's response was a defence mechanism of bravado. It hid his fear of something outside society and outside his general experience of what felt proper that nevertheless tipped him headlong into an unknown world that repulsed him and fascinated his curiosity simultaneously. His own constant demand upon an inbuilt reservation brought forth, like the drawing of a cork from a bottle, a confrontational spirit of defiance, or, if you like, a cunning retreat from what is inside it. The woman spoke good English.

'Because', she said, 'if I ask you for ten francs you will not give it to me. If I ask for only one franc you may give it to me. Then I ask nine others and usually I have ten francs. Besides, it passes the time.'

'Here's ten francs,' replied Gavin. 'Now you've got time on your hands. Why are you begging, and how did you learn such ingenuity? You obviously do this all the time. Anyway, how did you know I was English?'

'It's obvious – otherwise you would be walking faster. You are going nowhere in particular and this I noticed.'

An idea flitted across Gavin's mind as he looked back at the girl. 'Would you like a drink?' he asked. She nodded. 'I don't mean a drink in any old bar. I mean a drink where you would normally drink. Somewhere all the rejects go.' He knew that was provocatively

unkind, but he also knew that she was interested enough to trust him. Gavin wasn't your average mark. He was identifying with her. Artists are beggars too, he was thinking. We are all on the same side. Why not? He was risking a mugging but there was nothing of his to steal except his American Express card, which he kept up his sphincter in any city he visited, and a sketchbook which would not fit up there, and who would want a sketchbook in Paris anyway? They are ten a franc up anyone's boulevard.

'I know a bar,' she said, 'if you want, this way.' Gavin offered to carry her plastic bag. She shrugged. '*Pourquoi?*' He let it pass and followed a footstep to the right of her. 'You might not like it but you ask, so –' He tried to remember which streets she was taking him down. They were moving east. They passed rue Napoléon, rue des Ciseaux, rue du Four, crossed at the lights at L'Odéon intersection and turned right into rue Danton and down a piggle of streets vaguely back towards the Seine. She seemed to know exactly where she was going, like a homing pigeon. I wonder if she is always doing this, thought Gavin, luring her victims to a hideous doom? Left, back down the rue St André des Arts, to the heart of the sixth arrondissement, a right on to rue Séguier past the house where J.K. Huysmans had lived and there – a loud, broad-lit dull sort of place beneath a warehouse arch. It looked like a railway arch and it looked rough. Gavin pushed the door and held it open for her to pass, not sure whether he was urging her forward as a kind of protective shield, or was it an innocent friendly gesture?

The walls were festooned with art-exhibition posters, night-club show adverts, older posters varnished into the walls with the smoke of long-gone nights of someone else's fun. Posters for farcical French comedy, Georges Feydeau, L'Artisan Moderne *meubles* and *objets d'art et ensembles décoratifs*. A huge lithographic poster of a badly drawn nude covered in crude graffiti and woodblock lettering declaring *DÉFENSE D'AFFICHER*, hundreds of currency bills in dead deutschmarks and lire peppered the walls like prewar IOUs covering up the encrusted, damp-etched walls of dirt. Beaten chairs and black Formica tables with chrome steel legs supported equally beaten

figures who appeared to Gavin never to have moved from where they had been since the German Occupation. There were glances as they moved towards the bar which itself looked more like a barricade than a place of welcome.

'*Qu'est-ce que vous voudrez?*' said Gavin in an attempt to appear as though there was a smattering of French in his being which he kept for special occasions. '*Bière, merci, et vous?*' 'I'll get 'em!' replied Gavin as though he had just been stabbed. Still protecting his bravado, he turned to the barman. '*Deux pressions, s'il vous plaît, eh-ur un wheesky pour moi. Merci.*' Turning back to his companion he said, 'So this is where you hang out?' 'No,' she said, 'but you wanted to see where you thought I might come. Sometimes I do, but not very often. It is too rowdy and expensive, for me anyway . . . I think that you are being approached.'

Gavin glanced to his left and eyed a scruffy individual with a half-shaven head. The unshaven half hung down over his ears like a pit pony's mane, and the other half had scabs which reminded Gavin of two school kids he knew who forever caught ringworm and had purple circles administered by their poor overwhelmed mother, who shaved the back of their heads bald while they held a basin over their faces leaving the front scruff of hair intact. It was always thought that these poor kids were beyond the pale and were to be shunned by the rest of the school for fear of catching the taint. Their style of haircut was acknowledged as the sign of contagion. Such blatant rejection disturbed Gavin's naïve mind. Ever since he could remember, being cruel seemed the normal method used by communities to keep themselves clean and free from disease. There were no polite ways of maintaining the status quo any more than there was a polite way to slit a hanging pig's throat. Farming was a way of life and the abattoir was across the road from his primary school anyway. It was an after-school ritual to watch the cattle disappear down the tunnel for slaughter. Gavin and his school pals would listen for the agonised lowing of a condemned beast before the sharp crack of the stun gun arrested its fear. Throughout Twinge's work runs that dormant sharp crack. His work lulls the viewer into a false sense of tranquillity. But

this is a mask. Beneath an apparent levity lurks a savage protest against man's inhumanity. His sense of unease is perpetually present. It will never leave him, just as a nervous mistrust in an ill-treated animal keeps it forever on its guard.

But this beast spoke. 'Ah, Christina has found a friend. You are English?'

Gavin's reaction was aggressive. 'Would you mind – I am talking with this lady and I would prefer it if you left us alone. I will even buy you a drink but then – walk away.' 'Oh, pardon me, *m'sieur. Vin rouge, s'il vous plaît. En vacances?*' 'Here's your wine. Now please, leave us alone.' 'Why are you so unfriendly?' 'I told you what I was doing. That is sufficient explanation. Now please go.' 'But I am interested in all Christina's friends. Where are you from in England? You 'ave a sketchbook. Are you an artist?'

'Take no notice. This is François. He is always curious.' Christina tried to sound casual. Gavin felt threatened. 'I just don't want to have to talk with anyone else right now. I came in here with you. I need a quiet drink, not an interrogation.' 'You are very nervous. Why are you nervous?' Gavin turned and faced the man. 'Look, pal, I have nothing against you, but I feel I have the right to choose who I spend time with and who I talk to. Now, please, leave us alone.' François persisted. 'Just show me your sketches. Are you good?'

'Right! You bloody asked for it! I won't show you these drawings but I will draw you if you don't move away and if you don't think that is a threat take it as one. I'm not kind to my sitters. It will hurt you – up here,' and Gavin pointed to the man's oddly shaved head. 'Now please go away.' 'Now I am interested. I would like you to draw me.' 'No you won't. You'll wish you never met me!' Some of the man's friends were watching now. They had caught the sound of Gavin's voice. Christina began to move slowly away from Gavin. 'Don't move,' he said. 'This won't take long, then we'll get out of here and I'll buy you a meal – on American Express!'

He opened his sketch book on a clean page and started to scribble furiously . . .

'Your mother was a heavy smoker and you've got a nasty cough.

You are riddled with her craving. You look as though you have been sucking on your own umbilical. Now, bugger off and leave us alone. I told you you'd be sorry.' François looked weirdly fascinated and repulsed at the same time. Gavin urged Christina towards the door before the man came up with a response. 'C'mon,' he said. 'I'll buy you that meal I promised you but let me choose this time.'

Outside, they walked along in silence, then Christina glanced at Gavin and said, 'No one will let me into a restaurant looking like this.' She stopped and looked down at herself. Gavin looked at her and felt inclined to agree. The misshapen coat, distressed shoes and the plastic bag, the bloody awful plastic bag. 'They will,' he said. 'You can get away with murder on American Express. How often do you get asked out on Amex anyway? I tried a place once, not too superior but with atmosphere. I think it is somewhere around this area. It's called L'Age d'Or. Do you know it?'

Christina nodded. 'Yes, I know it. It is on the rue Guenégaud off the Quai de Conti. But they will not accept me.'

'They will have to. You are my guest.'

She shrugged. 'OK. Your choice but I will be surprised.'

'I'll say I am doing research for a book on wretched destitutes of Paris and you are one of my subjects. Besides it's worth a go – even if I have to beg.'

She smirked. 'OK, this way.'

When they arrived the place looked quite empty, empty enough to need the custom. 'Right, just stay close behind and er – here, comb your hair.' Gavin offered her his comb which he was never without in case someone needed musical accompaniment. He pushed open the door and went in and Christina followed. '*Une table, s'il vous plaît,*' said Gavin even before the *patron* had time to observe his new clientele. '*Bonsoir. Oui, M'sieur –*' then he caught sight of Christina. '*Une table pour vous, M'sieur . . .*' '*– et mon ami.*' Christina turned to go, anticipating the objection. '*Pour vous, M'sieur – en seule?*' '*Non, les deux.* Christina! Don't go. This man is going to apologise.' A fleeting look of alarm stripped the obsequious expression from the *patron*'s face. 'But, M'sieur, I beg your pardon, you are English and –' He

raised his shoulders in the helpless French way. 'Yes, and you are French!' snapped Gavin whose sense of social injustice was easily aroused, 'and you are about to insult my guest – and by that token me, too. I can tell by the way you are holding your hands. You all do that when you don't like what you see. And are you going to move your hand up and down like this?' and Gavin mimicked the limp hand of a Frenchman, flicking it up and down to emphasise '*Quel dommage!*' 'Well, the problem is your *dommage*, pal, not mine. I suggest you find us a table and I promise we will be *Très bien comme d'or*", as good as gold – or as good as my platinum American Express card anyway. L'Age d'Or, right. The name of your place, *n'est-ce pas?*'

'Of course, M'sieur. This way please,' and he gestured to a table in the far back corner near a stack of folded chairs kept at the ready for any unexpected coachload of tourists.

'*Merci, M'sieur.* Now, first and foremost, could I see the wine list, please. I may want to get very drunk and so may my guest if I am not very much mistaken. I found her in the gutter earlier lying in her own vomit, or was it someone else's, my dear?' Gavin turned to her and she was looking awkwardly at the floor as she sat down.

'Sorry, that was a cheap joke. I am known for my cheap jokes. It's how I make a living. Cheap jokes, cheap art. I am sick of this kind of petit bourgeois bullshit. He'll be OK. We have an understanding now. Once I have ordered some fine claret he will realise he is not dealing with rubbish but two supreme beings from another planet.'

The *patron* returned and handed Gavin the wine list with pronounced displeasure and retreated. Gavin opened it up and started to roll a cigarette. Christina watched him and asked, 'Is that marijuana?' 'Oh sure. Then we would both be out of here, like a shot.' He turned the pages as he lit up. '*Rouge ou blanc?*' he said. 'Whatever you have is OK,' and she smiled. Her teeth looked remarkably pristine. My God, he thought, she could hardly be more than twenty-six years old, yet she looks like, well, pavement. She seemed to have emerged from some barnacled shell and was actually enjoying this weird moment.

The *patron* returned and looked at Christina with a pained expression. Gavin responded like a connoisseur. 'Right! We would like to start with a bottle of Château Rauzan-Segla, unless you have the Gassies, the Rauzan-Gassies. It was out of production the last time I stayed in Margaux. Neither is worthy of a second-growth position in the classification anyway, but it will inform the palate while I choose something else.' The *patron* was visibly startled by Gavin's apparent knowledge. '*Oui, M'sieur* –' 'Oh, and *une bouteille de l'eau minérale gaseuze* to go with the Gassies, ha! ha!' The *patron* smiled weakly at Gavin's poor pun. 'I think we have an '83.' '*Oui*, something not too complex. *Parfait, M'sieur, merci.*' 'It is expensive, M'sieur –' 'You mean overpriced. Yes I know. That will be fine.' The *patron* bowed out without another word.

'You know about wine?' 'As much as old Gauloise guts there, but not much more,' replied Gavin with a modicum of pride. He was proud of showing the bloody French that they didn't have a monopoly on this territory and he was in the mood for a fight. Gavin gazed intently at Christina and changed the subject. 'Why do you beg? You seem – unsuited to the situation you are in. What happened?' Christina shuffled her backside in the seat as though she was trying to disappear and then did exactly what the *patron* did. She hunched her shoulders in her dirty blue coat and twisted her face, just like him. 'I don't know.' 'Yes you do.' 'Yes I know, but –' 'You've had a bad time, right?' 'Yes, it was bad. My father beat me. He say I took always my mother side. We lived in Meudon. He beat her too. But he never touch me – you know – like that –' and she gesticulated. Gavin understood. 'But that doesn't explain the begging. Why the begging? You don't have to beg.' 'My mother was drinking. She could not 'elp me. My father went away. I never saw 'im. My mother was 'elpless. I left too and I 'ated myself. I got a job – er – imprimerie – er – printing. Time. Everything was about time. Typing *les comptes* – er – bills. Always on time. Print, print, print. Bill, bill, bill. Clock.' 'So?' 'Well, so I watched the clock. Every day I watched the clock, every minute, even the second hand. Listen for the sound. I watched it as I type – I learned to type but I hate it. Why I watch the clock? It was stupid so I left and –'

The *patron* returned caressing the bottle like a newborn baby and presented it for Gavin's acknowledgment. 'That's the one,' Gavin said and kept his concentration on Christina. The *patron* uncorked and poured a centimetre into his glass. Gavin followed the ritual, swilled the sample around the glass and sucked on it. 'Fat and grapey, with strong tannic astringency, and what surprising power and presence in the mouth. Chunky in fact. *Merci*,' but he kept his attention on her.

'*Qu'est-ce que vous voulez manger, M'sieur?*'

'Ah eat, yes! La M'moiselle will have –?' Gavin gestured towards her. 'I just take *le boeuf, saignant*.' 'You can have whatever you like. You can have a *filet* if you like, anything. This is an experiment, an unexpected begout. No apologies. My pleasure. Anything. Starter?' 'OK, I'll 'ave the *escargots*.' 'Me too. I love 'em – and two *filets, moins cuit*, but make mine medium. *Merci*, and I reckon *pommes frites* and *cèpes*, don't you?' She nodded.

Le Patron.
L'Ange d'OR
avec
Toupee

The meal came and Gavin asked for the wine list again, feeling pretty good by this time. Christina had opened up and behaved in a more partisan fashion. Gavin wanted to push the boat out. He looked up at the *patron* and said, 'Do you happen to have Château Ausone – from '76 onwards?' The *patron* was now apologetic. 'Pardon, M'sieur. It is like Petrus – for us, and particularly our modest clientele, too

expensive. But I can recommend one other from St Emilion – le Château Beausejour-Fagout. It is very excellent.'

'I'll take it for the name alone. Bring it on!'

The wine came and the ritual was repeated. Gavin sucked and swilled and showed off as his manner mellowed with the wine. Christina had lost all inhibitions and insisted on tasting the wine in the professional manner too, which appealed to Gavin's serious appraisal of the truly surreal. Gavin ordered a third bottle, a Château Palmer this time, a third growth with a first-growth potential, a legendary '82 with soft, fat, oaky tendencies, warm and inviting, on account of the high percentage of merlot present in the *encepage*, more than in anyone else's mix in Bordeaux. This was the treat that Gavin was waiting for. The true seduction of wine drinking, the '*encepage des bouteilles*' as he liked to call it, the perfect combination of different châteaux which sent each wine's virtues into overdrive. They drank and slurred and slurred and drank. Gavin watched her when she had her eyes down eating. She was hungry, very hungry. The food was delicious but any food would be, considering the divine wine upholstery that surrounded it. Gavin thought of Lautrec's *La Goulue* – the glutton – a voracious can-can dancer who ate and drank compulsively from anyone's plate, or glass, and whom Lautrec had drawn in the bars and cabarets of Montmartre in the 1890s. Not that Christina was gluttonous. She was hungry, very hungry, and not about to blossom into a hot air balloon like La Goulue. She suddenly looked up as though conscious of the scrutiny.

'I need to find the toilet,' Christina said and stood up unsteadily, looking around vaguely and completely lost. '*M'sieur! La toilette pour la Mademoiselle.*' The *patron* frowned and pointed vaguely to his left down a small dark corridor. Shit! I hope there are no steps, thought Gavin, I'd better go too. They both staggered in the general direction, knocking tables and causing people to notice the state of Christina for the first time. Gavin found her already in the Gents trying to sit on a urinal. 'For God's sake no! It's the next one along – the door here,' and he dragged her off her perch, a pair of grubby knickers around her ankles. He supported her towards the Ladies,

both laughing like idiots. She closed the door, just, and Gavin took the opportunity to stumble back and have a pee himself. He peed like a fireman waving a hosepipe across a blazing building, with his forehead pressed against the wall to steady his aim. Then he rolled back against it, and waited. She was in there ages and when she finally appeared he got the distinct impression that she had wet herself. Gavin doesn't remember quite how they made it back to the table, but the *patron* was looking grimly unforgiving. 'What the Hell! we're nearly done in here. *'L'addition, s'il vous plaît, M'sieur!'* Gavin shouted out, eventually. 'And we'll take the rest of the Palmer with us. Did you know,' he said drunkenly wagging a finger at the *patron*, 'that Château Palmer sports a Union Jack on its turrets because the Chardon family who own it have English pedigree in the blood – Welsh, actshooly, but I won't splot heers. Oops!' Gavin swayed slightly as he took out his wallet and searched for his card. The *patron* slipped a plate with the bill on to the table near Gavin's steadying hand. He picked it up and stared at it closely to focus his wavering gaze. 'Bloody 'ell! *Très cher!* So what – we –' Then he paused and a wicked idea crossed his mind. This bastard has done bloody well out of us, he thought, and he's been a cheap shit all night. I'll make him beg for it. He dropped to his knees, held his Amex card above his head and started to crawl across the floor under the tables of the other customers. Poking his head above someone's table he whispered, 'Coooeeeee, it's over here.' A freeze of embarrassment gripped the restaurant. The *patron* was helpless. Beggars are one thing but now there was a crazy loose on his premises. He couldn't handle it. Gavin crawled again and emerged in another spot and warbled, 'Coooeeee, M'sieur. Over here. Here's my card!' Gavin persisted and, strangely, no one moved. Both fascinated and horrified by this flagrant show of drunken mischief, the place had galvanised into a wax museum. Christina sat unsteadily on the edge of her chair and looked as philosophic as someone who had walked into someone else's nightmare. 'M'sieur, now I'm here!' and Gavin popped up in another spot like a face on a stick held by a puppeteer. He waved the card again and taunted the *patron* like a father surprising his child

with a staring rag doll. *'C'est une blague, M'sieur.'* Some of the customers had stopped eating altogether and began to enjoy the unexpected floor show. There was nothing else to do and, most important of all, for Gavin at least, the desired result had been achieved. Gavin appeared above another table and forked a new potato off someone's plate. *'Choix parfait, Madame,'* then he scampered off to another corner, popping up with his Amex card in one hand and the new potato on a fork in the other. The *patron* was already on the phone. Oh, oh! thought Gavin, he's calling the *gendarmes*. Time to leave. 'Christina! *Il faut partir maintenant.* Time to pay up and get out. You OK?' She nodded floppily. Gavin stood up. *'Je vous payer, M'sieur, pas problem,'* and he held out his card eagerly. Police trouble he could do without. It offended his natural sense of law and order. The *patron* replaced the phone and took the card without looking at Gavin. Gavin signed the account printout with a flourish and then drew on the paper tablecloth. 'Something for your grandchildren, M'sieur.' He drew the *patron* and poured some wine on it which merged magnificently with the ink . . .

The cold air hit them as they stepped outside but Gavin felt the whole evening had been a treat. The door of the restaurant opened again and out shot a polythene bag. 'M'moiselle's luggage, M'sieur. *Bonsoir.'* The *patron* pulled the door to quickly behind him.

'Where will you sleep tonight?' Gavin looked concerned. 'Oh, it does not matter. I have always friends.' 'Every night? You must have a lot of friends and tonight I am your friend. At least you can use the facilities at my place – even take a shower, why not? This is your night on American Express – a night to remember. I'll bet you never got so much for a franc before. We can sneak in up one flight of stairs. It's a *pension* in the rue Racine. Nothing fancy. I always stay there. That's my offer. No strings and you are too drunk to say no anyway and I, Gavin Twinge, am an honourable man. Hey! Where are you going?' Christina had started to wander off towards the Seine. 'That's the wrong way.' And Gavin pointed uncertainly towards boulevard Saint-Germain and the streets around Le Musée de l'Assistance

Publique-Hôpitaux de Paris, full of antiquarian and medical book-shops. An area of constant fascination for Gavin.

Christina hesitated, looked away absent-mindedly, then back again at him. 'Oh, come on,' he urged. 'Not tonight anyway. I'm not a monster – just a total swine of the worst sort. I want to show you a bad time,' and he hunched his shoulders and lurched along like Quasimodo. They wandered up the rue Mazarine, she with her polythene bag and Gavin with the remains of the Château Palmer and a sketch book down his trousers – like Chaplin and Virginia Cherrill in *City Lights*.

They reached the rue Racine and the dim lights in the hallway of the *pension* showed a deserted front desk. With a touch of urgency Gavin pushed her up the stairs, for he didn't think even the most broadminded of concierges would take kindly to his bringing the street life indoors. He fumbled the key in the uncertain lock which always seemed worn-out to Gavin, and wobbly, like most French security accessories. He closed the door gently and sat on the edge of the bed taking a swig out of the bottle as he did so. 'Take a shower if you like. It's all in there – toilet an' all. Help yourself,' and he flopped back on the bed and watched the ceiling turn in two directions at once.

He must have dozed off because he woke to the gentle sound of weeping coming from the bathroom. 'Are you OK?' He got up and put his ear to the door. 'What's up. Have I said something wrong?' The weeping continued. 'C'mon, tell me. Have I upset you?' The weeping subsided. 'No.' 'Well, don't be daft then. Open the door and tell me what's wrong.' There was silence for what seemed like a long time. Then Gavin heard the lock turn and slowly the door opened. Her eyes were very red and, most pathetic of all, her face was streaked with the tears that had run through so much street grime. She looked like a municipal statue that had just been rained on and her face looked metallic.

'I wish I knew what was wrong. I can't bear it. Look at yourself in the mirror. You might even laugh.' She did laugh or at least shook with a kind of helpless relief. 'Do you want another drink?' No, she

didn't. 'Well, for God's sake take this opportunity to clean up. You can even borrow my rrrrrrrobe,' Gavin rolled his R's for light relief. She took it, picked up her polythene bag and closed the door and Gavin heard the lock turn again. He found his bedside water glass and poured the last of the Château Palmer. He heard movement, little coughs, the toilet flush and then the shower turning on. 'There's soap in a paper packet in a basket above the basin,' he said with a hint of encouragement in his voice, 'and if there are any other freebies in there, be my guest.'

The water ran for ages. What the Hell. He was checking out in the morning for Charles de Gaulle Airport. About an hour later the lock turned again, the door opened and she was standing there, clean, fully clothed and soaking wet. 'What th –?' Gavin's mouth must have fallen open like an earth digger. 'I showered everything. I always do. Here is your robe. I didn't need it.' 'But you'll catch your death –' 'No,' she replied. 'I never do. I am used to it, I suppose. It is the safest. I have cleaned even the things in my bag. They will dry soon enough.' She lay down on the floor without another word and turned sideways.

When Gavin woke again she was gone. It must have been a dream. He took a shot of whisky from his holdall to douse the battle raging inside his head. He showered reflectively, dressed quickly, looked around the room in case he had forgotten something and saw a note on hotel paper. 'I am in the boulevard Saint-Germain. I will buy a café and sit by Carrefour Odéon. You say you like to have a café first so I wait there. Christina.' Gavin checked out and walked down to the restaurant L'Odéon with his bags. Sure enough she was there sitting at a sidewalk table. 'Are you – well, damp?' was all Gavin could think of to say. 'You're lucky it isn't raining – although on second thoughts, it wouldn't matter to you, would it? You mad bugger!' He ordered croissants for two and a cafetière of coffee. 'So you go to the airport?' 'Yes. Off to Milan today and then Bologna to see old friends.' 'Can I come to the airport?' Gavin was taken aback. 'W-why?' 'For something to do. You were kind and funny. I keep you company while you wait for your plane.' 'Then what?' Gavin

couldn't make her out. 'How will you get back?' 'I walk,' she said simply. 'Bloody nuts, woman! That's what you are. I've been entertaining a maniac – and French too.'

But she did go with him to the airport. She even watched over his bags while he checked his flight and tickets, and he trusted her. He pushed a hundred franc note into her hand, kissed her on both fresh, clean cheeks. She looked at him for a few moments and hugged her bag of belongings to her shapeless old coat, then turned and walked beyond a tabac stand and disappeared around the curve of the airport concourse. Gavin gazed after her for a few moments and muttered, 'D for Daguerreotype. She could easily have been one, and I walked into frame. Now she just walked out of it and I'm a sepia shadow in a twilight blur.'

'So I did a show, released a lot of anger, that did. This one is a kind of follow-up, like the internal appearance of such misery, externalised, but not much different from the rest of us really. There is a kind of beauty there, expressing misery and suffering, the contusions and irreparable damage visited upon the miracle of nature. Whatever has happened to the human body, and however abused, it is still a miraculous mechanism.'

Gavin spoke of arrondissements as bodily parts. He mused over an idea which for him made Paris personal. He began to refer to the areas of the city as departments of his own body – his own being – his own personal city of arrondissements. He wasn't a Parisian. Far from it. He became Paris in a kind of mental sidestep.

To speak easily of Paris can only be personal if you are a Parisian. Not everyone who lives in Paris can claim to be Parisian. Parisians are people who protect these arrondissements as characteristic extensions of themselves which they cannot live without and which spiral outwards to arrondissements of less importance – the body's outskirts. Nevertheless, Parisians protect them all fiercely so they may function properly and completely, even though they will never go near some of them.

Gavin had bought a tiny studio apartment in the twelfth district near the Gare de Lyon but in no way felt Parisian. Only in Gavin's twilight world of Daguerreotype Paris could he do that. His body was his reality of Paris – the way it felt to him. He never wanted to take their Paris, but to use it as artists have used other cities, like Florence five hundred years ago.

Parisians don't like this kind of interference, this groping for bodily familiarity. Gavin understood this so he turned the whole exercise into a furtive game. Paris, he realised, was where the body is very much at work attempting to deal with all the exquisite substances bombarding it wilfully from any decent table of French cuisine, from the simple baguette, etc., through a cornucopia of French delights – add a French menu . . . frequent visits to the toilette, the cyclical terminus – the very hubcap to the Philosophy of French Plumbing – a study central to Gavin's work.

Gavin began with the BLADDER naturally. It never let him down. It was a holding bay and a way out for all the processed toxins and redundant fluids, the symbolically functional plumber's friend. The XXe arrondissement was just that for Gavin. Not a pretty sight but a processing exit along the rue Belgrano and on to the *périphérique* at the Porte de Bagnolet or maybe up the avenue Gambetta and clean out at the porte des Lilas further north for a quick relieving getaway past Aéroport Charles de Gaulle towards the French ports of Boulogne and Calais. Escape from Paris was sometimes a necessity, a change of pace.

Some may say why the Hell don't you just get out through the XVIIIe arrondissement, past the Gare du Nord and straight up the rue de la Chapelle – and don't come back, you fink! But Gavin had figured out his game plan. The Gare du Nord was for him the THROAT of Paris where he felt a heady anticipation as the train trundled in towards its centre – a grand entrance on an iron horse.

The XIIe arrondissement is Gavin's 'home' area and therefore his POSTERIOR, somewhere to sit and something to sit on at the end of the day of walking, exploring, drawing and getting tired. It was not his chosen arrondissement to live in any more than his posterior was

the one he would have fashioned for himself, speaking as a sculptor
with the sensitivity of a Rodin.

Surprisingly, Gavin chose his 'dreamy' arrondissement for the least
dreamy part of his body – the LIVER, Gavin's particularly. It
demonstrates the satirical edge to his personality which trembles
just below the surface. He chose the IVe arrondissement as the
LIVER, specifically the îles de la Cité and Saint-Louis for their
geographic shapes, absorbing the body's blood, the Seine, and
breathing it along past a fairyland of château towers and its own
ogre kingdom, Notre-Dame, with its phantasmagoric ramps of
grimacing creatures glowering moodily at the bright, dignified
prince's domain on the right bank, the Hôtel de Ville, which is
also in the IVe district but this would be the PANCREAS, the
regulator to the wilder excesses and potential lawlessness that could
ravage a body out of control, or protect Paris from itself and the alien
invasion from the tourism it thrives on. That is what Gavin believed
about Parisians. They complain bitterly about the restraints put upon
them for their own good.

The VIIIe arrondissement became Gavin's CHEST. Chests, he
figured, make windboxes of us all and we strut with them like
fighting cocks. The VIIIe is proud, monumental and pompous. It
puffs itself out all the way down avenue Des Champs-Élysées from
the outrageous Arc de Triomphe de l'Étoile and struts around the
place de la Concorde like a conquering Visigoth gathering monu-
ments as it goes. It reeks with bloated pride from an empire long
gone. But the air in its lungs wafts across wide-open spaces offering
welcome relief like a deep breath, or whips across them like a hacking
cough in mid-winter.

The Ier arrondissement is the broad BACK of Paris. It supports its
artistic heritage and vast treasures with sombre dignity and protects
its most famous work of art behind bullet-proof glass like a torso
wearing a corset to support its spinal column. Like the Elgin Marbles
– which should be back in Greece where they belong, Gavin mused –
so the Mona Lisa should be back in Florence where it was painted and
only resides in France by default because Francis I enticed a

disillusioned Leonardo da Vinci to work for him in Amboise, taking the Mona Lisa with him because he couldn't bear to be parted from it. He died there in 1519 and so the painting remained in France though hardly its property. What a gesture it would be if the French, in a splendid flourish of European Community Spirit, sent it to the Uffizi Gallery to demonstrate to us all what THEY mean by Community, huh!

'If I were the Italian government, right,' said Gavin, 'I'd demand that the English returned Turner's paintings of Venice too or have them seized by customs men disguised as a visiting company of La Scala opera singers. Whip them straight off the walls of the Tate, I would, because they were painted in Venice and that's where they belong!'

Those were Gavin's thoughts, along with other ideas like whether the French had built a glass pyramid behind the Louvre as a neat municipal *coup de grâce*, a political sop to pacify the Egyptians for stealing Cleopatra's obelisk from Luxor when the French swarmed all over North Africa. 'It's all wrong!' he would say. 'And why don't the English do a deal with the French government to swop the rotten painters that crowd the place du Tertre in Montmartre, along with the sweating tourists, for our bloody pigeons in Trafalgar Square? Rotten painters would do well in Trafalgar Square with our crap Philistine climate and they would get fed too, for nothing. They don't shit on the buildings either, as far as I know. And let's persuade the Italians to swap the Leaning Tower of Pisa for the Post Office Tower. The Italians could rename it Il Tour Consignia and everybody would be happy. Use the Leaning Tower as a tent pole to hold up the Dome and turn it into something useful, like 360-degree practice ski slopes for the swelling tide of ski freaks panting to get to the Alps. Makes me sick. If they sent back all those Egyptian mummies to Cairo, Samurai warriors to Japan, Buddhas to China, bit late for that now! Compliments of the Taliban militia. But, any other priceless *objets d'art* of colonial plunder, hoarded in the British Museum, the place would be empty and that's my point,' he says. 'There's a stack of stuff, new English stuff, looking for a home. The Tite Modern can't hoard it all and Saatchi is too personal to be believed, the arch-

manipulator of public taste, but that's his job. He's good at it, or how else did he get a whole nation to believe we were all natural Tories at heart? Yet there's a whole twenty-first century that has hardly begun and not an "ism" in sight. Where's all that lot going when it happens? – and it will! Answer me that! I say twin the British Museum with Battersea Power Station and you have two fabulous monumental centres, with the muscle to contain the best of all the arts, including Heavy Metal Industrial, which feels British like Goya feels Spanish. Perfect complements. Battersea is the greatest empty site in London, looking for a reason to stand there looking proud. And while we're at it the Americans could send back London Bridge too. That would be a wild Anglo-American gesture of the goodwill we all bang on about. London Bridge should be in the derelict shunting yards, next to the Power Station as a start for a sculpture park, and landscaped gardens. What the Hell's it doing in the Arizona Desert? That's for H-bombs and UFO sightings. At least Van Gogh and Rembrandt are back in Holland, Goya's safe in Madrid. Picasso's everywhere, but he always was, wasn't he? Now, there's a man who enjoyed the fun in art – HAD all the fun and took all the media shit, as part of the territory. Part of his art. Proclaimed the second coming like the savage messiah he was. Defined an era, and enjoyed every indulgence known to man without guilt, gave Francis Bacon his break, and just about every other artist since, every one. Every one, that is, except Marcel Duchamp. Duchamp demon-strated that anyone, like everybody who wasn't an artist, but wanted to be, WAS one. The irony there is that Duchamp WAS one, to the spirit and to the letter. He could be a "retinal" artist – as he called it – first, and then reject it, which he did. He knew before Groucho Marx that any club that would have him he didn't want to join. Master of his craft as painter, he realised before anyone that it would not supply the twentieth century with the gratification for its new cravings. Art did not engulf the mind, as it used to, and the compulsive innovative appetites of the new age. We weren't drown-ing, and we needed to be, in order to struggle, and reach safe haven, or even a raft, for the time being, at least.'

At this point we broke off as Gavin needed a change of drink. Eventually I tried to bring him back to the matter in hand. 'Tell me about your next favourite arrondissement.' He was slurping wastefully on a practically unobtainable bottle of 1961 Château Le Gay. 'Don't worry,' he reassured me, 'Pomerol ain't too proud of this one, great vintage as sixty-one was – dirty barrels and ducks shitting on everything, more often than not. What d'you want? A peasant in a suit playing the stock market? This one should have been drunk twenty years ago. Wine is like art. You may be great, but you have your off days, you don't create the work in galleries and you keep chickens. We have a lot in common.'

'And the arrondissement?' I persisted.

'Yeah, the sixth, vee one, the famous ubiquitously named "left bank", about as left as a French poodle. That's my BRAIN. A meandering area of tiny streets stuffed with bookshops, places of learning and medical institutes, phoney galleries, museums, and the thought-provoking boulevard Saint-Germain. Saint-Germain is the only street I know where for a single franc you can experience a whole new way of life, realise that the beggar is yourself, and by the time you reach the other end, at Pont de Sully, you've spent three thousand francs and you haven't bought a thing. The southern end of the sixth pierces boulevard du Montparnasse which trades heavily on its literary and artistic legends of the interwar years, when Paris was still a fit and decent place for an artist to hang, like a bat, and be fruitful. In a bar on the boulevard du Montparnasse there is a brass plaque screwed into the wooden bar top. Engraved into its polished surface are the words "Ernest Hemingway sat here". But what they didn't engrave was that he was a helpless noisy drunk, and he was thrown out on the street. History is very selective.'

'Do you drink there?' I needed to move him on.

'Occasionally, when I am feeling nostalgic, which is always. I was sitting there only last week and some ghastly gremlin in light blue-and-white canvas deck shoes came in and said to me, "You're sitting in Ernest's chair", and I said yeah I know, I'm just keeping it warm for him, James Joyce and Sam Beckett, and if Nicolas de Staël pops

in, him too. Everybody came to Paris then, as though it was the answer to all their ghastly hang-ups and frustrations. I don't blame them. What is frustrating now is that they have all gone and here I am. I missed the train.'

'Being an artist, what are your EYES of Paris?'

'OH, er – EYES? – the ninth, IX. The mount of the Basilique du Sacré-Coeur, or Co-Europe, as I like to call it. The sacred Community of Europe, that pipe dream of all economists who want to obliterate difference and make standardisation their ticket to a quick fortune, the bloody suits again! I still want to look at a twenty or hundred franc note and see Claude Monet – Monet as money – or Gustave Eiffel celebrating the Paris Exhibition of 1889 and the birth of the new architecture of iron and steel – real aspirations. What the fuck are they going to put on a euro, eh? The fat arse of a bureaucrat? Yeah! The ninth district is the EYES. From up there Paris can see itself but doesn't want to look. It weeps down steep streets, into topsy-turvy toytown squares. It weeps for those artists who never made it, for the loss of those who did and left, and for those who are still there, making a mockery of its past. It can see much of the rest of itself too, turning into cheap markets, and cheaper lifestyles, churning its insides into sickly doubt about its future. It can see the colour of itself turn into fluorescent Impressionism, as the old order of radical new art morphs itself into strange growths all over its heaving rooftops, reminding itself that it is probably a dinosaur by now, and still changing – but into what? Is it still the centre of the world – or is that now Bangkok? Are those pipes on the Pompidou Centre, near my belly button, really my intestines exposed by some arrogant megalomaniac architect, or is it a trick of light, as it used to be? Have I always looked like that inside, and do I really want to know that? Paris must surely ask itself that question. Am I just a has-been theme park of taste, or can I still hack it on the cutting edge?'

'Well, you're still here, Gavin, so it must be somewhere you want to be.'

'Well, looking from on high, from the Mount, west, between and beyond the Arc de Triomphe, and the Concorde Lafayette at Port

Maillot, I can make out the exclusive sixteenth "arrond" of avenues Foch and Victor Hugo, exquisite tree-lined boulevards and ivory towers, sliced from its other half, and natural complement, the Bois de Boulogne, by the Périphérique Ouest. It attempts to stay as one by growing over and around this demon race track it felt it needed, like a giant heart bypass, to avoid its arteries jamming up for good, with its maniacal traffic movement. But don't think I wouldn't want to live there. The sixteenth is the LUNGS. If you look at the region as a Daguerreotype it still works, but you mustn't move, and you mustn't breathe. It's a time capsule.'

'Where is the er – you know, the er – private parts?'

'PENIS? *Le DICK! Comme le week-end.* The seventh arrondissement. I search for that when entering Paris from whichever direction, France's nineteenth-century prototype for a space odyssey. Representing the dreams of such men as Georges Méliès and his *Voyage to the Moon*, the Eiffel Tower is now a TV transmitter for the greater Paris region. Did you know that? It stands like a sentinel, and not by accident, at the approach to the Parc du Champs de Mars, God of War. A monument to regimented discipline and the grandeur of war. That, of course, leads naturally to the massive École Militaire with its Hôtel for wounded soldiers, which speaks reams about the phallic mentality of late nineteenth-century France. So public a display of what I consider to be the body's most private part strikes me as ironic, but isn't that the case with all tall monuments? They represent the frantic expression of an irrepressible male aspiration, to be noticed for things we pretend don't exist. Show me a tall monument and I will show you the violence. *Liberty leading the People* in Delacroix's painting, though personified by the figure of a beautiful woman brandishing a French Jacobin flag, and displaying her generous boobs, did not inspire the construction of a more feminine monument to celebrate the storming of the Bastille. A different revolt, an earlier one, but it was for the people, after all, and everyone has a mother. Instead, another stonking great phallic monstrosity sticks up in front of an equally monstrous Paris Opera House, when a pair of diva's boobs would have been rather

appropriate today and so much more French somehow. Pass me that bottle, there's a good chap.'

'I think you are more romantic than you let on,' I respond as I pass him the remains of the Château Le Gay. 'Where then is the HEART?'

'I wondered when you would get to that. I thought for a minute you had forgotten we ever had one. We damn near haven't any more. It is both cerebral and physical.' He paused for a moment, drained the bottle and wiped his mouth on his sleeve, then looked hard at me.

'The HEART is Paris, of course, or, more precisely, the sum of its parts described, geographically at least, by the very *périphérique* that surrounds the main body of the city. It is as though, subconsciously, the Parisians have shaped a kingdom that is all heart with its rivers and canals, snaking through its regions like right and left ventricles, pumping life and energy into its well-worn body. If you can think of a more romantic metaphor for the world's most romantic city, then go look for it. At the very least my clumsy explanation makes it *my* Paris.'

As we talked the wine was disappearing rapidly. I think we were both a bit slurred, but Gavin suddenly started talking about his schooldays.

'– It was a brick wall – No! It wasn't a brick wall – It was limestone and it was my first day at real school – I had already been to nursery school – I was a big lad – I knew the score – I knew a bully when I saw one – I had felt the bruises and the nasty, sticky taste of blood in my mouth and the claustrophobic sensation of coagulated snot, an inability to breathe and the sense of choked protest in my throat. It was always in the throat. DON'T! I said. Why do you do that? Why that? Why must you hurt me? Why not ask me a question? Why not? Ask me – Ask me anything – Anything. Why not ask why I have a neck brace? I was sick, y'know. I suffered from self-pity and I needed a neck brace to keep my neck straight. That end of your foot – did it ever have a sympathetic thought in its life? – Thunk! – No. It never. It was a foot. It was a goddamn foot. Feet

don't think, only the head of the foot, way up there, which is too far away to imagine what it feels like to hurt, and for no good reason. Shit! Don't do that. Don't kick me. OK. Kick me. Beat the living shit out of my body but do it so I don't feel the pain. I'll die for you – but don't kick me again. Every time, I died – but I didn't know why it was me who had to die.'

Gavin talked often of his schooldays with an ongoing rage. The limestone wall. What was that?

'Oh. That! Shit! That was where I ended up. Against it. Always against it. Like a concert programme, and you read what to expect. This is what comes next. Part four, after part one, two and three. Thump one, thump two and thump three and then the brick wall. Had to be the brick wall. The limestone wall. What's the difference? They're both hard. No victory otherwise, for the bully. There needed to be a finale, a moment when the bully had made his statement. Not a single halfhearted bash which sent you flying off on to the impersonal gravel of that bastard's domain, but a continuous hatred of all I represented, which drove him crazy. I was different. I was a mutant. I had a neck brace. I had a catheter too, a hanging tube which didn't seem to have a reason. 'Course there was a reason, I kept wetting myself, that's the reason, but it don't make much reason in a playground where young unformed minds are supposed to find out these things which define us, and torture us. That's what play-grounds are for. They establish motivation for the strong, the leaders, the ones who carve out destiny for everyone, for the rest of us. Aggression is leadership. We tend to follow the one with the strong idea, the one who drives the hardest bargain, right or wrong, the strongest.'

'Did you ever fight back?' You have to ask such questions in the throes of somebody's intense explanation.

'Fight? Hell! Shit, I fought, I fought like a windmill, but how would you describe a worm, to whom the good Lord gave flailing arms, fighting for its life beneath a boot?'

'Yeah,' I replied. 'That's shit-messy shit. Did you have any good moments in school? Was anybody nice to you?'

'Whaddya want me to say? Eh? Someone took the side of an underdog? Someone said, "Hey I'm weak too! Here, take a hold of my withered leg!"? Nah! Nobody came forward. Not even Keith, my best friend, who came forward all right, but only to tell everyone I made a smell in the lavatory, and I wet myself before I got there, like some damp pariah, and like just about everybody else, for that matter. He always seemed like a friend but he was always watching for the best chance – a sneaky little bastard really. I was relieved when his family emigrated to Canada on an assisted passage, the gift that England gave to all its dross.'

'Do you think that these early sad experiences informed your art? Do you think that your art is a jaundiced view of life which you use as a weapon to avoid those hurtful years? It seems that the slings and arrows you suffered at the hands of bullies gives you justification for outrageous outbursts of your own, a kind of vengeance.'

'Hell, yes, but my vengeance needed to be nuclear to assuage my general sense of playground deprivation. I loathe England and all its claims of worthiness personified. All those early years of toeing imaginary lines to please my superiors, as they were then, added up to a deformed toe. Especially my right toe – it's bent, so I was useless at sport, particularly football. To be bad at sport is THE serious defect. If I was forced to be a member of a team, it was the lethal embrace of doom for that team; I was a boneless albatross, and the contempt heaped upon me slid off my bruised body like a mudslide. We weren't known as the Ancient Mariners for nothing. My only chance of ever scoring a goal was to aim for the corner flag. I figured that out at least, so I applied the same techniques of twisted logic to most things I did, even before I learned to draw, and that was something I did have to learn. There was nothing natural there. You might say that the only thing that came naturally to me was the twisted logic which I applied to most things in order to look normal to myself at least, in the face of everyone else's abnormality which was their normality, if you see what I mean.'

'You think of society in those terms, then, as something mal-

formed? Is there no saving grace for us all, no glimmer of hope for a cruel world to show its compassion?'

'Nothing wrong with the world, pal. The world is a beautiful playground and its creatures are wonderful and weird. Its dangers are fair and its disasters are a fearful expression of its unbridled nature. Man appears on the scene and tries to control his environment, or "democratise" it, as he puts it. Where there is wilderness, we fence it off and call it a National Park – not a World Park, mind you. A municipal flowerbed, with all the conformity that implies. Although we like the idea of wilderness, we don't like to get lost in it. We need signs to tell us where to get out. So we invented art as a wilderness of the mind, a kind of freedom, I suppose, which we thought we needed, and we probably do, but we have to have signposts to label everything so we know where we are, or maybe what we went there for in the first place. People get a vicarious thrill out of watching an artist make their own mistakes for them, and then display them like a public wanker. That way they can enjoy the freedom of it without the guilt. What scares them the most is seeing a degenerate anti-social outcast kick his balls at the corner flag and score a goal. Ha! Ha!'

Gavin laughs scornfully at his broad reference, and swigs again. He is still lucid, but his apparent carefree throwaway lines mask a deep mistrust of authority and its uses. Conformity, in fact, scares the hell out of him. 'Never liked institutions, even those attempting to do good. I got no time for joining things, but then again, I now find people joining me. That is, the nefarious group of hopelessly unfocused specimens, I wouldn't call them friends. I don't like what they do and they don't like what I do, but we admire each other's right to do whatever it is we do da. Hence the title of our dismembered movement – Doodaaa. We don't doodaaa much in many cases but our resonance lies in our diversities, doversities and, if you like, our daversties. We are probably at our best when we are drunk, or rather, the futility of it all seems more bearable that way. Art is not a dutiful thing, in the sense that if you try your best, you will be rewarded, like at school – well, not at school. I tried my best at school, tried to do all the right things, but somehow they became

the wrong things. They were wrong because my heart was telling me something else. My heart was saying rebel! But I wouldn't have recognised that at the time. Conformity was my environment and my will was submerged in a set of rules. Bullies were in charge, as bullies always are. But you have to learn that, and you have to wait for a sign of recognition of the fact. My sign came one morning during assembly after having to mouth such mindless profanities as "Thy will be done, on earth as it is in heaven", which I used to think meant "IT will be done". Something needed to be done so we had better do it, whatever IT was. OK. Let's get on with it. We, the kids, willing to have a go at anything. Our enthusiasms, as yet, had not been tarnished. You can teach a kid to do anything, good or bad, like a compliant virus, so you had better teach it to do good and be objective. I have no problem with that, as long as you tell them what it is. I hadn't thought of some imagined superbeing's monumental "WILL", which our superiors thought must be the most natural idea in the world. Some roaring God figure that must be obeyed, some bearded muscle-bound faggot, who had been sitting there since the beginning of time figuring out a creature in his own image dumb enough to believe in fairy tales and carry out his orders, and there are lots of them! (never mind the animals. They did what they wanted, and didn't have to pray either, though I did wonder if some articulate squirrel had got a copyright on that one) – er – where was I – I –'

Gavin looked sideways, across the bar and into the middle distance, but I didn't say anything. He was back on the whisky and chased from another fast disappearing glass of *bière*. I let him dribble on, he looked so lonely and lost. He had even forgotten that he had a show in Paris at all. He didn't remember me, how we had got into this bar and what we were talking about. I knew that it was the end of the interview. I left him trying to negotiate a taxi ride to the Hôtel Racine on the rue Racine, in crippled French. '*Prenez-moi à* – er.' I was seeing him the next week in his studio so I called it a day.

## CHAPTER 6

## SCHOOLDAYS: TAUGHT BY TYRANTS

G AVIN RANG me a couple of days later and rearranged our
rendezvous. He wanted me to come to Kent, where he had
an old outbuilding studio at the back of a seriously bastardised early
Georgian house that was still in the family. His sister came down
sometimes with friends from London. 'Where was I last week? What
was I talking about? Something about God, and . . . We were sitting
in that bar, and then it – I forget.'

I flipped through my scrawled notes and read out, God, er – Will
– Control – another whisky chaser. Bums and final solutions. We had
covered a lot of ground.

'Christ! I had a terrible hangover. I remember that.'

'God and authority. I've got that written down here – and
schooldays. Rotten schooldays. You were telling me about prayers.
Assembly – your headmaster . . .'

'That's it – headmaster and – er – damn! I – er – the bastard's
trying to confuse me – God – God's own prayers, these prayers, his
book of wants – mouthing pious thoughts of – kindness, gentle ways
– that's it! Peace on earth and goodwill to all men. Bollocks! What
was I saying? Will! That's the word – "will". Whose will? His! His
will. Not ours, not free will. Too dangerous. Control. The bastard
needs control! And our headmaster – that was it – was just the guy to
see that He gets it. He was there representing God and authority. He
was a Bible-carrying member of God's Order. These days, I will
complain at three o'clock in the morning to the front desk in any
hotel, anywhere in the world, if there isn't a Gideon Bible in the
drawer next to my bed, and what's more, where's my bottle of
Château Bouscaut, I say. I ordered it an hour ago. That always freaks
them out. Bouscaut, sir? Right away, sir! How many glasses, sir?

' "One, for God's sake," I snap back. "Whaddya think I'm doin', having an orgy? This is sacramental. I need to drink the blood of Christ right now. He is calling me from the empty drawer!" Every time they ring back and apologise for not having Château Bouscaut, as I know they will. "OK," I say. "Just bring me the House White, and don't forget the Gideon. Did you know that Christ suffered from acute anaemia? He's not that fussy." I get both within a minute.'

I wasn't sure if Gavin was joking because he gets so intense, and humour in the middle of this desperate story is not unlike his work. One moment he is expressing a powerful sentiment, and suddenly there's a red nose on everything, but he's not smiling. There is a shutdown mask on his feelings. Take it or leave it. 'Is that it?' I enquire.

'Fuck no! I smell a rat. Was I the only one? I wasn't necessarily popular in the way that popular is understood. That is, I wasn't disliked, but the "popular ones" were winning the prizes and winning them for running a mile on Sports Day, or Spots Day, as I used to call it, in defence of those, like myself, who were weak and pimply. On that day, particularly, we showed our deficiencies like blight-ridden tomatoes. And this was the sign. We had just finished repeating all those fine sentiments.'

Gavin nearly lost me here but I resisted the temptation to ask about the tomatoes.

' "Blessed are the meek –" ' he went on, 'our heads were buried inside our bloodless knuckles – "the meek shall inherit the world", and all that, when suddenly a commotion behind us, a whimpering struggle, someone in distress, the swing doors of the assembly hall were kind of stumbled open, and we instinctively turned to peep, and look and then turn to the front again, as we were always told to, none of our business, not yet anyway. It was the headmaster, the flying-black-cloak reptile of my dreams, the crimped brilliantined black hair, snap-combed into place, still in place, was dragging a girl pupil into the hall – by her ear – by her fucking ear! In his other hand he held aloft a grubby sheet of paper – we all knew what that was – struck dumb with fear – we all knew.

'Like King Lear dragging his fool on to the stage in front of us all – the

one who would hide his madness – she was held whimpering – by her ear. But his madness wasn't the grief-stricken, eye-bursting, self-loathing kind of madness brought on by a litany of stupid mistakes – someone who saw the error of their ways maybe. No. This was a self-righteous maniac in the throes of his mission madness. This madness we knew as discipline – cold, calculated, brutal discipline. It was what we knew. This was how we learned. And he had brought this poor girl up on stage as viciously as he had, to demonstrate his dominion over us, his "will", and we were witness to the meting out of soul-scorching contempt to exact the maximum humiliation – on a kid – a kid no more than thirteen – like most of us, all with the same kind of guilt and remorse – tiny little crimes – naughty nitty crimes, fumbling discoveries, girls as well as boys, and all of us guilty of them – and we knew what that piece of paper was, and what was on it. We had all read it. Our guilt was on it. Passed it around the school we had, like measles, we all knew what it was. It was a filthy poem, "material", as this sadist in a black gown of authority described it, mouthed it, with a sneer no cleaner than a snot wipe. I can still remember the poem,' and Gavin adopted a pompous, feminine attitude and placed a pink overadorned flowery hat of Belle Epoque proportions on his head and spoke with the voice of a dowager duchess:

> Dan displayed his enormous red cock
> Its length and proportions were hard as a rock
> It never went down
> Had a nose like a clown
> Which he tried to keep warm in a sock.

Gavin danced around the studio, fell over the installation of his *Tribute to Kazimir Malevich* done in black hose and red panties, threw the hat across the studio like a Frisbee, then turned to face me with arms outstretched – a third-rate comedian at the London Palladium.

'Da-Raaaaaaaa! Totally innocent!' he said. 'We were confronting something that was nudging all our thoughts, all our fantasies, which, let's face it, we had, have, no control over! The natural, the necessary,

the driving force behind our sniggers and our physical demands.
Nature was at work milking us for all she was worth, of all the bodily
impulses which invaded the darkest corners of our wettest dreams! It
was then. That was the moment, the moment I saw the sign. This was
what those gentle words from the Sermon on the Mount were masking.
This was what they were for. This demonstration of sanctioned,
institutionalised cruelty was being upheld by gentle prayer and that
was when I felt hatred for the first time. It was all a charade. That was
the first time I should have stood up, and everyone else should have
stood up with me. Stood up and confessed that we were all guilty,
guilty as hell, and yet we didn't know where it was coming from, the
infernal fountain that gave our youth its purpose. Damned, we were,
along with her, a thirteen-year-old contagious demon, or at least that is
what he willed us to think she was. She was sub-human. She was a
Friesian cow led out into a cattle ring for auction. She was us. What was
she worth? But we were numbed with fear, all of us, and it was every
man for himself. None of us dared know anything about it. We were
never there. All that goodness, kindness, gentleness, honesty, love of
God! Sweet prayer. Nothing. None of that mattered right now. We
had been programmed to fear, that's all. We knew he was wrong,
instinctively knew that, but knew nothing of the sexual thrill he would
be getting out of this, or the toll that he was exacting from his own
miserable failure as a man.

'We all hated him, and believed at the same time that we must
remain silent for the good of the system. That, too, we had been
programmed to believe. It would have been my finest hour if I had
acted as I felt. But courage was not part of the curriculum. Courage
was wrong. Courage identified a wilful spirit, that word again,
"will", not an intangible monster's will, but ours, mine. A culprit,
suddenly, a miscreant, antisocial ringworm, a contagion to be
eradicated, foot and mouth, a louse, a cockroach that was only fit
to scuttle in dirty grease-smeared corners, and with a sexual appetite
beyond its years. Nobody was prepared to be that. We were that, oh,
boy, we were that, but our faces were clean as fresh morning dew.
The same dew, incidentally, that evolves out of the natural mist of a

new dawn, a sunshine miracle on an empty field, or on a full field too, for that matter, of stricken beasts and healthy beasts, for nature isn't watching. Nature is doing as it must. Self-regulating. Forever self-regulating. That's why they gave us religion, gentle prayer, to plaster over the dilemmas, and the contradictions, the cracks, for God's sake! Polyfilla moments. Am I going on a bit?'

'Yes.'

'Good. Then I will tell you the next bit. I never argued with my mother. She was in a wheelchair and so I did what I was told, for her sake, which didn't mean I had no secret world. Here was all the more reason to have one, but for the sake of her and for appearances I became a church choirboy, head choirboy in fact, eventually, *Te Deum laudamus, Messiah, Hymns Ancient and Modern*, choir practice four nights a week and church, twice!, on Sundays. I've got a good voice too. Sang my heart out, I did. But my little mind was struggling with what the words said, and what they actually seemed to mean. I could make no connection between what my eyes saw on a page as the code for life, and what actually was going on at school. It wasn't going to make sense either. What we were immersed in as our total experience at that time was flawed, fundamentally wrong, and I wasn't Nietzsche either, so I couldn't reach down from his intellectual pillar of wisdom, or scumble around in the muddy bottom of our village pond, to identify in the sludge the elements that nail our contradictions. There was no joyful wisdom to hold on to. So I, in a sense, escaped. I escaped into a world of my own. I didn't flunk my homework, studies, anything like that. In fact, the first thing I did when I got home was do my homework. Anything that had to be done, I did. But I now came bottom of my class, every time. Whether that was a conscious effort on my part, I can't remember, but they could always count on me to bend over and hold the rest up. Someone had to do it, why not me? In some ways it was perfection. I never faltered. To me, now I think of it, it was a reflection of them, of him, him I wanted no part of. I was showing him what I thought of him – the pits. The lowest form of life – the bully. My escape route took the form of making working models, designing flying machines,

machines to fly away on in my mind. It became an obsession. I had an attic room for a workshop/bedroom and model railway, something I could never run on time, but it worked, that was the point, and I was controlling everything, up to a point. The flying machines, the experimental ones, inevitably crashed within seconds, but that didn't matter. That was reasonable. Those were the laws of nature at work, following certain principles, or a warped wing. It was up to me to pit my wits against those principles and win. It was between no one else but me and them. Sometimes I won and the sight of a model actually leaving my hand and rising up with grace and lightness was an exhilaration like no other. Except that the more successful they were, the further I had to go to get them back. But that was part of the bargain and that was the thrill. No institution could take that away from me. I was master of my own universe. I was the God but the only "will" to be "done" in my universe was the aspirational will to go up – to fly! There was a lot of willing at times, I can tell yer!'

He looked around the studio. 'Is there any of that Troplong Mondot left? I could murder another bottle. Want some? I'll be back in a tick.'

He left me alone in the studio with the hum of a small blow heater for company. The late-afternoon sun had triggered the first notes of a thrush in the heavily pollarded old horse chestnut tree just outside the door. The munch-crunch of some ragged old sheep joined the gentle harmony of quiet sounds as they grazed like woolly bulldozers just feet away in the orchard. None of it reflected the manic buzz of the artist, who worked in chaotic splendour, or the spirit that spilled like colonic irrigation from the mouth of a driven man. The wide radiator gurgled in the silence and I swear I saw the penis gourd that was balanced on the plumber's valve on its end tremble in anticipation. Obscure awards hung higgledy-piggledy along the walls, most of them upside-down. There was a back-view photo of a naked man in a peaked cap in some sort of dressing room, which I later found out was Louis Armstrong taken during a tour of English cities during the sixties. I lifted it carefully off its hook and looked on the back. 'Not for reproduction', it read. On a half-balcony which straddled the

studio I could make out, among the pile of objects, postal tubes and sculpture, the upturned legs of a table painted silver which was Gavin's salute to Battersea Power Station. Clay models of Renaissance figures grimaced for attention along with a hideous rubber dwarf, a lobster basket and a Cubist chair that he had designed and made for a ballet called *Dancing to Paint*, a celebration of Picasso's life choreographed by Mischa Bergese, with over 400 small drawings by Gavin to match the 347 etchings drawn by Picasso as his *fin de vie* act of defiance, plus twelve projected paintings based on his work and a Cubist backdrop screen upon which to display them. It was Gavin's *tour de force* to honour the volcano of twentieth-century art. It was a monolithic affirmation from one artist to another. It died in one night at the Queen Elizabeth Hall on the South Bank.

Suddenly he was back with a fresh bottle. 'Sorry,' he said, 'Troplong's all gone, so let's try this La Louviere. It's not classified, but what the Hell, neither am I! And I don't have a Gideon Bible either. Let's call it a fifth growth and slum it. What else do we need to know? What do *you* do when you're not listening to drivel?' The cork was pulled with a decisive pop! and the glug, glug, glug of poetry was spilled into our two stained goblets.

'Me? Oh, I trained to be an engineer, but I lost my way when I discovered Leonardo da Vinci. So I became an artist/psychoanalyst instead and let people tell me what is on their minds. I learned that other people's problems make mine seem trivial, so this is like a talking cure in reverse. People's ability to recall things accelerates as they talk and sometimes they start remembering things that have lain hidden under piles of repressed junk, and even that they didn't know they carried around with them. Talking things out loud to a third party is a way of deleting troubling thoughts. That is why I enjoy listening. It feels like I am doing something useful. I notice you haven't said anything about your father.'

'My stepfather? Shit! Never knew my father. Cosby used to try playing the violin. Not under his chin, mind. Between his knees like a cello. He has odd obsessions, like the juicy bits of famous operas, can't stand Mozart or Bach, and Beethoven brings him out in a rash.

Or Handel. Can't stand Handel. The *Water Music* really gets him going and he will don an old fashioned Victorian bathing costume and a swimming hat and prance around the place watering everything in sight with bum notes. Funny thing, he wanted to be an engineer too, but his father said that the only engineer he was allowed to be was a sanitary one. Probably why he doesn't like *Water Music*. Piss-pot work as far as he was concerned. The dream of his family to build a hygienic empire of bathroom suites fit for royalty wasn't in him. He joined the company but his spirit became perverted by odd pursuits just to annoy his own father. I think he wanted to be some kind of artist, a musician maybe, because he doesn't like talking about it. He spends most of his time trying to perfect a toilet that you could actually play. Oh, God! Pheargh!'

'What's wrong?'

Gavin was holding his nose like a hosepipe and holding his glass at arm's length. 'That stink,' he whimpered. 'The wine's corked, big time. I was so busy talking I didn't think. It is the most terrible pong in the world next to stagnant urine, or a tramp's overcoat. Sorry, be back in a mo,' and he was gone again.

I tentatively poked my nose into the glass and pulled back with the shock of it. It reminded me of paper which had been stacked in a corner of a barn under a leaking roof, hiding a damp rat's nest. If Gavin hadn't said, I would have gone on drinking it, convincing myself that it must be good because he told me so, and blaming myself for not recognising the taste of a superior experience. People will endure anything if it masks the humiliation of not appearing to know about something. Must remember that.

Gavin's work – a characteristic of his work is that deadly serious progression that involves him and completely engages the serious interest of a spectator, then quite suddenly, as though realising that he is taking himself too seriously and, by that token, the world, he blows a raspberry, or puts on a daft hat and continues to talk, but in another voice.

My eyes are roaming around the studio. Every surface seems to have a

project laid out on it. My eyes move back up towards the half-balcony and I catch sight of a teddy bear. Must be Gavin's, I reckon, only because it has gnashing teeth on it made out of paper and sketched. The specific Gavinesque sign which clinches it for me, though, is that it is stuffed inside a bird cage like a wild animal. Even his teddy bear is taken seriously, as though he can trust nothing. Nothing can be accepted at face value, not even a soft toy. Demons hide in the most unexpected places, and somewhere I remember him saying that, or something like 'Beware of old ladies. They have nothing to lose. They are likely to have sticks of dynamite in their handbags along with crumpled tissues, barley sugars, buttons and bits of beige wool. If the world has been tough on them, they never forget. They are merely waiting to wreak their murderous vengeance on an unsuspecting passer-by who wasn't even alive when the old lady suffered the injustice. Nothing personal – just a broad revenge that includes anyone as a victim and just as likely to be the guilty party who made some other old lady suffer in the first place and you can't even begin to understand what that might be. Hell hath no fury like an old lady with a grudge.'

'Try this!' Gavin was holding two bottles out for approval. 'North or south?' he said. 'It's an old *vigneron*'s trick, a hedge against a bad vintage or a lousy cork. Chambertin-Clos de Beze from the north of the Burgundy region, Napoleon's favourite, by the way, or "How come I lost everything in one battle when everybody said it would be a pushover?" Or the other, this Santenay, where they may get one fabulous vintage red out of ten from pinot noir, but it's worth the wait, though they are all better for the drinking. Take your pick.'

I chose Napoleon's favourite. He had to be lucky some of the time, I thought, to get where he did. Gavin placed the bottle on top of his office photocopier. Then he picked up an old silver Selmer trumpet and blasted a cacophony of savage notes around its cork as though exorcising one of those fiendish demons. Gavin couldn't play, not that well anyway. 'But you never know,' he said, 'my music could be what they love better than cork rot, and leave the bottle to follow me, the creator of purgatory – the hellish notes of a mind in torment.'

I washed the glasses and placed them side by side on his drawing

board. Whether I had made the right choice I wasn't sure, even though what I tasted in the glass was exquisite. Exquisiteness comes in a graphload of varying combinations.

'What were we talking about when I smelled that filthy cork? It was related, I know. Your father? You?'

'I asked you about your father and you said he was weird for all the reasons that make you perverse – you –'

'YOU!' Gavin was pointing the trumpet straight at my groin. 'I asked YOU about YOU! And when you tell me about YOU, and then you ask me about ME, I remember more, so tell me about YOU.'

'Well – er –' Shit, I didn't want to get into this area. I was a hopeless failure as a psychoanalyst and even my mother wasn't the problem. I was too normal. I didn't wet the bed every night – except at my auntie's when I had to stay over as a treat – or carry a security blanket into battle or collect my nose-pickings for later. Nobody bullied me and my mother and father were sanity personified. I loved my mother as the gentlest soul who ever lived, and my father grew old with a grace which had everybody wondering what kept him going. Lack of imagination was not the reason and he possessed a sense of humour, repetitive at times, but nevertheless a spirit that bucked the trend.

'Sorry,' I said, 'if I had anything to say, you would be interviewing me, and that is not what is happening here. My father was a commercial traveller who worked not far from the kind of area your whole family comes from – around Liverpool, Manchester and north Wales. He travelled in Ladies Knickers, as he would love to tell you, and made enough money to keep us in a council flat. About the only thing he did that might interest you was making wine. The council flat glooped with the constant activity of liquid decomposition giving off carbon dioxide from anything he could pick up for nothing at the local greengrocers'. He was too impatient to wait for a full fermentation of these beggared comestibles, and would tie down the corks on the bottles with hairy string and put them in the cupboard under the attic stairs. (Being a top floor we had an attic.) Most of the time the bottles exploded, which he put down to good

fermentation, and he was right, but he could never equate the action of fermentation at the right time in a large, stout container with the secondary fermentation which continued inside a closed smaller enclosure, i.e. the bottle – and that was his problem, in all matters relating to common sense. He never made the connection and that should explain my father, except my sister.'

'YOU – had a sister? I had two of them. What's it like to have one?'

'I don't like talking about my sister, not because I don't love her, but because she was responsible for me asking the question, "Do you have to love your family because they are your family?" I didn't make them what they were and I didn't choose them, but when my mother says, "But you must love your sister, or your auntie, or your uncle," and I say, "Why?" and my mother, the personification of reason, love and light, replies, "Because they are your sister, your auntie", or whatever, I am lost for an answer, because there is no answer. She is right and she is absolutely wrong. They are not reasons, they are obligations. I didn't want to play the family games any more.'

'Wow!' Gavin seemed weirdly interested. 'One of my sisters wanted a home life, husband, children, all that, but she hasn't achieved any of it, and not because of her hair lip. Plastic surgery has dealt with that. My other sister thinks only of herself, claims she has no womb, only her career in fashion and a mobile phone. She thinks having children is a biblical idea that was foisted on to women by men who wanted to be free agents. That's why she believes in God. He is a bloke who does what He wants and she thinks she is a victim who is only trying to please Him by being a bloke too. This is weird. *You* had a sister, was she the same age as you?'

'No, she was older, and she usually made me feel that I was to blame for any mishap that occurred. She always had a better argument than me and she used it as a kind of authority, in what I would have said was an unkind way. It was that which made me angry. She would twist the truth of the matter so that things would look worse than they actually were. I thought that was unfair so I would get angry about that particularly, and more angry with her because of it. There was an inherent injustice in her perversion of the

truth which appeared worse because it would make me shout, so I got
a clout for raising my voice, a clout for the shout, as it were, and not
for the actual "crime". So I understand a little about your feelings of
injustice within the framework of authority. By the time a sentence is
meted out, the judgment is out of proportion, and the so-called crime
is compounded by the recounting of it. My sister's view of the world
was reinforced by the certain knowledge that she had won an
argument, and therefore whatever she believed, whatever her atti-
tudes in life, there simply was no alternative. She closed her mind to
difference and looked upon anything unconventional as wrong.
Something to be pitied. I stopped getting angry with her a long
time ago because she won't change. She lives on railway lines and she
and her husband take their prejudices along with them on holiday.
They have a caravan, and so, I guess, the lock, stock and barrel of
their living room goes with them like an umbilical (because they
don't go far, which could have something to do with a fear of finding
something in the world that disrupts her own unchallenged version
of the truth). Now I am going on a bit. Sorry.'

'You poor bastard! You have had a dose of it yourself. You're right.
Listening to others and their problems sort of alters the perspective of
one's own sense of persecution. It doesn't lessen it, but it changes it.
Freud used to think that he could gouge out the problem that
troubled a patient and they would be cured, and you know about
that. But I reckoned that, particularly in my own case, say, you need
to learn to live with the problem, which seems then more like a
"cure". What Freud took away might well have been the driving
force that really needed harnessing, rather than extracting. Take away
the crutch and the body falls down. Artists particularly feed off their
sense of wrongness, their difference. The complex. Difference should
be hailed as a virtue. How else can we celebrate life?' Gavin grabbed
the bottle and recharged our glasses. 'Get pissed and nothing will
seem so bad, not until tomorrow anyway.' He smiled at the floor and
added, 'But tomorrow it is a different problem.'

I put another question to Gavin. 'I wondered why you keep a
teddy bear in a cage. Is that necessary?'

'Well, it must be, otherwise you wouldn't have asked about it. It's for his own good, anyway. Protection from the outside world. Don't you realise that this world is a dangerous place for a teddy. Teddies are often loved to death by small, innocent children. Sometimes the love is so intense that a teddy can fall to bits, and the grief-stricken kid can't figure out what is going on. Love can be destructive. Well, I'm kidding but it makes people think. It was in my exhibition at the Royal Festival Hall, that and my upturned silver table that I named Battersea Power Station. What a place, and they are letting it fall to bits, all because some asinine bunch of planners thought they needed something more significant to represent a thousand years – like an acupunctured white boob without a nipple. It was backscratched into existence, cost nearly a billion pounds, and now they are wondering why they let it happen. But it became a runaway train with no driver and nobody tried to stop it. So there it sits, a flop, with no context and screaming out as one hellish symbol of incompetence, a monument to its own abortion. If they had considered Battersea Power Station as a fundamental statement of twentieth-century optimism and worked around that, London would now have one of the most desirable riverside environments in the world, with the most exciting restaurant complex imaginable and a sculpture park incorporating dockside paraphernalia, sculpture in its own right, riverboat jetties and canals running through it all like an English Venice. Art would have become an integral permanent testament to the power of invention, and not some temporary sideshow, a third-rate circus that becomes an embarrassment because it won't pack up its stuff and leave town. It's almost too late now to put a preservation order on everything still standing, but they should anyway. My mother has talked about London before the blitz, and during it. In 1943 plans had already been drawn up to build a New Babylon on the ruins of Hitler's big idea, starting along the South Bank. She showed me a book with drawings from plans to excite a post-war Britain. But the Festival of Britain sort of got in the way, the hunger of Empire, 1851, 1951. The first one was right somehow, a glass palace, blatant optimism and nothing to hide. But –'

'Perhaps nothing to hide was the attraction for you?' I suggested.

'Yeah, maybe. They may have been wrong, and injustice was rife. Dickens was in his late thirties at the time, at the height of his powers. *Oliver Twist* was only thirteen years old, and *David Copperfield* was hardly published, so neither would yet be seen as social satire, more a kind of sentimental story-telling for the middle and upper classes enjoying the optimism. Social reform at that time would have dogged the plans for a celebration. Social reform only comes about when it can no longer be avoided. Science was winning, then. Science would have been the soft bed, the reassurance, so Dickens's work was social reform by stealth, in weekly instalments. It's only a story, guys! The "reality" inside the stories would have been applauded as the "rich imagination" of the writer, and therein lies the irony.'

'The irony?'

'Yes, the irony. Listen. At that time my forebears were designing shithouses for the élite. They were at pains to separate the illusion from the act. And they succeeded. But by that token they were also, unwittingly, supporting the social revolution that was yet only something intangible on their horizon. They were not wantonly trying to change the status quo. That would have been end of business for them. They were succeeding by default, as was Dickens. If I had been privileged then, I have to ask myself, would I have stooped, offered a helping hand blatantly, given it all up to help a dream become reality? Would I have risked social ostracism to make a change for the better? I seriously doubt it. But, if I had been an artist then, I would hope that maybe I was looking for a loophole, something unnoticed before, the same impulse that made me think of standing up in assembly, but didn't. Would I have been a Daumier, or even a Goya, who was also, incidentally, a social reformer by default? He was initially a painter, as was Hogarth, who first thought to be just that: socially advance his status by marrying the daughter of Sir James Thornhill, who decorated the dome of St Paul's, and serve "society" with flattery. But he couldn't, and neither could Goya, who served Charles III of Spain. While playing visual games with his patrons he was gradually usurping their vanities until he

descended, if you like, into his *Caprices* and ultimately his Black paintings which revealed his true feelings, the disquiet at the core of his very being. And that is what art is for, as one aspect of itself.'

'There are others?'

'Oh, yes, and Domes. People are obsessed with Domes. Not Cupolas mind, like something out of Brunelleschi's Florence, but Domes, like huge flat tits, as though someone was never breastfed and so tried to compensate for their deprivation, and that's bound to be spiteful in spirit. So these people wear suits and form old-boy committees and hunker down in circles to keep out the Indians. Then somebody notices the circles and says I've got an idea, how about a Dome, and everyone thinks of the tits they never sucked on, and before you know it, tits it is! But then they take it down and leave up the administration buildings which represent what these planners seem more at home with. The tit becomes an embarrassment, the Dionysian sensual abandon it suggests was perhaps a bad idea after all. They follow Apollo, the Sun God of order and reason, and the escape culture of Dionysus and revelry is manacled and put in a strait-jacket to be paraded from time to time under a set of state-controlled systems which tempers the outrageous in art, and uses it politically, like some secret weapon under wraps. Now see what you've done. Got me going and completely in a fix and wondering what in Hell I was trying to tell you!'

'What do you think of the Santenay?' We had finished the Chambertin and Gavin was pouring the 'southern' aspect. I had hardly noticed and I wasn't sure what Gavin was really trying to say at this point though there was some bee buzzing around in there, and it will emerge as time goes by, but not today, not today. I need to come at it from another point on the map, and talking of maps how the Hell am I going to navigate myself home in this state? As though reading my thoughts he offered me the use of his model's plinth with an old mattress and blankets. But it was time to get the Hell out. And if we were going to get to the airfield in the morning, I needed to make an early start.

# CHAPTER 7

# FLART: AERIAL ABSTRACTS

I ACCOMPANIED GAVIN to a local airfield. He was taking his first flying
lesson. He needed the experience for a very specific reason.
Nothing he does is pure idle pleasure. Using centrifugal forces,
he was determined to test a theory about what happens to colour
when released into the atmosphere inside an enclosed space. His idea
was to squirt deep cerulean blue watercolour from a plastic ketchup
bottle towards the floor of the cockpit. He believes the colour will fly
upwards and hit a previously arranged sheet of heavyweight Windsor
and Newton watercolour paper when the plane goes into a steep dive
from 3,000 feet. Gavin's magic rule of three, which serves him daily:
'What I say three times is true.'

According to Gavin, this will be a first in his new theme of flying
art, or Flart, as he calls it. He intends to intrigue the curious and
confound the carpers. He invited me along to witness the historic
moment. The pilot would be wearing a frogman's outfit to increase
the surreal nature of the idea and keep the cerulean blue out of his
face. Immediately after the 'drop', the pilot will pull out at 1,000 feet
and take the aircraft up and over in a 3-G loop to disperse the colour
across the surface of the paper. Gavin wanted me to participate in
another experiment whereby we would do a skydive together, and I
would hold the sheet of paper in front of him as we freefell to fame.
He intended to finish the painting before we hit the ground after our
chutes opened. I didn't think it was in my contract to leave the
ground under any circumstances, so I said I would see how the
ketchup bottle trick went first.

When we arrived at the airfield, a kind of early Billy Butlin holiday
camp with luxury sheds nestled inside a mud trap, the first job was to

run the gauntlet of some foot-and-mouth barricades of angry farmers with twelve-bore shotguns and disinfected green boots faded orange–yellow with constant sloshing through the stuff. Gavin held up a victory fist salute and murmured, 'These are my kind of people. They can sense my dedication,' and he handed out some sheets of handmade watercolour paper which they all grasped like helpless flood victims expecting to learn something to their advantage. When they saw that the sheets had nothing on them, cries and boos of 'More bloody government officials, never tell us anything!' filled the air. Things looked ugly already.

'Quick! Make for that hen coop over there where it says "RECEP-TION. You too can learn to fly above life's problems and fuck them all. NO SMOKING."'

We made a dash for it and just got beneath the chicken-wire barricade before a hail of buckshot rattled the corrugated iron roof above our heads. 'That was close,' said Gavin. 'Remind me to land in another field if we get down. I'll have precious artwork with me and they don't seem to comprehend the importance of this experiment. Ah, that looks like our pilot over there by the coffee machine.'

There was a mousy little man wearing a Marks and Spencer velcro flying jacket nervously fiddling with some papers and looking at his watch. 'Ah, here you are, thought you may have lost your nerve. Got your sick bag with you – er, no matter. Bradwell in the flight control office probably has a few left over from last week's Coach and Fly group. What a day that was! Twenty-five OAPs were taken up in that old Avro Lancaster bomber over there, a sort of memory-lane trip for most of 'em. Some were sick at the sight of it and we had a full-scale clean-up operation to deal with before we even got on board. It was like trying to put twenty-five four-legged tables into the fuselage. Most of them wanted to get back on the coach and go home. It'll take me ten minutes to get the plane ready and put on the wetsuit. Get yourself a coffee and relax.'

Flying magazines like *Wingspan* and *Skydive News* were scattered on a home-made plywood table with coffee stains all over them. One page had a headline about coupled skydives – the latest thrill with

your partner – and photos of grimacing men in crashhats piggy-backed on to women in spectacular goggles wild with pleasure falling past another couple taking pictures of spreadeagled maniacs caught in split seconds to show the kids. The coffee was grim and the pilot reappeared togged out in a light grey–white surfer's wetsuit, and a pair of glitter plastic goggles he said he had borrowed from his daughter.

'All set,' he said. 'It is just the one, isn't it? Which of you is Twinge?' Gavin stepped forward with his paper under his arm and tinted flying goggles which had been hanging in his studio for years. The ketchup bottle was in his flak jacket. 'When we get to three thousand feet I'll tell you the drill, we –'

'Forget it,' said the mousy man. 'We'll do it from two. I think I know what you're after and I have decided to take the old clothes-horse over there. The Cessna with the patch on its wing. We occasionally have a fruitcake who wants to climb out on the wing strut and get a shot of the pilot in flight. One was wearing a Prussian tin hat. I had to land with him hanging on to the strut and he punctured the wing skin in the panic. He dropped his camera, too, in Leeds Castle moat. Right. Let's get on with it.'

Gavin was very quiet, I thought.

I stood and watched as he followed the pilot to the tried and tested old aircraft which must have withstood the elements of chance and fat old ladies with unquenchable desires to fly just once before they die, and wing-walkers who have watched *Flying Down to Rio* with Fred Astaire and Ginger Rogers once too often and believe it's all done in the air – including the somersault.

The paper was fixed in position. The doors were slammed twice for safety. There was a lot of shuffling, fixing seat belts, plugging in earphones, wing flaps flapping, rudders tested, tail flaps pointing to this and that, choke-priming, and then the wheezing whirr of a well-worn engine coughing into life. A quick final check and they were taxiing across the field towards the grass runway where the flooded ruts were still visible and potentially dangerous.

The throttle opened with a sudden roar and they were off and up within fifty yards curving away to the east of the weald like a crippled goose trying to keep up with the rest of the skein.

I sat on an oil drum, rolled a cigarette and waited. The wind was stiff and still a little on the cold side. Bumpy flight I reckoned. I heard the engine overhead as they circled and began to climb into some low rain clouds threatening to soak the field yet again. Then I heard a cough as the engine seemed to stall, start up again and go into a steep dive gathering speed as it plunged out of the clouds and made for the sheep in the next field. I held my breath and closed my eyes. Stupid bastard! He's going to kill himself for an experiment that may not even work and I won't be writing a biography so much as a four-line obituary in *Wingspan* about the dangers of stunts that it's time were banned along with all the rest of the hairbrained schemes that flight pioneers had not bargained for when they risked their own necks to prove that man could fly.

My eyes were squeezed shut as I waited for that sickening explosion but the engine was still screaming on full throttle when I opened them in time to see the old banger pull out of a desperate sheep-shearing plunge and soar up again into the clouded yonder. I could see cerulean blue all over the inside of the cockpit windows and the fluttering end of Gavin's white linen jacket which must have got caught in the door as he clambered in. I could just make out the blue liquid seeping down it as it obeyed the laws of gravity while pulling out of the dive. Two of the sheep caught it too as the plane swooped by, which made them look as though they had just been gang-raped by ten rams.

The plane continued to climb, up, up, up, a-a-a-and OVER! The old bugger had done it! The pilot started showing off now because the plane careened, banked to the left, and then turned over in what seemed like a victory roll, no, wait a minute, another wobbling hiccup, an unnaturally sharp turn towards the airfield, a serious drop in altitude, a recovery and quite suddenly silence as the engine choked and died. I could just make out some kind of struggle through the blue windscreen as the pilot fought to drift the aircraft

into a crosswind which had got up in the last few minutes. All flaps were down as he manipulated every last ounce of lift from the surfaces of the wings. The craft bumped down heavily, rose up and bumped again, coming to rest up against a fat sheep that had wandered on to the airstrip. There was a commotion inside the cockpit, shouts of 'blithering idiot' and thumps as elbows hit the insides of the light aluminium fuselage and instrument panel. Both doors flew open and two violently blue figures fell out on to the wet grass gasping like wounded gladiators. Gavin was holding the paper and shouting ecstatically, 'It works!' while the pilot was screaming what sounded like curses and ugly words like sue and writ and your bloody watercolour fused the electrics and Gavin will never fly again as long as he, the pilot, lives, as he struggled to get his glitter goggles off, which, when he did, left two staring white eyes blinking through sockets of reddish-pink flesh.

'But it worked,' said Gavin when we had finally got away from the flying club. What little interest the pilot had previously had in art had now been snuffed out as surely as the watercolours had killed any last flicker of life in the engine's spark plugs. 'But the pilot was a bloody Philistine, anyway. If he had gone up higher we could have had another shot at it.'

'But the pilot couldn't see,' I reminded him.

'So use radar! Instead he gets out his crappy little elastic-driven kite and expects me to get serious. It's a good job I had my mind on the job, and by the way –'

'What now?' I shuddered at what might come next.

'I got a great aerial shot of my new black sculpture on the front lawn and I saw the studio through the blue windscreen.'

What a bonus, I thought to myself.

# CHAPTER 8

# VERA STEADMAN:
# STARLIT AUNTIE AND MUSE

GAVIN HARBOURED a particular fantasy for a lady he knew through odd references to her in film libraries, a little-known starlet from the early days of black-and-white one-reelers. He produced a series of strange nudes which brought Vera alive as though he had actually known her, and it turned out that, although he never had, they were in fact related. She was the little-talked-about daughter of his great uncle, 'J.T.', and Gloria Steadman, née Twing. He always refers to her now as great Auntie Vera. She was born in 1900 in the little stop-over of Gonzales in Monterey. He embraced her very memory and she became an integral part of Gavin's private world.

One of Twinge's obsessions concerns obscurity. Why do some stars remain obscure and why do some even hug obscurity like an old friend? Why do some individuals make it and others, who have such indelible talent it hurts, fail to do so? Why Twinge himself remains obscure and fiercely protects his life and his personal habits? And how and why did Vera keep her life so private in spite of such breathless one-reelers as *A Bedroom Blunder* (1917), *Are Waitresses Safe?* (1917) and *Whose Little Wife Are You?* (1918). This early flush of films was obviously thrust upon her at a time when film producers craved to display her ample charms, and press their licentious desires on to each new example of feminine pulchritude that walked through the door. Those gorgeous girls who put themselves into the system, that ruthless system, engorge that lifestyle which was, after all, the way of things. You were not a starlet, not even a harlot. You were less than that, and sometimes meat. A gang of rapists masquerading as artistic directors with a mission would take anyone who walked into their rapacious, grubby lives, and deal with them as a cornucopia of

orifice – a corporate hole, to be used and abused as a fleshly offering given to them, as the system conveniently dictated. Morals didn't even come into it. You were there as a sacrificial lamb for sexual slaughter. The pathetic hopefuls, who thought that stardom was but a corporate orgasm away, were nothing more than a gangbang to nowhere.

Vera figured this out pretty damn quick and found herself an agent, a glitzporn Svengali who also required his 10 per cent plus. Vera put up with some of it but not all of it.

Other films followed. *Stop Flirting* (1925), *Red Hot Tires* (1925), *Nervous Wreck* (1926), *Frisco Kid* (1935) and *The Drunkard* in the same year. During this period Vera was able to demonstrate her wider dramatic talents. In such movies as *Gambling with Souls* (a.k.a *Vice Racket*, 1936), followed in the same year by *Amazing Exploits of the Clutching Hand* to rave reviews, she gripped a nation ravaged by unemployment and the New Deal. Her looks of horror mixed with pathos and maniacal laughter had audiences in fits. Nevertheless, her life remained an enigma. Rumours circulated that she had entered a convent and taken vows of chastity. That she had joined the war effort to entertain the troops in Burma as the other Blue Angel. That she had married the Swiss clown Grock who laughed at his own jokes and commiserated with his own fabled distress. That she had gone to live in Russia to make films for Eisenstein. That she failed and came back to Hollywood only to be rejected for the part of Anastasia in favour of Greta Garbo who never really wanted to be alone as much as Vera. Vera, it seems, was the personification of 'aloneness'. In fact she was so alone that she was never considered a subject for investigation as a 'filthy pinko commie bastard' during the McCarthy witch hunts, even though she had lived in Stalinogorsk, spoke fluent Russian and appears in *The Battleship Potemkin* as a 'screaming old woman in broken glasses'. Destiny, it seems, passed her by.

It is this 'appointment with destiny', this 'promise gone weirrd', and a 'career in ruins', which fascinate Gavin Twinge, whose own life is mirrored in hers. Twinge quotes Scrope Berdmore Davies (1783–1852), another unknown: 'Babylon in all its desolation is a sight not

so awful as that of the human mind in ruins.' The resonance between Vera's life, his own, and that statement forged Twinge's own direction, his art and his fate as we know it. And she was, after all, his Great Auntie.

In 1976, ten years after her unnoticed death in Long Beach, California, Gavin embarked on the series of nude pictures of her, his *Gavinudes*. They are published here for the very first time though Gavin himself insists that they are not finished. He has also produced an installation of her life which can be seen at the Tricycle Theatre's new four-million-pound cinema in the Kilburn High Road. That such devotion is lavished on a star acknowledged to be seriously minor expresses the deep human compassion that Twinge feels for her, his own Olympian efforts, and the realisation that so many brilliant lives just don't take off.

Vera was born at the turn of the twentieth century to John Thomas Steadman – a craftsman, idealist, sculptor and, like so many others before him, humble plagiarist – and his new wife, Gloria, the daughter of a Giggleswick mayor and Plombier Provocateur, Gordon Twing, and his wife, Doreen. They met at the festival held every year in the village. Gloria was demonstrating home-made wine-making and her 1899 Elderberry Rich Ruby was the best she had ever achieved. John Thomas had just hit the gong in the test-of-strength contest and was feeling pretty proud of himself. He stopped off at Gloria's wine stand, took a swig of her '99 Elderberry and their love matured quicker than Gloria's next vintage. He realised that she was the daughter of Gavin Twing, for whom he had made a pair of carved legs for Twing's top-of-the-range Siphon-Jet Closet with low-down tank, which won a prize back in 1879 at the Paris Exhibition. J.T. had been a talented young lad. They decided to wed and follow the 'unfortunates' to America and seek their fortune together. And, better still, get into wines with the real stuff, grapes. He would carve his own barrels, using only a spokeshave shaper and a hammer.

Monterey was a wide-open part of California in the San Joaquin Valley. Some went to the Central Valley to grow vegetables like they

had always done back in England. Some became Cabbage Kings, some Marrow Magnates, and some formed a Masonic lodge and called themselves the Carrot Cavaliers. Their habits earned them these titles, as most acted like early film-makers – flamboyant characters who threw money about like weed killer. Vera was conceived on the voyage over at latitude 55 degrees north and 38 degrees south and was born into the community of the little Mexican town of Gonzales in the middle of nowhere. Gonzales became a stopover for trucks in later years as the vegetable industry boomed and the whole region became known as the Salad Bowl of America. Route 5 became a busy road that served the West Coast region as far north as Portland, Oregon. Vera watched her mum and dad struggle with the earth, plant vines and hope that in the next five years they would see some results from their labours. John Thomas grew vegetables like everyone else to make ends meet and Gloria's Carrot Wine became a staple drink at the shanty bar in the town.

Carrot hangovers were different from any known state of mind suffered by destitutes of the new century. Those who survived them spoke of nosebleeds, phantom limbs sprouting from their ears, and strangling passers-by, paralysis of the left eye, a compulsion to use obscene language, throbbing sphinctral lumps unlike any haemorrhoids most of them had ever endured, and, worst of all, perpetual urination that unless treated with another hair of Gloria's vicious dog left them no alternative but to seek the only medical assistance available, a blessed relief in the form of terminal dehydration.

Vera wasn't much for agriculture, or school for that matter. She languished in the twilight of her daydreams, usually those about getting into vaudeville with Gruntilla Humboldt, the Human Cannonball, or Haroldo T. Carsonelli, the Singing Latin Lover from Merida in the Yucatan. She was crazy for show business and would entertain any traveller her mum and dad took in for the night. A string of songs ranging from 'Oh! Muki Muki Oh!', through 'Forest Warblers', a duet in which she would perform both parts, to 'Take Mah Boots Off When Ah Dies', a novelty song, made her a star in Gonzales, but nowhere else.

She was now fifteen, and after an exciting trip to New York with

her father, to greet her grandparents off the *Lusitania*, she was ready to leave home once and for all. She fell for a weasel, Grezny Coppelshlitz, son and heir to the Coppelshlitz Corn fortune, who happened to own one of the first Model T Fords thereabouts. He promised to marry her when she was sixteen and take her to LA. Well, he took her to LA, shacked up in an early form of motel called the Auto-Vehicular Travellers Repose in Terra Bella, just south of Fresno, and kept her there while 'they waited for the licence to come through', as Grezny put it. In fact he was waiting for a valid invoice for his new Model T to arrive by post to legitimise ownership, when he would be on his way free and clear. Vera was left to pay the bill at the Repose, so she sang for her supper instead. This was a good lesson that served her well when she finally made it to Los Angeles, and it got her an audition on the strength of her song 'You Took Me for a Novelty and Left Me for a Model T'. She recorded it in a phonograph studio in Pasadena, and sold the copyright for ten dollars. One precious cylinder of it exists at the Ford Museum in Detroit.

Los Angeles was at that time a giant film lot and growing, as aspiring film-makers flooded in from New York to 'capture the light', attract the sweet young hopefuls like moths, and make fortunes beyond the dreams of just about everyone. The Keystone Company was flourishing and Charlie Chaplin was already writing and directing one-reelers for Mack Sennett. Sennett was a power freak who could not control Chaplin or his insatiable appetite for young ladies yearning for fame and fortune. Everyone wanted to be in a motion picture and prettiness was in plentiful supply. Vera knew this and yet she tried to get auditions in just about every Keystone movie that came up. She was always overlooked in favour of Edna Purviance, Georgia Hale and later Gloria Swanson. But Vera never wavered from her resolve to get into movies and by the time she made *A Bedroom Blunder* in 1917 she had already made a few stunning appearances.

She was a star on the move. She was an active participant in all things physical. She could ride horses, she could swim and she could dive, and she became one of Mack Sennett's leading Aqua Lovelies, in his most ambitious silent water extravaganza, *King Neptune's Harem*. Then

Sennett learned that Vera was also a contender for the 151 cubic inch Speedboat Championships. He cast her as an escaping plaything and filmed her driving the fastest speedboat of the day up a water ramp and over the Niagara Falls. Vera survived, but Sennett cut the sequence from the movie because the footage seemed too outrageous to be true. He considered that his audience would find such a stunt an unbelievable piece of science-fiction, gratuitous sensationalism, and therefore not acceptable. No copy of the event now exists, as far as anyone knows.

Vera Steadman was before her time and played her roles with the fervour of an early template/prototype for *The Perils of Pauline*. Unfortunately, Vera was overlooked for the part in favour of Pearl White. 'She is just too beautiful,' everyone said, and that was that. Her last film, *Teen Age*, made in 1944, and the first time the phrase was coined, saw her as the mother of a truculent young daughter. Now in middle age, her ravishing presence behind her, she was compelled to play the supporting role, as always, in a diminishing career, which nevertheless sowed the seeds for later 'revolutionary' films like *The Blackboard Jungle*, *Rock around the Clock* and *Rebel without a Cause*.

Gavin feels that he owes her something and his *Gavinudes* are his tribute to her exacerbated, unsung talents.

Her father, 'J.T.', as he was known, pursued his love of vinous prime stock, and developed the first vintage of cabernet sauvignon and merlot in the area, which could be compared to anything Bordeaux had to offer. In fact, some of his rootstock was commandeered and sent back to France in 1906 to replace the vines decimated by the hideous root bug, Phylloxera, which plagued its way throughout the whole country. Gloria continued to believe in carrots and drove perfectly harmless working men into the depths of abject misery and downright wretchedness. J.T. tried to ignore his wife's ruthless obsession with carrot gargle and took up his old skills as a carver and artist of no obvious talent then, but he did provide the neighbourhood with its first monument, a soaring carrot-shaped obelisk, in memory of his wife, who left him for a passing carpetbagger. J.T. never recovered from the distress and threw his energies into building a barge from vegetable packing cases, boiling the

pieces into a solid prefabricated mass and carving the barge as he went. That there were no canals in Monterey to sail his barge was immaterial. J.T. became the first man to realise the strength of laminated forms used in twentieth-century furniture. Josef Breuer, a furniture designer of revolutionary forms and a great businessman, adapted J.T.'s rudimentary methods and created collectible chairs, impossible to sit in but works of art in their own right.

J.T. meanwhile wrote to his father-in-law Gordon back in England, apologising for his daughter's desertion, for he considered it his fault, as a man of requited failure. Silas had long since gone down 'drain 'ole int' sky', and Gordon was considering retirement since the bottom had dropped out of plumbing, and he had, after all, 'made his pile'. J.T. suggested a trip to America.

'There's three brand-new boats, three iron-clad beauties to choose from, the *Britannic*, the *Olympic* and the *Titanic*. Take yer pick, Gordon. Yer'll never regret it. Travel in sheer luxury. I'll persuade Vera to join me, and we'll travel by railroad to New York and meet you off ship.'

Gordon and Doreen chose the *Titanic*, and made plans to come over. Doreen was very excited and planned a wardrobe fit for a duchess, which she nearly was considering that she was the wife of a Giggleswick mayor. Unfortunately, Doreen caught a serious bout of influenza, and the voyage was put off till the year following the outbreak of the First World War. They chose the *Lusitania*, a Cunard ship, since it was the only ship still making Transatlantic crossings at the time. All the others, including White Star's *Britannic*, the *Olympic*, and Cunard's largest liners, the *Aquitania* and the *Mauritania*, had been commandeered to transport troops and wounded soldiers around the Mediterranean. Gordon and Doreen took a suite with the best of plumbing Cunard could offer, and crossed the Atlantic in style. Gordon was in wistful mood.

'Ee, Doreen. I feel a hint of nostalgia already, and an unfulfilled dream. I'd love one last go at that flat-back Urinal wi' contained floor-trough an' spray pipe, complete wi' self-contained urinal bowl attached to wall. A simple design, all in one, and a hint of elegance fit for the finest hotels int' world. Our *coup de finale*, eh, Doreen?'

Doreen wasn't listening. She had her head stuck down their own personal suite closet. Doreen was not much of a seaman.

On the same boat was the artist who was fast becoming a legend in his own time – Marcel Duchamp. He had been invited over in a hail of publicity, on account of his outrageous claims for the denial of art. He had been part of a show, along with a like-minded group of true independents, calling themselves Dadaists: artists who denied art for serious consideration as no more than a 'retinal shudder', and instead embraced the works of industrial artifice, which became known as 'ready-mades'. These were articles originally designed and manufactured for utility purposes, but identified by the Dada movement – specifically by Duchamp – as works of art, simply by the act of choosing them. But Duchamp was travelling to New York because of his Cubist paintings, based on a *Nude Descending a Staircase, Demonstrating Time, Space and Motion*. Having been rejected in Paris and Barcelona as works guilty of being critical of Cubist 'orthodoxy', these remarkable paintings had found their way to New York, to a show staged in 1913 at the Armoury of the 69th Infantry, on 67th and Lexington Avenue, where they immediately caused a sensation.

Now, two years on, Duchamp had been invited over to enjoy his new status as a radical trailblazer.

Owing to Doreen's unwillingness to get on a boat ever again, the Twings decided to stay on in New York, 'just for a bit'. Gordon was dreaming of his Urinal, and introduced himself and his composite design to a plumbing factory downtown called the J. L. Mott Iron Works and, as with all revolutionary men of destiny, his fame too had crossed the water. He was welcomed with open arms, owing to the neatness and ingenuity of his new Urinal design. They had an opening in the city for such a utensil. Hotels were mushrooming up right across Manhattan, and Gordon suddenly found himself a wanted man. All his other plumbing works were eagerly studied and a deal was worked out. Gordon oversaw the manufacture of his plumbing masterpieces, and contracts soon followed. The Twings took a residence on East 61st and Lexington, a busy area a block away from Park Lane, where servants and cooks did most of their shopping for the big houses. The bustle

reminded them of Giggleswick market back home. 'Park Lane were too grand' but for Doreen it was heaven, being hardly a hopper's heave away from the newly established Bloomingdales department store. J.T. was persuaded to stay in New York and became Gordon's stylist. All Gordon's designs were first carved in wood, from which casts were then made, and J.T. had found his vocation. Vera, still determined to follow her own dreams and get into films, went back to California, where she soon landed that first role in *A Bedroom Blunder*.

Meanwhile, Duchamp was pursuing his own retaliatory plans against the established Society of so-called Independent Artists back in Europe, and happened upon the J.L. Mott Iron Works, where he purchased a glazed porcelain Urinal. As 'Richard Mutt' from Philadelphia, he submitted it to the 'Independents' Show in New York, called it *Fountain*, and signed it R. Mutt, 1917. As Duchamp expected, the directors were horrified that a mere bathroom fixture was offered as a perfectly good example of art to the New York Society of Independent Artists, just as the 'Independents' of Paris had been offended by his *Nude Descending*. It was rejected, but made headlines.

Such was the brouhaha surrounding such an offensive act – and what's more, he hadn't even made it himself – that word of a 'Urinal', renamed *Fountain* by Marcel Duchamp, came to the notice of J.T. It seemed very familiar, and it was.

It was a pattern designed by Gordon Twing himself, and indeed carved in the original by J.T. Steadman, but Duchamp was not to know that. His concerns were far more esoteric. Gordon, however, felt otherwise and was determined to see his sanitary utensil honoured as it should be, in a temple of art, along with other items, which he considered less than his own masterpiece. J.T., who had first suggested a visit to this strange outburst of a show, guided Gordon and Doreen to the Armoury building, to see his work on display. But, as Gordon said at the time, he'd rather have seen the munitions contained therein, the front-line weaponry of our new allies, and any other military ephemera left over from the Crimea that was being shown at the same time. Gordon was a nationalist before he was a plumber.

*Fountain*, before Duchamp

The Urinal was reinstated, much to the annoyance of Duchamp himself, who felt the same contempt for this lot as he had for the crowd in his own country. He intended to sue for damages, as R. Mutt, since a mere reversal of their original decision was less than satisfactory, and evidence of the same hypocrisy he had known of all societies, artistic or otherwise. He also resigned his directorship, and never joined another group.

At first it was difficult to get near Duchamp's work for the crowds, who had been whipped into a frenzy by the press, partly

because several members of the public had been arrested for using the Urinal, either as a convenient place to relieve the call of nature, but primarily because a common object was now a work of art and therefore no longer a convenience of personal utility. The public pissed in protest. The people committing this act of natural outrage pissed for the camera, which was fast becoming an outlet for personal opinion. The American Independents, however, knew a golden opportunity when they saw one, and commissioned the most eminent photographer in New York, and a champion of avant-garde art, Alfred Stieglitz, to photograph the Urinal like an icon, against the backdrop of a majestic canvas called *The Warriors, 1913*, by Marsden Hartley, legitimising the Urinal, and changing the course of art for ever.

''Ere!' declared Gordon. 'I designed that! That's me new siphon-flush model wi' built-in faucet! What the bloody 'ell's goin' on? It were meant for a public lavatory, but it's nowt t'do wi' bein' that bloody public. I protest in the name of all good plumbers every-where. Thou's not 'eard the last of this. By 'eck! I'll sue the buggers, too! I didn't come over 'ere to be ridiculed by a bunch of arty-farty ponces wi' nowt else t'do but make fun of perfectly good pisspots! I want to see the brigadier!'

The brigadier was called. He sympathised with the Twings' point of view, but saw no reason to take the matter outside regimental boundaries. He told Gordon a few hair-raising stories about latrine accidents during the Battle of the Somme and suggested that Gordon and family should calm down and take a look at the fine collection of howitzers, gatling-guns and bombs, along with regi-mental flags and ephemera, displayed along the corridor on the second floor.

'Bugger off!' said Gordon. 'Yer as bad as rest of 'em, and aggressive wi' it, too!' He wanted no further part in the affray, or New York, considering Americans to be a bunch of upstarts and disgusting exhibitionists. He had become homesick, anyway, and he had, after all, realised his dream receptacle, and seen it cause a fuss. He was secretly proud, but didn't let on. He just kept a copy of the *Boston*

*Evening Transcript*, which carried a picture of his Urinal. 'Somethin' fer grandchildren, t' make 'em proud. Aye.'

He and Doreen packed their bags, got the next available liner, the *Britannic*, and sailed for home. Sadly, Gordon died in mid-Atlantic, dumping a turd as hard as granite, which, if kept, would be an icon of monumental importance today. He was on one of his own Siphon-Jet Marine Hoppers, at 50 degrees south, and 49 degrees longitude. He died of acute constipation, brought on by too much of the new junk food, which his system could not adjust to. 'No bloody sprouts!' he used to grumble. J.T., however, stayed on in New York, got embroiled in the breathless art scene, developing his laminates and creating soaring abstract carrots and giant chess sets, which influenced Brancusi, Kurt Schwitters and Hans Arp, to mention but a few. He took a place on Avenue B on the Lower East Side, immortalised by George Bellows in his Hogarthian painting of new immigrants called *The Cliff Dwellers*. He accidentally set fire to his whole studio, lost everything, and Vera never heard from him again.

Doreen inherited the business and, with her two loving sons, went on to rule the sanitation departments of every local council, from Land's End to Kinloss – the only true Queen of Passage from A to Z.

Gavin's mother, Fanny, in turn inherited the family fortune and spent a lot of her energies trying to keep it quiet.

# CHAPTER 9

# A BLOT ON THE STAVE:
# MUSICAL DIVERSIONS

Gavin persistently attempted to create and organise musical events. There are musical instruments all around his big studio, and constant references to his fascination with reports of anarchic concerts given by poets and artist musicians during the early Dada days of Zurich, Paris, Berlin, Munich and anywhere else artists congregated and performed to largely hostile audiences. But it wasn't hostility that exacerbated Gavin's attempts to realise most of these creative ideas. He was used to that. Hostility in all its forms, real or imagined, invaded his dreams and pursued him in his daily attempts to give shape to his existence, and its meaning. Living the life is really no problem, but finding justification for it was his eternal battle.

Probably the most likely reason for Gavin's lack of musical success was his inability to play instruments with any degree of professionalism to match his performances in his art. Instruments mocked his attempts to reach their souls. Although he could touch their bodies, finger their strings and valves, and caress them for their aesthetic beauty and tantalising shapes, they remained remote. He was so familiar with them, lying about the place as they did, but they remained strangers. He longingly watched as other musicians interacted, spoke to each other through their instruments, with such ease, such enjoyment, and such consummate skill. Many of his friends were musicians, composers, drummers in jazz bands, trombonists and squeezebox demons, song writers, and anything musical – even blind piano tuners. They all held him in thrall. All his life he has tried to do likewise. He has written songs to guitars, written librettos, blown his brains out on trumpets, made guitars, collected

violins, flutes, organs and clarinets, mandolins and banjos. If he has seen broken old instruments in salerooms and junk shops, he has bought them, taken them home, nursed them back to health, and then tried to play them. Always they resist. He just cannot reach their being, and so their reason for being. He has sung his heart out, drunk and sober. He pleads with them to open their secret doors and let him in. But he has never given up on his attempts to create concert ideas and ballet productions, musical dramas, orchestral extravaganzas, ingenious fashion shows, live-action and animated films.

'I never seem to get the components together all at once. The business, the finance, the venue, the necessary production team, everything needed to get things to the next stage: and if you haven't got a stage, you've got a studio full of written ideas, projections and musical instruments that look like strangers in a strange land. If there is disappointment in my life it must surely be in this field.

'Only last week I approached the Albert Hall with a piece called *Underground Symphony*. The idea was to collect together all those musicians – good, bad and indifferent – who play anywhere on the Underground, in the grottiest venues from Archway to Earls Court; who suffer derision, contempt, cold, hunger, homelessness, and arrest. I wanted to assemble them all together, the willing ones – the unwilling would follow – and organise them into a mass orchestra.'

'To do what exactly?'

'To perform an orchestrated work based on the simplest melodies, common to most of them but transformed into a collage of sound which could be augmented, computerised and added to the overall sound-wave, which is what it would be. It would be a spectacle, too. All those diverse and aimless characters contain within themselves unknown talents and some of them do have fine musical ability. Some are students still, some never were, and the only thing they have in common is that they have all busked for a living. That is their bond.'

'That would require an enormous amount of organisation. Where

would you get that from? Just the logistics alone, getting them all there at the same time.'

'They'd come, and there are plenty of street networks with the nous to get the word around – *The Big Issue*, free papers, word of mouth – and get the straight press interested too.'

'It's a great idea.'

'I have thought so for years. Every year we celebrate The Proms – a huge, very English, very middle-class and wildly popular institution. Think of it like that. An Underground Proms with a celebratory sense of occasion. It could become an annual event, and let's bring all these people in out of the cold. It would fulfil the first of Apollinaire's three Requests to Marcel Duchamp, which was: "Please reconcile art and the people."'

'What were two and three?'

'Er – one was to be unafraid of being criticised as esoteric or unintelligible, which Duchamp wasn't –'

'And the third?'

'To concern himself with the nude, in all possible manifestations, and this he did also.'

'Where does the nude come in with a motley crowd-scene of heaving, rootless humanity?'

'That, Ralphael, if I may say so, is the daftest art question you have asked since we met!'

'Sorry. You mean some massive work-in-progress of a huge nude created on stage during the performance, by you?'

'Nearly. I would propose a huge fragmented nude, performed by street artists, as a massive backdrop, connected only by each individual's right to be themselves, and realise the nude in whichever way they choose.'

'Wouldn't that distract the audience from the music?'

'Only if they stopped playing to watch the art.'

'Ah, yes. It is almost something that John Cage might have dreamed up in the nineteen-forties.'

'Except that Cage was always looking for something to leave out. I am insisting on putting things in.'

Gavin then produced a music manuscript and proceeded to show me an extraordinary progression of pages with blots along the staves like notes, but only in appearance. They were arbitrary blot patterns that he had applied. His intention was to get them notated. That is, he hoped to find someone who was courageous enough to try. But Gavin insists on only one rule: you can delete as many of the blots as you like – but you cannot add a single one. Only time signatures, bars and bridges, as a composer would, to create the rhythmic and the emphasis of conventional composing methods. Gavin reckons that if it looks pleasing to the eye, wild and aesthetic, then it will be pleasing to the ear also, according to Gavin's Theory of the Universality of Everything.

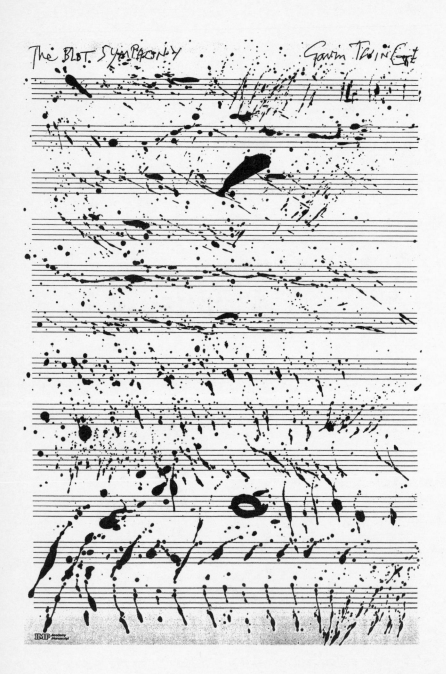

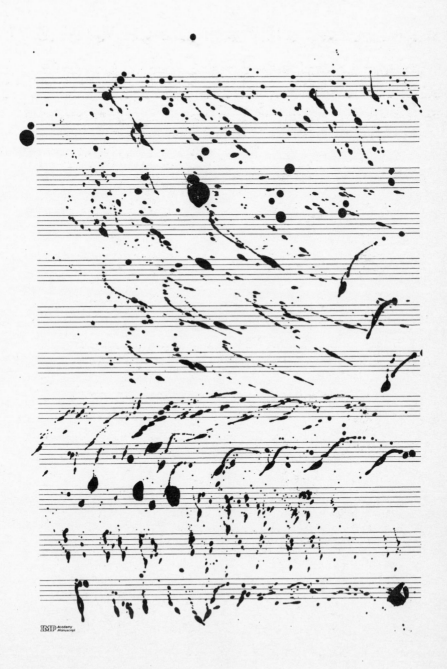

It was a stunning piece of conceptual creativity. I told him so.

'Then you might like this too,' he said eagerly. 'You remember my idea for imagining the parts of Paris as body parts – exploring my interest in anatomy – the nude, inside and out?' I nodded. 'Well,' he continued, 'here is another multi-dimensional idea for music, I think you will like it.' He handed me some typewritten sheets headed *Death of an Orchestra*, and while I read them, he picked up his old Selmer trumpet, and attempted to play a heartfelt rendition of 'Georgia on my Mind'.

# PART II

## CHAPTER 10

## CHRIST'S BRIDE STRIPPED BARE BY
## HER RELIGIOUS MECHANICS (ALREADY)

I HAD JUST staggered over a fallen heap of reference books, old newspapers and magazines, hid my head inside the wastepaper basket and surrendered to the engulfing salve of weeping self-pity which swept over me like the dump from a terrified camel, and was about to insert my head inside a Ryman's plastic shopping bag when . . .

'Mother Superior! MOTHER SUPERIOR!' The cry came from the mouth of an addled figure looking like the sole survivor of a paint-factory explosion who leaped into my inner sanctum without so much as a polite burp. It was Gavin Twinge. 'W-What the fu –?' I stammered

'Mother Superior! MOTHER SUPERIOR!' he said again. 'There's a case of AIDS in the convent! and the Mother Superior replied, "Thank God for that! I was getting sick of the Beaujolais!" TARAA! Sorry to barge in on you like this but I had to tell someone. I just thought of it. I have had a night of untarnished creativity and this joke just popped out like a final splat of Alizarin Crimson. Everyone in the Doodaaa group is away in France or Lanzarote doing whatever they do and I needed to tell someone before I forgot it. Got any coffee on the go? Glad you have moved into the area. You'll be seeing a lot more of me from now on.'

I didn't know quite how to take this revelation since I had merely moved two doors along in Parthenia Road because it was a basement flat with a garden and I do like a bit of garden. 'That's nice,' I replied. 'Actually I was thinking of driving down to France in my old London taxi so I will be gone for a while. Thought I might pop in on some of your pals. Do you know if they work down there?'

'It's the only bloody time they ever do – when they run out of booze. Most of 'em end up in Pézenas or Lodève at the markets trying to sell local scenes *à la* Bayswater Road. Anything so they can stock up again. They're all piss artists to a man but you can buy a 28-litre polythene can full of the co-operative stuff from a petrol pump on the Montpellier road for about forty-eight francs. It's the best *vin brute* in the region. All you need is that, baguettes and Brie and you can live down there for next to nothing for a whole summer. Let me know when you are going and I'll come with you. The break will freshen up my tastebuds.'

That wasn't what I had in mind but I nodded weakly and motioned to the coffee machine which had started squelching and sputtering like a nasty bout of flu.

Since I began this biography of one of Britain's great unsung titans, an artist of peculiar and robust obscurity, doubts have invaded my thoughts about the wisdom of such a project. Who is he, this man? Who ever heard of him and, more important, who cares? Absolutely nobody, actually, because he embodies all those things which deny the everyday experiences of what we have chosen to refer to as the common man or woman. He or she has his, or her, ideas of what constitutes art. They don't know much about it, but they sure as Hell know what they like. Their lives don't include art as an integral thematic presence, but they will use it if they have to, simply to justify a carefully protected section of their conscious thought which says that what we are is total life as you see us, and what we are displaying is all you need to know to make your lives complete. Art plays no part in this scenario but, whatever you imagine, think only conformity. When art is mentioned talk only in reverential tones about the accepted, the acknowledged, and parti-cularly the puerile. If you have had too much to drink, mention the profane, if it's in the news. That brings conversation back to an acceptable level.

They don't like Gavin Twinge, that's for sure, even if they have heard of him. But there is an odd, sneaking, niggling thought in the dark scum-filled corners of everybody's mind that snatches at some-

thing that somehow exists and lives for a brief second, then retreats into a blackened vacuum.

Maybe Gavin Twinge represents all those wild thoughts in a common man's mind, and a woman's. Maybe Gavin is what they do at dinner parties and implant in themselves, experiences which garnish their lives with a wild insouciance of which they are otherwise devoid. What they will not do is admit it. They will not admit to the blatant aridity of their puny lives. But they will talk to you about it like it actually happened to them . . .

I had prepared my old black London taxi for a long journey. It was six hundred miles to our destination and taxis were never designed for distance, or hills for that matter. This may even be a first, crossing the Massif Central in a chugging old timer like this. But what the Hell! At three hundred quid it was an offer I could not refuse and there was plenty of space in the back, if hotels were out of the question. Getting out of London was an operation to be achieved only at the crack of dawn when cats still roamed the streets like prehistoric beasts. I always like that time of day best. It is a time like no other. The world belongs to you and each moment is relished and you hope that that particular feeling is going to go on for ever, but it never does. The thought lingers in the mind nevertheless. I think it has something to do with that perfect world that does not exist, except in the mind, and this is the nearest we will ever get to it.

Gavin was late, of course. This I will accept, and this is what I agreed to, when I bit the bullet. I stood out in the street, and wondered if I should go over and remind him that we said we would take off at dawn, like now. Maybe he is never serious about anything he does, or perhaps he is only serious about those things which propel him to act through his art and the rest are just irrelevances which play no part in his scheme of things.

Then I began to get annoyed and resentful of this bastard's attitude. Fuck him! Who does he think he is, keeping me waiting like this? I have a life too, and right now this part of my life is being wasted trying to accommodate Gavin's lack of consideration. I was

about to stride across towards his studio, hardly two hundred yards away, when the uneasy sound of a vehicle in trouble reached my ears, and around the corner from an entirely different direction swerved a black London taxi, not unlike my own. A first customer for Heathrow, I thought. Out through the back streets of Fulham, into the Fulham Palace Road and out past Hammersmith on to the M4 to the airport. Of course. But the taxi pulled up right next to me, smoking oil like a torched scrapyard, and driving it was Gavin himself. There was nobody beside him because London taxis don't have passenger seats up front. There was baggage, though, a huge mound of cases and boxes, metal spare parts and mysterious objects that would fit well into any skip.

'Ready?' shouted Gavin through the windscreen, smiling broadly. 'Anya's on the back seat trying to get some kip. I kept her up last night. I was determined to try to get started on that time, space, motion thing of Duchamp's. The *Nude Descending a Staircase, Demonstrating Time, Space and Motion*. He never really finished experimenting with that concept in case he repeated himself. What, for instance, happened to the nude after descent? Even though movement was only an abstraction for him. I'll bet he thought about it. Where was she going? Come to think of it, where are we going? Do you know how to get out of London?'

I tried my best to hide the limpness brought on by panic, as though a boa constrictor had just gripped my larynx and sent asphyxiation visions across my eyes. Two London taxis – crossing France like a convoy. We would be less conspicuous going by panzer tank. 'What the hell have you got that for?' I spluttered. 'I thought we were going in mine?'

'No room in yours for all the gear and Anya too, and a staircase. I saw yours and reckoned I needed one too. A hundred quid! 'Sall right. If one of us breaks down, I can go on with the stuff while you get the duff one fixed. Anya will stay with you, keep you company. I can prepare for our stay. Got tons to do, not least the drainage. Never did get to finish that toilet system. How's your French? *Fosse septique*, just remember *Fosse septique*. That's a septic tank in French. I know that much.'

'I know,' I sighed, 'but can we just get going? We'll probably need a toilet long before then.' Resigned to this new development, I said I would lead and see how things went. The first sign of sunlight was creeping into the atmosphere and we needed to be clear of London before the rush-hour traffic fouled any plans we might still have.

I had been warned not to get too close to my subject. Biographers are advised not to get pally. Objectivity starts to slip away as one becomes enmeshed in the day-to-day trivialities of an artist's life. You begin to ask yourself if these things matter, and whether a certain distance is preferable in order to avoid drifting into a familiarisation that could just as easily undermine the artist's work as reveal insights that one would otherwise overlook.

Well, it was too bloody late now as we set off down the Wandsworth Bridge Road, two lumps of black cobbler's wax on wheels, trundling over the river and out across Clapham Common, through the endless suburbs, picking up the M20 somewhere around Eltham for a straight run to Dover on the open highway. I have always loved this route as part of that euphoric feeling – the heady sense of getting away from it all and the early morning sun lifting the mist from fields that probably haven't changed since the Hundred Years War. Armies would muster in these fields and prepare for Edward III's plundering raids across the Channel to northern France, an early form of guerrilla warfare. His skirmishes became highly organised business campaigns, employing the services of soldiers of fortune whose only loyalty lay in how much they were encouraged to plunder and exploit along the French coast. Mediaeval thugs with cross- and longbows, they were the Terminators of their age. These are thoughts I often entertain as I pass through miles of open countryside which have not yet been covered in creeping urban sprawl.

I checked my rear mirror. Gavin was still there, chugging along nicely. Perhaps I was worrying needlessly. He wouldn't have come if he didn't think it would work. Bringing a staircase along struck me as the pinnacle of personal dedication to his art. Already I was eager to watch this process at first hand in the place where he had founded his

'colony'. He had happened upon this 'arena of rocky possibilities' quite by chance when he heard of perfectly sound old ruins that could be purchased for a song, quite literally it would seem in Gavin's case, whose outdoor parties on rough patios were rarely without a guitar or two which would be sung to with a modicum of professional flair. The essence of it all lay in the heart and the strength of feeling poured into a song, for which words were often made up on the spur of the moment and just as soon forgotten. Gavin got his place for fifty pounds, and a hundred pounds for the notary to legalise the conveyance.

The landscape changed to the characteristic whiteness of chalky rock and silt as we neared the coast, hit urban Folkestone outskirts and trundled along the coastline on to a skirting dual carriageway that wound around and down into the harbour town of Dover. There are road signs everywhere in Dover, pointing back to Ashford and London, on to Deal, or straight on, follow the signs to the Docks, east and west, and the Ferry to France and an entirely different lifestyle, which has only recently absorbed the English habit of loutish chic honed to perfection by hordes of daytrippers whose only objective is to get over there, buy what they can buy over here anyway, only cheaper, and pig it back before sunset. Whatever they see of France is best scribbled on a postcard and taken back to be posted in England.

Arriving at the Customs barriers is the one obstacle which pulls you up short as it radiates a last-gasp officialdom that a subject must suffer before slipping up the ferry ramp, over the hump, and into the hold. This moment is always the reminder that no matter where you run, you cannot hide. I edged closer to the arched barrier with the red and green lights changing from one to the other as each successive carload of hopeful tourists cleared customs or was hauled over to the side to answer a few more questions about a particular crude package that invariably turned out to be twelve bottles of tomato ketchup, a hundredweight of teabags and a mini-drum of Nescafé.

'Now, sir, good day, sir,' said the Customs man. 'Bit out of our way, aren't we, sir? Business a bit slow in London, is it, or have you got a lottery winner for a passenger, ha-huh?'

'Well, I am not alone actually, Officer. There is another one right behind.'

'I see, sir, smuggling taxis out of the country now are we, sir? There are laws against that kind of thing, sir. Have you filled in the necessary export forms? They will never make it back, believe me.' I must have grimaced. 'Only kidding, sir. I take it you are together?' He gestured towards Gavin's taxi with a smirk.

'Well, yes,' I replied. 'Safety in numbers. You can't be too careful these days. My friend has more on board than I have. Check out his staircase.'

'I see, sir. His staircase? You wouldn't happen to be taking the piss out of me would you, sir? I have all day, of course, but I think you are trying to catch the next ferry. Just pull over there for a minute. I'll check out your friend.'

I gripped and hugged the steering wheel like a security blanket, and waited. Through my wing mirror I could see some kind of interchange. The officer had his hands behind his back in a casual hands-off confrontation. It's an old trick. Interference and physical restraint are out of the question in a court of law. 'My hands were neutralised, your honour, when the defendant made a totally un-provoked attack.' Gavin had leaned sideways towards the window and into the face of the Customs man, a mask of inscrutable indifference. I could see by Gavin's expression that the matter of a staircase on board had been raised. Staircase? OH, the staircase! Sure. Need the staircase for my painting. Have you heard of Marcel Duchamp? No? Ah, well, he was a Dadaist. 'A what? Are you pulling my leg too? Your friend there has got the same habit. Would you like to pull over there and you can both enlighten me.'

We were going to miss the ferry. Anya had woken and was looking puzzled. I was motioned to move over to allow innocent tourists to get by, and on with their holidays. Gavin had set about dragging the staircase out of the back, and the pillow with it, which Anya had been sleeping against. Setting the wooden structure upright, Gavin climbed to the top, and then, adopting an effeminate attitude, minced down the steps to the floor. The Customs man's face

was a picture of frozen incomprehension. Gavin climbed up the steps and minced down again. 'See what I mean?' he said. 'It took time to move down the staircase, so time was involved. I was moving diagonally, and downwards, so I was moving three-dimensionally through space, demonstrating motion, right?'

'OK,' said the man. 'Then what?'

'Well,' continued Gavin earnestly, completely oblivious to this man's cynicism. 'Anya! This is Anya, and she will walk down the staircase when I am painting. Oh, yes, and she will be nude. This preserves the purity of the vision and, naturally, holds your attention. Art isn't that pure, y'know.'

'No disrespect to the young lady, sir, but don't you mean filth, pornographic filth, and we don't have to know much about art to know what you mean by motion, do we, sir?'

'Certainly not, Officer! This is art. Well, to me it is art, or was art. It has already been done, but Duchamp never answered the question "Where was she descending to?" or even "Where had she been?" '

'And where are you going, sir? A holiday camp? Or a nudist colony perhaps? I doubt they would let you into a hotel with your own staircase. Even on a camping site people are suspicious of staircases. Three-piece suites are acceptable, and even tables, but staircases make people nervous. There is only one floor in a tent, sir. What do you intend to do with the er – art when you return to England, pass through Customs, sir? I can't wait for that, sir. Whatever vision you have inside that head of yours, I cannot prevent you smuggling out, but speaking as an officer of Her Majesty's Customs and Excise, we would take a dim view of you trying to bring a nude back into the country. Nudes are VATable, sir, particularly art nudes. And that would not be all, sir. How much would the art be worth? Customs duty and VAT would be a necessary formality you would have to satisfy, to our discretion. Or, sir, confiscation is most definitely a possible outcome, particularly if the er – art is of a pornographic nature. Rules and regulations, sir, even in art –'

'Her Majesty has loads of it!'

'Loads of what?'

'Loads of pornographic art, Officer. Did you know that she owns one of the most disgusting sets of etchings that have ever been done, in the style of Rembrandt? Actual seductions, scenes of raw sexuality in minute detail. They are priceless invocations of what was probably on his mind at the time. They were a wedding present from the duke to his bride. Mythology. All in the mind.'

'What his Royal Highness chooses to give to Her Majesty is none of my business, or yours as a matter of fact, and I should warn you of the laws of libel, sir –'

'No, Officer. You miss my point. I was wondering if the duke had to pay duty on those priceless items when he brought them through Customs, or did someone let him through surreptitiously with a diplomatic bag? Those images, sure as Hell, were not created in England. More like Amsterdam, or even Greece. Isn't he Greek, Officer? Can I put the staircase back in the taxi now, or do you want to see the zaniest stack of positions from the east ever known? I have things in my own personal diplomatic bag which would rip your eyeballs out, but your wife may ask you what you did today, and you would have to confess. I would not want to say. I think they are starting to board – sir.'

I froze at that moment, and Anya too, who had been silent through all of this. She turned her eyes skyward, looking as innocent as an Italian Madonna. An ominous raincloud was forming above the harbour and spots of rain began to drop on the bare wood of the staircase. The officer looked at Gavin, then at me, at Anya, then down at the bottom step.

'You'd better get a move on, but I shall make a note of this, in case I am off duty when you come back. Beggin' your pardon, ma'am, I'd keep an eye on these two. I wouldn't trust them as far as I could throw that staircase.'

'Really, Officer! What kind of a girl do you think I am?' replied Anya. She was smiling.

We stooged our convoy towards the embarkation point and breathed a sigh of relief at the sound of the clunk, clatter, clonk

of the wheels trundling over ramps and down into the hold. Saved by the rain for a change.

Solid earth, another land nevertheless. I never lingered in Calais. I drove along quayside roads looking frantically for signs which said Amiens, Rouen, Orléans and Paris. Always make for Paris even though you don't intend to go there. Boulogne, Montreuil, Abbeville. Amiens, yes, Amiens, if you want to see one of the jewels of Gothic splendour, sucking up from the Somme all that blood of countless wars it has lived off since the Crusades. That is what the monumental columns are for – osmosis – the sucking towards heaven, of all that mortal man has to offer. In this area alone, the cathedral is just one of many in a battlefield of memories and nightmares. Another battle, another cathedral, always in the name of God, because He is always on our side.

Gavin honked to attract my attention. I pulled over to the side of the road and he pulled up right behind. He poked his head out of the window and said, 'If you're thinking of Amiens, let's forget it and make for Rouen. It's a straighter route and guess what? Duchamp was born there and we can pay homage to Monet at the cathedral. I doubt we'll have the energy for Honfleur, but it's lousy with Impressionists and Pointillists at the Musée Boudin – though we could have too much of a good thing, and anyway, just look around you as you drive. Normandy is an Impressionists' playground. Crawling with 'em, it was. We can have lunch and then take off for Chartres. Wasn't that where they burned Joan of Arc? I just love driving towards it and seeing those fantastic towers loom out of the Loire valley like a pair of fairy-tale rockets. We'll have to leave the Brittany Gauguin thing on this trip. Pont-Aven is a bit out of the way. Keep going for Blois. We may just get to see the octagonal staircase that Leonardo da Vinci is supposed to have designed for Francis I. Now that's what I call a staircase. I could get fifty nudes descending that one and that would be it for the day. I have decided to concentrate on the staircase theme. It's a powerful icon. How's your cab behaving? Ours seems to be overheating, so we'll have to

take it easy. We could buy a picnic and stop the other side of Rouen, if you like. Give the old crates time to cool down.'

'Maybe it's the weight of the staircase,' I said.

'You're right. Anyway the weather looks clearer, so we'll set it down in a picnic area and arrange an outdoor feast fit for Manet's *Luncheon on the Grass* when time and motion froze. But I see it including the staircase. Wow! What a thought. Setting time free in a landmark painting, and introducing space and motion. Would a staircase look out of place in that? What do you think, honey?' Gavin turned and looked at Anya who was struggling to keep her own space against the staircase pressing to take over in the back.

'I hate to mention motion right now,' she said, 'but we really should get a move on. Look at the time. It's the bewitching hour, noon, when the French disappear – like canapés at an opening – to eat, of course. We might just be lucky if we rush over to that *alimentation* and get some fruit and *saucisson*, definitely Camembert, before they close. We are in Normandy after all. A few olives, a few bottles of plonk, a loaf of bread, bingo! Stop when we like. Find a grassy knoll, then you can move through time and space as much as you want. All right, sweetie?'

So that is what we did, and not a moment too soon. *Le propriétaire* was just covering his wares with gingham cloths to shut up shop and disappear for the next two hours. It wasn't the last time I noticed how practical Anya was, and how much of a foil she became to Gavin's wild enthusiasms, which tended to scatter best-laid plans like a cat in a pigeon loft.

We did manage to stop in Rouen long enough to admire the flamboyant intricacies of Gothic detail, in the wealth of architecture, dripping like molten stone everywhere you looked. The churches of Saint-Maclou, Saint-Ouen, and the *tour de force*, the Cathedral of Notre-Dame, the preoccupation of Monet, who produced more than forty paintings of the light effects which dazzle the massive multi-arched façade, like a thick brocaded tapestry, and never the same twice at any time one chooses to gaze upon it. Monet himself rented a room overlooking the west porch of the cathedral, in order to capture the different lights and weather conditions, at varying times of the

day, making rapid notes and sketches which he later transformed
into finished paintings. The fact that his subject was immobile
reinforced his ability to capture the formal compositions that were
created by the translation of light effects into colour. At Givenchy,
his country home outside Paris, he was able to apply the same
approach when painting haystacks, poplar trees, and water-lilies. He
employed his eleven children to carry a range of canvases, and to
change them every seven and a half minutes, systematically, as the
light changed. Gavin and Anya just stood, and fixed their gaze on the
edifice, and I wondered, as I watched them, whether Gavin had such
devotion, or whether that spirit belonged to a less impatient age.
Gavin has obsessions, but his restless ways would deny such single-
mindedness. Maybe that was running through his mind too.

The city was still deserted, due to the lunchtime *repas*. The Gros
Horloge, the huge and colourful clock set on the central Renaissance
arch, struck twice as we made our way out of Rouen, over the Seine, on
the south road towards Évreux where we hoped to find La Grande
Place du Picnic! La Fête de la Grassy Knoll. We were nearly in Évreux
before I thought, there! The very spot. A short country lane leading in
among a copse of trees, a perfect place for a private stop and a gentle,
easy lunch, when the simplest of culinary fare seems to taste like the
food of the gods, and the humblest *vin ordinaire* tastes like nectar.

Anya tumbled out, dusted herself down and stretched as though
she had been curled up in a box for a fortnight. Gavin threw an old
tartan blanket out the window and broke a piece of bread off one of
the baguettes and filled his mouth with it. He got out and lifted the
bonnet to help cool the engine. Laying the blanket out, Anya started
arranging the comestibles on it. 'Oh, damn! We forgot a corkscrew.'
'Here, give a bottle to me,' said Gavin, and peeled off the foil, held
the neck of the bottle firmly at the very top, put it between his knees,
and applied steady pressure on the cork with the tip of his index
finger, wrapping part of his other hand around it, for extra support.
Very slowly the cork depressed into the bottle, and with a small
squirt disappeared inside. Gavin tipped the bottle slightly to lose an
inch, leaving the cork floating. 'Cups,' he said, holding out his hand.

Within seconds we all had a glass of cheap red nectar, and a scruff of French bread to dip. A faint breeze rustled the leaves of silver birches nearby and the small wood seemed alive with birdsong. The sun was out, and a glorious late-summer warmth breathed through the atmosphere. Anya sang 'Raindrops keep falling on m'head', and pranced around like Isadora Duncan, making exaggerated leaps over the blanket. I did my best to cut the *saucisson* as thinly as possible, on my knee, though it is just as great in half-inch chunks, which was as thin as I could make them without cutting my trousers with the blade of my pocket knife. Gavin took another bottle, and opened it the same way, glugging generously into our plastic beakers. Moments like this are without equal. The ambience and the open air augment the body's ability to capture the sensations with fingertip perfection. I watched as Gavin put down his beaker, walked around the taxi, opened the passenger door and, with straining noises, puffs, groans and curses, pulled out the staircase, dragging it across the grass and setting it by a birch tree sporting a long arched branch that, incidentally, described an exquisite spatial arc. In fact, it reminded me of the escalator reaching out over the cool harbour in Gavin's architectural concept for the new William Turner Arts Centre in Margate. I reminded him of this as he was adjusting the position of the base.

'Precisely,' he answered, 'it has just fired a whole new aspect of Time, Space, Motion for me. This is something that Duchamp completely overlooked, or maybe he didn't overlook it, but his desire

to break free from mere "retinal art", as he called it, made it imperative that the movement had no relation to actual events whatsoever, no connection to real blood-warm activity. The movement for him had to be purely intellectual. It was never about "real life". It was about the painting itself. He wasn't painting pots and pans and guitars, and fruit in a bowl, or even trying to see them in a different way. Many made that mistake, particularly in Cubism. Duchamp's concept was a total divorce from reality, which is what upset the Cubists who followed Picasso and Braque, who had already left the party anyway. At the time, Duchamp wallowed in the dictates of Cubist theory, but only as an experimental exercise, rather than a conviction. In 1912 at a famous Salon des Indépendants, the "cutting edge" of radical art got together in a scrum and then asked Duchamp's brothers, Raymond and Jacques Villon, to ask Marcel to take down the bloody *Nude Descending* – a request that Marcel considered an aberration, a new kind of tyranny imposed by the very ones who claimed to have overcome the blindness of the general public. That caused a rift between himself and the "Independent group", and his brothers, too. The cosy group looked at his *Nude Descending* painting as a "betrayal of the Cubist movement", for Christ's sake! Isn't that the problem with all movements anyway? They become as blinkered as the cause.'

Gavin picked up his beaker and poured himself another generous quaff. 'Something else occurred to me, which I doubt had been considered in this set-up. The nude *ascending* the staircase. Where's the nude goin', eh? Up the scaffold, that's where! So, the nude then takes a whole other trip. The inherent contradictions of life take on a very real "unreality" in this context. This nude is a swift nude in more ways than one. Up the staircase slowly, stand on point A in space, a trapdoor. Rope around the neck – the restraining force B. Trapdoor A opens and nude descends swiftly, only to be pulled up, abruptly, by the rope B, which not only arrests the downward motion instantly, but in that brief moment transports the nude into a new dimension, er, C? C can be oblivion, or, suspended animation, or even a new life of boundless possibilities, if you believe in reincarna-

tion. Now then,' and Gavin climbs up the staircase and walks down it again, as though to demonstrate some aspect of his theory. 'Now then,' he continues. 'Up! Down! Then, somewhere else entirely, another life, in an instant. The psychic opposites in alchemy. Base metal into gold. The Elixir of Life. Mortality. Immortality. But Duchamp would have been an alchemist, without necessarily being aware of it. Do you see what I am getting at?' said Gavin, pointing at me with a screwdriver he now had in his hand. 'Go on,' I said, 'but watch what you are doing with that – weapon!' 'I haven't finished,' he said, and went on.

'Jung's theories were historically, and intellectually, synonymous with Duchamp's, at that very time, just as Freud's theories, you could say, coincided with Picasso's erotic revelations, at the time of Freud's death, in 1939. As though Picasso took the baton from Freud, and ran with it, in a manner of speaking. Picasso's more erotic work evolved as his physical powers diminished, the reincarnation theory, and the duality of opposites. Freud and Jung begged to differ, and became the most important psycho-pioneers of the twentieth century, while Duchamp and Picasso reached in opposite directions, to become the most important artists of the same period. C'mon, Anya, do us a favour. Just strip down to your T-shirt and knickers and climb up the staircase. Here, grab hold of this rope, and wrap it around that branch. I can show you what I'm getting at.'

'No, I don't feel like it right now. Let's get going.'

'Yes, I think Anya's right. We ought to be making a move again. It's nearly four o'clock, English summer time! That makes it five over here.' I thought I ought to say something, but I could see what Gavin was getting at, and he was just getting started. If I had let him go on, we may have had a lynching to deal with.

Gavin was obviously irritated, then he shrugged and walked over to his taxi. I watched as, seemingly in slow motion, he proceeded to ease the screwdriver between the fins of the radiator which had crushed, here and there, over the years, reducing the airflow over the membranes, and inhibiting the cooling principle of the radiator. I was about to ask him what he was doing when a small bead of water

suddenly appeared at the tip of the screwdriver. At that precise moment, the birds stopped singing, a single cloud covered the sun, and we all knew that something terrible had happened. We were in the shit. Even if we carried five-gallon jerry-cans on board, the taxi was going to dry up every few miles, and we were going to be lucky to get to Évreux before nightfall.

'Damn!' Gavin had his head in his hands and sobbed, with grief-stricken laughter, at the predicament we had now tumbled into.

'OK! OK!' I brusquely took command and started to drag the staircase towards his stricken motor. 'No good crying over it. It's done. Let's make for Évreux, find a *pension*, and at least enjoy the evening.'

We did make it and found a gorgeous little *auberge*, Le Blague. Pricey, but what the Hell! That's what book advances are for: paying assholes' bills. It occurred to me, just then, to reflect on Gavin's income. How did he make money, and did he pay taxes like every other mortal? I wondered, too, if he had a National Insurance number and, more important, had he insured the taxi? Things like this are often overlooked in the furnace of creation, and seem irrelevant at the time. A bit like asking Dante if he got expenses for Virgil. (As it turned out, Gavin had more money than he knew what to do with. Toilets are big money. But Gavin's mother didn't want to shout about it.)

We parked the two black juggernauts around the back of the *auberge* and, amid the stares of clientele who had already checked in, the more curious among them going over and slapping the wings muttering, '*Très fort! Mon Dieu!*', we managed to secure two rooms for the night and an evening meal . . .

The extent of the problem of the punctured radiator became apparent the next morning. It was a Saturday and no one was going to attempt to repair anything before Monday. We found a particularly oily-looking place with Michelin signs and ancient Castrol adverts, and an old wind-up petrol pump standing like a sentinel by the gaping door. I peered inside, and against the back

wall I could see an isometric workshop diagram of a stripped Citroën which Gavin said reminded him of one of Duchamp's diagrams from his theoretical book about *The Bride Stripped Bare by Her Bachelors Even*. Benches were littered with tools and bits of engine; tyres leaned crazily in heaps in corners, 'like fat black nudes', said Gavin. From the back strolled an overall-clad mechanic, a French archetype, wiping his engrimed hands with an even dirtier rag, a Gitane lolling on his bottom lip, stained brown, with a combination of nicotine and spit.

'*Qu'est-ce que vous voulez?*' he said without removing the cigarette which bounced up and down like a long white polyp.

'*Le taxi. Il ne marche pas parce que il y a un trou dans le radiateur, M'sieur,*' I stumbled in my get-by French.

'*Ooh, la-la! Quel dommage!*' he replied and banged the bonnet with his right hand. '*Très fort, eh, hehheh?*'

'*Oui, M'sieur. Très fort!*'

Anya took over from me and explained our problem and the need to get it fixed quickly.

He flapped his hand up and down and shook his head with a worried look. '*Impossible,*' he said. '*Mais, je peux regarder le problème lundi. C'est ça,*' and he shrugged. I began to panic. I was stuck in this place. My work was stalled. I'd never get to the south. I'd never get back! Trapped like a rat in a petrol tank.

Gavin had disappeared to the back of the garage, and was inspecting the piles of coiled springs, gear boxes, transmission shafts, sprocket mechanisms, dab shutters, flaps, sump bellies and prongs. He had a gleam in his eye. He called Anya over and whispered in her ear. She nodded and skipped back to the mechanic. At first he looked puzzled and then decidedly worried, then his face relaxed, his eyes lit up and suddenly he was saying, '*Mais oui – vive le week-end! Formidable!*'

I asked Anya what the devil was going on, and she told me she had just made a deal that allowed us to stay in the garage over the weekend while Gavin set to work on a monumental sculpture, a mechanical nude descending a pile of sculpted rubbish. The

French love art, she explained, and when he learned that you are a famous artist/writer from England doing a book about the legendary Gavin Twinge, and that his garage will be part of the book, tidied up like never before, and that we will leave the sculpture here when we leave, and he can get on and fix the radiator on Monday, and –

'And then what?' I asked earnestly.

'Well, you will get an insight into how Gavin works.'

'And –?'

'And you settle the bill.' She smiled sweetly, and I guess that was that. I realised I was on board for the whole ride. Let's face it, I reasoned to myself, this IS work. That IS what I am here for. We brought in all our baggage and the staircase. An upstairs wooden office, on stilts, with its own open staircase, would serve us as a bedroom. It was the open staircase that gave Gavin the idea in the first place. He still wanted to try some descending experiments with Anya when the daylight had gone.

The garage owner, whose name was Gaston Lupin, turned out to be a real sport and, as he pointed out, he too was an artist – a *poète Mécanique*, I think he called himself. He wrote poems about old cars like the Delarge, the Hispano-Suiza and, of course, the Bugatti. But mainly he waxed lyrical about car parts. He pulled an oily piece of paper out of his overalls and proudly showed it to me. It was a poem about the classic Bugatti Type 54 Grand Prix made between 1932 and 1934. It was written in ballpoint:

Monobloc
À paliers lisses
Deux soupapes inclinées par cylindre
Commandées par double arbre à cames en tête
     Deux carbus. Zenith ou Solex,
Compresseur type Roots
     Embrayage! Embrayage! Multidisque à bain d'huile
Trois rapports et marche arrière,
Levier central sur rotule
     Suspension avant. Ressorts à lames semi-elliptiques
Suspension arrière. Ressorts à lames quart-elliptiques inverse
Freins. Commandés par cable
     Dimensions des pneus. Six par dix-neuf, mais oui!
Roues en alliage léger coulent avec tambour
De frein intéger et jante à bas creuse
Vitesse! VITESSE!
MAXIMUM, mon ami
MAXIMUM! Plus de deux cents kilomètres par l'heure.
Superbe, superbe, superbe!
La Grande Marque.

I handed it back to him. *'Très, très bien, Gaston. C'est comme la Poésie Concrète. Formidable!'*
     *'Le prenez, M'sieur. J'ai des autres. C'est un cadeau, pour vous, peut-être pour le livre, n'est-ce pas – et voilà!'*
     *'Ah! M'sieur. Très gentil. C'est une bonne idée. Et après l'imprimerie, je*

*peux vous envoyer un exemplaire.*' I hoped I was doing the right thing. Maybe he was expecting royalties.

A clatter made us turn and watch Gavin disentangling wild shapes of metal, holding up old wheel rims, lengths of air duct, exhaust pipes and steering tie bars. He had already stood an old chassis up on end, the torso of his developing *nude mécanique* – his own found objects, which he was convinced were lying there waiting for his own taxi to break down, and guide him inexorably to this place, to find these specific items. Why had he poked a hole into his radiator otherwise? It all made sense. He needed them all and he needed Anya, too, to be the Bride Stripped Bare, a perfect example of opposites, juxtaposed, the angularity and rhythm of the machine as the spatial structure, inside which to pose the soft vulnerable flesh of his muse. And, marvel of marvels, he had located a block-and-tackle hoist hanging from the steel girders above the pile of car parts, his perfect device for lifting and lowering Anya, as his Nude Descending and his Nude Ascending. The only problem he could anticipate, he said sternly, was how fast he could raise and lower her without causing a nasty accident. Gaston had also had second thoughts about knocking off work, since he had never ever seen a nude going up and down on his motor hoist before. '*Vive les arts!*' he cried, and fumbled inside his pockets again. He brought out another poem he had written about the back axle and transmission of a Bugatti Type 44 Tourisme of 1930. He had written it for his bride-to-be, Françoise Crouton, to celebrate their engagement. It was called '*Châssis d'Équipement*', and it waxed lyrical about the beauty of Françoise's upholstery.

Then he offered us his *pièce de résistance*. He beckoned me over to the corner of the huge building, and showed me a 5,000-litre wine barrel, full of last year's vintage of a local grape, grenache. He took down a 'thief', the pipette used to sample the must, and sunk it deep inside the barrel. What he drew out stopped Gavin in mid-swing on the block and tackle, as he tested the feasibility of his constructions. Glasses were brought, and each of us in turn was given a generous quaff of the deep red liquid. I thought the weekend was beginning to shape up.

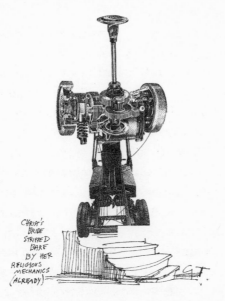

CHRIST'S
BRIDE
STRIPPED
BARE
BY HER
RELIGIOUS
MECHANICS
(ALREADY)

Refreshed by this on-tap revelation, Gavin threw himself with renewed vigour into what was beginning to look like an explosion at an Earls Court Motor Show. It had taken on the iconish appearance of a motorised crucifixion, and he had already got a title for this gargantuan scrap heap. He wanted to call it *Christ's Bride Stripped Bare by Her Religious Mechanics (already)*, which, if it had been made in another age, say the fifteenth century, would have made Gavin a heretic, and may well have ended with him being turned on the spit along with Joan of Arc – *bien cuit*! But it was quite obvious that to Gavin this was no challenge to any established church or religious sect, but a deeply felt tribute to the inherent qualities of metals that had been shaped for another more practical purpose. Gavin was acknowledging this useful past existence and was now giving these twisted parts and machined shapes a chance to live again and reveal their natural aesthetic presence. Any religiosity was in Gavin's own intensity, which surprised me by its ruthless objectivity and calm persistence. Something that did amaze me was the way he could use welding equipment, lathes and shapers as though he had been born with them in hand. I later found out that he had trained in an aircraft factory, and had only left because of the ant-like toil, which simply did not suit his fierce and independent personality.

While we drank and watched, Gavin drank and worked. I asked Anya if Gavin was in any way religious.

'Well,' she mused, as muses often do, 'Gavin is fanatical about his family legacy. Whether fanatical means religious is anybody's guess, but he talks often of one of his ancestors, Gordon Twing, the bastard son of his great-great-grandfather, Silas, who made the family fortune in drains, though the bulk of the fortune has long since gone down the pan. For Gordon, water-closets – his speciality – were like altars, or shrines. When he looked at a T-junction on the pipe-work of his sanitary masterpieces, so the story goes, he would always cross himself and mutter, "Holy Mother of God!" In fact, I think his trademark was an engraved version of *Mother and Child* by Botticelli, with a family motto, *Terrus Esprito cum Gravitas*, set beneath it in Trajan lettering. So a well-wiped T-pipe joint was as important to him as a sacred cross. Gavin told me that the great discovery of his family was that to get the finest wiped joint it was best to use a mole skin. When I asked him if that hurt, considering the heat and all of the blow-torch on the metal, Gavin replied, "Only when they bite." Mole fur, apparently, doesn't stick to silver lead solder, which is, incidentally, why mole skin is used on the end of a marl stick. A painter is able to steady his paint brush and touch the surface without pulling off the paint. You might say that that is religious, but, whether it is or it isn't, I know that Gavin's commitment grows out of those family drains. Out of the bowels of the earth for him, his roots, comes this conviction that whatever he creates is rooted in an honest foundation. Striking out in a new, unknown direction has to be worthy. Like a climbing plant that searches for the light, and a place to hang on, producing a unique new shape, never before the same, and never again. Surely that is pure creativity? I think Gavin reaches out and grasps the first thing that comes to hand. Whatever that thing is becomes part of his destiny. A considered object would be anathema. That would suggest some artistic intrigue, something subversive. Gavin always reveals. He has no interest whatsoever in covering up a revealed discovery. His instincts are instantaneous and he would no more think of hiding his revelations again than Gaston

Crucifix sculpture – Plumber's Wipe

here would –' Anya paused trying to locate a metaphor in her slightly befuddled brain.

'Hey! What's Gavin doing now?' I pointed to where he was swinging the block and tackle back and forth across the garage in an upside-down posture, like an acrobat without a safety net. A primal yodel like Tarzan of the Apes woke a boozily snoozing Gaston to kick his legs in the air. '*Mon Dieu! Qu'est-ce que c'est que ça?*' He rubbed his eyes and slid off some tyres on to the garage floor. '*Ma fiancée, elle arriverai à quelque moment bientôt. Il faut expliquer la situation. Qu'est-ce qu'il fait maintenant?*' and he pointed to an inverted Gavin in full flight.

Anya explained that Gavin was experimenting with the directional forces of his swings, to build them into what he hoped would be an invisible structure, within the overall concept of paint in movement, as a solid element contained within the sculpture he was creating.

'*Ah, c'est ça! D'accord. Je comprend,*' replied Gaston, and for a moment there, I do believe he did. The sculpture itself was monumental. Gavin had used tow ropes as supporting torsion cables, to stabilise the whole structure in an attempt to defy gravity. I don't think it had yet sunk in just how surreal this situation was, how privileged he was, and we were too, to witness the complete transformation of some complete stranger's oily tip into Ovid's Temple.

The best bit was still to come. Anya's contribution, which we decided to delay until the following day, the Sabbath! Tonight we were going to have a party and Anya was making *coq au vin* with a cornucopia of vegetables she had procured in the Saturday market in Évreux. Aubergines, artichokes, avocados, garlic, fresh coriander, onions, tomatoes, celeriac, and a chicken the size of an Eagle!

Then Françoise arrived. She looked puzzled. After a brisk interchange between her and her Knight among Oily Parts on Tyres, she smiled, glanced up at the *art mécanique*, at Gavin, upside-down and in mid-swing, and then at Anya. I think she knew she was beaten. Gaston too was a poet, so what's the difference?

When she first met Gaston, she explained to Anya, she hadn't liked the look of him at all. She had driven into his garage in her old Opel mini-car, which had been stalling every time she stopped at lights. Everywhere else she had taken it, they had flapped their right hand, shrugged their shoulders, pursed their *quel dommage* lips, taken a short, sharp breath and advised her to buy a new car, but she was attached to the thing, and thought, bugger them! When she drove into Gaston's life, he immediately waxed lyrical about the charm of this old, grey French classic. The Gitane was hanging on his bottom lip as always, she said, as he fiddled with the carburettor. He talked about other such cars as though they were old friends. He started up her little car again, and it chugged over merrily. Instead of handing her a bill, he wrote her a poem expressing his love for her little car, and how beautiful she was. That was it. She fell in love with him, then and there, and complained that the only thing that she found irritating about him was that he was forever forgetting to take the cigarette out of his mouth when he kissed her. Luckily, on most occasions it was out so she was rarely scarred. It was only when they became truly amorous, and he roamed her person like a jungle explorer, that she instigated a strict fire drill.

Anya produced some large traditional Provençal paper tablecloths, glowing blue and yellow with irises and sunflowers. She spread them across a bench, and stood back to consider the effect. For a moment, I swear, it looked as though we were in a cathedral. Gavin's Christ Bride installation radiated a mystical aura as the sun caused magical shadows to cast wonderful shapes across the yellow patterns on the table and over the garage floor.

Gavin had come down from his trapeze and was thieving another pipette of Évreux Grand Cru Ordinaire.

'What d'ya think?' he said. 'I'm shagged out!'

'Gavin,' I said, 'twenty-four hours ago I would never have believed it, neither your monumental madness, nor the finding of a mechanic who wants to be boy-poet Rimbaud. Weirdness has its own reason. All bad luck has its flip side. Does it often happen like this?'

'Only when I laugh at the gods for having puny legs,' he said with a smirk. 'I want another drink, and it's going to take more than a weekend to shift that lot,' he added, pointing to the alcoholic arsenal beneath the office staircase.

Paper plates were found in Gaston's upstairs office. Anya had bought packets of plastic knives and forks. She must have anticipated this feast. She had bought some elegantly cheap wine glasses too. Gaston had old wine bottles, great thick beauties, and Gavin picked one up and looked at it against the heavenly light and turned it in his hands watching the light play *son et lumière* fantasies across Anya's face.

'These must be pre-war bottles,' he said thoughtfully. 'They don't make glass like this any more, unless it's for exhibition. Everything then was made as though it was going to be used for ever. Even those oil drums at the back of the garage could quite easily have been fitted with false bottoms to secrete *agents provocateurs*, or whatever you call them. Maybe Samuel Beckett hid in one of those very drums. He spent the war hiding out, living like a hunted animal, and at the end of it worked for the Red Cross in Normandy. He made his way out of Paris and down to Roussillon via Vichy, Toulouse and Arcachon where Duchamp went to live with Peggy Guggenheim. Beckett and his wife Suzanne lived out the war as fugitives from Nazi persecution with far more heroism than Ernest Hemingway could generate in a lifetime of playing romantic hero. That's not fair, I shouldn't have said that. Yes, I should. In fantasies one is allowed to have a sudden mean thought.'

He plunged the pipette into the barrel again and drew up the blood-red liquid and replaced the bung. We had taken our seats around the bench. Anya was up in the office tending the *coq au vin* on the garage gas ring. The light was changing to the reddish glow of early evening, and Gavin's motorised crucifix burned like a blacksmith's furnace, reflecting our complexions like faces in a painting by Caravaggio.

Gavin stalked his creation, tilting his head, moving around the back, watching the light changes through the tortured gaps in the

metal, and playing hopscotch with himself across the oil-impreg-
nated floor. Hop one, hop two, hop three, hop four, turned, and
hopped one again, and paused.

'Y'know,' he said from inside the reverie of his solitary game, 'I
often wondered if the story was true about Picasso shopping his close
friend Max Jacob, a Jewish poet and writer. Gertrude Stein mentions
it somewhere. Rumour has it that he betrayed his friend to the Nazis
in exchange for permission to pursue his own work unmolested when
they occupied Paris. I think it's possible, because he believed that the
pursuit of his art, and I mean "his" art, was more important than
morality. Picasso never fought in a war, y'know, it seemed never to
have been a part of "his" world, and throughout the war he
continued working, and pursuing women, and entertaining curious
German Oberleutnants, who were forever calling on him. How come
he was never arrested? Wouldn't his painting of Guernica have given
him away? Is it possible that Nazis tolerated great art but could never
read the implications? They stole enough of it. What a wonderful
cover he had fabricated for himself, which allowed him to pass all
manner of information back to the Allies, and the French Resistance
too. They must have trusted him, for some reason. Was his art
already above common currency? Had he devised the perfect neutral
mask, as consummate genius, or token genius, that flourished
beyond the fierce loyalties of mere mortals? He lived like a Greek
god and, like the jammy bastard he was, continued to work inside his
bullet-proof alibi. Except that, during those four years of occupation,
all his paintings were outlined in thick black lines, as though he was
indicating in graphic symbolism that he was imprisoned, but the
Nazis wouldn't notice that, only that he was Picasso.'

'Taraa!' Anya was descending the staircase carrying the casserole
before her. She was nude, except for a plastic mac. She stepped down
majestically and delivered the dish to the table. 'The vegetables will
be but a moment. All the sauces are around the chicken. Help
yourselves.' She disappeared back up the staircase and then came
down again, as though practising for tomorrow, while bearing the
rest of the cuisine. She then gracefully climbed Gavin's staircase on to

the old bench, and gave us a pre-prandial display of Flamenco freestyle. Gavin produced a beat-up guitar and gave a passable flourish of Spanish arpeggio. We all clapped like aficionados and the bench vibrated like a gymnast's springboard.

Anya threw on a T-shirt and jeans, and sat down.

There was much yummy-yummy talk as we tucked into the feast that settled into a more introspective mood as the remains of the daylight breathed away into darkness. Every now and then, one or other of us turned and gazed at the huge sculpture. Françoise brought out some candles and their glow sent other flickering shadows over it. *Christ's Bride Stripped Bare by Her Religious Mechanics* (*already*) loomed out of the darkness and cast a spell over us, like a Messiah's blessing.

Gaston rose unsteadily to his feet and lifted a piece of paper up towards his face to read by the light of a candle, while brandishing a spanner like a baton. '*Maintenant*,' he pronounced, '*Je lirai un poème à Anya.*'

> Anya. Le Dieu créa
> Une femme qui peut passer
> Esthétiquement extraordinaire
> Aussi bien que mécaniquement
> Pour un chef-d'oeuvre du soirée
> Plus beau que – ur –
> La 57S Atlantic
> La plus extra-terrestre de toutes les Bugatti.
> Anya est comme ça
>    Les panneaux de la carrosserie
> Sont pleins avec les legumes des Dieux
> Sont rivetés le long d'une crête saillante
> Qui donne le Monde Anya
> L'aspect d'un engin de science-fiction
> Anya est comme ça
>    Anya, Tu es une Goddess!
> Merçi

> La découpe très contournée des portes facilite
> L'accès à l'intérieur
> Tu es un exemplaire en seule
> Tu es Anya
> Qui doit descendre l'escalier nue, demain
> Merçi Anya. Anya.

Gaston looks hard and long at Anya, and then at us all, one by one. His face is wet with poet's tears, and he stretches his head upwards and shakes with emotion. Then silently he falls out of sight beneath the table without another word. Wild applause and hoots of *'Vive le Gaston!'* follow him inside his drunken slumber. The rest of us sit in gentle stupor, and Gavin picks up his guitar and sings a song I had never heard before called 'Drift'. It was Gavin's own love song to Anya, full of personal devotion to her, her wilful bloody-mindedness, and declaring that his dependence on her presence was probably the single most important element of his whole life, but don't bank on it. I may mention, just here, that Anya and Françoise were showing more than common interest in each other. I didn't say anything at the time, but I had wondered before this evening whether Anya's secret was the occasional love for another woman.

As it turned out, I was right and it explained much about the uncluttered relationship between her and Gavin, whom she so obviously idolised. Gavin turned a half-blind eye to such amorous diversions, considering relationships in her own private life to be her own business, not to be tampered with, but instead absorbed and appreciated — every generous offering she showered upon him as a gift.

'Anya is not my prisoner,' he told me. 'She gives of herself unstintingly. What more can I ask? She demonstrates her fidelity in everything she does for me. What more can I expect? She is always there when I need her, which means always, as far as I can recall. If she is not, occasionally, I am deeply engrossed in something else anyway and suddenly she is there. Our rhythms are in harmony. There is no contest to win or lose. Ways to love find their own levels

and, in a world of abstracts, make their own unsullied patterns instinctively. It's art, and art is life.'

Sunday morning's early light crept silently into the gloomy corners of Gaston's garage as I awoke, lying stretched across the tyres. I was aching all over, having spent the night pretending that they were a revolutionary kind of waterbed. My eyes focused, and towering above me was the massive assemblage, which I thought for a moment was part of a dream. It was no dream, and a groan coming from beneath the table bench caused me to squint underneath. Gaston was still there, struck down by his poetic exuberance of last night, but about to emerge from what must have been a fitful sleep. I tried to scramble up, and felt like a jammed gearbox on a cold chassis.

Gaston was mumbling, '*Urgh! Café! Café! J'ai besoin de café, immédiatement!*' Françoise stirred and looked around, startled for a moment. She watched me struggle to right myself like a crab on its back in the sand.

'*Bonjour!*' she said. '*Vous avez bien dormi? Je ferai du café. C'est ça. Reste là,*' and she rolled awkwardly off the table, on to her feet, and walked stiffly over to the coffee machine.

'Taraa!' I looked up. It was Gavin standing at the top of the office staircase scratching his midriff and snapping the elastic on his underpants. He stretched his arms and cried out, 'Let my people go!'

The gentle gargling of the coffee machine and the aroma of fresh coffee pulled everyone into a mutual dimension like magic and we were soon all sitting around the table bench. Gaston had produced some Cognac as old as the bottle it was in. Anya, the last to appear, descended the staircase with studied grace, like an actress about to deliver her lines. She was clutching a bulging paper bag and approached the table with mock-severity. Then with a flourish she tore open the bag and croissants tumbled out on to the wine-stained yellow tablecloth between us. Coffee, brandy and croissants were about all we could handle in that split second and a warm glow

spread like summer sun over the assembled bride's mechanics. Then it was second helpings all round.

Gavin pulled the staircase over to the sculpture and set it in a frontal sweep before it. The two elements seem to suit each other, like reflections of the same concept. The idea was firmly rooted in Gavin's mind. The stabilising core, established by the chassis, plunged down and picked up the gentle curve of the wooden staircase. Whichever way Anya moved, it was always going to appear in vertical equilibrium, the essence of the original concept. The wheel rims incorporated in the framework of the chassis described the spatial rotations of planets spinning on their axes as one would expect to see in a Victorian orrery.

Spatial augmentation was the driving reason for all the descriptive armatures of metal that Gavin had assembled together. Dynamic ornamentation was provided by the purely accidental mechanical repetition of the beautifully engineered parts he had chosen in an entirely intuitive way. Gaston was busy scribbling on the back of his invoice book what perhaps he had been grappling in his mind to express for years. He had spent a large part of the morning dismantling the radiator of Gavin's taxi which was now on the bench waiting for Gaston to apply some rather delicate brazing.

Gavin had set up a 6 × 7 reflex camera before the metal structure, and he had been playing with focus and exposure in many variations. The light streamed in through the skylights as he had hoped. There was no need for artificial light of any kind, save a sheet of aluminium that lay against the garage wall. The aluminium would reflect sunlight into the shadows, and create the inner glow Gavin wanted inside his work. This would allow him to reduce the aperture in the lens to the absolute minimum, giving maximum depth of field. He was covering himself in all dimensions. What he was hoping to do was slow the shutter speed to at least half a second, and capture the double imagery, planning how Anya moved and particularly how she stopped, started again, and stopped again. Practice runs were necessary to give Gavin the confidence to go for it. As the sun progressed through the morning and into early afternoon, Gavin

insisted that Anya move up and down, over and over again, then climb on to the block and tackle, rising and falling, with the same persistent repetition.

Leftovers from last night's feast were picked at, and Gaston's wine was constantly replenished in the old partisan bottles. Fresh bread had been found in the Sunday morning *boulangerie* a few doors down from the garage, and nobody wanted for much that day. All of us were fascinated by the determination with which Gavin closed in on the nature of his quest. He would achieve what he set out to do before the best light of the day was spent. In fact the light seemed to soften and achieve a more intense illumination, but with more contrast in the shadows. It was time for Anya to strip and grasp the block and tackle for the real thing. Gavin asked if there were any objections, religious or otherwise, to Anya standing naked before the world. If they preferred, people could step out of the area, or turn their backs, or, better still, wear these sleep masks that he had kept from various long-haul flights. We were all eager to watch this strange, minimal, balletic performance about to be captured in a multiplicity of halting movements, through the lens of Gavin's camera.

'OK! Hold it everybody. Anya? Ready, my turtle dove? From the top. Ralphael will hoist you up as far as he dare, so hang on. He's got bad nerves. Would you like a safety net?' Anya smiles and shakes her head. 'Just get on with it!' I pull on the block and tackle, hand over hand, which gives me a guide: each arm length is a move. Anya rises slowly up in front of the metal edifice. When her head is just below the top of the chassis Gavin signals to stop as she is now 'in frame', as it were. The sight is glorious, and her flesh glows in the filtered skylight sun, but this is no time to stare.

'OK. I will shoot in sets of sixteen per roll and I will shout stop! at the end of each roll. We will overlap the first and last frames of each roll. I don't want to miss a single intervening move. And no bloody laughing anyone. We are about to recreate a moment in history — and, Gaston, *prenez, s'il vous plaît.*' Gavin hands him an old Pentax S500. Every artist had a Pentax, if they couldn't afford a Leica. '*Peut-être vous pouvez attraper les ombres avec celui-ci. Blanc et noir. Ça va?* Look

at those great shadows the whole thing is casting across his floor. We may get this concept in shadow too – why not?' (An idea to develop. Duchamp did works from shadows alone, influenced by his friend Man Ray.)

Religious Mechanics .

'Every time you hear the motor wind on my camera go off, make the next move. Follow your instincts, and may the force be with you. OK. Let's just jump in. There is no other way. All set? Start now!' I let Anya down one arm's length at a time, but decide it needs to be two arms, on account of the high-ratio weight-lifting capabilities of the hoist. Click! Bzzzz! Another move. Click! Bzzzz! And again. Click! Bzzz! And Click! Bzzz! Sixteen times and hold it. 'Yes, hold it there. Fine. Fresh film, relax, but don't move.' Gavin reloads, squints through the viewfinder and says go! Click! Bzzz! Another film is exposed. Same process. Nobody move. Anya is now dead-centre in the frame and looks simply exquisite. Same again. Click! Bzzz! Another film, but Anya wants to scratch her nose. 'NO! Anya! Hold it! Don't scratch!' New film, same process and a strange, mechanical automation hypnotises and controls our concentration. Anya is now nearly at staircase height, and glances down to judge her foot-

position on to the top step. Click! Bzzz! She's there as Gavin works swiftly to change the film but he signals her not to transfer her weight until he has taken three more shots. Gavin's Rule of Three. 'What I do three times is true.' We repeat our method like old pros. Anya is now at staircase level. Françoise has been watching this process well out of range, as though she is thinking that the whole contraption will fall at any moment. Or is she thinking to herself, thank God Gaston is only a poet? The finale is the graceful descent, down the wooden steps of the staircase from England. One step at a time, she stuns us all as she moves through a set of attitudes which gather provocative gestures on each step down. Click! Bzzz! 'Perfect!' says Gavin. 'Now let's try that again with your clothes on! Only kidding. I can't wait to see the results. Maybe we can get them processed while Gaston is fixing the radiator. Thank you everyone. That's a wrap.'

'Is that it?' I sat down next to Anya, who had covered herself in a towel gown and flopped on to the bench seat, dropping her head on to the table. 'If they come out, sure, but I have known him to start again because I smiled or something. But I think it's OK because it's time we got out of here anyway, and I'm sure you don't want to hang around either. I'm amazed how kind these people are because they sure as Hell aren't like this where we are going in Languedoc. It's probably because we are not neighbours, and we'll be on our way in the morning.'

'What are they like down there then?'

'Well,' she replied, 'they tend to shit on you for trying to improve your property or, worse, they call in the gendarmes. You just wait. They hate foreigners, particularly eccentric ones. Gavin's had several run-ins with the mayor of our village because his brother is our immediate neighbour, and he wants our place for his son-in-law. You'll see a lot of that, but talk to our friends. They learned to live with it, especially the early settlers like Lily Potsdam, the Muralist, and Maurice de Rim, the Wheelist.'

'I can't wait,' I said, and for the first time felt that I, at least,

should make a move. They could be here for days, while I could be down there, doing a spot of discreet research, as a complete stranger. My mind was made up in that moment, and I offered to take the staircase in my taxi to give Anya more room. I decided to put a few kilometres between me and Évreux before nightfall. I needed some time alone and, if I made haste, I could reach the mining district of Menat, where I knew a small *auberge*. I had never had a problem finding a room there. I had a last look around, took a few shots of my own of *Christ's Bride Stripped Bare* and said my *au revoirs*. Gavin reckoned that, provided he didn't poke the radiator again, they would be down within twenty-four hours.

I was relieved to get going.

# CHAPTER 11

# DOODAAA: THE
# PHILOSOPHY OF FRENCH PLUMBING

THIS CHAPTER is concerned with the movement known as Doodaaa, and how it came into being – the Philosophy of French Plumbing, which is the Doodaaaists' creed. It is related to a person, or persons, within the group, who wish to avail themselves of toilet amenities in a public place, like a restaurant, a bar, or other such establishment. When offered, these amenities are invariably in a basement, the traditional French hole in the ground, in pitch dark, the light switch is often life-threatening, so the luck of the user is equated with how good their aim is and how much shit they get on their boots. This theory runs parallel to the experiences in the average life of a Doodaaaist, and how much luck, good or bad, a Doodaaaist is likely to suffer throughout his life. On this assumption, the whole movement of Doodaaa is based. How much blame can an artist shovel on to society for the level of merit, or lack of it, within his life's work?

This formulation began to take shape in my mind as I set off for the mountainous ride across the Massif Central towards Languedoc, the acknowledged region for the creative fervour of the group, the melting pot of futile lives that struck a bargain with the gods, but heroically, it has to be said, came off the worst.

I headed on through volcanic spa country, the puys and plumbs that still generate the hot mineral springs, and the mystical reverence of deep mountain funnels that had once been the escape routes for volcanic eruptions. The Romans prayed to them as oracles, and orifices of Apollo. Le Puy was a favourite area for retired gladiators and their slave girls. Rural life predominates, and a strong mediaeval sense still holds the route in a state of atrophied Arcadian splendour.

It is always worth the trip, and I imagine that during many wars the rocky wilderness has been both refuge or resistance for some, depending on their predicament. A desperate man can live out here for years on berries, fruit and an abundant supply of Volvic natural mineral water, plus the Frenchman's answer to Cheddar cheese, Cantal. It was in such a region as this that Gavin imagined a Beaver of Wild Ambition, who dreamed of building a monumental opera house over a precipitous waterfall, to house the animal kingdom and teach it to sing in tune instead of waking him every morning with its cacophonous clamour. I imagined these mountains to be full of trembling fault lines, which would become the ever-present threat of disaster for anyone foolish, or brave, enough to embark on such a project. It was the project of a madman – the folly of an artist.

I had discussed the idea with Gavin when I first decided to write a biography of him, because it seemed to me that madmen and artists are alike and the same kind.

Philosophy was a subject that Gavin felt drawn towards, when he considered that an artist is regarded by his society in general as an uncertified lunatic. The artist, he felt, was mentally, if not physically, separated from other citizens by a different set of preoccupations.

More than once Gavin has been reprimanded for staring fixedly at another person, or more often at groups of people, who fascinate him not because he admires what he is looking at but, more perversely, because he can't stand the sight of them. The aversion worries him and preoccupies his quieter moments.

Gavin had brought the subject up with various people in the group. It turned out they had similar troubling preoccupations. When he mentioned it at the opening for Kochl Binswanger's *Bum*, his irreverent exhibition in Pézenas, Kochl (a descendant of Ludwig Binswanger, one of Sigmund Freud's early followers) admitted his irresistible habit of staring absent-mindedly at the backsides of fat women, particularly at first-night gatherings.

'What are you thinking of?' Gavin asked Kochl, who replied, 'If people didn't have bottoms, what shape would they be? What if they were concave? Or square? Or imagine if each buttock was a pyramid,

and a bone structure supported them from the central pelvic region. I ask it not as a sexual question but more as a philosophical one.'

'It's because artists ask such damnfool questions like that that others get the impression that artists are somehow mad. And because they dare ask the madman's question from Nietzsche's book, *The Joyful Wisdom*: "What were we doing when we unchained the earth from the sun?" A simple enough question, but the madman supplies his own answer too, amid laughter from a crowd. We have killed Him, you and I, he says. We are all His murderers. Then he goes on to describe some cosmic thoughts which indicate that if he is mad, he is certainly not simple. There was a huge imagination at work. That was the first time I really decided that artist and madman are one and the same.'

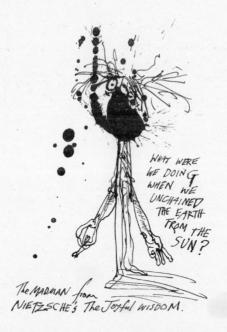

The MADMAN from NIETZSCHE's The Joyful WISDOM.

Gavin looked intently at me with defiant apprehension, as though I was going to disagree. On the contrary, I wanted to know more.

'In what way?' I said.

'Because', he replied, 'of the breathtaking ideas of the madman's statements – How have we killed *God*? How could we swallow the sea? Who gave us a sponge to rub out the entire horizon? What were

we doing when we unchained the earth from the sun? These are huge concepts. Anyone with what we refer to as a normal mind could never encompass such original thoughts. The mind has to be in another dimension to conceive them.

Oct. 2nd 2000

I never meant it to be like this.
I opted for the better world but
the rest wanted to reconstitute my
prejudice just so they could get by.
'Sanctions' are Saddam fault
but they are ours as well! Our fault.
Our preconceptions, fears and refuse
of impotence.
          The world situation, our
sense of loss, is all a part of the principle
of cause + effect. We all made it
happen because we cannot forgive
the difference and the difference is in
each individual, and we find this difference
unforgiveable, because difference is a
VIRTUE. OK.

'Then once free of the sun –' he continued – 'the concept develops, and the madman wonders where we are going. And like a child he answers his own kind of child logic – are we plunging straight downwards into darkness? and, better yet, is there still an up and a down? These are huge thoughtful questions. And I was thinking, these are like pictorial imaginings, lurid pictures. The madman is an artist. He imagines it will get colder. That empty space is breathing on us, and night is closing in on us, and we are burying God, and as we bury Him so it gets darker. WOW! I thought. This is a magical proposition. But it could only have been thought of by someone whose mind is so deranged, so strict-orthodox-belief-FREE – free as an artist who has made a bargain with himself, and in spite of himself, to let the mind do its own thinking in order that the artist can do its bidding.'

There was a passionate insistence in Gavin that an artist has to be deranged in order to function in a creative way, in order to fill the vacuum that he imagines is always in the ether, like an abstract invitation. In Languedoc I am expecting to meet people of this nether region of the mind who, in their own indefinable way, express minds cut loose from everyday experience. This would not be because they are so very different from everyone else, but because they say out loud to themselves, I cannot stand this life and there must be something else.

Lempdes. What? Le-em-purr-duurrr-su. I had just read the town name on my right. Lempdes. Lem-purr-durr-su. It always gets me and for the next twenty-five kilometres I kept mouthing that strange place name. Nowhere else in the world, only here in Lem-purr-durrrrr-su. It rolls out of the mouth like a spoonful of lumpy honey.

'Taxi!'

I wasn't sure I heard the cry the first time, but I sure as Hell heard it on the second hail. I glanced around me to try and ascertain where such an English outburst could be coming from. Not from the dishevelled figure with the John the Baptist staff and the rough cloth thrown around his shoulders, that's for sure. Unless the fact that he was running towards my slowing chariot was an indication that he

*left:* Portrait of Silas Twing, having arrived from Leeds with his walking stick.
*right:* Elspeth Pumice, Silas Twing's mistress, Mother of Gordon.

*left:* Silas with his bastard son, Gordon
*below:* Silas Twing, the well-to-do citizen of Burnley

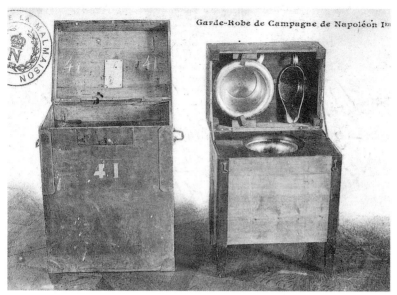

Garde-Robe de Campagne de Napoléon I^er

Napoleon's Porta-Loo, a source of Inspiration to Silas

*below:* Mr Rambottom's 'Aprodite Bathroom Suite'

Coucou!... C'EST MOI!

*Est-ce votre pas que j'entends ?*
*Vous qui m'aimez, Vous que j'attends...*

REX
811

Doreen Ramsbottom in her father's display bath

*below*: Gordon Twing and Doreen's engagement photograph
*right*: Gordon in old age

The D'Eau sisters, Elsie (*left*) and Doris (*right*), Gordon Twing's aunts

Gordon and Doreen Twing on their wedding day

*above left*: Sidney Twing, Gordon's son, who made a fortune in continuous rolls of toilet paper

*above right*: Sidney with sister Doreen

*left:* Sidney Twing, aged seven with grandmother Elspeth Pumice

*right:* Raphael Twing, son of Gordon, who became a Mosley blackshirt

Sidney Twing *(front row, third from left)* at the 1921 'Continuous Disinfected Toilet Roll Convention', Poughkeepsie, New York

Gloria, daughter of Gordon and Doreen, mother of Vera

J.T. Steadman as a boy with his family in Burnley

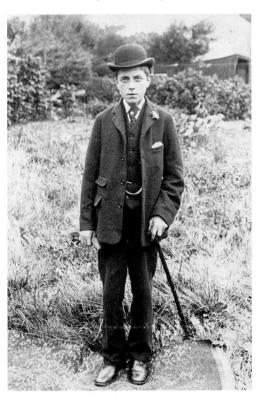

J.T. Steadman as a young journeyman

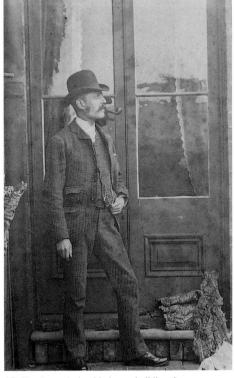

J.T. Steadman during his barge building days

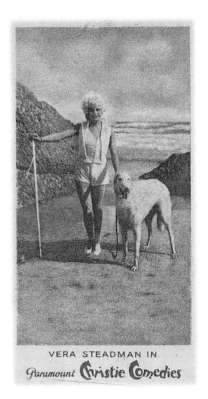

*above:* Gresny Coppelshlitz, Vera's lover and heir to
a corn fortune
*right:* Vera on the road to stardom

VERA STEADMAN IN.
*Paramount* Christie Comedies

Vera in *Great Expectations*, Monterey Drama Group

Vera Steadman

Gavin Twinge: War Mother. Gavin's portrait of his mother during the Spanish Civil War

Bob Donlin, Neal Cassady, Allen Ginsberg, Robert La Vigne, Lawrence Ferlinghetti, North Beach California 1955, photo by Peter Orlovsky. © *Allen Ginsberg Trust, courtesy of Fahey Klein Gallery, Los Angeles.* (It may have been on this occasion that Howell Northern, Gavin's natural father, took Jack Kerouac's cheque for $11.00 to Nunzie's Wines and Liquors in search of beer.)

Gavin aged six. 'Airships were my escape.'

Gavin's Mother at a demonstration, 1958

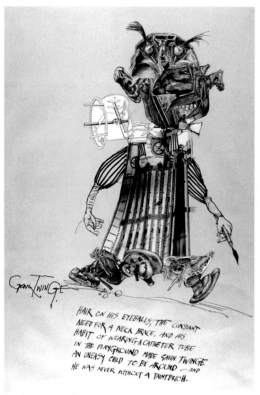

HAIR ON HIS EYEBALLS, THE CONSTANT
NEED FOR A NECK BRACE, AND HIS
HABIT OF WEARING A CATHETER TUBE
IN THE PLAYGROUND MADE GAVIN TWINGE
AN UNEASY CHILD TO BE AROUND — AND
HE WAS NEVER WITHOUT A PAINTBRUSH.

Gavin Twinge: Self-Portrait in a Neck Brace –
Pain Remembered

Gavin sketching in Bernard
Stone's bookshop, Kensington
Church Walk, London, 1970s

Gavin During his Paris Show, Who?
Me? No! Why?
*© Philippe Vermès, Paris, 1996*

Wrapped Gargoyles, Notre Dame. 'When I wrap something', says Gavin, 'I still want to see it.'

*right:* The studio of Schlemiel Weiss under construction.
*below:* Public fountain, Les Salces — gossip corner before television

Gavin's house next to
the church, Les
Salces, Languedoc,
France

Anton
Schminck-Pitloo
and Aaron
Dickley during
the fête at Les
Salces

The 'Higgle Piggle' rooftops of Paris from Montmartre

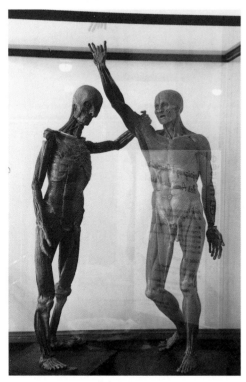

Anatomy of Paris: Figures in Musée de l'Assistance Publique-Hopitaux de Paris

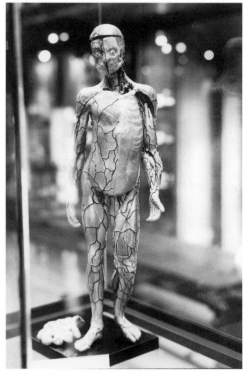

Anatomy of Paris: Figure in Musée de l'Assistance Publique-Hopitaux de Paris

The Armory, Site of the 1917 Independents Show which displayed Gordon Twinge's Urinal Found by Marcel Duchamp

A Longdrop Urinal discovered by Gavin Twinge in a bar two blocks from the armory.

House overlooking New York harbour at the lower end of Wall Street, 1970s. At one stage, Gavin planned to blow the whole Twing sanitary fortune in one glorious frenzy, rename it the String o' Beads Museum and dedicate it to the Manhattan Indian Nation.

Parked Sculpture, New York. Gavin passed this early example of Municipal abstraction on his way to the Bowery to study bums. Every day he renamed it: *Sand Bunker, New World, Idea Cubed, Bum Shelter*, etc. In two months it had sixty esoteric titles.

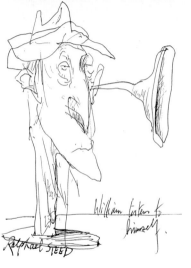

*above:* 360° Portrait of William Burroughs waiting to shoot by Gavin Twinge
*left:* Drawing of William Burroughs by Ralphael Steed

was indeed the hailer with one idea in mind. His arm was in the air brandishing his staff as though to emphasise his intention, with all the inscrutable authority of a city gent waving an umbrella on a rainy afternoon around Mansion House. 'I say,' he said, as he caught up with me, and put his arm on my window sill, leaning heavily to catch his breath. 'You wouldn't, by any chance, be going anywhere near Lodève, would you, old chap?' My eyes narrowed as I scrutinised his framed head. Damn! This was no time to get into detours, even though that was exactly where I was headed. '*Non capito*,' I mutter, trying to put him off. '*Me compralo le machina di Inglese per le famiglia. Me dispiache.*' '*Ah, Italiano! Bene!*' Shit, the bugger could speak Italian and I couldn't. The game was up. 'OK,' I say, 'hop in the back, but you'll have to share it with a staircase. Are you hiking around France?'

'On my way to India actually. Catching up with my family background.' He was already clambering into the back. 'Last thing I expected to see out here, old sport, and the staircase adds a certain, well, a certain surrealism to the whole damn coincidence.'

'Coincidence?' I shot him a startled glance through the driving mirror.

'Good grief, yes! Some chap dropped me off at Vichy in the self-same kind of cab. Said he was going to St-Étienne to watch a football match. Didn't seem the sporting type but these days it takes all sorts. Lucky to get the lift. And now you. Can't believe it. Seems too weird and damned queer, if you ask me. Are you in this line of work?'

'Sure. After Eton I did my stint at Oxford, Philosophy and the Classics, then this. It was all I wanted to do. Get The Knowledge, you know, The Knowledge, then take off and circumnavigate the world. See if I can get into the record books.'

'I say! Oxford! A cabby at Oxford. Amazing. In the driving seat, as it were. You wouldn't happen to be going through India, would you?'

'Of course. Where would you like me to drop you off, Delhi or Bombay? I love picking up people like you. You're one of life's little indulgences. It gives me an opportunity to repay, in some small way,

the magnanimous gestures we have learned to enjoy since the heady days of Empire. The staircase suits you, by the way. I forgot to bring along the ermine wrap, sorry. You'll find the Dom Perignon in the ice box, but the oysters have gone off. Cigars are in the side pocket. Make yourself at home.'

He went quiet. I could see that he was turning things over in his mind. Why me, here, why now? I couldn't possibly have been to Oxford. Look too old. Cabbies would never have had an earthly in the 1960s. 'Ahh – er –' He went quiet again. He was looking for an explanation. 'Er – Wittgenstein, wasn't it, and Karl Popper? You'd have been there about the same time?'

'No, no, no, not me. That was Cambridge Moral Sciences Club, ole sport. But you would be too young to remember that. (So was I.) R. D. Laing, me, and Humphrey Lyttelton. That was my crowd. Serious post-war lefties, with a taste for the flippant. Head banging and jazz, then the invasion of the Beat poets from the West Coast. Couldn't get enough of it. Then I think we went into a social threshing machine, and came out in the sixties with guacamole brains, laughing at Woody Allen and digging The Beatles. The only jazz we would tolerate was Miles Davis and the Modern Jazz Quartet. Dizzy Gillespie for old times' sake, and Erroll Garner, then it was all rock'n'roll. Now it's people like you on the open road, like tramps, hailing cabs in the middle of nowhere, expecting hand-outs like all of us, and trying to make sense of another world replacing the old one. That's what I can't figure out either. What happened to privilege – eh? It's a bitch.'

'Ahh – umm – yesss –' I looked in my mirror and watched as he fumbled around looking in the side pocket for the cigars that weren't there, and the ice bucket which never materialised. He sat back against the staircase and looked very thoughtful. He was going to get out, I was sure. 'Haven't got any smokes on you have you, old chap? Spot of tobacco, just to tide me over?'

'Sure,' I replied, 'but not enough to share, I'm afraid. Here, have a drag on mine. 'sall I got, sorry, till we get down there.' I offered my stoagy through the separating window, which he declined, and went

quiet again. I drove on in silence, maintaining a deliberate con-
centration on the road ahead. 'What do you do for a living when you
are making one?' It was the least I could do. Make small-talk until he
could see no future in it.

'Oh, me – I – er – Christeby's the auctioneer's. New Movements.
They've closed the department for the time being.'

'Why's that?'

'Don't know really, except that there isn't any to speak of, not in
Christeby's terms, anyway. They're a top-flight crowd. They don't
take anybody's rubbish, unless it makes the tabloids, then they're in
there like feathers in a mattress. Time has to pass, y'know. Profit
margins, credibility at the cutting edge, scarcity value, and over-
subscription in the market place. Plenty of buyers, but far too many
artists. Glut saturation. No "belief collateral". Everybody is an artist
nowadays and nobody is – yet, if you get my drift.' I got it all right,
all too well, and a cold draught blew around my buttocks as I realised
that he was talking about the likes of Gavin Twinge . . .

'Ever heard of Gavin Twinge?' There was a wild wind blowing
past the open window on his side and I don't think he heard me.

'Who?' he said suddenly, and continued looking for the cigars,
and the booze.

'Gavin Twinge!' I repeated and turned my head to help the
direction of sound.

'TWARNGE?' he said again. 'How do you spell that?'

'T-W-I-N-G-E.' I articulated the letters as crisply as I could.

'Oh, Twing! That fellow! Didn't he cause a bit of a rumpus at the
Turner Prize ceremony? They would have to give him the prize *before*
he showed them what he had done?'

'That's him,' I said.

'What was it called? It had a catchy title, if I remember. *The
Emperor's Voodoo*, or something like that.'

'*The Emperor's Tutu!*' I shouted back.

'Oh, yes! I don't think Christeby's ever saw it, and I think he was
disqualified, wasn't he? Otherwise they would have been in there like
a shot.'

'Spot-on,' I replied. 'No one has ever seen it. And it remains an enigma to this day. He's got it locked away in an old Scout hut down in Kent. Reckons it will stay there till some museum offers it a permanent home. A kind of installation peepshow.'

'Don't tell me you are in the art racket too –?'

'Not exactly, but I'll come clean and tell you that I am a biographer – *Einstein's Kneecap*, *Napoleon's Portaloo* and *Humboldt's Current* are a few of my titles, and now *Twinge's Tutu – The Balletic Art of* . . . etc – heard of any of them?'

'I say, sounds pretty impressive. Oxford, cabby and now author. You'll be telling me next that you are a mountaineer.'

'Oh, had to give that up. I developed cartilage trouble halfway up the north face of the Eiger, and frostbite on the last lap of our assault on Everest without oxygen. "Everest – Shit or Bust" was a disaster. Ah, great! We're at Millau. We'll be in Lodève before you can find the cigars. By the way, you never told me your name – mine's Ralphael.'

'Good grief! What I wouldn't give for a name like that. I'm stuck with Norbert, I'm afraid, Norbert Nance-Montmorency, but it gets me through doors – the hyphenated bit.'

The panorama over the rocky terrain was spectacular in the late-afternoon sun. They had straightened out the road since my last visit, and the descent wasn't so treacherous, and it was downhill all the way.

'Where are you staying in Lodève?' No answer. I glanced in the mirror again. He had fallen asleep. Poor sod. He still had an empty hip-flask in his hand which was about to drop. He hadn't needed champagne, even if I had had any. Must be living rough. One of Oxford's losers, the ones that live as though the world owes them a living, and get on the familiar escape route to nowhere. Probably never had a worry in all his young life until the day came when his family became more than a little pissed-off with persistent demands for funds to finance some stunning scheme and make a fortune, or to travel, absorb a world of experience, and become an editor of *National Geographic*.

We were near Le Caylar, a remote mountain region. No place for a sleeping drunk, nowhere I would want to spend time anyway, but a perfect spot to drop off one of life's deadbeats. The tricky bit was getting him out on to the roadside verge before he woke up enough to call out to me to stop, and take him back on board.

As it turned out, there was no need. The engine quite suddenly began to sputter, revved up as I pressed down on the accelerator, sputtered once more, clattered like a tin of dried grasshoppers, and died. We were on a hill, so I let the old thing freewheel on, all the way down. What met my eyes at the bottom, like a mirage, or an impossible dream, was a garage, the old kind, with pumps that looked like something out of a pre-war *Illustrated London News*; an advert for Shell, or some such thing. We were still freewheeling, slower now, but trundling inexorably towards the forecourt of this unbelievable place in a million. Coming to a halt awoke my passenger.

'I say, are we there?'

' 'fraid not. We've conked out, but as luck would have it, we've conked out right where one should conk out. Hopefully, it's a friendly garage.'

A youngish man in green overalls came to the front and looked curiously at the taxi, and then through the windscreen at me. I had slid into his life as silently as a Rolls-Royce. He walked all around it, kicked the tyres, and approached my window.

I shrugged. *'Il ne marche pas, M'sieur.'*

*'Anglais?'*

*'Oui, M'sieur.'* God, does it show already? The man indicated to turn the engine over on the starter and, when I did, the clatter of spanners in a tin box sounded again. He held up his hand to stop.

*'Je connais le problème. Le moteur est très, très chaud, comme un chauffage!'* and he smiled, shook his head and flapped his hand. *'C'est pas trop mal.'*

'I say. Can he fix it? Dashed bad luck.'

This was my chance. 'Norbert, you'll have to walk, I'm afraid. You're on your own, ole sport. About twenty kilometres, and you're there. I must hang about, probably leave the taxi and come back in the morning. Here, here is the rest of my tobacco, and some papers. Best I can do.'

I turned and addressed the mechanic. '*Vous pouvez le fixer, M'sieur?*'

'*Oui, peut-être – demain!*'

'*Pas ce soir?*'

'*Non. Il est trop tard maintenant,*' and pointed to his watch.

'OK. *Ça ne fait rien. Il y a un hôtel dans la ville?*'

He nodded, as though English people were always conking out at the top of the hill and rolling all the way down to his little garage, where he would be waiting with open arms. What a saint!

What luck anyway, if it had to conk out anywhere, this was the place, right in the heart of France.

'*Je peut manger à l'hôtel, M'sieur?*'

'*Oui, pas de problème. Je peux vous prendre. Attendez.*'

He drove at breakneck speed into the next village, Caillac(?), and let me out at the hotel, a quaint *pension* called La Philosophie du Plombier, which lived up to its name. A shared toilet on the second floor boasted a French small-bore plumbing system, grimed with age and use, and a hole worthy of Doodaaa enshrinement. What a find! As though it was meant to be. A soul could bury himself in a place like this, and lose himself in deep philosophic thought. To Hell with the world! It's what you always dream of finding but never do, unless your taxi happens to conk out on that particular hill, but I don't believe in coincidence. This was design, pure design, and I had lost my passenger too.

The toilet system proved to be an absolute gem. When the chain was pulled, the detritus of daily accumulation disappeared in a flash, like inspiration. You could watch it go in one wicked flick. Gavin had spoken about this sense of cleansing, this brief moment of breathless relief, a mountain stream, gushing, bubbling and carrying away all we wish to forget. Gone. God knows where to, but gone. I tried the shower and the power of water in the main

supply was more than I can describe, except to say that it felt like it was descending from a mountain of the gods, and I felt cleansed inside and out. I decided to dress for dinner. I wore a fleecy pair of 'DOG TIRED' trousers with elastic bottoms I had purchased in Jean, Nevada, a 'can't wait' gambling stopover from California, on the road to Las Vegas. I also wore the shirt I had bought at the same shopping mall. On the chest it displayed a badly drawn dog in puff satin appliqué with machine-embroidered lettering which said 'Sweet Dreams'. I sauntered downstairs like the Prince of Kitsch and ordered a cold beer and a brandy, in the broadest glass the *patron* could find. This is always my supreme moment. This is the moment you look forward to all day. This is sanctuary, my moment of bliss.

I sipped the ice-cold beer delicately, and swigged a slug of pure four-star Courvoisier, from a glass which contained my whole face. I was sliding into refuge and contentment . . .

'I say! Old Whatsisname! Fancy meeting up with you again. I thought you were stuck in that jolly old garage for the duration. Couldn't say I envied you, but I could bloody well do with a drink, or two. How about it, ole chap, eh?'

'Oh, bloody 'ell. You again. Thought you'd have been in Lodève by now.'

'Transport problems, ole chap. They don't stop, these days, even for a gentleman. I suppose I look a bit odd in hand-knitted knick-knacks and sock boots. Carry the old briefcase, and no problem, but I left all that paraphernalia behind. I'm on a crusade, fer God's sake. Got no use for office equipment.'

'What's your tipple?'

'I say! Jolly nice of you, ole sport. A large beer for the thirst and a double Scotch for the soul. Do they have rooms here?'

'Don't know. I probably got the last one.' I had, actually.

'Well, look here, I'm not fussy. I can share with you.'

My soul gave up the ghost and my eyes watched it go.

'Jolly good! Jolly generous offer. Do you snore? Ha-ha! Only joking. Have you ordered supper yet?'

I had unfortunately ordered enough for two, which was meant for one, but my extrasensory perception immediately saw my portion split asunder.

'I take it you have your luggage with you?' I said wearily, pointing to his distressed backpack and shepherd's crook.

'I'll say,' he replied. 'Never know when you need a jolly ole stick to ward off riffraff. Freeloaders everywhere these days. What have you ordered for supper?'

'Well,' I said thoughtfully. 'I thought we would begin with the melon stuffed with cold slime of snails, followed by raw liver marinated in bile of sheep's stomach and lemon juice.'

'I say! A sophisticate. And don't forget the spleen slivers to augment the acidic aftertaste. Wow! And then?'

'Skunk's eyes and bull's scrotum, without the balls. Calabash and yak butter, braised and sautéd, on a bed of weeped thistles and bruised nettles. How does that suit ya? Steak and kidney pudding of course, for dessert.'

'You certainly picked up a lot from Eton, ole chap!'

'Oxford. I said Oxford. My father thought Eton a trifle passé, and sent me to Shrewsbury. Didn't like the ponces' uniform on a boy. That must be your problem. Mummy really didn't want to let you go, and Daddy wasn't home to make the decision. Daddy never there when you wanted a free lunch?'

'Something like that,' said Norbert. He went quiet and I knew I had hit a tender spot.

'Well, cheer up, Norbert. Here comes the wine. I'll play Jesus Christ, and you can pretend to be the twelve disciples. Every time I pour one for me, I'll pour twelve for you. Let's see who can drink who under the table first.'

Three bottles later Norbert was asleep. I took the cheese plate, biscuits and the rest of a decent Sauternes up to my room. He couldn't be roused, so the *patron* shrugged, covered him with his prophet's mantle and left him there for the night. *'Dormez bien, M'sieur.'*

The garage mechanic called by at 8am to say the taxi was ready. Norbert was still sleeping, so I had a strong black coffee, settled the bill for Norbert too, and left him to his own devices.

By the time I got to the little village of Les Salces, near Lodève, it was night-time. The main street was deserted and I saw the blue flicker of TV sets in the windows facing the street. I parked the taxi up a side lane and made my way towards the little church, with the graveyard that Gavin had told me overlooked his mulberry tree and patio. I heard whooping voices and laughter from what must have been the very place. I walked around towards the sheltered confines and saw a generous barbecue fire and smelled the gorgeous whiff of sizzling coils of local *saucisses*. I had found the place and it seemed an actual Doodaaa party was in progress. I stepped into the firelight and introduced myself.

# DOODAAAISTS: THE NIETZSCHE FEATURE

'INSTINCT IS still the most intelligent of all the kinds of intelligence ever discovered.' Gavin considered this aphorism from *Beyond Good and Evil* to be the closest explanation for what an artist of decent ability can expect to achieve in a lifetime. Realising that 'societies are built on simplifications and falsifications, and how we have made everything around us clear, and free and easy, how we have been able to give our senses a passport to everything superficial – how from the beginning we have contrived to preserve our ignorance in order to enjoy an almost inconceivable freedom, thoughtlessness, imprudence, heartiness, and gaiety – to enjoy life. Here and there we understand it, and laugh at the way in which precisely the best knowledge seeks most to retain us in this simplified, thoroughly artificial, suitably imagined and fiendishly falsified world; at the way in which, whether it be our will or not, it loves error, as living itself, it loves life!' Nietzsche was getting so close to describing that irrational output, the result of the artist's creative struggles, those surprising results of instinctive effort, which signify an art as opposed to a product. The art itself is the defining of it and the pleasure is in its unexplained appearance, the explanation of itself without words. 'The granite-like foundation of ignorance', to the uncertain, to the untrue, becomes the plinth upon which to exhibit the instinctive form, true only to itself. Thus spake Gavin Twinge.

In order to involve the Doodaaaists in the black forest of Nietzsche's most complex simplicity, Gavin devised a game of chance, the Nietzsche Feature, which would engage the interest of even the most insensible and drunken fool among them, who had to be Garton Pimpless, the Brawlist. Garton wrestled his canvases to the ground and fought with them as he squeezed pounds of paint

from tubes across the surface wearing a wetsuit and snorkel. Gavin knew the game he devised was right up Garton's alley.

GARTON PIMPLESS —
The BRAWLIST.

I seemed to have arrived in the middle of Gavin's game. Gavin had arrived only hours before me, but had already rounded up the usual suspects for an impromptu party. Gavin's Nietzsche game was well under way, but was stopped while Gavin made the introductions and Anya plied me with wine and gave me a peck on the cheek.

'Hi!' she said. 'Thought you'd got lost.'

'Nearly,' I replied, 'but I decided to take the pretty way and got into some deep conversation with another ace mechanic and a pilgrim on his way to India.'

I settled down on a block of wood and the game continued.

The game was, quite simply, this. Seated at a fire under a starlit sky, amid the constant rattling buzz of cicadas, Gavin produced a pack of cards, shuffled, snapped them dramatically and asked Garton or Hooper Zpeed, his partner, to take a card. They both loved to be first, so they tossed a coin for it, thus pushing up a notch the element of chance. A copy of a book by Friedrich Nietzsche, *Thus Spake Zarathustra*, lay on the table next to a storm lamp. The chosen card is slipped at random between the pages of the book and then the book is opened up at that place. The King in this game represents thirteen lines, the Queen is twelve, Jack is eleven and the Ace is a whole page, or one line. Black suits mean a left page, red a right. Hooper won the toss and drew the first card. King of Spades. Perfect! The first full

paragraph on the left-hand page. He opens on Part 5 from the
'Drunken Song'.

Hooper stands unsteadily and reads with an alarming display of
thespian stagger: ' "It carrieth me away, my soul danceth. Day's
work! Day's work! Who is to be master of the world?" ' (Here Hooper
is allowed to stop and challenge the rest of us, because he has hit on
an actual question. He chooses to continue because he is enjoying the
flourishes of his delivery too much to stop, and he is already pissed.)
' "The moon is cool, the wind is still. Ah! Ah! Have ye already flown
high enough?" ' (Here is another question and Hooper must chal-
lenge one of us to answer the question, or forfeit the rest of his act,
which he is loath to do.) 'Amanda!' (That's Amanda Ell, who I later
discovered was a Lyric MDF Board, Graffiti Queen, down for the
summer.) 'Have you flown high enough, Amanda?'

'You betcha,' she replies, 'flown higher than a kite. But that is
Zarathustra asking, isn't it? Flying by night, after midnight, asking
his friends, the animals like serpents, eagles and asses, he is inviting
them all to join him along the mountain ridges, in the wild places

away from dumb civilisation. So Nietzsche is inviting those who want to be better than they are to make the effort. Any good?'

'Not bad, Amanda, not bad. I'll go on. "Ye have danced; a leg, nevertheless, is not a wing." That's not necessarily true, but Nietzsche was only a philosopher, so what does he know? "Ye good dancers, now is all delight over: wine hath become lees, every cup has become brittle, the sepulchres mutter."

' "Ye have not flown high enough: now do the sepulchres mutter; 'Free the dead! Why is it so long night?" ' Oh, shit! Another question. Move on. "Doth not the moon make us drunken?" Another bloody question! OK, er, Skrim!' (Skrim Sikhfuc, the Symbolist Printmaker from Bombay, on his way to England.)

'I agree!' says Skrim (who doesn't drink as a rule, on account of his diabetes rather than his religion). 'A harvest moon makes me drunk just looking at it. It's like a goldfish bowl full of German lager. Is that what Nietzsche is getting at? Did he drink, by the way? I say he didn't but wanted to −'

'He didn't need to,' said Gavin. 'He took chloral instead, to make him sleep, and opium to ease the pain of profundity − and syphilis. Go on, Hooper. Finish the last bit.'

' "Ye higher men, free the sepulchres, awaken the corpses!" Er − what's a sepulchre, by the way?' Hooper was now drinking straight from the bottle, and dribbling down his striped blue-and-white matelot T-shirt like an anorexic Picasso. He was bald too.

'It's a tomb, dummy,' said Amanda, who was now lying out straight with her arms crossed, balancing her wine glass on her bosom.

'O-oo-ooh!' Hooper pranced around in his infectious effeminate way. 'O-oo-ooooh!' he said again. 'Here we all are having a party next to the village graveyard and we're about to be joined by the stiffs. O-oo-oooh, stiffs, awaken stiffs. I'm all yours! O-oo-oooh!' The rest of the party jumped up and started prancing around like Hooper, chanting, 'Awaken stiffs, awaken stiffs,' and stepping and stumbling over Amanda as the token sepulchral figure.

'What's next, Hooper, or is that it?' Gavin was trying to keep it serious.

'If only. There's another two lines, and there's another question too,' said Hooper, flinging out his left arm with a theatrical wave and stuffing the bottle up his T-shirt. ' "Ah!," he said, "why doth the worm still burrow?" Question! Naughty worms, want to do some burrowing – o-oo-oooh! Hurry somebody! Because it goes on, "There approacheth, there approacheth, the hour –" ' and the very second he said that the actual village clock, on the actual village church, adjoining the graveyard, struck twelve times, at five minutes to, the way it does in all French villages, at all hour-changes of the day, to alert those working in the vineyards that the hour will be struck five minutes from now so that the specific time can be counted.

' "There boometh the clock bell," ' continued Hooper, ' "there thrilleth still the heart, there burroweth still the wood-worm, the heart-worm. Ah! Ah! The world is deep!!" And I have read three lines too many. Who is going to answer the question?' he added and fell, with a last flamboyant flourish, into the bed of tall nettles which hid the cesspit beneath the mulberry tree beyond the patio. That finished the game on that occasion as Hooper suffered nettle stings which, although he didn't feel anything at the time, kept him laid low for a week with a rash like a tyre skid on a hot road.

That broke up the party. There were lots of drunken hugs, avowals of eternal friendship, Doodaaa *viva los vivas*! and weeing in the bushes. A quiet descended on Gavin's patio and enveloped the cicadas' buzz as the night air cooled. There were more stars in the clear sky than I had ever seen before. There were no city lights to dim their display, in the firelight's dying embers. The church clock struck twice.

'Follow me,' said Gavin. 'You can sleep on the couch beneath the half-balcony. We'll fix you up tomorrow with a proper bed.'

If any work had been done by any of the Doodaaaists, it would have been taken care of during the morning. Lunchtime was for fierce concentrated attacks on *filets* of steak, cheeses from the market in the town, artichokes, olives, *saucisson* and other bountiful goodies from the Thursday market in Clermont-l'Hérault.

So, the next day, after a leisurely lunch on Gavin's patio under the mulberry tree, I took advantage of the soporific heat mattress that clung to the landscape and kept everyone in dark curtained rooms for the duration. No one was working but there was always someone thinking and theorising. I discovered that the best time to catch anyone was late afternoon.

There was no one in the little village square of Les Salces, and the constant running water of the fountain which drained down from the rocky terrain of mountains seemed to be talking to itself. There was a time, I thought, when that fountain would have been the village laundromat, a meeting place for gossip and opinion, idle speculation and peasant dreams of owning a grey Citroën, a black-and-white television set, and a kitchen that would defy all the reasons for struggling with blocks of carbolic soap, distilling your own *eau-de-vie* and keeping enormous spiders as pets with a purpose. Flies had always been a problem, and meat safes were the only known protection against infected meat, short of fermenting the meat into glorious examples of edible bacteria – together with wine and cheese, France's most eloquent contribution to civilisation and the art of living.

But the kitchens arrived, and Citroëns, with air conditioning, and the television sets, in colour, that drove caterpillar tracks through the whole of peasant culture like juggernauts out of control on public footpaths. It happened overnight. One day there were whole communities, struggling but thriving, with their own built-in logic for scything and stacking lucerne in one breathless movement, rendering precarious steep slopes workable as growing plantations, using dry-wall terracing techniques, controlling water rivulets into irrigation systems of ingenious sophistication, growing tomatoes as big as melons. Sitting in the streets on balmy evenings was the entertainment, and the cohesive chatter cemented villages into vibrant units of peace, love and turgid undercurrents of human drama, like elements in a novel by Zola. Then they were all gone, gone indoors, into their space kitchens, gazing balefully into monstrous Formica television sets, at a world of idiot quiz shows that would have passed

them by, as they farted peasant farts into the ballooning upholstery of
brushed nylon 3-piece suites they bought last week from mail-order
catalogues.

'You can't blame them!' boomed Aaron Dickley, a Primal Scream
Sonic Environmentalist, when I mentioned my observations to him
in the lean-to home he had acquired back in 1968 for fifty quid.
'They have had to jump a long way in a short time. I can remember
the old kitchens of bare stone walls, when agricultural machinery and
kitchen utensils were one and the same thing. If there was a chicken
wandering around the crude room, it was about to be eaten, but if it
was on the table, it was usually about to eat with the family. In this
part of the world conditions were still mediaeval. So you can imagine
the power television had on them. The bristling clarity of what they
found themselves watching highlighted the reality of their own
existence, and in no time at all they were covering up beautiful real
stone walls with plaster of Paris, then wallpapering the whole lot in
lookalike stone-wall patterns. They were duped, and anything real
was tossed on to mountainous junk heaps outside the village, which
suited people like me just fine. That's how I furnished this place. The
irony is that what they were running away from, we were trying to
rediscover. That was why we came – looking for the rural idyll –
John Ruskin's Artist as Romantic aesthete, without the God bit –
and a touch of rough-cast hedonism thrown in, which was no
reflection on the communities. Though saying that, animal buggery
has been popular for centuries – all part of the close proximity of
crude country living, I suppose. These days, mind, trying to bugger a
pig on a settee while you're watching *The Barretts of Wimpole Street*
with French subtitles does seem a tad incongruous, even indecent,
especially if you have guests in to show off your new acquisitions.
Though let's give them their due, they would all bugger the pig and
then sit down to a jolly good meal of pork thighs with *sphincter au
gratin*. One thing I have noticed about the French peasant – they are
not subtle.'

'When did Gavin and Anya arrive down here?' I thought I had
better try to focus on my quarry.

'Not long after me, actually. It was me who told him about the area in the seventies, though things were getting a bit pricey by then. I think he paid about five hundred for his hovel. It was full of rabbit shit when he bought it, but he grew some fabulous tomatoes that year. It was all part of the adventure – the antithesis of urban squalor. It made such sense and it fed our dreams to find whatever we wanted to, in our own way.'

'What exactly is a Primal Scream Sound Environmentalist, if you don't mind me asking?'

'Well, that was Gavin's idea, sort of. We were on a hike up around the Hérault river which flows slowly through deep ravine-like passages in the mountain ranges around St-Guilhem-le-Désert, and especially the grottoes which echo like something from *The Sound of Music*. I got lost and started to shout for help. What Gavin heard was the ricochet of my voice coming at him from everywhere around. It took him hours to find me, but it set me thinking about recording the effect and augmenting the delays into recurring themes, for concerts of poetic repetition. I have always had a passion for electronic gadgetry, sound warping and augmented freakery. I have had a few concerts in Montpellier, and a regular spot in the Annual Arts Festival in Clermont-l'Hérault. It goes well with Heavy Metal stuff, and I make all that on a synthesiser. The only real bit is the variety of sounds that I can generate from what I record in natural surroundings. I couldn't do that in London without getting arrested, though you can make some interesting primal screams in a

prison cell. I tried it, and I was released on compassionate grounds. Here, let me play something for you,' and before I could make my exit he had switched on a huge old reel-to-reel tape recorder. The small room was filled with a block of sound, and the whole region of Languedoc was violated with a blast of repeating echoes which broke the wine glass I was holding and sent me lunging for the door with my hands over my ears. The whole mountain range seemed to tremble with the echo of disgruntled gods having a shouting match. My head absorbed what must have been the equivalent of the decibel level of two pounds of pure dynamite compacted inside a private safe.

I spent the next two days in bed nursing possible inner-ear damage. It seems that I caught the full blast of Aaron's highest inaudible note to date so far. It was, as far as Aaron himself could ascertain, something even a dog could not hear, and he had finally reached the Plateau of Apparent Silence, the ultimate 'sound without a voice' he had been searching for since his first sound experience in 1973. Pink Floyd tried to reach such karma, but failed when their sound system crashed in public. I was assured by sign language that damage to my ears was not permanent. The high-pitched decibel wall of silence had blasted through the tympanic orifice of the Eustachian tube – stunned the middle ear's auditory ossicles in the tympanum, jangling the cochlea in its vestibule, thus rendering the petrobasilar synchondrosis behind the body of the sphenoid bone a limp membrane of its former self.

Luckily, the small muscle of the helix held firm, which preserved the gelatinous sensitive parotid gland secreted snugly inside the squamous portion of the temporal bone. Which was lucky, according to the French doctor, Professor Charles Bonamy, Professeur d'anatomie à l'École préparatoire de Médecine de Toulouse, down for the summer, who looked into my ear as far as the external auditory meatus of the auris media. No doctor can do more on a first visit, nor charge more than he did, but I simply put the receipt in my folder marked 'Expenses incurred. Refer to PUBLISHERS.'

Apparently, the apical whorl, middle whorl and basal whorl of the cochlea were straightened out momentarily by the terrible sound, to offset the inhuman timbre of the sonic aberration. Otherwise, said Professor Bonamy, I might now be stone-deaf. In other words, I could say goodbye to, or, as he put it, *dois dire au revoir*, to my labyrinthus osseus, the sound box of my being.

'Don't go near that Aaron guy,' said Gavin, when he crept into my stable bedroom to see how I was getting on. 'He claims to hear voices from Zeus which are louder than pneumatic drills in a portaloo.' 'What?' I said. 'Your lips are moving but there is no sound coming out.' 'Read my lips,' he said. Gesticulating wildly, he tried heroically to express his thoughts visually. 'When we have a party, he is not allowed to bring his PA system, but he did arouse my interest in audio phenomena. Haven't you seen my sound tower? Obviously not. Shit! Where ya bin?' Gavin's stare was the only sense I was capable of interpreting at that moment, with nerve ends shot to Hell. 'A visit to the Empire State Building', he continued, 'convinced me that altitude, sound and mountain echoes are very much related. But you have to be in freefall to appreciate the difference, or the power of sound blocks your ears with overload, which is what happened to you. Aaron was naughty to do that to you, but if you were hang gliding, bungee jumping or in a Bondi Beach surf roll, you would have been carried along in a barrel of sound that you cannot experience any other way. You have to roll the sound like you roll a wave, then it's natural sonic vibration consumes your whole body – a nuclear explosion contained in the velocity of your body. Only then

can you sustain it. Rock bands have still to discover that trick – high-speed quadrophonics driving the whole stage show. Feedback distortion is only the beginning. There is another sound out there that drives sound into a fifth dimension. Only Aaron has done it so far, but he has only done it inside a granite container – his house.'

I looked at him and wondered if I would ever hear him speak again. I was trapped in a silent world as though looking through a window in my head and watching figures mutate in front of me. I wondered if Professor Bonamy had slipped something in the herbal infusion he had administered, and was that what I was paying for? Will my publisher reimburse me if they discover that the huge expense incurred on account of my mishap was in fact for mind-altering drugs? Thoughts rushed through my brain more speedily than usual. Funny – and come to think of it, how was I able to write down what Gavin just said, when I couldn't hear a single word? Had the Doodaaa group discovered some secret elixir, and was I going to be allowed to leave once I had spoken with everyone and learned some of their secrets? Was the Doodaaa group some strange religious sect? Do they induct innocent people like myself and use them as specimens for their dark practices? Is art a religion, and does it consume its practitioners and transform them into fiendish zombies with alien motives? Do they realise that they are possessed, if they are, and am I the only one who realises this, and therefore cannot be one of them? Gavin was standing in front of me performing a strange sign language and, even stranger, I can understand it! Why can I see but not hear? Why are they lighting a fire on the patio and why is Gavin smiling?

I turned away, and hid my face in the rough blanket grating along my numbed body. I sensed a nameless fear rising from the pit of my stomach, up through my chest and gathering in my skull as though it was about to burst, and my feverish brain matter was going to explode into the stainless steel bedpan above the pillow which I was sure was what they feed on, when the moon comes up. Why did I ever begin this project about this weird freak of an artist? Why didn't I stick with the cooking maestro, Lars Teledyne, from Copenhagen,

who cooks with marijuana instead of basil, coriander and garlic? Far less complicated, and he had already given me his recipes. I held the top of my head in my shaking hands, trying to prevent what I was convinced would happen at any moment. It was then that I discovered that the top of my head was covered in hair, when in fact I had been bald for twenty years. Impossible, I thought. The front part of this new growth was slicked down across my forehead, reminding me of the characteristic style of Adolf Hitler. Instinctively I felt my top lip, and yes, there was a stiff stubble beneath my nose like a tiny hedgehog. I turned my head and looked towards where Gavin had been standing. What-is-the-matter-with-me? He was still there, but he was covered in hair from head to foot, humpbacked, and dragging the backs of his hands across the floor like a huge gorilla. He was holding a brush. Anya was there too. She was searching through his hair, picking out things, and putting them in her mouth. There was an easel in the room now, and a canvas, half-painted, resting against it. On the canvas was a reclining figure. It was me! I seemed to have intravenous pipes coming out of my body, as though I was attached to some kind of life-support system. Good God! Perhaps things are worse than I thought.

I tried to sit up and do something, anything, rather than lie so helpless. But belts of webbing were holding me down as though I was in some sort of strait-jacket. I grappled with the buckles but I felt as weak as a kitten. I must be in a nightmare. I tried to slap my face and wake up. That hurt and I poked my finger in my eye. 'What are you doing?' I said. 'Why am I tied down?'

'Oh! You're awake. I have just found my model for an *Imprisoned Christ Reclining*, after Mantegna. Sorry about the straps, but I didn't want you to move when you woke up. I hope you don't mind. I have nearly got what I need. Here, let me untie you, but try and keep still. It won't be for much longer, and I think you needed the rest. Old Bonamy said you were suffering from heatstroke as well as that sound burst. I've told Aaron to warn people before he switches anything on again. He can be a bloody menace. Anya's just giving me a trim while I work.'

'Hello,' said Anya gently. 'You seem to have had a bit of a blast from Aaron. Last time he did that my mother's hearing aid flew off and dropped into the soak-away tank under his concrete balcony. But she didn't need it any more. She could hear again. I th –'

'Wait a minute!' I said. 'I can hear again! I'm OK! That's fantastic. Better than before. Like having your ears syringed. God, I feel great.'

'My father does that.'

'What?'

'Syringes his ears himself. Says it clears his head and organises his thoughts. But he is always confused so I think he imagines it. In fact if anyone is deaf, it's him. He says "what" before anyone finishes a sentence. It's one of his favourite words. Glad you're feeling better. Anton Schminck-Pitloo is hoping you will call on him sometime. Wants to give you the dirt on our wayward crowd. He puts pickaxes through old pianos and digitalises the sounds. Though on second thoughts, perhaps you should go and see Lily Potsdam and be soothed by her. You need soothing. She is a Whiplash Muralist, that's what she calls herself anyway. Claims to be the echo of past causes, the antidote to political oppression. What she can't tell you about walls isn't worth knowing. Look, she may come on strong but she is sweetness personified. Nearest thing to Anya I know. You'll have to climb on her roof to get in, because she has filled in all doorways and windows. She has this idea that walls are not prisons but doorways to a new future. The way she paints, I guess. It's OK. She won't eat you. She is the gentlest soul imaginable and purrs over people who are interested in her theories. Go see her. I think she will ease away all that trauma you seem to have suffered. If you want pictures, take a camera with flash. Her place is dark. But the whole of the interior is an infinity of landscapes, horizons she is convinced are there in darkness just as much as they are in the mind. She is a painter of our minds. She loves silence, too. So if she says nothing for a long time, she is probably assessing your potential perception of what she is about. But wear tin knickers. Everything above the horizon is in the mind. Everything below is up for grabs. What more can I say?'

*       *       *

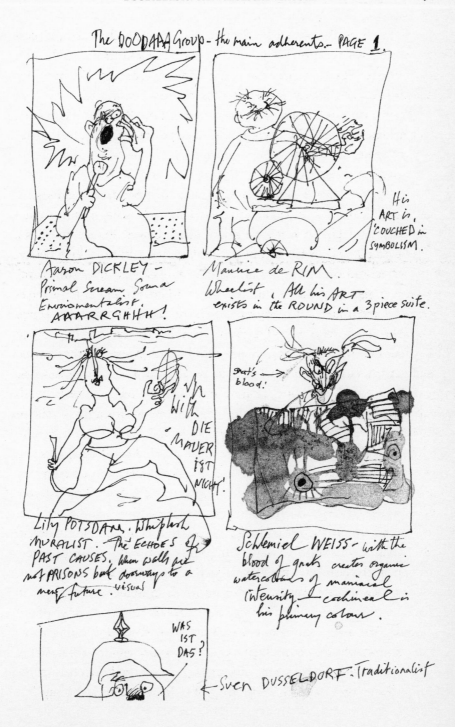

The DOODAAA Group - the main adherents - PAGE **1**.

His ART is 'COUCHED in SYMBOLISM.

Aaron DICKLEY -
Primal Scream Sound
Environmentalist.
AAARRGHHH!

Maurice de RIM.
Wheelist. All his ART
exists in the ROUND in a 3 piece suite.

WITH 'DIE MAUER IST NICHT!'

gnat's blood!

Lily POTSDAM. Whiplash
MURALIST. The ECHOES of
PAST CAUSES. When walls are
not PRISONS but doorways to a
new future. visuals

Schlemiel WEISS - with the
blood of gnats creates organic
watercolours of maniacal
intensity - cochineal is
his primary colour.

WAS IST DAS?

←Sven DUSSELDORF. Traditionalist

The walk over to Lily Potsdam's was a pleasant half-hour amble, to the next village in fact, and I could hear the cicadas again. I passed the dump on the way over, so I paused and looked at the stuff that people had been throwing away. Among the usual bottles, plastic containers and old tiles were stoves and cookers, enamel buckets and crude leather shoes, dried and cracked in the sun. They looked as if they were longing to talk about where they had been, who had worn them, what they had heard and seen in old kitchens and the sadness and laughter of life as it used to be. I ferreted around in the rubble, like one does at jumble sales. Apart from odd smells of someone's discarded food parcels which had been torn apart by mangy dogs, the 'sad ghost pets of a lingering past', and maybe wild boar, there were old beams and broken stone *dalles* that had been common building material for roofing before round terracotta tiles became the favoured *midi*-style *rustique* alternative. They had been hand-made until someone invented a machine method for extruding miles of it, and founding builders' merchant empires. Gradually, labour-intensive traditional methods of building were rejected in favour of corrugation and concrete convenience. Anyone can now construct a concrete balcony as fast as it takes for concrete to dry. Gradually we see the utility graft of new materials change the face of villages, which otherwise still make you feel in touch with mediaeval ways of life. Finding a piece of hand-hewn doorway or pillar is now rare, but occasionally you see a fragment, incarcerated in grey shuttered concrete, used as nothing more than ballast, but still informing the imagination that, once upon a time, a mason sat astride that very piece of stone, chipping away, searching, shaping and finding the natural aesthetic within it. The artistry was inherent, the artisan was allowing the stone to speak. It is a romantic thought but I have gazed at such stones often, and conjured up their history. They do speak, and even if I were still deaf, I would see what they were telling me. Having moved aside an old burned oak beam that would still hold up half a house, I caught sight of something strangely mechanical. I pulled it out before letting the beam crash back down.

It was some kind of screw press: a wooden base and a cast-iron U-

shaped hoop which housed the machined thread. A small tin cup, about apple size, sat inside it, and from that I figured it must be a simple fruit press. I took it along to present to Lily. I had nothing else to give her. Her place was the first building in the village; part of it formed the doorway to the village of St-Privat. I felt that there should be a drawbridge somewhere, or maybe a portcullis. But it was just the building, like a toll gate. There were no windows and I could see nowhere to enter. A small pathway to another level gave me a clue, and I scrambled up and saw a ladder. I climbed gingerly, and stood on the roof looking around. A wooden trapdoor was set into it. I knocked on it with the fruit press, and waited.

'Coming!' The shrill voice rose up from below. I heard what sounded like a whip cracking and a fumbling, scraping, drawing-back of rusty bolts, and a head emerged through the trapdoor. 'Hi! You must be whatsisname.'

'That's me,' I said, 'checking the facts, ma'am. Just checking the facts. I brought you a found object. You might have a use for it.'

'Ooh! That's weird,' she said. 'I threw away one exactly like it about nine months ago. Perhaps I am supposed to have one after all, whether I need it or not. It's a sign. Come in, and mind your head on the beams. You'll have to excuse the mess. I have been in a turmoil of activity, and I'm running out of candles.'

I couldn't see a thing. The contrast between the brilliance of the late-afternoon sun and the tomb-like ambience inside Lily's place was more than my eyes could adjust to. I tried to blink some sanity into my sensory mechanism. I squeezed my eyes shut and opened them again. 'Why do you work in the dark? It doesn't make sense. Coming all this way down here for the light, and then living like a mole.'

'Ah, well,' she replied, which told me she was in the room some-where. 'I try to work like a camera. I capture the light outside in my memory, then I come in here and recreate it by candlelight. I develop my memory, as it were, to the natural glow of soft candles as though, like a photographer in a darkroom with his safelight, I simply need candlelight. In this way the memory isn't destroyed by the sharp, extraneous light of a window. The film of my mind is not wiped out by

harshness, which destroys the memory, just like on a film. Get it? We may seem weird to you, but each of us has method in our madness. I'm done for the day. Fancy a drink? I've got a torch here.'

Suddenly her studio was lit up by a huge spotlight that cast wild shadows across the objects that furnished it, and I had to start all over again getting used to the new light values. When I did, Lily was standing over me holding out a huge goblet full to the brim with what looked like blood but which must have been primitive red wine. I took it from her and looked for somewhere to sit down. 'There's only the bed,' she said, as though reading my thoughts, which were not the thoughts she may have thought I was thinking, 'unless you want to sit on the loo,' she added. 'One of the first washdown water-closets in the region. Gavin fitted it for me. Did you know that he is a plumber too. He seems to know how to do everything.' I nodded. 'His family background serves him well,' I murmured. 'We call him the Loo King. The Loo King – and good looking with it.' She shrieked with laughter at her own joke, and picked up the whip that I had just noticed, and flicked out the candles that she had left burning. 'My little trick,' she said. 'I pretend I am also a ringmaster in a Circus of Light. Not Son et Lumière, but Daughter et Lumière,' and she shrieked again at her own joke. Lily was a big lady, fulsome in a horsy kind of way, but every time she laughed her breasts trembled up and down like India rubber waterbags. I couldn't keep my eyes off them.

Funny thing about breasts. They have a strange effect on all sorts of men. I think it has something to do with the first memories of succour, mother and child, one of the artist's favourite themes. Gavin has done many pictures of that very situation. Not as a child always, but as a fully formed man, sexually and emotionally complete. And yet he is incomplete. His mother's schizophrenic metabolism had coursed into his being during the few weeks he was able to feed from her. Finally she had rejected his insistent need and he was forced to accept the bottle, and his father's finger. Wheelchairs and Mother Love became a constant thematic sledgehammer/anvil scenario in his work. Love personified, love rejected. Roles honoured and roles annihilated, inside a torn moment. The moment is the thing, the moment of severance. It

is the moment that bonds, or the moment that tears. The energy within the blast of a hammer blow is the revelation of a destiny. Either I know what I am, or I am cut loose. The human condition actually cannot accept the reality of nature because the human condition has allowed reason to enter the equation, and nature knows nothing of human reason. That is our invention. We have built into nature's random plan our own rational explanation for why things happen the way they do. And they don't happen that way. They never did. Maybe that is also part of nature's design. You will never know the secret of nature, because nature does not intend that you understand all her tricks. And isn't it extraordinary that nature is feminine? She is nature. Nature is a feminine world. Men merely procreate, like ON buttons, or feverish bees; women nurture and expand. Women give nature the catalyst for a future. Even nature herself, Lesbos and Lesbia, sucks on women. Perhaps nature is woman's great lover. Man is necessary, but only as an extraneous process-conduit. We are not irrelevant, and we are certainly not disposable, though that is not beyond the bounds of possibility. We merely suck.

As I was thinking such thoughts, in the womb of Lily's dark studio, my eyes were still mesmerised by her voluminous breasts, the nipples dark and membranous. The drink she had supplied droned inside my less-than-total account of myself. It must have been strong, and more than I usually need to decide for myself what I should do now to give a good account of the situation. In this way I am pathetic. Sitting, as I was, on the edge of her bed, I fell into the luminous folds of what seemed to be home, the place I had spent most of my life in the mind, but where I seem never to have left. It was a place I needed to be. Not as a biographer, at this point, but just as a member of the human race.

All I had suffered as an outsider, a non-artist, a nothing, trying to assemble a profile of what I was, conspired to spreadeagle me over a precipice, to glide me down, dampen my wings and enfold me in a landscape of flesh mountains. I struggled to stand upright, fell again, flapped through potholes, and rose majestically in underground caverns, lit from within, until, drained as a drained beast, I sank.

What is there in healthy human bodies that does not yearn to experience every pleasure that nature bestows? These things are there, and it does not require an artist to discover such purity. Nature bestows, and yet retains her mystery – like a stone castle.

A language has been devised through centuries we cannot count, which denies these promises that are showered upon us, like confetti – the same confetti that informs us within the constraints of what we have decided is the most convenient way to live. We, as human beings, made something up, in an attempt to figure out just what nature meant.

I look hard and long at Lily's paintings. We have the time, and we explore every avenue. She is an artist and she, like several others of her ilk, must be taken seriously, as packhorses, bearers of the dream lode of each lonely quest. She, too, must look for absolution. As much as I love her, she has to bear the burden of unsolicited derision. I appreciate her notion of landscapes remembered, and I also see the weakness of talent – that indefinable morass that declares more clearly than a traffic bollard that if you hit me, so shall ye be hit. I marry her in my mind, and I consider that what she is, as an artist, and as a woman, is the most precious expression of human form that God has made. She is my muse. Her pictures are the echoes of past causes. Walls are not prisons to her but doorways to a new future.

Tomorrow, I must confront Schlemiel Weiss. Lily tells me to go easy with the questions. He seems nice enough, but has been known to get violent if pressed too hard about what he thinks he is doing. I suppose there is method in his madness, but anyone who sees in gnat's blood the elements necessary for his art, well, that too contains the elements of an unbalanced nature. But I will keep an open mind. If he can create organic watercolours from the blood of gnats, with maniacal intensity, using cochineal as his primary colour, that is not a long way from a cook using the substance to make pink sponge cake. But whatever I say to him, I am not to mention pink sponge, or any other sponge for that matter. He grew up in Berlin and spent his art school years painting graffiti on the Berlin wall, as did a lot of others, which might have been the most significant work that any of them did. Watching the wall

come down took its toll on many of them who watched their work come down as well, a symbol to many that it was all futility. Some became businessmen and recreated those painted fragments to sell to tourists at Checkpoint Charlie and the Brandenburg Gate. Others painted their homes as though they were walls of containment. They longed for the good old days when they lived with a defining statement, a barrier of certainty. When that was gone, many suffered severe agoraphobic withdrawals and built their own walls, as though trying to snatch back a huge part of their lives that had somehow just fallen away, leaving a gaping hole in the mind.

'Schlemiel Weiss?' I shook a long, thin, sweaty hand proffered beyond the doorframe. The doorframe was, in fact, just that. The rest of the wall around it had been knocked down to accommodate some load-bearing scaffold poles that had been jacked up to support the wall above. An ashen face stared out from inside the doorframe that was somehow 'from the outside', just as I was. I looked up above it and saw the open blue sky. Of course! Schlemiel was in the process of renovation, like almost everyone else, his face was masked in sweat-smeared cement dust, and he had removed the roof from his one-up, one-down ruin to rebuild it into a single tall space, to accommodate the fig tree that lived there. The tree was a focal point, but for Schlemiel it had a practical function, the 'reclamation factor'. 'Art is nothing', he said, 'if I cannot accommodate a tree's own home as part of my reason for existence. How do I know if the tree self-seeded because it chose to? There were no estate agents involved in the transaction. Nobody noticed, nobody cared, and the tree just grew unhindered, and ground rent was not an issue. Probably the last person who lived here went off to fight in the First World War and was never seen again. And isn't that a telling thought?'

'What is?' I asked, dusting myself down, having now crossed the threshold to stand in the walled space.

'That this ruin apparently belonged to nobody – nobody, that is, until I wanted to renovate it. Then four people came forward and claimed a wall each, and two guys played a game of boules for five hours to determine who owned the tree. As it happened, I was having

an affair with the *notaire* who handled the transaction. Well, I wasn't at first, but the process of law and possession took nearly three years. The *notaire*, a sweet lady of high degree, had an affair with each of the owners, played boules with the winner of the tree championship, and I was the last in line to sign the conveyance deed.'

'Is that legal?'

'It has something to do with the French clause of "possession by seduction". It's perfectly legitimate, and any illegitimate children resulting from any of the liaisons – in the goodness of time, that is – can claim future inheritance of part of the property.

'Are you thinking of buying a place down here?'

'Well, no. I am trying to do a biography of Gavin Twinge, and the Doodaaaists, like yourself.'

'Oh, sorry. I thought you were one of those English goofahs who fancy a second home to smother with their appalling bad taste. I was trying to put you off. I get them around here, trolling the area, looking at olde worlde charm as though they were thinking of transplanting it to Kent. I can't be dealing with them. You are something else. They warned me about you. You have been asking awkward questions about the arts. Why we do it? What possesses us? And is rubbish a sign that an artist has real talent?'

'Well, no, actually. I was wondering why you want to keep that tree in the middle of your house?'

'To attract the insects, naturally. I need constant supplies to continue my work.'

'Which is –?'

'Sangfroid – my attempts to capture a new realism in cold blood. I use insect blood, preferably mosquito, and mix it with the pus of someone's bite as an extender base. Did you know that the poison from one bite – the female's, incidentally – generates in volume nine times the liquid volume of its own body in reactive mucus from our own bodies? They are trying to lay eggs on you. That's the awful truth. Have you been bitten at all today? Because I could farm off you, as it were. Let me look. Hee, hee! This is the way I discourage would-be neighbours. Most people run a mile from creepy crawlies as

it is, and when some freak like me asks them for any bite pus they might be secreting on their person, they go look elsewhere for a place. But I can see that you are a man of perception, know what I am getting at, and a lover of art in all its manifestations. And your legs are perfect – look at them. A battlefield! Lumpy custard! Super!'

'What are you doing?' I scream as Schlemiel dives for my legs with a biologist's convex sample glass in one hand and a scalpel in the other.

'It's OK!' he reassures me, 'the scalpel is sterilised. This won't hurt a bit, and I have surgical ointment to ease the soreness afterwards.'

'Oh, shit! What the Hell? I'm in it for the ride. Just answer a few questions and I promise not to move.'

'Suits me,' and he sets about me like a body snatcher.

'What exactly do you paint with this blood – ooh!'

'My pictures are tiny, naturally. Some say they are abstract, but I say no. They are the perception of a gnat's eyesight, and size is therefore relative. The paintings are miniature visions of what a gnat sees before she bites you. It is nothing personal, but you represent a kind of standing Ayers Rock to a gnat. And that is something that some people won't understand. Those idiots who fry in the hot sun are like red rags to a bull. The colour red has a physio-telepathic effect on a gnat. They always attack those people first who have been out in the sun a tad too long. The gnats are actually in pursuit. Their motivation is in fact a violent blood lust augmented by the colour red. Hence the red Ayers Rock analogy, crawling with tourists who probably wouldn't be half as attracted to it if it wasn't red.'

'Ouch! So you think quite visually then?'

'Like a gnat. Keep still. You've got an Ayers Rock of a beauty here. I'll cover it with a plaster after, ooh, lovely! You're better off without it, believe me. That could have turned septic in this heat. There, that's stopped the bleeding. Far superior to the mediaeval practice of blood-letting with leeches, I can tell you. That was dangerous. The practitioners had no indication of when to stop, and often let leeches suck away for hours while they repaired to ale houses and brothels. Whereas me, I stop when I can't find another gnat bite to drain. Gavin's a

walking storage tank for me. Never known anyone attract gnats like Gavin, which is why he will turn up at barbecues wearing a wetsuit, flippers and a snorkel. They can only get at his neck then. He drinks his wine through a straw, though he has been experimenting with a funnel down the snorkel tube. Bit naff though. Spoils his fun too. Likes to sing and play the guitar, but dressed like that tends to diminish his stage presence, and he has loads of that, especially in drag. He does a great Corsican drag queen in a peasant's black dress, with a chair, dead straight face and a disdainful sneer. He's got a thing about Corsicans and their stolid dourness. Very like the Welsh. Steady. I'm nearly finished. Oops! Sorry. Didn't hurt, did it? I'll put another plaster on that. I got carried away. You'll live. Anything else you want to know?'

'Er – do you sell your work, and if so where?'

'Good question. I have a gallery just off Museum Street in London that sells miniatures. Well, it's not exactly a gallery. It's more like a few shelves on a wall in someone's shop. It cuts down on the overheads and occasionally the owner looks after the shop. Wheels within wheels. Doesn't sell my stuff like hot cakes, but does a nice line in repro miniatures looking like the real thing. She wants me to do some gnat's blood lockets, but I find that a bit commercial. We all have our pride. Though I've done a few to see if they look authentic. Wanna see some?'

'Yes, please. Have you finished?'

'Yep! But I'll get you again, if you sit outside this evening. Follow me,' and we go through the door frame to a far corner of his one large room, by a small window, which lights up a tiny drawing table in front of neat shelves full of tincture bottles containing – 'Blood of gnat, and sting pus,' he says, seeing me eyeing the shelves rather carefully.

'– and here are some of my works.' Schlemiel has carried over a briefcase-sized display case and opened it on his desk in front of me. Tiny works of art are arranged neatly in rows like jewellery. There is a lot of red in the pictures, but surprisingly there are strange oranges and purples, deep greens and rich blue-blacks and magentas. 'Fancy a drink? I'm having a pastis. Pus-coloured, of course. That's why I like

it.' He fails to put me off, and I join him. He brings ice from a tiny fridge and serves the pastis in eyewash glasses. The ice cubes are made in bubblewrap plastic and drop out like tiny sweets from a children's toy sweetshop. I realise that his whole perception of relative size has been affected by the nature of his work. He hands me a magnifying glass to inspect his art, and switches on a minuscule halogen desk light.

I am astounded by the sweep and depth of his work inside such small dimensions, and I make sounds of astonishment which he acknowledges.

'It's like I said. Everything is relative and if you can try to imagine that you are looking at the individual pieces through a microscope, they can look like vast rocky landscapes, or even warts and pimples to a gnat seeing them as something to attack. Something to stab its proboscis into, which has vicious mandibles and maxillae, fine

serrated stilettos which emerge from it and plunge through the skin at the moment of biting. I try to bear that in mind to keep my sense of proportion, which may seem out of proportion to some. This is the microscopic world made large in my mind. Ask Gavin about his experiments with microscopes and oculist's equipment. He wants to project visions of the world of bacteria on to vast surfaces to expose the beauty of detail. He figures that the way we see things is related

to our eyesight, obfuscations become perfection in the hands of an artist, or at least a source of inspiration. Seeing is not always believing but, more importantly, food for the imagination. That's Gavin's line. He accepts nothing at face value. Toilets hide a multitude of sins, he says, but I don't get that. That's some part of his personal past. Toilets are some kind of philosophic icon to him. Particularly French toilets. Will you be at the bash tonight?'

'Which bash is that?'

'Oh, it's the antidote to the village fête – the most hideous manifestation of peasant culture ever devised. To me it is a conscious effort on their part to discourage foreigners from settling here. It is held in the square at the height of the tourist season for optimum effect, middle of August, and goes on for three days. French pop singers moan saliva down cheap microphones in obscene attempts to sound like Charles Aznavour singing "She". French pop is chronic at the best of times, but no one has found anything worse than fête music. Their PA systems make Aaron Dickley's equipment sound like "Cathedral under the Sea" from Chartres. I don't know where they find them, but the combination of fairground tackiness, candy floss hanging from overhead wires and the synchronised, prophy-lactic snap of peasant lust echoing all over the mountainside is a sound like no other. The worst outcome, I think, is the recording of echoes throughout the region, which I believe Aaron has captured for posterity. His *Sounds from History* project promises to blow the real thing out of the water, which is what the bash tonight is all about.'

'Oh, no! I thought he was forbidden to bring his PA system anywhere near the group?'

'Usually, yes. But things are getting worse and we need to assert some proprietary authority over sound-pollution dynamics before peasants realise that it is an artform. Otherwise, the French autho-rities will step in and claim fête music as a national treasure. They have already stolen the Mona Lisa, they have appropriated Picasso as a tax settlement. Can you imagine them realising that their peasant class has invented the ultimate chic in Sensation Art. It would make the Royal Academy Summer Exhibition seem like tourist souvenirs.

We decided to bring out our secret weapon, Aaron Dickley's Sonic Echoblaster, invite the press, and announce our claim to the Doodaaaist's rightful crown, as the new century's serious movement with a purpose. Gavin's idea again. "Sound", he said, "has only just begun." Something to do with his obsession with a silent movie star called Vera Steadman. She never really made it in her lifetime, and her career was on the wane when sound became the big movement and crushed her delicate presence – like a gnat,' he added. At this point Schlemiel wiped his eye significantly. 'Gavin wants sound to reassert its prominence again as an integral part of vision. There is not one without the other. Beethoven is claimed to have had vision. He was deaf, but he had vision; therefore, it was vision that made his music great. If Beethoven had been both deaf and blind, where would his music be? Dumb? This is Gavin's greatest concept to date. A conceptual idea as host to physiological certainties. These are the kind of ideas he has, those almost intangible but physical ideas that defy the filling-in of forms. Most ideas are almost destroyed by the need for public recognition, form-filling art, official stuff, so that it can legitimately be consigned to history, with legislation. Society doesn't like new ideas that plumb the depths of its existence. Society feels irrelevant, though they would never admit it, so they bluster through with apparent acceptance, particularly in all media forms, until they can digest it as a natural part of historical development – to engineer its oblivion, when it suits.'

'When does it start – this party?'

'As soon as the fête kicks off. If you are going back there now, wear these. They were last worn by Pierre Boulez, who had been down for the summer,' and Schlemiel hands me a pair of earplugs. 'Big influence on Aaron. Especially *Répons*. The inter-relationship between sound of instrument and its recorded echo – oh – I don't want to go into that now. You better get off. Especially if you want a snooze beforehand. You'll need one. The fête will go on all night, take five, then start up again for the next stage.'

# CHAPTER 13

## PEASANT HEAVEN: THE ANTI-FÊTE

I WAS AWOKEN from a particularly deep torpor by the sound of rusty nails being drawn out of damp wood. Plucked guitar strings, drum riffs, Tannoy feedbacks and loud Gallic instructions barked over speakers as loud as air-raid warnings. Disembodied voices, total strangers, rusty squeaks again, and taps of nervous hands on microphones warned me that the fête was revving up to begin. I put the earplugs into my ears and turned over. But the dull thud of muffled sound vibrated my body. There was no escape. I sat up, rubbed my eyes and looked around. I stood, crossed the tiled floor, swilled my face in the square sink and looked outside on to the patio. Gavin was adjusting speakers, moving wires and listening to Aaron explain something. He had a faraway look in his eyes, and I knew that he was working, though on what, I couldn't say.

Anya was laying out plates and glasses for the party helped by a couple of other people I didn't think I had seen before. One looked like an owl in perfectly round horn-rimmed spectacles and was holding up the metal band of an old wooden wagon wheel and turning it slowly in his hands. He was framing one of the other figures inside it, as though he was going to paint her. That must be Maurice de Rim, the Wheelist, who considers everything in the round. He was studying the layout of the plates intensely, so maybe the table-laying ritual was part of an artwork. One or two others were wandering around with drinks in their hands. Anton Schmink-Pitloo had arrived with an old beat-up baby grand piano, a pickaxe and a couple of strong-looking lads who must have been his piano movers. Someone else was cutting up salad and vegetables and arranging them in patterns on plates, part of Emilio Castelar's new edible

aesthetics project, perhaps. Wine was dispensed from 28-litre containers and people were freely helping themselves. I could still hear the fête in the village square tuning up. Others began to arrive, dressed for a carnival but not a fête. They all looked like artists, or at least what I think some people dress up in to look like artists. It was strange looking down on to the scene with the muted sound drumming in my ears through the plugs – almost a silent-movie scene in slow motion.

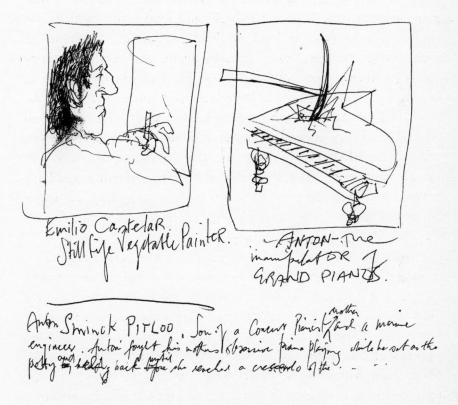

Emilio Castelar. Still Life Vegetable Painter.

ANTON – The manipulator of GRAND PIANOS.

Anton Shwinck PITLOO, Son of a Concert Pianist/mother and a marine engineer. Anton fought his mothers obsessive piano playing while he sat on the potty and held back until she reached a crescendo of the. —

I decided to join them. Amanda Ell had just arrived so I went over to her and said Hi! She moved her lips before I realised that I was still wearing the plugs. I removed them and suddenly the whole area seemed blasted with sound. But that wasn't only the fête. Aaron was playing with two huge speakers face to face, and hitting a huge gong with a kid-skin ball on the end of a stick.

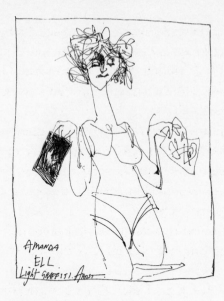

AMANDA
ELL
Light GRAFFITI. Artist

'Had a good day?' said Amanda. 'Great,' I replied. 'I've been in the dark with Lily Potsdam, and had my legs cut to pieces by a mosquito fiend. How about you?'

'I've been in the dark too, solarising old film stock after shadow-exposing parts of the film through window shutters with a pinhole camera. I'm trying light-graffiti.'

'Didn't Man Ray do that?'

'Sure,' she bounced back. 'Sort of – that's why I am doing it! That positive/negative effect in three dimensions intrigues me, and I am wondering if I can do something with the basic principle but expose near-darkness for huge lengths of time, then stress the colour process chemicals by using them as paint in different strengths. Encourage mistakes by accident. I am getting colour hues that I have never seen before except perhaps on a pathologist's analysis bench. Certainly never on a sheet of MDF board. Gavin wants to try something with optical devices using the same thing, so we are trying a collaboration. You ought to come over and see me sometime.'

'I'd like that. Tomorrow, maybe?'

'If tonight doesn't get out of hand, sure.' Just then a piercing gong echoed and trembled through the babble and I fumbled to get the plugs back in my ears. I relaxed inside my silent world, and focused

on the scene around me. Aaron Dickley already had earphones on. He seemed to be recording sounds, and Gavin was adjusting the angles of two echo dishes. I strolled over to him and asked what he was up to. 'Ah, Ralphael! How's the writing coming along? Are people being nice to you?'

I took the earplugs out and he repeated his question. 'That's what I thought you said. Marvellous. Couldn't ask for more. I am already getting some sense about the general thrust of the Doodaaaists. I thought maybe it was some kind of joke, but you really interact with each other. It's almost organic.'

'Don't get too sensible, though, or you could undermine the whole nature of the pure impulse. It's all about vacuums, and Doodaaaists abhor them.'

'I must remember that. I must keep any conclusions suspended. This is no time for resolution.'

'That's the drift. Aaron here has been recording fête sounds for the last couple of hours from different positions in the village, spatial sound dimensions. These he is "shuffling", like an aural pack of cards, with the gongs here. A kind of sound poker. Here is where you can make yourself useful. Get ahold of this condom. When Aaron nods his head, stretch the condom as tight as you can, let go of one end, then let it snap the surface of the gong like a whip. In fact, Lily is bringing hers along, and you will hear the difference. She can get a really high-pitched sound out of the depths of the deep gong tone. Kind of extract it out of its very hub. It's weird. It's not a new idea, mind. Nothing is! Pierre Boulez has been working with sound transformations since the late seventies in Paris. Taking a musical idea born in the belly of orchestral instruments and flipping its body of sound through echo delays into the layers of electronic mutations which are endless, as you know, in a computer. These snaps of sound made extraneously, and outside the time frame imposed by a specific recording session, extend and free musicians from mechanical time frames, to float, as it were, in space time. Einstein would have been in his element messing with us.' I was nodding rhythmically, as he spoke. 'Get it?' he said. 'One, two three, one two three – pause – and

again. There ya go. Every time you nod your head, snap a condom. I don't think Boulez has done that yet. Condom-snapping ensembles are few and far between. That's the essence of fête music, which shall be ours!'

'How d'you mean? What do you consider to be the essence of fête?' I had caught Gavin on a moment of natural explanation, unhinged his work/reason pattern, and got him branching out to elaborate but not define.

'Fete! What is fête music? Fête is a French phenomenon, as yet undiscovered officially, but in mortal danger of being polluted by commercial aggrandisement, or depravity. Yes! Depravity is the word. At the moment, its hideousness is pure, unadulterated badness – the worst expression of a social group's soul – one of Gaston's Bugatti gearboxes but with granite in the oil. It comes out wrong because it is mixed in with its mangled relationship to modern life. It malfunctions to perfection, but it doesn't grind to a halt. Their engineering is too good – a thousand years of it, at least. Like the scythe that not only cuts the grass but deposits it in rows, to music – the wrong music! What they have picked up is what they got, hence the Boulez dimension. Their trousers are still in the shit, but their heads are being guided by cheap ethics – rubbish in the form of bright new futures at knock-down prices. Am I making sense?'

'Perfect sense,' I replied. 'Perfect sense.'

'Then there must be something wrong. It has to be nonsense or we are lost. I don't do art because it is sensible. I do it because it defies sense. *That* is the nearest I have come to defining the Philosophy of French Plumbing. Slap that gong with a condom! I need a drink!'

I stuck the plugs back in my ears and followed my quarry towards the 28-litre container of co-operative fire water. It does taste better as you drink more of it. I didn't even need the earplugs, and I tore them out and stuffed them into a condom for safe keeping. There was something here to watch, and to listen to.

Aaron was picking up the increasing crescendo as the fête in the square got under way. He was recording arpeggiated guitar riffs and general hubbub that rose with the increased clamour of more people. He smeared them together sonically, and extended their time-base like elastic, creating peaks and troughs of amazing diversity. Some sounds were 'compressed into walls and sunk beneath electronic lakes', as Aaron put it. More folk had arrived for the Doodaaa bash, but they couldn't all be Doodaaaists. I was right, and gradually found out who people were as they introduced themselves, not all at once, but throughout the night. People opened up and lost inhibitions. Some were just passing through, India bound!, but on their uppers for the time being, working in all manner of viticultural ways to keep heads above the barrel. One couple had decided to stay for the lifestyle. Unable to buy even a tool hut, they managed to work for a piece of rocky terrain on a slope, their 'bramble kingdom'. They were in the process of building their home out of mud bricks like a couple of pioneer sodbusters. Fortunately the land was graced with its own mountain spring, and they had learned how to cap it and pipe it, which is how they got to know Gavin, who showed them how. Gavin admired their absolute independence and hairy survival tactics, particularly their use of packing cases to make a roof. He considered them to be the archetypal Philosophers of French Plumbing, because it couldn't have been easy, particularly producing five children as well, each coinciding with *vendanges* over the last five years, vintage years to them.

I hadn't noticed but what I was beginning to hear all around Gavin's patio was the village fête encroaching on our party, as though we were ghosts walking through alien territory. What was happening defied initial expectations. French voices entered our space, mixed

with jarring musical cacophonies, gong snaps, elemental sounds of scraping tarmac, scratching flesh sounds, snatches of cheap commercials elongated to distort and degrade, filling the area with embarrassingly intimate noises which evolved into the clear, quivering tremolos of a restless clarinet. The gong snaps were incisive and though I knew I had contributed the odd snap, I couldn't detect where mine started, or where they finished. As the actual fête burgeoned and got out of control, so Aaron's *Fête Symphony* responded with modulated energy, and people went quiet and concentrated on the wine. The press had arrived: two ace reporters and a photographer. They were handed drinks, swigged them straight back and went for more. They were the high-class kind who only drink while they work. They strolled over to Aaron's Gongophone and stood between the phonograph speaker horns and the party. They were intrigued, fascinated even, and the photographer started shooting away with knee-jerk regularity. They cornered Gavin, and I could see that though he didn't seem to care for them, they were a necessary part of the Doodaaa plan to announce the 'discovery' of fête chic. His arms were flailing around describing and expressing the theories. 'Why shouldn't we just record the actual fête?' said one of them, and Gavin replied that in its total adulteration the essence of the musical flatulence that is fête would be missed and they would go away with nothing. But what Aaron was doing at this very moment was assimilating the waves of coarseness and releasing the inner purity of badness within.

Lily had just arrived and she made a beeline for a drinks canister. Then she flicked her whip around my neck, drew me towards her and gave me an affectionate hug just as Anton Schminck-Pitloo drove a 15lb pickaxe through the baby grand for Aaron's recorded use. The sound was gut-wrenching as he twisted the pick between the strings, and the tiny voice of a boy, singing 'Frère Jacques, dormez-vous', rose above the general cauldron of sound, waxing angelic and totally inappropriate. Aaron was lost on his own cloud of approval as he mixed and echoed, echoed and mixed, generating tidal waves of sound that were beginning to drown out the blast

from the square. The curious thing was that the new wave was hardly noticed and the original crashing dissonance played on and became one with the auditorium of stars that began to appear over us like scattered paint spatters. A barbecue fire had been started and endless rings of unlinked sausage meat began to sizzle on the grill irons.

Aaron was on them like a mump, smear-recording what might prove to be the sound-fill echo of the snap-gong condom chirrups, to which we had all contributed like willing slaves intent on helping Aaron realise his Sonic Pyramid. Lily flipped the lash of her whip around the mulberry tree on the patio and hung on her weight.

'Been in the dark today?' I ventured, trying to resuscitate our very recent meeting of souls, to re-establish the roots of our earlier encounter in the thin rock soil of a strangely different environment. 'You need another drink,' I said, 'hang on and I'll get our own supply.'

I was back in a jiff with our very own 28-litre canister of Cru Ordinaire de Saint Felix de Lodez and six plastic cups, in case someone was looking for another drink. The wine was ice-cold, which is the only way to enjoy it, thanks to Gavin's voluminous shop fridge he had purchased for a song from the village's doomed *alimentation*, an optimistic seventies try at a local *supermarché*. The venture died, on account of the bright new air-conditioned Monoprix Kingdom near Lodève, ingeniously sited to entice everyone who could drive anything from a grey Citroën to a skateboard to shop like lemmings, even if they only needed a snorkel and a box of Brie. Usually, the outcome was a month's worth of shopping, a free-offer club card, and a lift home if you had spent more than a thousand francs.

'Top up!' I held the polythene canister in my armpit and let the wine whoosh out and fill Lily's proffered cup. We sat on the cut-stone remains of a door pillar and lolled against each other like bookends. She was so easy to be with. 'Can you identify some of these people, Lily?'

'Sure can', she said. 'It's like a who's who in Doodaaa. Point to someone and I'll try to fill in the details.'

'Well, I know Aaron Dickley, Schminck-Pitloo, Amanda Ell and Maurice de Rim there, putting up the disco ball. Maurice seems to be always in the round.'

'Maurice's father started a doughnut factory in Margate. Maurice worked for him. He told me he invented the hula-hoop. I don't believe him, but circular draughts, well, that's possible. I know he has been tinkering with a chess game that never ends, on a circular board, obviously. You have to sit inside it to play it, like a toy train set, or horse racing in opposite directions. I tried to play with him earlier in the year. Almost impossible. The moves are always forward if you are winning, and you must retreat the whole of your game if your queen is threatened. And the queen can cross a circular configuration in a straight line if she needs to assert her authority, knocking anything off the board that happens to be in the way, except a king, that is. But you don't move your kings, ever. So as the game progresses both kings can be passed by, and somehow end up out of the game. That is the weak spot that Maurice hasn't figured out yet. How to be in the game when you are out of it. Arm-wrestling was one idea he came up with, making the game both physical and intellectual. He has considered pawns becoming kings and taking over, like proletariat revolutionaries, castles in the air on arched wires, and gay bishops moving sideways and being allowed to mount the knights, but that must be cheating, surely –?' I had a mouthful of Syrah as she said this, and I exploded over the back of the white jacket of one of the journalists, who was busy listening to Gavin explain the essence of crude. I collapsed in a fit of coughing and held my cup out for a refill. 'Who's that over there with Anya slicing a cabbage?' 'That', said Lily, 'is Emilio Castelar, Painter of Vegetable Still Lifes. He prepares a mean salad. When he paints he invariably uses vegetable dyes. Then he mixes them with bull's blood, like Rembrandt. He used it to draw with, which I think is called gall – gall the essence, and gall to even try – but Emilio gets an amazing richness when he mixes it with pumpkin juice. Not as dark

as you might imagine. He has developed what he calls Mayonnaise Yellow, using whisked egg base and marigold pollen. He's an absolute purist.'

'Hey up! That journalist is falling about a bit. He just tripped over Aaron's wires. Now what's he doing? Who's that Amazon he is trying to chat up?'

'That's Moxey Bedvetter, the Abstract Meteorologist. He'll get short shrift from her. She hates the press, and he looks a mess. You ruined his suit, y'know, and I think someone has thrown up down his front too. We need the press but we don't like them, and they always turn up in white suits. We had an art critic, Brendan Suet, here last year. He trashes our group shows every time, deliberately. Pretends everything is beneath him, and in his personal life it usually is. So we invited him to Brod Norkitt's silkscreen art factory to experience an art happening. He was wearing his white suit as usual. We struggled him on to the printing table and held him down while Brod did a seven-colour screen print all down his back from his new piece, *Seven Deadly Runs*. Then he signed it. Thing was, Brendan loved it, especially the signing, so we got him to exhibit himself facing the wall with the finished print on his back and called him *Artist's Poof*. He is a bit of a sport in his way. He actually arranged for himself to be stolen and we didn't hear from him for ages. But he turned up at our Fresh Flotsam Show in the spring dressed as a daffodil. He had his partner, Noser Parkinson, with him, dressed as a bee.'

Gavin's place was getting crowded. The Carnivalists were really getting into the swing of things and all of them had bent feathers and running make-up from the humidity. I couldn't tell the difference now between the works of Aaron's *Fête Symphony*, the village fête, and people trying to sing along as though they were in Southend. Which was when I realised that most of the people here were refugees from an England of Philistines, finally driven to admit defeat and search for a new life among a race of people who were actually more Philistine than themselves, but comfortable with the trade-off: rural earthiness in exchange for crisp, space-age convenience.

'Who is Moxey Bedvetter, and what exactly does she do?' I turned

sideways to ask Lily, who was leaning over my way and struggling to get another drink from our personal container while trying not to wake a comatose figure whose face was buried inside her huge breasts. She looked like the epitome of mother earth. 'But come to think of it, who the hell is that?'

Putting her finger to her lips, she said, 'Shsh!' or so I guessed amid the din of creative tumult. 'It's Egley Bupa, the Charismatic Charlatan. He has turned scrounging into a fine art, which is why he is a Doodaaaist. Don't wake him, poor dear. He has always looked upon me as a source of eternal succour. He's harmless, and he's rather sweet.'

'Doesn't look harmless to me. What does HE do?'

'Just what he is doing now. All his paintings are verbal declarations of constant need. In England, he paints colours, any colours, then scrawls GIMME, GIMME, GIMME over each canvas. They always sell. People can't resist a beggar or a brazen gimmick. The press love him too. It gives them a chance to sneer while they gobble it up. In France he does French variations, and scrawls, DONNEZ-MOI, DONNEZ-MOI, DONNEZ-MOI over them. In Berlin recently he did a German suite, and scrawled GIB'S MIR over them and had a sellout. They loved the commanding tone of authority. His colour sense is mesmeric and nobody can scrawl quite like Egley. The tension between his hand holding a brush or a pen and the surface tension of a canvas are in direct conflict with his aversion to work. It's a physical dynamic that accounts for the electricity in the vibrant letters. GIMME really screams GIMME! ASSHOLE! People cough up for fear of enraging his creative gods. But he's an absolute pussycat. Look at him, the poor baby. What mother could deny him his natural cravings?'

'Mine for a start, and I reckon Gavin's is a close second. Look! Moxey Bedvetter's trying to prevent the press guy from throwing up on her. She just dipped her hand in his drink and held it up in the air. Is there some significance in that?'

'I'll say. That's her trademark beginning to any work she does. She tests wind-direction with a wet finger, then projects weather scenarios into high- and low-pressure weather charts, which become

Cold front          Synoptic pressure plot          Isobar symphony

her climatic abstracts. If she was in the Sahara and needed to wet her finger, she would use her own fanny for damp rather than waste the water supply. Bridget Riley made swirling linear abstracts in the nineteen-seventies that provoked optical aberrations in the viewer, throwing the brain into a turmoil of indecision. Vasarely was another.'

'But you can't compare the work of Riley and Vasarely with Bedvetter, can you? Vasarely's kinetic works of suggested movement on a two-dimensional surface were a breakthrough. They were not only optical illusions, they were physiological sensations, on account of the effect of black-and-white stripes. The effect on the retina of the eye causes apparent movement and bodily disorientation. Do Bed-vetter's pictures do that?'

'Not exactly. They make me want to go to the toilet, especially the low-pressure charts. I think it's autosuggestion. I get so used to looking at low-pressure charts and knowing it is always going to rain. Moxey agrees with me. She can't watch a weather forecast without getting emotionally involved. She has been known to wet herself at her own previews. She's very sensitive and she is totally involved in her work. She identifies with it and relates to any prevailing atmosphere, rain or shine. If there is a high-pressure forecast for her openings, she gets all hot and bothered.'

'Oh, look. The press guy has fallen on his face. What's his name?'

'I think that's Jacques Pruneaux, works for *La Provence*, a regional

daily. The other one, can't see him now. About half an hour ago he was slobbering over Emelda Carcasson, who is always trying to get her name in the paper. Half an hour with him in the vineyard and she will get her headline at the weekend. I think his name is Paolo Passout. We call him Pissup. He never manages to file copy before his midday deadline but the paper is prepared to wait. He's good, and at his best with a raging hangover. In their way, good journalists are artists too. They go out of their way to make their job anything but an office one. Otherwise, they can't write. Maybe they can't anyway, but it's more human when they fall. Oooh, God! Egley's getting heavy. Gerroff! That's enough of that. Too much of a good thing is bad for character. He'll sleep now till morning.' Egley was face-down in the lucerne that grew in abundance around Gavin's plot. Lily turned and gazed at me. 'Now then, what can we do for you? You do ask a lot of questions.'

I turned my whole frame and addressed her head-on. She looked very dramatic and beautiful in the light of the barbecue. Boadicea with her own agenda, I thought.

'I need to,' I said. 'That is why I'm here. Just like you, I am here for a reason, and with a purpose too. I'm getting pissed, but on a need-to-know basis. I am trying to ensnare the essential signals that might tell me what makes Gavin tick, and all of you, for that matter. It's a bit like trying to find out why Dr Frankenstein invented a monster, and then following the doctor up to the North Pole to watch him try to destroy it. That's art after all. Half your life you spend trying to create a monster, and the other half pretending not to know it, until you can kill it off, as an embarrassment to all humanity. Humanity probably won't even notice, but you, the artist, will. You are the one who must feel the pain. You are the messenger of your own worth, and your own failure. Not the critics. They won't have been through your rite of passage. It's all part of the journey, and without the journey there can be no destination. It's not about flavour-of-the-month, or being first, or blazing trails – or – or – the first earthling to use carbon fibres to create the only orbiting sculpture above the ozone layer, which you wouldn't be, anyway, 'cos it's been done. I don't think it is any of these. What I am trying to determine is, why someone is an artist, what makes them so, what qualifies them to assume the role and, if they think they are an artist, how they capture the elusive threads that draw in the essence of their work, and define it – and the artist too, incidentally. Shit, what a load of bullshit! Sorry about that. It's the booze speaking.'

'Good ole booze!' Lily stands up, grabs one of Aaron's microphones, takes another swig from her plastic cup, then climbs on to Anton Schminck-Pitloo's pickaxed piano. 'Whoo-Haa! Ladies and –' There was a kind of quiet. 'Lily here to say hello and welcome you all to Gavin's Fête Party. I think we are beginning to make as much noise as our neighbours. I know Aaron has consulted his Gongophone Blast-ometer and is stealing their thunder. We now sound worse than them and are working on it. As you all know by now, the Doodaaa group consider fête music to be the raw material for a new artform. To add a poignant note to the travesty, I would like to sing you a little song that I learned at my mother's knee, whoever she was!' Whoops and whistles from around the place. 'Anybody play the geeetar?' I put my hand up and shout, 'Anything in G, Lily!'

'OK! Ralphael gonna play along!'

I take a guitar that comes passing over heads and start a riff of folk chords to tune up, twiddle the top E string and lean against the piano. Lily calls for her whip and then stands motionless with closed eyes. She looks magnificent in her safari fatigues. I give her a couple of bar intros, play a few bum notes, recover and settle down with a rhythm an' blues lick. Lily cracks her whip once, from the top, and starts:

> Although my heart is free
> And money's tempting me
> I'm crazy 'bout my boyfriend Dave
> Shall I be an ole man's da-a-arling?
> Or shall I be a young man's slave?

Whoops from the audience, and shouts of Me! Me! Me!

> The old'un may be bent
> And he can pay the rent
> But can he buy the love I crave
> Shall I be an ole man's da-a-arling?
> Or shall I be a young man's slave?

Screams and whistles from all around. Dozens of condoms with small stone weights land on the old piano strings like spermatozoa rain bombs, plunking and plinking in organic harmony. Aaron picks up the random sounds from the microphone he has secreted inside the body of the piano. I am reminded of the ingenious concept Gavin devised back in London to direct random blots of ink along staves on a music sheet, as part of his *Blot Symphony*.

> David! David! Make some money, David
> Don't let filthy lucre come between us
> David! David! Make some money, David
> If you don't, you'll lose your little Venus.

I try a little musical interlude here, a flourish of arpeggio fumbles, crescendo vibrato, and two or three random key changes for good measure . . . and Lily continues.

Well, shall I sell my soul?

Cries of Sell ya soul, Lily! and more whoops . . .

. . . Or – shall I draw the dole?

Cries of Nah! Booh! Never!

. . . And do without me Marcel wave

Lily twiddles her hair and drops it over her face, pausing dramatically.

No! I won't be an ole man's da-a-a-a-a-a-a-arling!
I WILL BE A YOUNG MAN'S SLA-A-A-A-AAAAA-A-VE!

Hoots and cheers and cries of MORE! Lily, MORE! Lily does another round of the verses and cracks her whip as everyone joins in. Aaron opens up on the Gongophone and the place heaves with writhing dancers, each trying to outdo the other in snake impersonations. Aaron has managed to record and weave the song in with the fête music in the square and give it an augmented replay, lower Lily's voice an octave and make her sound like Marlene Dietrich in an oxygen tent. The square has gone silent. There is an eerie moment when quiet settles across the whole mountain region. The church bell chooses that moment to strike eleven o'clock, and a united cheer fills the whole village. There is a general hubbub of approval, before the fête music gets under way again like a runaway train. Lily was a hit.

The Carnivalists staggered forward as a group. They had gathered a few more drunks among them and dressed them in cardboard boxes, paper napkins, towels and grass. One of the group stepped in

front and attempted to mime himself out of an invisible box. Lily pointed to the mime man. 'That's Carlton Whisp, the Mime Artist. The whole group does something. They put shows on in Montpellier, and pretend it's Zurich 1915. Carlton's brilliant and doesn't need quiet to perform. He has done lunchtime shows in a sheet metal riveting shop at 3pm when they are at their busiest. Management say they get twenty-five per cent more from their workers if Carlton's there because they work like hypnotised zombies on strings. Otherwise the job is too boring to contemplate – so Carlton has a contract to perform as many shows as he likes in any week. Art and commerce, hand in hand. Watch this, I think he is going to do his mobile phone routine, in which he tries to escape it. You'd swear he actually had one stuck to his ear and can't get rid of it.'

The rest of the group interact with him like passengers on a train, attempting to shut him up and tear the imaginary phone off his ear. But then he fights them off and clutches his ear again like a demented lunatic, nodding his head, clutching his other ear and frenetically imitating the antics of the rest of the passengers in the compartment. Out of their clown clothing they throw clouds of pillow feathers and produce plastic balloons, and start blowing them up, falling, struggling to their feet, blowing again and miming horror as the balloons inflate into swollen ears attached to skull-caps. Wearing them, the Carnivalists stagger about with their heads in their hands trying to escape the hellish din of fête music, gong blasts, and the nightmare they are creating in front of us. They turn away from each other and, like Carlton, attempt to break out of a mimed enclosed space, describing a shape which looks ominously like a long railway compartment. Then, in the same split second, each of them bursts their swollen 'ear', and falls to the ground, 'dead'. Feathers stick up like arrows after a Red Indian massacre. The performance is a frightening indictment of phonemania. There is a monstrous drunken cheer and the Carnivalists get up, take a bow, and from their costumes, hand out huge crudely rolled reefers, and, offer lights. The air is filled with the delicately pungent aroma of home-grown cannabis, the most abundant horticultural miracle of the region . . .

The sounds of the fête and Aaron's *Fête Symphony* have now reached inhuman decibel levels. The bell in the clocktower has itself begun to chime with air-sound vibrations. If the press are still here they have either fallen in the stream that runs along the bottom of Gavin's piece of land or they are tied up in the nearest vineyard with something that doesn't concern me. The photographer was in a corner in deep conversation with Amanda Ell in some sort of positive/negative embrace and he seemed to be taking weird angle shots down the front of her black top with his Nikon Sureshot . . .

Unable to focus any more, bereft of co-ordination like a rag doll, I fall where I stand. Gavin is floating in front of my eyes. He is pointing at me. There is a huge canvas – an enormous billowing canvas – a tunnel – in a landscape, people are disappearing into the tunnel, I scramble up to follow and fall again.

Gavin has a flat box. He opens the box and I can see that it is full of optician's lenses and the frames they stick on your nose to assess your eyesight.

'Here, try this experiment', said Gavin, 'while you're stoned. I will slip lenses into the frame trays, and you look at that canvas of a landscape and tell me what you see. Pretend that it is a letter card like they use.' He drops a lens in either side and I squint ahead. The canvas has disappeared in a haze of blur. People, or rather liquid apparitions, stagger and float like half-formed thoughts across the canvas area before me.

'Disembodied corpuscles of living matter,' I say. 'Amoeba cells wriggling on a microscope sample glass. Jellyfish wafting in sunlit waters, and seaweed fronds beckoning like sirens on shoreline rocks. Goitres pulsating like sick mountains. Vast plates of swollen intestinal obstructions from Baillie's *Morbid Anatomy* dissolving into swirling floods of muddy waters, impure blood entering the heart through veins, and surging out through arteries to the lungs to be defecated, re-oxygenated, and recirculated through arteries, to re-affirm life's constant struggle with life. Gargoyles, armies of gargoyles, leapfrog each other as they gasp for air in underground tunnels of rich-city effluence, gagging and grimacing through fluid

aspirations of waste. Plumbing, floating gondolas full of the proto-
plasm of albuminous nature, re-organising itself into organised
tissues, indistinguishable in higher and lower forms of life, the
medium of existence, elaborated, articulated, according to the nature
of itself, and bearing no relation to the physical basis of life, or
individual philosophies. Life as we refuse to know it, no God, no
predetermined destiny, no fate, but living, a primordial state, living
nature merging insensibly into itself, defying classification. The vital
fluids of mortal struggle, in front of me, but don't quote me . . .'

'Hang on! Hang on! I only wanted you to tell me what you saw.
What the hell are you on? Let's try another set of lenses.' Gavin took
out the first pair and inserted some others. 'Now what do you see?'

I squint sideways, up and down, and feel a surge of startling reality
pierce the obfuscations of my senses. Everything is crystal-clear and
larger than normal. I know I am spaced-out, but a part of me is still
playing the game, willing, but a million miles from any thoughts
Gavin or anyone else is having. Everyone is somewhere down the
road, but not down my road.

'I see monuments. I see glass towers on frozen plains of grass.
Glistening dead trees stand in avenues, thermometers with
branches, deep red veins rise up and indicate how hot are the
icicles which hang from them. Now the trees are moving, no, they
are turning upside down, standing on their branches, bouncing on
rock pedestals, bouncing towards the horizon in your picture,
falling over cliffs into deep ravines. Splinters of ice crash on to the
rocks and join together into perfect spheres, crystal-clear orbs,
static protozoa, hovering like party balls. Maurice, I see Maurice de
Rim. He is so clear. Speak to me, Maurice. What has happened to
your eyeballs? You have square eyeballs! You, of all people. They
tell me you are round, all round. I see only square. I see cubes –
you are a Cubist at heart. You are fighting your roots, your
doughnut roots! Turn back before it's too late, return to the womb
of your ancestors. Be round, be big and round, like these two orbs,
yes, be round, good Maurice, round, like your father, and your
mother. Is this your mother? These huge, soft cushions are there to

help you, Maurice, crystal-clear polyps of desire, your friend,
Maurice – and mine – didn't I tell you? – your friends, Maurice,
mine – go home, Maurice, take a holiday – I – clear – distant –
landscape – purple – peaks – dark summits – hurry – hurry down
– drop on top – suck – gobble – take – sink – wobble – plunder –
uh-uh-uhh – uhummmmmmmm-m-m-mm – mm-mmm = = %
$$&_% ^^%$£%%%$&&%**&*&^^(*&)()*&%&^^ ................'

# CHAPTER 14

# FUGITIVE DOODAAAISTS:
## THE SLUNT FACTOR

'WHERE'S EVERYONE gone?'

I was sitting, hunched and alone. No music, no lights. The church clock struck – one, two, three, four, five, six – s-six. Six o'clock. A light early-morning mist softened the detail that only a moment before, it seemed, I could see so clearly. Who was I speaking to? No one. I was speaking to myself. Mine was the voice and mine was the reply. I burped, and my cheeks inflated. I tried to move my lips. They were stuck together. I tried to move the inside of my mouth and that was stuck. My whole face was stuck, a frozen mask, numb, twitching in front of something behind it, something conscious. It must be my brain, the brain that was telling me that down below my neck there lay another part of me, which my brain could not reach. Nothing responded. I tried my fingers. The index finger of my right hand trembled. Signs of life. By a slow process of elimination, I checked my moving bits, one at a time. I tried my toes. One by one they moved. I was on the move. I had survived. But where was everyone else? I tried to sit up, collapsed and tried again. Looking around I could see that there had been activity; half-eaten sausages, broken bread and empty wine containers proliferated. Scattered around in the lucerne was an alarming array of condoms. I picked one up and looked at it. As I did so I became aware of faces. They were looking hard at me. Hard faces, brown and bitten by weather and a hard life. They could have been harsh etched faces out of a bitter drawing by Otto Dix. They didn't say a word. I was being misunderstood by the second. I held up the condom, smiled at them stupidly, and began to blow it up like a balloon. Then I let it go and it farted around the garden in a fast loop and fell wrinkled on the ground. *'Bonjour,'* I said. *'Ça va?'* The faces shook and the bodies

shrugged, turned and disappeared from view, back towards the square. Not a good start to the day, I thought.

The sun warms the rocky terraced vineyards quickly in these parts. Half an hour later, I was still sitting like a martyred Buddha looking down at the land which sloped away towards the *petit ruisseau* running along the bottom of Gavin's domain. A figure less significant than a shapeless form rose up like a vaporised zombie from the matted green undergrowth of Gavin's little piece of paradise.

'Oooh! Mon Dieu-daaa. It must have been the *écrevisses*.' The spectre spoke.

I rubbed my eyes and looked again, saw the apparition and held my head in my hands again. I knew I was going to have to talk to this remnant of a night too far.

'Hello! Tim Slunt?' The figure staggered like a skid-row superstar, wasted, braised, sautéed and served up cold.

''s me,' he replied, searching his pockets for a fag or a bit of one. He rolled his own. Most people of Doodaaa pedigree did. He offered me a light and I tried to catch his wavering fag end before he dropped it again into the clumps of undergrowth.

'You never talked to me,' he grunted.

'No, I never did. You were talking in a kind of frenzy to everyone else and I let you be!'

'Uh, sorry. I do go on a bit. Haven't got anything to drink by any chance?' He swung his arm around the landscape like a landowner.

'I can find some dregs. Probably acceptable for a hair of the dog.'

Dregs later, Tim Slunt was holding forth again. There was colour in his cheeks that seemed to be more collage than actual.

'I must get on today,' he said. 'I've hardly done anything all summer and the Turner's looming.'

'Got any ideas?'

'Sure, plenty of them. There's enough garbage tips in this world. I've got all the material I can use. So I'm going for a nine-part homage to Hans Arp and Kurt Schwitters. Three triptychs, in fact.'

'Want to show me anything?'

Time to push the ON button, I thought, and Tim was now eager to show me what he was assembling.

I followed him through the village square which was strewn with streamers, plastic beakers and half-dismantled stage props from the night before. Red-eyed peasants offered limp wrists as handshakes in the familiar French manner and we *ça va*ed our way down the main street, turned right down the road towards Lily Potsdam's place as Tim fumbled in his pockets.

'Lost your keys?' I asked, half-joking.

'Yeah!' he said. 'I'm always doing that.' He picked up a piece of limestone, walked towards an unpainted old door, the entrance to a basement cave under a detached house, and brought the stone down hard on a padlock holding it fast. The lock fell away.

'Never fails,' he said.

We walked inside the dark hole and Tim switched on a bare light bulb hanging from a beamed ceiling. The place was furnished in a rudimentary way but it did have a fridge. He walked towards it, opened the door and reached into the freezer compartment for a bottle of vodka.

'Fancy a drink?' He offered me the bottle and I took a swig.

'Good man!' he said. 'What's a liver for if you don't make use of it?'

I smiled and sat down on a pile of newspapers balancing on a wooden wine case.

'Everything you see here I scavenged from the local village tip – even my art. What do you think?'

I remained silent and let him continue.

'They are my homage to Hans Arp and Kurt Schwitters.' I looked at the Triptychs. 'That one there is called *Bank Robbery*,' he said. 'The wire mesh has a certain symbolic presence, don't you think? The others, I thought of calling them *Millbank Intrigue*. The pieces reminded me of the flotsam I see floating down past the Old Tite towards the Houses of Parliament. I was going to use them as firewood at first. I particularly like the use of that old Michelin guide, separating the two planks of oily wood, and the stretched black knickers bridging the gap. Schwitters, in his *i Manifesto*, thinks of artistic creation as recognising the rhythms in one part of nature, or in my case the rubbish tip. There is no need to fear

any loss through transference, that is, nothing will disturb that recognition of the creation, when I first saw it.'

'I understand what you are saying, but didn't you say you were initially going to burn them?'

'Ah, yes. That was before I schlepped them home and dropped them by the back door to chop up. Then the full force of the elements struck me and I could see the art staring me in the face.'

'Er, did you see the art before you chopped them up or after?'

'During, actually. It was touch and go for a moment there, and it was nearly all over, but I hesitated, for a moment.'

'Why was that?' I said.

'The village fête. Perfect excuse. I stopped work. But that is where the element of chance entered the process. One second later and that lot would have been firewood, mate! But, again, as Schwitters says, a fragment of nature does not necessarily become a work of art. The material is unimportant in art; it is enough to give it shape for it to become a work of art. Both Arp and Schwitters agreed on this matter, and they both agreed with Tristan Tzara in his *Dada Manifesto* of 1918: "Dada is the signpost to abstraction", meaning, in the original sense of the word, to draw away, to separate, to isolate. This supposes taking ordinary reality and transforming it artistically. I took it away from a rubbish dump. The fête interrupted me, and bingo! Art! The new artist protests; he no longer paints illusion but creates directly in stone, wood, iron, tin, boulders, wine cases, baking tins, mechanical moving parts, ballcocks, whose original purpose is no longer relevant. An abstraction has taken place, a transformation, an artistic liberation of an object's inner being. Its aesthetic has been revealed, though I have to admit that those black knickers still look like black knickers to me because I know where they came from. I wore them last New Year's Eve at the Chelsea Arts Club Ball, and I know what I did in them! Non-transformation by association. "Familiarity leads to blindness." There I go again – quoting Gavin Twinge. He believes that familiar objects defy an artist's ability to transform them. They remain what they always were, to that particular artist. His sensibilities are blinded by a close historic association between him and it,

the object, those knickers. But seeing something for the first time, the artist is open to its fresh statement of beauty, or he never sees it at all, in which case he may never have been an artist in the first place. I asked you what you thought of my creations.'

'I think you are wrong about the knickers. I think they have very real significance in the context of the title you chose to give that one,' I said, pointing to *Millbank Intrigue*, 'but it is more of an intellectual statement than a purely aesthetic one. It reeks of innuendo and smut in a political sense. But I happen to like them, yet I can understand why no one wants you to have your work next to theirs. It could be mistaken for a flippant attempt at art, a cruel joke at their expense. Do you think that is what they fear most in your work – a crude sense of abandon, an apparent lack of seriousness?'

'Oh, I know what you may be referring to. My non-selective work back in London called *Skip*. A couple of years back, there was a skip out in the street, and I bought the whole lot, skip an' all. I had the council shift it for me to the Weightchapel Gallery as my entry for the Young Contemptibles show. It wouldn't go through the door, so it was set down directly outside in front of the gallery as an attraction for the show. Unfortunately, it looked *like* what it was, a skip. There was no transformation, no artistic liberation. It was, in fact, still in its usual context. Its inner aesthetic being was still imprisoned. The press slated it, and the show inside was tarred along with it. The show was dubbed "The Tip behind the Skip", and flopped. The Doodaaaists were a laughing stock for a while. Then Gavin saved the day.'

'How's that?' I asked.

'He found a buyer for the whole show in Denver, Colorado, by calling it all *Junk Truck's A-comin'*. He bought another skip, and persuaded the group to throw their work into it, just like that. No arrangement, just hurled in any old how. Some advertising exec paid $75,000 for the lot. He used it to promote underarm deodorant for truck drivers. He superimposed each skip on the earlobes of a nude model in a photo. Brilliant concept, though truck drivers don't use deodorant as a rule, but they do hang nudes in their cabins, and the nude became famous. Unfortunately, people associated the poor

woman with body odour, and she never worked again. She sued the advertiser for a million dollars for loss of earnings, so she did OK, and became known as "the nude who sued". It's a daft story, but I think that is why I am avoided by the group. They will put my name up in a group show, just so long as I don't enter anything – which is OK by me. People see my nameplate on the wall and look around for the work. To date, I've been credited with a fire extinguisher, an exit sign, a gallery attendant's chair, a packet of ham and cheese sandwiches left by a visitor, and a heating pipe. My non-participation is referred to as the Slunt Factor. It's now an acknowledged artform, but man can't live by bread alone. I still need to work.'

'I was going to ask you about Gavin, but you pretty well filled me in with that story. He seems to be a bit of an entrepreneur. People have asked me how he makes his money, and you have practically answered the question. It's time I started making tracks. I've got a taxi to get back to London.'

'You know about his allowance, don't you – the family business? Water-closets et cetera.'

'Sure. But I thought he had rejected that side of the family history, in case it affected his destiny as a great artist.'

'Good God! Not Gavin. His first confrontation with art formed his attitude to his own output. He saw the Urinal called *Fountain* by Marcel Duchamp at a Dada retrospective in New York. He looked for the family name on it, saw only R. Mutt, 1917, crudely written, and assumed it was a forgery, based on one of his family's products. He was pissed off, if you'll pardon the pun. He decided, then and there, that his future lay in that area, but as an artform, in whatever direction it took him. Down, out, and up, like the rat – his great-grandfather Gordon Twing's motto. He was determined to have his ancestors recognised as great innovators and benefactors to mankind. He had never heard of Duchamp then. This was the early seventies. He was only twenty or so, but it set him thinking. That is how he began to see the germ of a movement – our movement, the Doodaaa movement – a bodily movement, as well as a spiritual one. His background and his future were somehow melded at that point.

Marcel Duchamp became his great hero, but for a time his name was muck. It was Gordon, his great-grandfather, who designed that very urinal, inspired by a picture postcard of Napoleon's Garde-Robe de Campagne, his very own private Water Loo. The postcard was sent as a get-well-soon wish from an old auntie living in Marvejols, about 1908. It galvanised him into action. Of course – he thought – the wash-down urinal! Neat, self-contained, modern, elegant, and not without a certain artistic flair. The wash-down urinal was the last thing the old man ever created. He had his old auntie fitted out with one in her home in France, though, being a widow, she really had no need for one. Rumour has it, she did try to sit on it once, slid off, and promptly had it removed, where it languished in the backyard until Duchamp happened along. Seeing it, he would have admired its artistic flair, its direct simplicity, and its utility. Not realising, however, that it had been made by an artist, albeit an industrial one, Duchamp chose it, and declared it art, a ready-made art object, thinking that he was being extremely radical, ironic and anarchic. In actual fact, Gordon Twing had beaten him to it, but in the name of practical utility. All Marcel Duchamp did was turn it through ninety degrees and display it in a gallery. Meanwhile, the town hall in Burnley was full of them, largely unsung, but certainly well used.'

'That's a great story. You really look like you need some sleep. I'll see myself out. Thanks very much, and good luck with the Turner!'

I checked the tyre pressure and the radiator (still no leaks – well done, Gaston), filled the tank, bought a baguette, some Cantal cheese and a bottle of *vin cru* in the village square, and got on the road.

I thought a lot about the group on the way home, the people I had seen, the people I hadn't, and those I would write about once I was back in London. Their dedication to a kind of wilderness futility should be honoured, like footsoldiers in any battle. They devote as much time as life allows to their specific fields, and courageously brush aside the mockery of others, who mock incidentally more for the emptiness it highlights in themselves, than to celebrate any creative pursuits they could ever offer in exchange. Filling in lottery tickets, picking the

winner in the Grand National, scratching Instant Cash cards or watching football through a whole weekend do not qualify, even remotely, or quite fill that slot reserved for the rest; the rest who go stock car racing, rock climbing, snorkelling, shark fishing, clock golfing, potholing, hang gliding, bungee jumping, chicken-dare trainspotting, race rioting, mugging, raping, pillaging, rambling or even equator crossing in canoes and barrelling over the Niagara Falls. These are the heroic counterparts to their creative brothers. Doodaaaists pitch their physical beings into the fray to declare, at least, their senseless involvement in the daft game of life, and they pitch their precious souls into the intellectual struggle, holding up their creative crosses against the suited judging committees and establishment bum snufflers who have made membership-inclusion on august cultural rafts into an artform. These parasitic fat arses are the honoured and knighted scum sliding beneath the froth of creativity that laps undissolved on to the beaches that aspiring artists were hoping to claim as their own, for a while at least. These are the people we are asked to tolerate, who are no better than the plastic cups, ice-cream cartons and bottle tops washed up in the wet mud of a strong tide.

Doodaaaists do not complain. Doodaaaists like Benchley Craig, the only member of the group who has attempted to unite his love of sport with his desire to find fulfilment in the arts. Rejected by Meadowbank FC following an injury to his right knee he sustained on the M1 in a Robin Reliant – one of the first models, way back in 1962 – Craig turned his passionate love of life towards art. He attended Dundee School of Art, gained a scholarship to Cheltenham, a retrograde step, some would say, and discovered an outlet for his raging temperament in Taschism, a short-lived movement that attempted to release the energy in paint through speed of execution and active participation of the body. In Craig's case, he became a left-footer, and drove footballs coated in paint at white surfaces of various materials, from different angles. His acknowledged masterpiece, *Corner*, explores the multiple trajectories of a paint-soaked ball kicked in from left and right wing as it 'scores' or hits the surface, continuously, and smears its coating with dramatic intent.

*Sudden Death*, perhaps his *tour de force* of the last ten years, explores the nature of impact, the expectations of a roaring crowd and the hoots and jeers of derision suffered by a squad member who is unlucky enough to lose a game on a final kick. Four splats of paint spread like violent explosions from the first four balls in Manchester United red, and the fifth splat in heart-rending Chelsea blue just catches the edge of the area, and the irony in the dashed hopes following palpitating suspense is plain to see. His *Shed* graffiti paintings encapsulated the passion in a football crowd, and many frustrated fans aped his work like angry chimpanzees. Their scrawls can still be seen on stuccoed walls of every London borough, or sprayed big on railway hoardings from Fulham Broadway to Cockfosters, stained into the embankment walls and building sites around Millbank and Victoria. Yet to date Benchley Craig has never had his own London retrospective. 'The walls of London are my retrospective,' he has declared philosophically, 'and every kid who kicks a football through a greenhouse is my monument. It makes a lovely noise!'

Ormond J. Street calls himself an Oxy-Pathogenist. As a male nurse at the Middlesex Hospital, he was often assigned to the disposal unit in the basement, where old equipment that had served its useful life was broken down and rendered harmless before reaching the scrapyard. To Ormond, this was unutterable waste, and gradually he gathered and carried home hundreds of pieces of equipment, to be reconstituted by him into sculpture objects with another life. Oxygen tents became tropical plant propagators, patient trolleys turned into hanging mobiles, anaesthetic apparatus transformed into miniature cities, phials into teats on his *Medicine Woman* (currently on permanent display at the American Indian Foundation in Sante Fe), molecular demonstration models became startling experiments in spatial, molecular theme parks, destined for the proposed landscaping around Battersea Power Station when it finally becomes the Electronic Museum of the Twenty-First Century. Ormond has many plans, and his demotion to hospital janitor means that he can spend a lot more time dismantling stuff in the basement through the wee small hours. He has had to move, and as luck will shine on

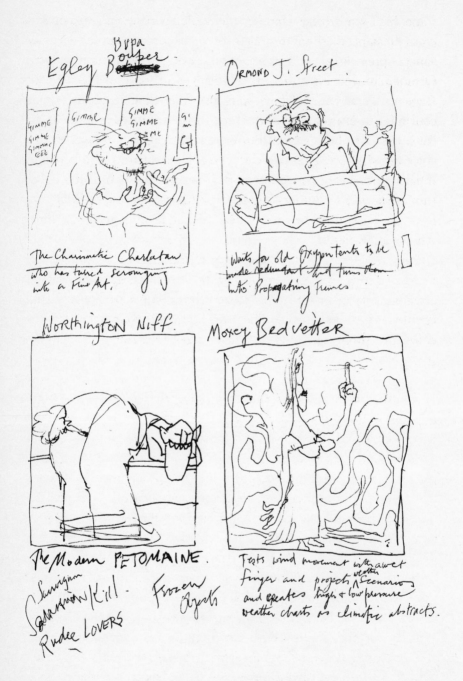

some, his twin brother Harley, who made a fortune in magazines for cross-dressers, died mysteriously of a cocktail overdose, or prawn canapé poisoning, or a mixture of both. It was nasty, anyway. Ormond moved his stuff into Harley's penthouse overlooking the Regent's Park Canal. There were no other beneficiaries. Ormond continues to janitor and work through the nights. He loves it, and considers it to be his contribution to the National Health Service, since he will accept no payment, except perhaps the odd bronchial inhaler or catheter stand. He works to create a monumental collection of *Medical Curios and Absorbed Mechanisms* which, one day, may form the basis for a Medical Oxyart Foundation of Ideas and Fresh Air Anaesthetics.

Rita de Passage, one-time lawyer and now a Montage Title Deedist, intrigues her admirers with breathtakingly delicate re-arrangements of private possessions, from defunct early nineteenth-century legal documents. She fastidiously reworks old deeds of covenant, promises to pay, foreclosings, indentures, conveyances

Rita de Passage

Poses for herself.

and writs for defamation and fraud, and 'transforms the tragedies of
people's lives into poetic affidavits for a new world order'. She says
that if she hadn't been a lawyer she would have liked to have been a
revolutionary like Leila Khaled, the freedom fighter and fight for
human rights of every kind. Now, as an artist, she creates fantasies of
people's rights as they should be in her ideal world. She is a new
realist, a social mechanic, who takes what has been, what was a
swindle for some poor bugger and leads the way forward towards her
idea of utopia, which she admits is an impossible state of grace in an
equally impossible world of squalor. Instead, her new realism makes
humans into very special people in a very special country. Her
activities are her devious means to an end. She is an artistic
Machiavellian. She has also stated that if she ever gets a bad critical
review of any of her exhibitions she will 'Sue the arse off them and
engineer a permanent injunction against them never to work again.
If anyone doubts me,' she declares defiantly, 'try me!'

Anton Schminck-Pitloo, who was at the party and who made
amazing gut-wrenching sounds with a pickaxe through a piano, is
the disturbed son of a concert pianist mother and an Irish labourer who
played the fiddle. Anton fought his mother's obsessive piano playing
while he sat on the potty and held back until she reached a forte
crescendo. Then and only then would he let it all out in a splattering
blast of foulness, which required his mother's immediate attention. She
hated it and would retch uncontrollably as she cleaned him up. His
father's job was to take it outside and bury it in the garden. For the next

two hours she would bang out intense renditions of what Anton describes as Schoenberg backwards. Gavin is convinced that Anton's work with a pickaxe demonstrates a deep pathological deprivation of mother love. He does his best work, it has been noted, on a Monday, when he has been up to Manchester to see his folks for the weekend.

Phlar Namdeats is a Reversalist. His work is a studied attempt to draw and paint in minute detail, but backwards. This is extremely difficult if you imagine that every impulse informed by the eye is drawn the opposite way round, and upside down. And to intensify the effect, each object is inside out. Gavin believes Phlar's work to be the new Cubism, and possibly challenges photography with its appearance of *trompe l'oeil* accuracy, in as much as it defies logic and sends the senses on a journey to Pluto. People have been known to lie down in front of one of his canvases in a vain attempt to grasp Phlar's point of view. Some have claimed that his pictures are hung upside down, and in certain ways, they are. Namdeats is always there to hang his own work, but his process of reversal is forever busy, and he attempts to turn the pictures around again, in order to make them look right again, 'like he remembers before he painted the picture'.

\*      \*      \*

ROYSTON BALLS                          TIM SLUNT.

Cabaret Maestro.

'Pity you missed Royston Balls's performance,' Gavin told me on his return to England. 'It summed up the anti-fête wonderfully.'

Royston Balls calls himself a Poet Primate of Spontaneous Utterances. Each year he designs and makes a new costume. For this year's fête he had plundered the village dump that I too had visited on my way to see Lily. His outfit consisted of three car tyres, a sheet of Formica, a cement bag, dangling polythene disinfectant bottles, mattress springs, a portrait of Apollinaire silkscreen-printed on to the crotch of a pair of cardboard underpants, a wooden wine case fashioned into a square hat, not unlike an eighteenth-century tailor's box hat containing needles and thread, a pram wheel, articulated duct piping for trouser legs, and sundried mediaeval shoes from somebody's attic clear-out. He couldn't move, I gathered, and had to be carried into the arena of Gavin's garden, where he stood motionless before a music stand. The silence that preceded his performance was electric. It took place just before dawn, soon after I passed out, when the gargled notes of drink-sodden revellers had squeezed the last rattle out of a dumped and dying fête. Balls stood facing the rising sun and began the 'Poème Sonner Conccru' that he had

written especially for this moment. He flapped his Formica sheet symbolically, like an arthritic butterfly, turned on the spot, as he couldn't move in any direction, and attempted to embrace the dawn. Then, in the monotone voice of a monastic chanter, he launched into his sound poem for a dawn chorus:

> evah isthgir ylno ehtrof thgif lli
> seltsiht eht urht rednaw lli
> thgin ta ylfrettub ahctac lli
> seltsihw no seton mub wolb lli
> talf sgniht gnis lli
> tac eht kcik lli
> tam eht no eeffoc ym pord lli
> yad yreve raob dliw gnitnuh
> dnuor og dlrow eht sekam

> sefac thgin lla ni efil ym dneps lli
> seirrol ni sedir ym hctih lli
> nap gniyrf a ni skcos ym hsaw lli
> seirrow ym lla elkcip lli
> god eht eenk lli
> gof ni eep lli
> gol a ni seottom edur evrac lli
> yad yreve raob dliw gnitnuh
> dnuor og dlrow eht sekam

Balls paused, turned one revolution, significant and slow, and, pulling out a ukulele from beneath his Formica topcoat, finished the last stanza with mounting emphasis and a few well-chosen chords . . .

> EFIRTS WALTUO LLI
> EFIL YM-DNEM LLI
> EFIW YM SSIK DNA SNIOL YM DRIG
> YAD YREVE RAOB DLIW GNITNUH
> DNUOR OG DLROW EHT SEKAM

At this point, if Balls has orchestrated his act in harmony with nature and managed to recite all thirty-three verses – the whole point of his performance – the sun will be rising above the horizon. However, on this occasion it had clouded over as he uttered his vowelled incantation and it started to rain.

This is a common occurrence with mountain weather. When it does happen, Balls holds his ukulele up in front of him, arms akimbo, and, as a sacred ritual, breaks the instrument across his duct-covered knee. Symbolically, his violent action breaks the spell, and people are released from the harmonic resonance between themselves and the mountain spirits who have been invoked, if that is their wish. All, however, bring umbrellas, and open them up as a sign that they want Balls to continue. If he is lucky, the spirits will attend his performance with thunder and lightning, and the audience are blessed with an awe-inspiring demonstration of nature's own version of *Poésie Conccru*. This natural cloudburst has happened seven out of the last ten years. To some, Royston Balls is a Godsucker. The peasants, 'Philistines' to the audience, curse him for his persistent knack of causing rainstorms immediately after the fête and just before they are about to start the *vendange*, which requires dry grapes at the quintessential moment of picking, otherwise a whole vintage is flawed.

It was a strange crowd, and Tim Slunt was one of its stranger members. It's not that he is particularly flawed. He is not flawed as a good and warm friend. On the contrary, he is everybody's favourite person. But as an artist he sucks. He never was one, he never could be one, and to date, if he has contributed to any group show, the show withers, the pictures on display inevitably become the objects of derision by local vandals. Something possesses them, and within twenty-four hours, having entered the venue as law-abiding citizens, they are the vandals of our worst nightmares. Collapsible umbrellas are produced, spray cans emerge from leg side-pockets. Some have rolls of anti-art posters and bone glue. Some have managed to get past security with chainsaws. They do not come to gawp in awe. They come to mutilate, they come to destroy what mocks them and

their own empty lives. The reasons for this outburst are not the genial offerings of the majority of these artists in our midst, for they come to gape at what they could easily do themselves. No problem. The citizens prefer to slob it out and wait for the pitiful to offer up tokens of human existence like canapés at a cocktail reception.

Slunt is the problem. At first, all artists wish to claim authorship for any outcry provoked by a simple exposition of which they are a part. They bask in a mysterious glow of notoriety for a while, and each, in their pathetic way, thinks that it is they, and they alone, who have caused a stir. That is any artist's wildest dream. But suddenly, a name bubbles to the surface like an oil slick. The oil slick keeps growing, almost unbidden, until the awful truth nudges the simple artist, lost in the glow of reflected opprobrium, that their work is of no importance. It just happens to be next to Slunt and not just next to it, but part of the same exposition. The public see only Slunt. The odious Slunt. Slunt casts a virulent contagion over the whole show and an inflamed public have to take revenge. Justice must be done. Justice must prevail. Art has its place and we don't want no epidemic in our neck of the woods, but we want to read about it – and don't forget to spell my name right, either. It's Hueknjenbikunst, Gludphial Hueknjenbikunst – an' don't forget the umlaut over the J.

So Slunt, for all his charm and engaging ways, is about as useful as a basin of stewed plums for irritable bowel syndrome.

I had been right to leave when I did. There was nothing else I could have learned about Gavin down there, not even by visiting more Doodaaaists. I don't think I could have stood it. They were all too involved in the helpless obsessions of their own struggles. This was where they all came to play mud pies. I could make up the rest and use my imagination for a change. What I was looking for was Gavin the individual, Gavin the outsider, Gavin the serious warrior, fighting for his own right to express his life, and ours. Gavin is not a joiner who needs other people in order to survive. You can never find the real artist on holiday.

# PART III

# SIGMUND GONAD: THE DOCTOR WHO DELIVERED GAVIN

'Gavin's birth was rather difficult. It all seemed so easy at first and then things went horribly wrong. His mother at the time thought she was Orpheus and was descending to Hades, the er – infernal regions in Homer's *Iliad*. She was convinced that she was giving birth to a piece of shit, which in fact she was, but this piece of shit was the result of nine months of sheer hell. You can imagine the trauma it caused in her mind. She was already suffering from an acute form of schizophrenia in which the dual personalities she occupied were now invaded by a third character, Lucifer, the devil who, she said, was offering her an alternative lifestyle in exchange for her soul. So to her, was this piece of shit her soul, or the alternative lifestyle? Because she had actually made the deal already!'

I was listening to Dr Sigmund Gonad, a retired gynaecologist who specialised in seeing disturbed women through their pregnancies. In fact Dr Gonad's dedication was such that many say that he was often with some of his patients at the moment of conception for, as he himself put it, he would prefer to oversee the whole process from beginning to end – 'from the top to the bottom', he would say with a mischievous twinkle in his eye – his one eye. We were sitting in his heavily wallpapered consulting room. He was always eager to tell people that he had done all the wallpapering himself, through the letterbox. He would guffaw loudly at his own joke, which, he said, always helped to put his patients at ease.

'You were saying, Dr Gonad – about Gavin's birth, that is, it seems not to have happened yet. What happened next?'

'Yes. Mrs Twing's condition worsened when she realised that she was now, in a very physical sense, not one but two beings and yet

Fanciful portrayal of Dr Gonad by Gavin Twinge

again, to herself, three people. The continuous tempting whispers of Lucifer in her ear caused what we in the profession call quadrophrenia – the psychological presence of four distinct personalities – and it was all I could do to hold her attention. So I hit upon a method of sign language, or "prophylactic gesticulation" as it's called – well, that is, I like to call it that. Luckily, I have webbed feet and –'

'Wha – did you say webbed feet?' I instinctively looked down but Dr Gonad had slid his feet back under his consulting chair.

'Yes, I know it sounds strange to a layman. It is what we in the profession associate with too much inbreeding. My family were always at it. We are a deeply religious family who believe that the family that breeds together stays together. That's why I became a gynaecologist, entered the Born Again Family business, you might say, which puts me in a unique position to understand the peculiar mental aberrations of Fanny – er, Mrs Twing. You see, when I was born, I was convinced I was a frog and simply adored bathtime. Never wanted to get out of the bath – often slept in it, in fact. I

wallowed in it as though I was still in my mother's womb. My mother, whose own peculiarity was a small horn growing out of her forehead, used to call me her "little prince". A term of affection. We were a happy family – but I digress. Where was I?'

'You were just about to gesticulate in front of Mrs Twing.'

'Ah, yes, prophylactically. It is a twiddling technique of wiggling the fingers in a pair of surgical gloves around the nexus of the womb. It concentrated her mind on the body itself, diverting attention from the presence of other beings possessing her. She had a job to do that needed her undivided attention, and I find that this is the only method that works, for me anyway. Others disagreed vehemently, which is why I retired.'

'What happened?' I enquired. 'I was struck off.' 'Oh,' I said, and shuffled uncomfortably in my chair and tried again to get a peek at Dr Gonad's webbed feet as I did so. 'But I take it that all went well with the birth, for the world now has Gavin?'

'Oh, indeed, and not only Gavin but his twin brother Crispin, so in some respects she was right about the others.'

'The others? What others?' Dr Gonad was getting me extremely confused.

'His twin sisters, of course. Well, not exactly twins but the rest of the quads. Mrs Twing wasn't schizophrenic at all. She is as normal as you or I. That is, sure, she suffers from mental visitations but I don't believe that it is that serious. I can't convince her of that, of course, and I continue to treat her on a friendly basis. She still prefers my bedside manner. She was five people in actual fact and I didn't realise it. Sadly, she never walked again, firmly believing that, after a 28-hour titanic struggle to "relieve herself", as she put it, her bottom had dropped off. She enjoys life in a wheelchair, however, and moves about faster than an Olympic sprinter, which of course she was also. She represented Britain in the 1936 Olympics in Berlin, knew Jesse Owens. They ran a friendly three-legged race together for laughs and she insisted on carrying a toilet pan under her free arm which actually upset Hitler more than Jessie Owens's victory.'

'Would you say that Gavin inherited his perversely satirical sense

of life's moongasp madness from his mother who went on to found Kryptic Kaiser Krionics, the obscure movement she established in Soho Square in the 1940s during the blitz while knitting balaclavas down Tottenham Court Road Underground for the sons she might never have?'

'Absolutely! She was a wilderness prophet of protest. Hitler insisted that her actions undermined his idea of the true spirit of the games and insisted that Leni Riefenstahl cut the sequence from her film of the games, destroy it in front of him and never mention it again. It would have been a bit like Goebbels arriving on the podium at a Nuremberg rally wearing a clown's red nose, loose trousers and big boots, blowing a party whizzer and slipping a whoopee cushion under Hitler as he sat down after a moving speech into a microphone at maximum sound level. Following her mother's rejection of plural voting and subsequent flight to Italy to live with her one-time chambermaid, Fanny Twing went off to Spain, in defiance of her father's wishes and joined the POUM Militia to fight the nationalists just as her father, Raphael Twing, a respected water-closet magnate from Burnley, son of Gordon Twing, the inventor of Washdown water-closets, and the Dada Urinal, joined Oswald Mosley's Black-shirts as a favoured lieutenant. He had a brother, Sidney, who conceived an idea for continuous rolls of disinfected paper, suitable for sanitary use, and made his own fortune. An ingenious family, all of them. This was when her schizophrenic behaviour disorders began to surface. Her reputation as the "stopcock in her father's eye" went down the pan and he disowned her. Her act of disrespect could never be forgiven or categorised. Except for the suffragettes of her ilk, and her mother's lesbian liaison, there had never been anything like it, ever, and therefore a whole world dismissed her. She had no pigeon-hole or not a pigeonhole large enough, anyway, to contain her.'

'She was a big pigeon then,' I hinted, hoping for some recognition of her possible involvement in the rallies organised in Trafalgar Square when the South Bank was developed in 1951 to host the Festival of Britain. The toilet facilities to service the 8.5 million visitors who visited the Festival were no better than they were in

1851 and Fanny – Mrs Twing – being, as it were, raised in the business, found the optimistic grandeur of something called the Dome of Discovery, masking the 'accumulated effluence of humanity', a gross hypocrisy and struggled against the bureaucratic machine and jobs for the boys to secure toilets for everyone. But nobody was listening, and if they did, reckoned she was simply trying to win the contract for her family. Most people anyway didn't complain and simply waited until they got home.

'Well, as you probably know,' continued Dr Gonad, 'in those early post-war years of rationing, lard, and a first-ever Labour government with back problems, a common complaint among the working classes, any idea was a grand idea. Criticism was unheard of. This was the Brave New World, times five, of Aldous Huxley, rather than George Orwell's *Animal Farm*. Protest was antisocial and a National Health Service had just been established, of which we were all to be the beneficiaries, especially the sick and dying. This was no time for bellyaching and gripes. It was time to tighten our belts, do what we were told and be thankful to have something to be proud of again. But this wasn't good enough for Fanny. When the Tories got back in power again in 1951, using the Festival of Britain to mark a new era of reconstruction and take the credit, when she knew all along that facilities just weren't up to it, she interpreted that as a metaphor. Beneath the surface gloss everything was as rotten as ever and no one was going to flush society out of its complacency. I fear she passed that attitude on to her son Gavin and there was still the Campaign for Nuclear Disarmament and the sixties to come. So she upped and went to America, first to New York, to look for her lost uncle, J.T., then on to California to try and locate her cousin Vera. She hated Los Angeles and her search took her to San Francisco where she met a Beat poet in the City Lights bookshop and fell in love . . .'

I asked Dr Gonad to tell me a bit about that time but he said that the next time he heard from her he was treating her for what turned out to be her bountiful pregnancy back in England; a few years later she was banning the bomb in 1958 at Trafalgar Square rallies along with Bertrand Russell and other concerned intellectuals.

'She did talk about a writer called Sartre, an existentialist who had written a book about being and nothingness,' he continued, 'but she lost me there considering that she was about to disprove any such ideas four times over. A more schizophrenic display of her mental state I couldn't imagine. I concentrated on her pregnancy and an early stage of delirium tremens, a condition brought on by her intense involvement in the activities of this group of Beat poets in America. I think the father called himself Howell Northern, an unlikely name if ever I heard one, but Americans find such peculiar names for themselves to mask any connection to a past and what Fanny said Mr Northern wrote about was as far away from any past she could recall. But she loved him though he never stayed around when he discovered she was going to have his child. He left her a poem which she found when he was gone. She gave me a copy of it. I have it here somewhere,' and Gonad fumbled around in a drawer of his partner's desk and handed me a broadsheet printed in San Francisco in 1958. City Lights Press. I took it and read it:

Four –
That's what I scream about
Four!!
Yeah! FOUR!!!!
FOUR FOR A FUCK's SAKE!!!!!!
Four
   Shafted inside
Doldrum quaaludes broke my spirit
Dyed my soul
Spoken for by four shacked up tieballs
Of the Apokalypse
   Says
No tangiers for me faggot slut
Constellation fire balls
Balls on fire
A trapped mangle's spontaneous eruption
Slips the noose

And levitates
　Disgrace a good family once a day
At least. I did
Sucked the life out of Hozomeen
Sucked it dry as a mountain top
When Jack London comes this way
Comes down here
He will be proud.

'Did Fanny Twing ever talk much about the group – their travels, habits, way of life?'

'Only that they were like a family of brothers and always buggering off to some place, usually without her – Mexico, Tangiers, Paris, New York, Denver, places like that, almost a family, angry at a feeling of exclusion, of being left out of a bruised war generation which they didn't want to belong to anyway. They wanted to be individuals in a group, which interested me only because it was so like the behaviour of schizomanic freewheelers flushing out each other's obstacles as though none of them had had a shit in years.'

'What?' The last phrase startled me. It sounded like something out of William Burroughs's *Naked Lunch*.

'Something she said to me, often, always with a sneer, as though part of her was disgusted and fascinated simultaneously. She tried to protect Howell but he was weak, by all accounts, an advertising copywriter, famous only for a paper company slogan which was appreciated by his colleagues but not the agency. It was something like "IF YOU CAN'T WRITE ON IT WIPE WITH IT". He was fired. Then he started hanging around Fisherman's Wharf bars and hooked up with two or three of the gang. I don't like what they wrote myself but I reckon it was pretty infectious stuff. For their own sakes it was better out than in. Fanny met Howell around that time and kept him pretty straight for a while – and you know the rest, or she can tell you herself.'

Dr Gonad let me see myself out, which was a shame because I was hoping to see his webbed feet, just a glimpse would have been fine.

We shook hands. His were decidedly damp, probably cold and sweaty, or maybe he *was* a frog. His account of life from a frog's point of view may not have the ring of authenticity about it, but at the same time, what's a frog got to lose? I was at the front door and about to leave when I thought, Oh, shit! I wanted to ask him about anatomy, not his, but Gavin's preoccupation with all things anatomical. His obsession bordered on the profane and maybe a doctor may be able to shed some light on that aspect of his work. And a frog doctor. Maybe I am dismissing something I may need.

I about-turned and knocked on the consulting-room door and opened it in one smooth movement.

What I saw horrified me.

No it didn't. It shook me and I wondered if I had walked into a forbidden time warp and I wasn't meant to be there. Dr Gonad – I think it was Dr Gonad – was in a crouching position. His butt was bright green and he was staring at a jam jar on the desk. It was full of flies and he had just removed the lid. He was waiting for the first fly to escape. He hadn't noticed I was back in the room. A fly spun out of the bottle and a long tongue whipped out of Dr Gonad's mouth and back again with the fly firmly caught inside a curl of saliva. For a moment he stayed motionless, then his one eye disappeared into its socket and he swallowed before his eye bulged up again while he remained immobile for another fly to emerge. One by one the flies left the bottle and disappeared inside the flashing curled tongue. Dr Gonad burped as one does after a good meal, settled himself with a single sideways movement, then sprang on to his desk and was quite suddenly aware of my presence. 'Oh! Forgive me. I was just checking my in-tray. Was there something else?'

'I-er – forgot to ask you about Gavin-er – about his fascination with anatomy, and particularly weird anatomy, er – distortion, impossible creatures, er – Leonardo da Vinci made some creatures, made them out of parts of dissections he had performed, the er – impossibility, er – something he thought, er – God would never have thought of or, er – may have, er – created and, er – rejected. Unlikely combinations, and there are no fossils or, er – evidence that, er – such

creatures could ever have existed. It-I, er – perhaps – I-er – sorry I barged in. I-I – can come back. It, er – well, sorry.' I turned to go in delayed shock. Christ! Maybe he will have to eat me. Maybe I am the only one who knows and the secret will die with me in a horrible splurge of saliva. Does he think I am a fly all of a sudden? Oh, shit! I need to get out of here, need air. Say something, anything. 'ANAT-OMY! Dr Gonad! Medication, not medication – medical reasons for mutant derangement. Sure, surely, sure as Hell fascinates me, Dr Gonad. Where would we be without variety, eh? Biodiversity, huh? OOOOoooooH! Strange world, isn't it? W-W – what d'ya think? Ah –'

Dr Gonad opened his mouth and I could see the spittle slide down into the bowl of pink flesh beneath his tongue. His one eye sunk and re-emerged again and his face began to look just like Dr Gonad. Did I relax? Who can tell? In strange moments which have no rhyme or reason, who remembers?

'Mr Ralphael, do relax. Please take a seat. What is on your mind? You are sweating. I noticed when we shook hands a moment ago. Let me tell you something about Gavin. Gavin harbours a peculiar fascination for the weird and the obscure. It fuels his art. Normality is not an issue here. In Gavin's world, beneath apparent normality there lives another life force. He would never accept that everyday life as we know it is the whole story. What we appear to be and what we are inside are two separate states. Gavin is not thinking of good or evil. Neither does nature. Nature does what it must. Gavin does what he can. Good or evil don't come into the equation. Wasn't it Nietzsche who said what we do for love is beyond good and evil? Gavin contemplates and loves the abnormal as a very real aspect of life in any high street. What you or I may think of as just a scene may be a seething mass of mortal combat in the minds of the figures in any landscape, but, more importantly, in the perception of them in Gavin's mind. The minds of figures going about their daily activities are battlefields. We don't see the turmoil, we cannot access the struggles battering at the walls which contain them. What we see is what we hoped we would see as we pass by. Life appears as it should.

That is the most convenient state we desire to live in. We cannot help if all we see is suffering and struggle. We can hardly help in a preferred world, that is, as we prefer to know things. If figures walked our land, anybody's land and wore their inner turmoil as, say, an overcoat, we, you, me, would be the victim of an emotional massacre, shredded by blades of doubt and hate and lust and resentment. You would be flayed into flakes of fresh wet humanity, which would float through the air and adhere to the overcoats like brushstrokes – Gavin's stock in trade.'

I think I was beginning to understand the essence of the work. I was no longer afraid. Dr Gonad was a freak, a simple homespun, back-street freak and I had been letting my imagination run away with my emotions.

'I'll catch you some flies,' I said eagerly. 'I used to have a Swiss tree frog. I had to catch flies for it every day. He was my pet. I called him Spring. Spring because he was so green and Spring because when he did spring all I saw was the repose after the act was done. The speed deceived the eye.'

'When you have tasted fly, you have tasted caviar. But to Gavin one fly equals a bucket of maggots. We disagreed vehemently about that aesthetic. It's all in the mind, I told him and on that point we did agree.'

'So why is Gavin so obsessed with the parts of the human body? Why would he split them into elements of another reality?'

Dr Gonad sprawled his legs across the desk, perfectly at ease now with what we both knew. The green scale flesh of his lower torso was as natural as the pink bulbous top part of his torso covered only by a loose shirt, floppy collar and flamboyant yellow cravat. His pudenda were secreted inside a beautifully tailored crimson jock strap. His orange corduroy pants and his stethoscope were draped across a surgical trolley bedecked with rubber gloves and sterile wipes, the tools of his trade. Somehow he was more relaxed now, more in control of his thoughts and in tune with his philosophy.

'Gavin cannot accept that we are as we are on the surface. So he devises scenarios which display visually what he calls the "What if"

factor. People recognise the parts but know that they are not where they are supposed to be. In this way a question erupts in the mind of the viewer which says, "Why not?" and a dialogue has begun. Once you have dialogue, nothing will ever be the same again. Rules of engagement insist. That is the nature and the essence of art. Once suggested, life is changed for ever. Call it a "new normality".

'Inside each element of human anatomy is everyone's personal point of recognition. What Gavin does with those elements is his responsibility as an artist within the context of his creativity. No one can argue in there. That is Gavin's world. That is an artist's world. People who are not artists spend most of their time arguing against what they think they see. Something they see before their very eyes. But it seems that is not enough. They question what they see because they cannot believe their eyes. People don't like change and that is all that Gavin is offering.'

'Isn't it perhaps, Dr Gonad, that Gavin's emphasis on the weird tends to make people uneasy even though it is true? Things ARE weird but folks somehow are able to transform their perception of events into a normal happening. A bit like our eyesight, the way the brain adjusts what we see to look the right way up even though the image on the retina is upside down.'

'Yes, that's right, Mr Ralphael, an interesting metaphor.' Dr Gonad is looking at me now, staring, it seems, straight through me, or is it at me, or at something ON me?

'Have you ever heard of that experiment by a German psychiatrist who constructs a room in which he places furniture of wildly different proportions?' Dr Gonad's head moves ever so slowly towards me, his eye fixed firmly on something beyond my head. I continue, 'He gets a newlywed couple who are obviously in love and puts one partner inside the room and has the other observe their loved one through an observation panel. Apparently, the wildly different-sized furniture "normalises" to correspond, relatively, to the loved one, who remains the constant factor inside the room. In other words, the lovelorn observer sees only their loved one, their "love

object", as the correct size, irrespective of the size of other objects in the room, which the brain adjusts to fit the observer's constant vision. It is a physiological expression of love, of obsession. Then the psychiatrist swaps the couple for another pair, who have been together for twenty years, and –' Dr Gonad has raised himself from his seat and his face is just a couple of feet in front of mine '– and, anyway, this time the observer sees their partner change size in relation to the furniture, which may be bigger or smaller and so the partner changes to relate to each object as we normally accept the world around us. What are you doing, Dr Go –?'

'Keep still. Don't move a muscle, Mr Ralphael. Steady, don't move, stay absolutely sti-iii-lll and –'

THWACK! A long wet pink saliva-clad tongue whips out of his mouth and slaps my forehead and flashes back into his mouth. Startled, I sit as a dribble of spittle falls down the side of my face and drops inside my collar.

'Got it!' cries Dr Gonad. 'You had a bluebottle on your head but it's gone now. Didn't you notice? You were saying, Mr Steed, I interrupted you. You will have to excuse my antisocial obsession.'

'Oh, er – that's OK. I was talking about comparative aberrations inside relationships. I – I've finished – not important. Time I was off, I think. You must be very busy, lot on your mind. You have been more than kind. I'm beginning to get the picture. Nothing is as it seems and Gavin is proving that over and over again. I'll see myself out. Goodbye, Dr Gonad.' He doesn't hear me. He is looking hard at the ceiling. Something is about to feel the fury of his peculiar powers . . .

## CHAPTER 16

## COSBY TWING:
## A MANIC DEPRESSIVE POPULIST

Dear Mr Steed

Thank you for your letter and request. Gavin doesn't get home as often as he used to. His mother is a self-centred, crabby old bitch these days and can never make up her mind if she is Lucretia Borgia or Joan of Arc. Consequently, after his brutal upbringing as the runt-son quarter of her quads, the one she decided would be the executor of her every sick wish, he never knows whether to smother her as Cesare Borgia did before turning his sister inside out and hanging her cadaver over the Ponte Vecchio to dry in the midday sun, or to douse her in lighter fluid and just set fire to her before walking out and locking the house behind him. I haven't been near the old whore myself since she tried to flush my own memoirs down her wretched invalid loo because I went on at length about her self-inflicted bedsores. Luckily, I had made a copy, because she peed on the original before trying.

Gavin was always writing some treatise or other, theories on portrait painting, embalming techniques and a new world order, things like that, you know what kids are like. You probably already know what he's like yourself. I have to say I was a bit shocked about his methodical plans on how to get rid of his parents. I never really thought he felt like that. I knew he resented our treatment of him and our own behaviour, but he always said he loved us in spite of the neck brace but I don't think he ever forgave me for lifting him off the floor by it as a bit of fun. I think he really turned weird on us when I pretended to play a tune on his catheter on his fifteenth birthday in front of his friends. I think that must have been the spur for his elimination plans. It was then I realised that he could be very

sensitive. He designed a grave arrangement to contain us both. I was to be buried headfirst in the upright position in a main drains pipe as a symbol of how he viewed the whole damn family. Bat face – er, that's Fanny, my wife, if you can call a peripatetic old muffin with jam in it a wife! Ha-ha! She's OK really. Her father gave her a bad time so you have to be charitable. Did Gavin ever tell you how the old bastard used to hold her head down the pan and pull the chain to get her to like the business? She never did. She was a rebel, a bit like her son, I suppose. That's why she went to America to make a complete break. Got into that whole Beat scene. I think she was pregnant when I married her, some poet – didn't think much of his work. I didn't mind actually. I pretended they were kids. I rather fancied being the devoted father of bastard quads. Thought I might get a spot of mileage out of that and help my own career along. Newspapers like stories like that, skeletons in the cupboard, well, four in this case. Ha-ha!

I could go on but I had better get this off to you with the gubbins. Anyway, you are coming to see me next Friday on the old barge. Don't forget to ring the ship's bell for quite a while, or jump up and down on the deck. I may be next door with Mrs Stokes. I said I would fix the rudder on her houseboat. Ha-ha! She does a nice line in single malts. Her husband was a member of some whisky club or other and she doesn't drink it herself. Thought he was a selfish ole git, she did, being a gin soak herself, though don't get me wrong. I make her sound like a bit of an habituée. But she doesn't like to drink alone since her husband fell overboard and choked on seaweed.

Enough of my trials and tribulations. Please find enclosed the odds and ends.

Yours etc.

Cosby Twing

I was going to have a day off. Then the phone rang. The voice on the other end pulled me up short, and reminded me that I couldn't take the day off. I had arranged to visit Cosby Twing, Gavin's father.

'I'm just checking we have our times right.'

'Oh, sure, I said, er – midday. It's eleven o'clock now. I'll be over in an hour. Just leaving, in fact.' Damn! I thought, as I put the phone down. I had completely forgotten and had planned on a visit to Tite Modern, for lunch.

I checked my tape recorder, tapes, pens, notebook and camera. Better get a picture of the old bugger. He might be better-looking than his son, but then checked myself, because Gavin was not his real son, as were none of the quads. He told me he was writing a book but I didn't want to get on to that subject, or he would be asking me to show it to my publishers. I scrabbled around and found his letter to me with all the details. OK. That should be it. Ask about his wife. Didn't seem to like her very much – the quadro-schizoid cripple. Have to tread carefully. Didn't want to cause any anguish or dredge up painful memories.

I decided to walk to his houseboat since it was about half an hour's walk from my place in the Parthenia Road or an hour's swim from Putney Bridge. I wondered if Gavin and Anya were back from France yet. God, that seemed aeons ago. I hadn't expected such good material from Tim Slunt. I'll ask Cosby about that, because if he wasn't Gavin's father, how come Gavin referred to his forebears as the Twing family, unless, yes, that's it, Cosby changed his name to Gavin's mother's name. She was a direct descendant of the Twing Empire. She was the moneyed side of the family, which is where Gavin gets his support from, even though they didn't get on. I wonder if he knows anything about Gavin's idolised Auntie Vera Steadman from Gonzales, and did he ever contact her?

I have never liked boats, but I warm to the ambience of lapping water, seagulls and a sense that you could, if so inclined, take off at a moment's notice for far-flung places with strange-sounding names, like Tilbury, Margate, Sandwich and Deal. You could, that is, if you were not connected to the Embankment by mains cables, flexible toilet facilities and real-estate claims.

I scrambled over boarding planks, walkways and garden gates until I located his craft, the *Coca Leaf*, stranded between an old barge, somebody's floating garden, washing lines and Sky dishes. The ship's

bell was hanging on a simple arch that was his front door. I gripped
the rope, clanged it furiously, and waited. A few seagulls fluttered up
from power cables, swooped around a bit and settled again on other
perches. The traffic along the Embankment was busy with taxis and
late rush-hour drivers trying to miss the rush hour. A monoxide-
polluted jogger, wearing an I'M JOGGING FOR JACK T-shirt and beige
Crimplene baggy pants, wheezed past, shouted, 'I think he's out!'
and jogged on. I went aboard and called down into the hold. There
was no reply, so I clambered off and tightroped my way across to Mrs
Stokes's barge next door, and stepped onboard.

'Hello!? Anybody home?' There was a scuffle, a cough and a 'Hang
on! Be with you in a jiffy!' I waited.

'If it's Mr Ralphael, come on down, slowly.'

I stumbled down the steep steps into the tomblike interior, and
waited for my eyes to adjust to the cosy nest light of a landlubber's
nightmare. There was a perceptible heave in the whole structure that
told you that while it looked like a regular home, there was oily water
underneath the floor. Cosby Twing was sitting on a stool at a rudely
fashioned cocktail bar-cum-kitchen sink with a selection of single
malts in front of him and various metal quaichs, the traditional
tasting glass of a committed Scotch imbiber.

'Fancy a drink? The finest malts known to man. We are just doing
a tasting of the Islay malts. This one is a Bruichladdich, but Mrs
Stokes doesn't drink the stuff so have one of hers. Ha! Ha! I'm forever
having to finish them. She's in the loo. Bin at the gin again. I keep
telling her, that is no drink for a manic depressive, but she persists.
She enjoys being manic-depressive, like me. Ha! Ha!'

I shake Cosby's clammy cold hand and take a dram of a fine malt.

'Mmmm, that fortifies the innards. Mr Stokes must have been
quite an aficionado.'

'Actually, he didn't drink but, having joined the society, he felt he
ought to support them. There's hundreds of gallons in the hold – like
rum ballast. Keeps the ship steady in a storm. Ha, ha! He liked to see
others enjoy his impeccable taste. I try and help him out and always
toast his memory. Till I got to know them I used to make my own in

the sink with sugar water through a coiled pipe, but raw ethanol spirit is deceptively lethal.'

'That will kill you, won't it?'

'Always have a good breakfast, my boy, and you can withstand drain fluid. But, you're right. I gave that up. It's suicide. Then I went to Peru, tried coca leaves and brought some cuttings back to try here. I was living in a high-rise then in the Barbican, twenty-five floors up. It will grow there, under glass on a balcony. I told people I was growing cocoa. I was forever having to make visitors a cup of hot chocolate to keep up appearances. Home-made, I would say. Ha, ha! Then I came to live here, but it needs altitude, and excellent drainage.'

'How about the top of your flagpole?' I suggested.

'Good point, but you can't fool a coca plant. Gavin has found a spot on his rooftop studio that he has transformed into his own cocal. He has a big earthenware tank full of clay soil, holds the moisture, it's alkaline and rich in iron oxides, common at certain altitudes in the Andes. Anyway, I came to live here, and met the Stokeses. Ah, here's Mrs Stokes now. All right, love?'

'You must be Mr Ralphael.' Mrs Stokes was a well-built, blowsy woman, whose last night's eye-shadow had trickled down her face. She had made an attempt to wipe it away, and comb her henna-dyed hair. She held out a small hand and I noticed the pulled wrinkles on her forearm, suggesting that she used to be fat. 'Since you're all drinking so early, I'll fix myself a G and T. I expect you are here to get the lowdown on Gavin?'

'Yes, but I seem to be learning all about coca.'

'Ooh, don't get him on that subject or you'll never get him off it. Did he tell you his clever maxim regarding its so-called benefits?'

'No,' I replied, but I knew I was about to.

'Cosby tells people that whisky helps you row a boat – but coca helps you live a life. I said, tell that one to the marines. He's done bugger all since he's been here, and I haven't seen him rowing many boats but he pushes a few out, from time to time. I will say he lives his life to the full. He has anyway, since he met me and my late

husband, rest his soul – but I would put that down to whisky. I don't think coca gets a look in –'

'Anyway,' interrupted Cosby, 'this gentleman doesn't want to talk about my obsessions. I'll take him next door, and he can ask me about Gavin to his heart's content.'

'I guess that's why your houseboat's called the *Coca Leaf?*'

'Kind of, sure. A nostalgic name from a nostalgic time. When I told Gavin about Peru he got really fascinated, and it's the only time we really found common ground. I had to fill him in about it. He wanted to know the whole thing, where, how, what with, what's it like, and generally everything you can't get in your average gardening book. He has always been interested in growing vines, and drinking the stuff, of course. When I told him about Hiram Bingham and his discovery of the lost city of the Incas back in 1911 at Machu Picchu, the centre of their universe, he couldn't get enough of it. It bonded our relationship. Just one little thing can start it off. Now he's an expert on the subject. He tells *me* things. That's the real reason I called this old tub the *Coca Leaf*. When I bought it, it was called *Broadside Brenda*. I needed to change that, so I did, when the right name came along.'

'He never told me about his interest in coca.'

'Did you ever ask him?'

'It never occurred. He has been more interested in his art theories and his childhood memories. I wouldn't have thought of asking about something as specific as that. Maybe I will.'

'He went to Peru. He did a series of paintings about the Nazca lines. Some of his best work – I think, anyway. The scale of monumental concepts that, even today, leave us wondering what the Hell the Peruvians believed in and, intriguingly, what they were on. It is those things that grip his imagination, and he is somehow in there, intuitively, recreating the likely reasons for such wild leaps of faith. Ask him to show you. Take a look at this poem he wrote while he was there. I'll get myself another drink. D'you want one? We left five on Mrs Stokes's bar sink. Here take a look.' Cosby knelt down and pulled a box from under the bed, lifted the lid and brought out a

sheaf of papers and a couple of threadbare notebooks. 'I'll be back in a tick.' And he left me alone.

I scanned the first two pages, and wrote down what I could. 'PERU IS PURE,' it started.

A Song Walks Naked through the Valley of the Incas by Gavin Twinge

URUBAMBA! URUBAMBA!! URUBAMBA!!!

Dream river threading needles that stitch great forms together
Through feathered landscapes in linear rhythms

Crafted to grow and farmed to feed
A growing need
In pastures smiling gently
Sighing under the half-lit cushion of a starlit blanket
Patterns learn to display their ingenuity in a watcher's eye
Described by the writing of age in a goat woman's face
The writing writes on like a pulse
Dark writing browning steadily
Withering gently and weaving the years across a whole landscape
Christened for eternal life

Thunder passes over –

Cosby came back in before I had finished. He was looking a little worse for wear.

'Sorry to keep you. I reckoned you wanted to look quietly at his things, so I was chatting with Mrs Stokes. Had a couple of shots too. I don't know how they make the stuff, but it's liquid magic. All that peat. There is still alchemy in Scotland – a lot of people rowing boats, claiming bloodlines, showing off, bothy wogging an' stuff. Cold, damp pride in all things arduous. Kilt covering just about anything that moves, ginger hair. I wonder where the ginger hair comes from?'

Cosby was wobbling about, unsteady, and I knew he had forgotten to bring me my drink, probably drunk it. He sat down hard and a sigh came from him from deep inside. Not a happy man, I thought. He was looking straight ahead in the middle distance.

'He writes a lot,' I said.

'Who? Oh, Gavin, yes – thinks he can do everything. Like that myself once – that boundless spirit, never any doubt, just does it. I always had to earn a living, travelling, keeping out of the way, actually. Fanny, his mother, never had much time for him, or any of them, the other three. Wrapped up in her own problems, and she does have problems. Who wouldn't, in a wheelchair? Bit of a wild time, joined the idealists in Spain, didn't want the family business, just the money. It probably keeps her sane.'

'How did she become chairbound? Dr Gonad said it was the birth – having quads and complications – believing herself to be her own fifth child.'

'Nah! Gonad told you that? She was shot in the butt by a sniper of the POUM Militia, though some have said it was a jealous lover who just wanted to wing her. A lot of scores are settled in civil war situations. Lot of jealousy. Shot in the butt splintered the ilium of the pelvic girdle, I think that's it, the wide bone around the hip, above the femur socket. Somewhere. She did show me – once. It didn't stop her getting pregnant, though. Managed to get about, hobbled her way through the war, vivaciously. A protective weapon, I suppose. Vulnerability is a powerful defence. Then she just upped and went to America, looking for her sculptor father, "J.T.", John Thomas Steadman, I think, who was last heard of in New York, carving carrot obelisks at the north end of Skid Row. Some say he probably skidded right into it on one of his carrots. Joined the Twing family in the nineteenth century, carving posh lavatory seats for posh northern bums. Married one of the daughters, Gloria? Yes, Gloria. Daughter Vera. Fanny never found him. Never found anyone. Fanny ended up in San Francisco. Loved the lifestyle, Beat scene, antithesis of her own family and their values, but her father did make sure she had money, enough anyway. Had an affair with

Jack Kerouac, she said. I doubt it, but y'know, anything happens, and nothin'.'

'But Jack Kerouac wasn't the father, was he?'

'Well, it sure as Hell wasn't Ginsberg. Might have been Ferlinghetti. He was the one who declared that the Beats were homewreckers, perverts, child-seducers, anarchists, subversives, pathetic marksmen and saints – anything you want them to be as long as it wasn't ordinary. But it wasn't him either or Neal Cassady. She said it was probably a complete unknown called Northern, Howell Northern. She used him. He took her around, when she could still walk, ran errands for her, groceries, the liquor store, and found her a chiropractor to give her some physio. May have been him! Huh! But Northern was the one. When he found out, he was out of there like a shelled pea. He could see the problems down the line. Didn't want any part of it. Can't blame him really. It sort of put the cap on her American adventure. She came home, bought herself a wheelchair and advertised for a "skilled pushover". I couldn't resist an ad like that. I answered it and went to see her at her place at Hogarth Roundabout in Chiswick. She was pretty strung out, but furiously independent. The chair was like a stage prop. I was there for the births – Dr Gonad, Hammersmith Hospital, private room. Her father paid, but she went through pain, the old wound, it played up and caused complications with four of the little buggers. That's when the schizo-fitzo complex kicked in and she believed she was five people giving birth to herself – times five. That's when her bottom dropped off, so she said. She's been pretty bitter ever since. Been in three wars, she says. Spanish Civil, the blitz and childbirth.'

'Is she still in Chiswick? I'd like to go and see her.'

'Sure, but take along some Kleenex, she's a good actress, big imagination. Probably passed it on to Gavin, but not the others.'

'What about the others?' It was an instinctive reaction. I had heard of them, but no one really wanted to talk about them. Maybe in his present mellow state, I could get Cosby to open up. 'Get yourself another drink, and bring me one too, then tell me about them. If you have the time, that is. It would provide interesting insight into the

workings of Gavin's many preoccupations. Perhaps. Only if you want to.'

I held my arms up as an open invitation. I think he wanted to talk. And, I thought, I'll ask him about the coca. He knows more than he is telling. I don't know anyone who really knows anything about it. He may be bluffing, but who knows. It is a taboo subject for just about anyone I have ever listened to, from magistrates to medical practitioners, gurus and, particularly, police experts.

'Good man!' he enthused. 'How long have you got?'

'All day!' I replied. 'Talk on.'

'I'll go and get a bottle and we can rabbit all day then.' He leaped up and went on deck and I heard an 'ahoy there!' as he clambered over to the next boat. Playing Kim's game, an old scout exercise in memory, I looked around me, taking in the silver cups on an old upright piano, certificates of excellence taped to the hull, old sepia snapshots, Polaroids, scribbles and phone numbers on paper, sketches, letters on headed notepaper, awards, newspaper cuttings, a school report, old books on popular science, a trumpet, a tattered penny dreadful booklet entitled *Tu Es Un Monstre!*, an alembic in need of a polish, complete with coiled worm, a 35mm strip projector, a strange bottle that seemed to be bones attached to a table leg, a music stand with a song called 'Bugger Bognor' placed on it, a violin in its case propped against the piano, and something I had barely noticed, when I heard his footsteps stumbling down the forecastle steps – it was the ceiling! The ceiling was festooned with chamber pots, lavatory seats, Victorian enema pumps, soil-glaze drainpipes, grease traps, earthenware urinals, calking tools, spanners, closet hoppers, faucets, tack moulds, basin wrenches, yarning chisels, a very old thawing steamer, bibcocks, a jerking shank and numerous blowtorches with assorted ends. He handed me a tumbler full of what looked like whisky – pale in colour as though watered-down. 'Port Ellen,' he said, 'from the cask – about sixty-four per cent proof. Twenty-one years old. Want some water?'

I nodded. 'Please,' I replied. 'Otherwise I'll need open-heart surgery. Must keep on my toes. Er – Mrs Stokes all right?' I stood

up and got myself a pint mug of water to spread the effects of the impending alcohol invasion.

'I think she must have gone out – probably to the stall. She has a hardware stall in the North End Road. Keeps her out of mischief. It was her hubby's. She likes to keep it going. Gives her something else to do.'

'Else?' I said.

'Well, she would just sit in nursing herself otherwise, and she hates afternoon telly. She says it's decadent. More loansharks and insurance claimers on it than bums on Skid Row. "Not putting my barge in hock just for the sake of a few readies," she says. She doesn't need a package holiday, and has got no use for a ride-on tractor-mower. Reckons there are so many moneylenders around, their front doors must be manhole covers. I did concur. She makes me laugh. Right! Where were we?'

'Goca,' I said, 'and Cavin's zziblings an' hizzart.' I needed to slow down on the whisky. It was stronger than it looked, and a red rubber suction cup hanging just above Cosby's head appeared to be melting from kitchen-fume rot and gas-stove heat. The fact that it was didn't lessen my resolve to go easy on the hard stuff. Cosby flopped down in an old, deep leather chair next to a corner cupboard of books, took out some Golden Virginia, and proceeded to roll himself a fat stoagy.

'If you are that interested in coca, I'll fill you in on some facts that nobody knows these days. The old knowledge has been conveniently forgotten. In fact they have made it illegal so that people don't get ideas about finding in it something that would make half the NHS redundant, but it's true. It's all part of the great power struggle conspiracy. If the NHS, the education system, social services and all general infrastructures of society had everything they need, all problems were solved, and administration worked like clockwork, then there would be no need for Government. Did you ever think of that? All those self-important gasbags and their toady officials would be out of a job. Coca would soothe away all need for legislation, broken election promises and religion. I guess you know where coca comes from, why it's sacred, and what it does for the constitution of a human being?'

'I'm not sure really. Why don't I switch on my tape recorder and you just chat on, and I'll tell you if I've already heard it.' What follows next is a mind-boggling transcript, verbatim, of Cosby Twing's story of coca, the sacred plant of the Incas.

'Sometime in the late seventies, I was lucky enough to get a Traveller's World Trip. I won it for being travelling salesman of the year. I was keen in those days – so was the competition – and could, if pushed, talk anyone into buying their own overcoat on a hot summer's day. Anyway, they asked me where I wanted to go, and I said South America. Don't ask me why, but I fancied it. Everyone was doing their own thing, so I thought why not me? Fanny was in therapy, the kids were into their own stuff, so off I went. I found myself in Lima, City of the Kings, an overpopulated, polluted, third-world kind of place, rats in the streets, Sendero Luminoso graffiti on the sides of old colonial government buildings, jerry-built real estate, open grounds of junk, and shanty hovels grey in dust at the ends of town leading into the coastal desert foothills known as the Cordillera de Los Andes. Everything was for sale, but I wasn't buying. The waste products of six million struggling hopefuls goes straight into the biggest cesspool on the planet – the Pacific Ocean – ha, ha! I was keen to get out of Lima and make my way inland to Cuzco and hopefully the higher slopes of the Andes, just to get a feel for the real. So I got on a coach, and shared it with mestizo Indians, their chickens, some campesinos, the peasants, and their llamas, which they tried to get to shit in a bucket. Llamas spit too! But they look nice. The smell sticks to everything, but it was nothing compared to the stench of fish meal that hangs in the air over Paracas where they process it for fertiliser, I think.

'The roads were terrible, but it's good for the liver, so they say. We moved inland, and began to climb. We crossed the Nazca plate, the most astonishing no-man's-land I have ever seen. They drove the Pan-American Highway straight through it without realising that its surface was decorated with some of the most intriguing alien symbols ever devised by man. It was only discovered in 1954 by some guy in a light aircraft. That's what got Gavin there in the first place, and he

saw it from an aeroplane too. You have to if you want to see those vast earth canvases covering hundreds of square miles. That's why I like the paintings. Gavin has conveyed the vastness of it all. Anyway, got to Cuzco, the Royal City, conquered by Francisco Pizarro in the sixteenth century, bit of history for you there, stayed a few days, and then got on a train for Machu Picchu. It happened to stop at a midway town called Ollantaytambo, and crowds of local women were holding up paper bags and what looked like plastic cups of ash. Obviously trying to sell stuff, anything, the poverty is pretty horrendous. Other people on the train actually started buying these bags, and cups of the ash. A few pesos were changing hands, so, out of curiosity, I bought some myself. The bag was full of dried leaves. I thought I had been swindled. Then some of the other passengers began ceremoniously pouring some of the ash on to a leaf, rolling it like a cigarette, and sticking it in their mouths, between the cheek and the gums. Then they sat back with a quiet look on their faces and watched the beautiful scenery. Meanwhile, I was beginning to feel pretty damn breathless. The train was steadily climbing, and we must have been at about nine thousand feet, and we still had a couple of thousand to go. I began to palpitate, and I could feel the panic rising in the pit of my stomach. I started sweating. A man obviously noticed my distress, because he walked across the carriage and pointed to my paper bag. He gesticulated and I caught on, took out a leaf and clumsily poured some of the ash into it, spilling most of it. Gingerly I shoved it inside my mouth and pushed it down. The ash was horrible and I was going to spit it out, or choke, but the guy admonished me with a wag of his finger. "Coca! GOOD!" he said. So I kept it there like a small boy whose doctor has told him to hold still.

'The train trundled on and I sat there trying not to throw up. I felt the strange thing in my mouth with the tip of my tongue. It was still horrible. But then I noticed something. I wasn't palpitating, there was no panic, I wasn't sweating. I actually felt fantastic, like coming out of the dark tunnel of a Hellish experience into the light. Everything seemed to slow down. The wheels of the train

clackity-clacked on the rails and I began to follow the rhythm. Nothing mattered, everyone else seemed calm, and, well – normal. I remember looking at my watch, but it was still on English time and nothing mattered. When we finally reached the tiny mountain station on the edge of a deep river ravine, I felt in all senses of the phrase on top of the world. There were more women there in those characteristic flat-topped bowler hats, and among the souvenir stuff they too had bags of coca and cups of ash. I decided to buy a year's supply then and there. I checked into the only hotel in the village like James Bond on a mission to meet the drug barons, and settled in.

'I chewed coca the whole time I was there and never once suffered from mountain sickness. I climbed the last fifteen hundred feet to the Lost Inca City of Machu Picchu, all thirteen hairpin bends of road, in an hour – on my hands – Ha, ha! It takes you a tortuous twenty minutes if you take the bus.

'Anyway, to cut to the chase, after watching the sun come up twice – probably the most spectacular natural phenomenon I am ever likely to see – like being in God's backyard, with its plunging ravines, towering ranges and breathtaking panoramas, though nothing was taking my breath away for real, I sort of found myself. I decided I had had some kind of religious experience, and I descended from the mountain like Moses, who forgot the tablets, but found something else – Ha! Ha!

'I determined to find out all about coca, its cultivation, its history and its sacred status in the hearts of the people of Peru.'

Cosby stood up and steadied himself against the piano, then reached for his violin. He fell over, stayed where he was, stuck the instrument under his chin, fumbled for the bow, and began to play *Liebestraum*. It was very moving, and as he struggled up again and sat down in his deep old chair, he put the violin between his knees and continued to draw a haphazard melody out of it. He spoke on: 'In places where the foot of man has not yet trodden, and such places still exist, the coca plant, a shrub, grows in profusion, uncultivated. The leaves resemble the orange tree, in shape.

'During the early ages of man, when the Amazon region was the garden of Eden, the Incas regarded the shrub as "the divine plant", so all-important and complete in itself that they called it "khoka", which simply means "the tree", beyond which all other designation was unnecessary.'

The story of coca is so intimately entwined with religious rights, superstitious reverence, false assertions and modern doubts 'that to unravel it is –' (*at this point the tape ran out*).

Cosby rambled on about Catholics, Hebrews, the Parsees, Zoroastrians, reproductive stimulation and the whole terrible story about coca's suppression by religious zealots.

'Am I being didactic? Don't get didactic with me! Sorry about that, but it is a wonderful subject for a sermon. Gavin is worse than me. He should have been a preacher.

'He has written an operatic work about the Nazca lines called *God's Drawing Board*. He imagined that the Nazca Plateau was just that, but God had taken the plan away, and what we are left with are those pressure lines, like you see on a telephone pad from the sheet above that has been written on with a ballpoint or pencil. God used his enormous pencil to plan His universe, but what we are left with are only impressions. The whole region, in Gavin's libretto, is God's laboratory, and that is where God planned a new universe for the third time. I think I can find you that piece, where God lays down

new ground rules, so that man has to do what he is told. No muckin'
about this time, or "the devils multiply", as Gavin wrote. I'll let you
take it away, if you want to read it in detail.

'Ah! Here's Mrs Stokes. Back from the fray. Doesn't she look
flushed? I'll make her a cup of tea, want one?'

'I think I ought to be going. I've been here all day. You must have
a load to do and I need to walk off the booze. The bit about *God's
Drawing Board* sounds interesting. I'll read it.'

'Suit yourself. Anything else you want to know, you know where I
am. Maybe next time we'll talk about Gavin. Ha! Ha!'

I left him with the sound of that laugh like a jackal ringing in my
ears. Must be a nervous old soul. Kind, but wacky. Had to be that, to
take on a neurotic, physically challenged mother of four equally
neurotic kids, who must equate life's shit train with toilets; like
survivors of a railway accident, who were all using the same loo at the
time.

# CHAPTER 17

# FANNY TWING:
## A QUADROPHRENIC PARTISAN

I was nervous. Meeting Gavin's mother was the one task I felt least able to confront. Although I had not yet met her, there were stories about her that made her sound like the mother of Svengali. I really had no idea why I felt that, but I did. I made my way round Chiswick's Hogarth Roundabout at the top of the Great West Road, and pulled into the garage that blocked any view there might have been from Fanny Twing's Georgian cottage on the corner of Church Street. In spite of that, an unexpected benefit was offered by a backside brick wall that shielded the little house from the constant noise of traffic. The street itself was pleasantly leafy, and made its way back down towards Fisherman's Wharf and a river frontage to die for, called Chiswick Mall. William Morris lived in one of the houses, making his daily chores a delightful routine, even before he had produced any work on an average day. A church, complete with a graveyard, added to the rural charm, and a pub on the corner served as a bastion against an horrific sixties monstrosity, the Cherry Blossom Boot Polish factory, further on round towards Heathrow. If that wasn't bad enough, a temporary-looking flyover spanned the roundabout and zoomed off crazily towards a featureless bridge over the Thames to Kew Gardens. Still standing, but smothered beneath this masterpiece of municipal vandalism, the house of the great English satirist and painter William Hogarth had survived the onslaught, by a whisker, I suspect, on account of its historic pedigree. It is still open to the public on certain days.

I bought some petrol, and asked the hole-in-the-wall cashier if I could leave the car at the side of the forecourt while I delivered a package to the cripple living at No. 1. This lie seemed to do the

trick, so I locked the taxi and carried my package obtrusively, as token credentials of intent. I had brought Fanny a bottle of rich tawny sherry and a selection of tapas tidbits, a habit she had picked up during her time in Spain. There was no gate, just a front door set back in an arched vestibule. I pushed on a bell which electronically played 'When the Saints go marchin' in', and waited. Nothing happened, so I pressed the bell again, and this time it played 'The Star-Spangled Banner', all the way through. There was still no sign of life. I was just about to press the bell again when a voice behind me said, 'If you are looking for Fanny, she is probably in the church across the road.' I turned, and an elderly cosmetic lady was walking a poodle with ginger-red ears and a shaved bald patch, revealing a recent ugly operation scar. 'She likes to go in there to change the flowers and candles. It's all she can manage these days.'

I thanked her and out of curiosity pushed the bell one more time. This time I got 'Take the "A" train'.

I walked across the road and up a ramp, through the open gate, and into the churchyard. I stopped to read the notice-board. 'Chiswick Parish Church. Worship has been offered on this site for over 1,000 years.' Wow! 'St Nicholas of Myra with St Mary Magdalene notices: Welcome. There will be a Jumble Sale on Saturday 7th June. Please bring your unwanted rubbish to sell on Saturday, the 6th. The umbrella that was left after last Sunday's service will be auctioned off to the highest bidder if not claimed beforehand. It is a very posh one, and seems to have belonged to the owner of a Mercedes Benz. The Vicar owns a Morris Minor, which is also for sale.' 'Choir Practice Tuesdays and Thursdays. Many come but few are chosen.' 'Lost. A Poodle with red ears. Answers to "Arnold". Has recently had an operation for incontinence. Please call if you have seen him. Please call anyway. He is named after my dear late husband, a sufferer.' There were a few other limp notices about allotments and chess championships, but the weather had rendered them illegible.

Someone had been at the undergrowth with a strimmer, and the headstones stood like wonky sentinels that no longer served the original purpose. All the carved letters had worn away to meaningless

surface marks. No one was buried there, they seemed to declare, or if they were, any relatives had moved away long ago. How many life-spans does it take, I wondered, for someone's memory to be eradicated? Did they have a good life? What did they do? Were they broke? How many mean tricks had they played on their loved ones, and were they just a constant pain in the ass? Had they known William Morris, and what could they tell me about him, or Hogarth for that matter? It must have been a country village in their time, and these were not paupers' graves. Everyone would have turned out to line the route for the send-off. Hats doffed, forelocks tipped, and pints quaffed to their memory, as they thought to themselves, Who's next? Graveyards are great places for contemplating mortality. The ghosts always seem readily available to invade the mind with fleeting thoughts of what had been, and what the point was, finally.

I meandered through the cut grass, and the raised box tombs, the names on them still fairly legible. Manners of death were recorded, like 'killed by boxing', 'endeavouring to go over ye railings in ye night. Jabbed in ye vitals', 'hung by ye neck from bell rope', and 'burials of ye poacher, soapboyler, swordsman, wheelwright, butch-ers, bakers and candlestick makers, brewers, ladys of ye nyght, all are forgiven in Him', and 'duchesses, one Duchess of Cleaveland, mistress of Charles II, highwayman who f*ll unde* wheels of y* co*ch', all dating from the early 1700s. An imposing monumental tomb surrounded by railings stood ominously proud, overlooking the river. 'William Hogarth, painter, engraver and caricaturist. 1697–1764.' That's it! There he is – my presence was a pilgrimage, no less. Nearby, the tomb of James McNeill Whistler, a sombre black effort, not quite his style, I would have thought, if he had had a choice. And to his left, the crucifix tomb of Henry Joy, the trumpeter, who sounded the 'Charge of the Light Brigade', and died from it in 1893. It was time to overcome my nervousness and charge into the church.

I pushed open the door and peered inside. Through the quiet gloom I heard a soft squeak of wheels moving over the tiled aisles. Then there was silence. I looked at the leaflets and found a brief history, various

charitable causes, and an invitation to look at the church records by appointment. There was mention of Oliver Cromwell, whose headless corpse had been exhumed from Westminster Abbey and moved to Chiswick. 'We are sending you to Chiswick!' 'No! No! Anywhere but Chiswick!' 'Anywhere but Chiswick?' 'No! No! Chiswick!' I peered through the gloom. There were monuments to war heroes from both wars, royal arms of past monarchs, second-class, and a beautiful font set inside the area of the old tower, in appearance the oldest section of the building, and which turned out to have been built of Kentish rag stone in 1425, a halfway time from the age of the original pagan shrine, upon which the church was established. The bricks of the old church had been ground down and mixed with the mortar, a direct link with its past. Chiswick was a fishing village, 'Chesewic', cheese village, or cesil, a landing place for sailors, shipbuilders, farmers, basket makers and local whores, it seems, who lived in a row of cottages called Slut's Hole, against the riverside wall of the church. The river was Chiswick's life, the parishioners' lifeline, which must account for its local saint, St Nicholas, patron saint of sailors and fishermen – and, strangely, of bankers and pawnbrokers. I wondered how the whores made a living, and thought of passing kings and bishops on their way to Hampton Court, the Thames being the main thoroughfare from Tudor times onwards.

I looked past the intricately carved choir stalls lining the chancel, towards the carved alabaster screen behind the altar. A figure was standing on the altar. Not exactly standing, but doing a handstand and waddling backwards and forwards across its length. I ventured in and walked down the aisle towards it. It was a woman. It was Gavin's mother! I could tell from the sidelong look in my direction, not exactly regarding me head-on. Gavin does the same, as though he couldn't care less.

'Are you a vandal?' she snapped.

'Well, er – no, not me, well, not all the time anyway.'

'The last time we had vandals here they burned the organ. That was in 1978. Little bastards! Stole the money from the poor box, too.'

'Are you Mrs Twing?' I said.

'Sometimes,' she replied.

'Well, I am Ralphael Steed. I rang you and asked if I could come and talk about Gavin.'

'Oh, you. Beg your pardon.' She was still doing a handstand on the altar, which was quite impressive, and I think my mouth fell open. 'Just a minute,' she said, 'I do this when I am alone in the church. I suppose you know it used to be a pagan site, about a thousand years ago. This helps me get in touch with the vibrations of the earth. Spirits will always choose the devout centre of any religious establishment to make contact. Besides, this makes me feel whole again, like a walking person, unshackled, free from the bondage of earthly mechanical aids. Quite impressive, don't you think?'

I nodded. 'Take your time. Don't mind me. If I may say so, I expected you to have – er, dimensions? Good word?' I tilted my head quizzically.

'Perfect word!' she whooped, and in a pretty deft way dropped down on her backside and slithered into her wheelchair in one practised movement. 'Vicar doesn't like me doing that, but I call it my spiritual therapy. He says he is worried I might fall, but I think he's worried in case he would be liable for damages. But not much more can happen that hasn't already happened, if you see what I mean. Do you know anything about this place?'

I said I knew about the famous people buried here, and the old fishing wharf when Church Street went straight down to the river, and the cottages terraced along the front.

'I love it here,' she said, 'though there's only one seriously old piece left, the tower, and even that lost its octagonal corner tower when it was all rebuilt. The rest was sacrificed as being too expensive to repair, even though it had a rare walnut hammer-beam roof, which was discovered under whitewash during restoration. But it had to go. Rebuilt by a local brewer, y'know, related to Fuller's Brewery round the corner, late nineteenth century. Must have been a pillar of society, paying his way to Heaven. It set him back £8,000! Are you interested in old things, history?'

'Very much,' I said.

'Then you ought to look at the old records. They are a hoot. Go back as far as 1622, and would have gone back further if Oliver Cromwell's men hadn't burned them to keep warm. That's the story anyway. Follow me, I'll show you. In the vestry. It's pretty well a who's who of births, marriages and deaths. Old Monty was married here in 1927, whose father was a bishop. Charles Fox, the Whig politician, was baptised here. He was also crucified – but not here – by James Gillray, the satirist. The Earl of Burlington's black servant, Joseph Caesar, was baptised here. And look at some of these entries.' Fanny carefully pulled out an old heavy ledger, and placed it gingerly on the vestry table. Opening it at random, she read out some of the exquisitely hand-written entries: ' "Waterage for poor Goody Crowe to Bedlam who was distracted, For mending the howre glass in the church, For bringing by water the timber and boordes that mended the churchyard rails, For a sheet to burye a creeple." Huh! Bet that's all I'll get – "Stowlin out of the church, 1552, valuable plates, gold artifacts, and pictures, leaving only 2 brass potts and 4 pewter dyshes." Edward VI that was. Greedy buggers, royalty. The brewer really tried hard. The brass lectern with the eagle on it was a gift from him, that one down near the chancel, as was the stained glass window of Death, Resurrection and Ascension. In fact he paid for most of it – must have been a guilty man, I'd say.'

'You're probably right. Probably got a visit from the Temperance League. A favourite target of do-gooders. Pay up, or else, hellfire and damnation!'

'That clear glass window over there on the south wall of the chancel, I have virtually commandeered that. I call it Gavin's window. I would love him to submit a design for a stained-glass one. It needs it. The old one was destroyed by a bomb in the last war. He's thought about it; never done any stained-glass work though. Makes him a bit nervous. But for all his faults, he has produced a couple of designs based on something he said he has already done as a sculpture. Do you know anything about it? He said he has an idea to do Christ's bride stripped bare by her religious mechanics! What the Hell does that mean?'

'I think he might be referring to a mechanical sculpture he produced in France, on our way down south a while ago. That was the title of it, anyway. It might be a bit radical for here, but the time is ripe for such a statement. It would definitely make people think.'

'That's what worries the vicar. He says it might distract his congregation from his stirring sermons. He doesn't want them to think while he's preaching, not about nude pictures of Jesus anyway. Is it sexual?' she asked me.

I said I must ask Gavin to explain it.

'He told me he sees the window as part-shrine, like the Chaloner Memorial in the lady chapel, a kind of nativity. "Collage", he mentioned. Objects dredged from the Thames and set into the coloured glass, a sort of symbolic connection with its history and the river. I quite like the idea. We argue a lot, but sometimes he makes a lot of sense. Just a window isn't his idea of a challenge. Since the old window was blown away because of war, he sees a certain significance in the window reflecting that disaster – as though Christ is stripped by the mechanics of human destruction and, worse still, so is the mother figure with child – using the wheelchair as a symbol of tragic events. The wheel, he said, is an abstraction from the explosion, every explosion. I wonder who he is thinking of?'

'Maybe it's his roundabout way of telling you he loves you, and hates war. I think it's a great idea. Are you on good terms with the vicar?'

'He pops in from time to time. He persuaded me to be baptised, y'know. My father didn't believe in all that tosh. He used to say that a font immediately made him think of washdown water-closets, and how impractical fonts were, because there was no flush mechanism. "What made the water in them any more sacred than the same water that's flushed down one of my loos?" he said. He was a ghastly reactionary, a Blackshirt no less, but I agreed with him about that. One of the most thoughtful things he ever said. Sprinkling bacteria-infested water on an innocent infant was not his idea of a blessing and more like a curse. I insisted that the water was boiled before the vicar

threw it over me. I wasn't taking any chances. People actually believe that sacred water means that it is free from germs and potable. It's heaving with bacilli, for God's sake! or not for His sake either, in a manner of speaking. But because the devout can't let practical common sense rule their beliefs, boiled water suggests to the feeble-minded the Fires of Hell. Some don't even think that the water comes out of a tap!'

'Did it make you feel any different?'

'It just made me want to go for a pee, so the service was held up until I had been. It made the vicar laugh, actually. So I knew he was human. So you think that Gavin's idea should be taken seriously, then?'

'More than ever, I would say. I watched him working on the massive *Christ's Bride* sculpture in France and I knew then that he harboured a strange ambivalent belief, as I think you do too. When did you last see him?'

'He was down here a week ago. He brought me some cheeses from France. I'm a sucker for cheese and wine, though I am rather partial to sherry, since my brief scuffle in Spain in the thirties.'

'I've brought you some, because I'd heard you liked it, and a spot of tapas.'

'Oh! You doll. Let's get back to the house and have some lunch.'

Fanny Twing insisted on leading the way with a skilful piece of bump-navigation. It was obvious that she had done this kind of thing regularly, owing to the score-marks at a certain level throughout the church. Fanny blames it on the spirits who try to claw their way into the vestry in search of sanctuary. The vicar doesn't dare argue, for fear of sounding prejudiced. 'What? Against spirits?' I remark.

'No. Cripples!' she snaps. 'Ever since I told him that I thought that Lazarus was as phony as his religion. Any slob on his knees can stagger into the arms of any evangelical sleazeball and plead for an instant cure, get slapped on the head, then get up and walk away to collect a reward behind the marquee. You don't even need to carry a

bed. Just look as stupid as the congregation, and people will believe. Water into wine is the oldest conjuring trick in the world. Tommy Cooper showed me. Permanganate of potash. One particle secreted in the palm of your hand will transform a glass of water into rich ruby-red liquid instantly, but you don't want to taste it. Tastes like iron. But they don't mention the taste in the Bible. There were no wine-tasters discussing the oaky, chewy, full-bodied, plummy, peppery, tannic, diffuse, exuberant long finish of the wine, but I'll bet there were a Hell of a lot of people spitting it out.'

'You don't believe in miracles, then?'

'Only if it feels good. No point in rejecting life if it's motoring.'

We reached the front door of her house. Fanny rushed at it like a ram-raider, and the door opened before her.

'Aren't you afraid of burglaries?' I said.

'I get them all the time, but it's company to have someone in the house occasionally. It pisses me off if they steal the last of the milk, or the last of the sliced bread. It means I have got to go out again and that white crap at the garage is really foul. I told Gavin not to bring me any of his masterpieces either, particularly his cut-metal ones. I don't want to be sued by insurance companies for harbouring hazardous waste on my property. Anyway, international art thieves haven't caught on to Gavin yet. He hasn't yet appeared in the Christeby's catalogue, the rogue's price list, so he's safe for a bit.'

We move through to her kitchen that has been adapted to suit her every need at her level. Cupboards, the sink and all drawers. Door-handles don't exist. She points a remote at doors and they swing open. Light switches are on remote. 'Let me show you the toilet,' she says, 'in case you are too polite to ask.' I follow her to the back of the house and a door opens to reveal a bathroom so automatic as to leave the user nothing to do but sit back. The toilet flushes before it is used. The shower comes on; Mozart's *Jupiter* symphony oozes gently from speakers in the ceiling. Then she turns deftly, wheels herself out and the mod cons switch themselves off. She aims her remote at the wall back in the kitchen, and a table slides out of the wall, and plates are already in circular wells set into the table. 'There you are, young

man. Pour out the contents of your cornucopia of a plastic bag. I see you've been in Harrods food hall. Looking for glasses?' A triangular cupboard swings open at her height, full of glasses and a selection of drinks. She proffers two sherry schooners. 'I don't know what you want, but I'm for the sherry.' 'Me too,' I say, breaking the seal on the screwtop and pouring. 'Cheers!'

As I took a swig from the glass, my eye caught sight of one of Gavin's pictures on the wall, and then another. Both were pictures of his mother in a wheelchair, one quite serious, the other a caricature he had done of her for a birthday. There was also a photograph of the bombed refugee child sculpture he had made from an old pram he had found in the Thames mud. It was a powerful image of vulnerability and pathos, without an ounce of sentiment.

'Does that sculpture still exist?' I asked.

'Maybe,' she replied, 'but Gavin has the silly habit of scavenging from his own work to make something else and that hardly adds up to a complete collection of anything.'

'I believe your father idolised you, but you turned against him?'

'Is this book about Gavin or me?'

'Sorry, I don't mean to be nosy, but each incident and revelation can often help to explain my subject, or show influences and whence they came. Don't tell me anything you don't want to. But your own life is not without its drama.'

'Oh, sure! Fanny, the wilful child. Fanny, the human water-closet. Fanny who used to pretend to use her father's products – but I just weed on the floor and pulled the chain. I would tell him that it was the bad design that made the floor wet. But it was my protest against his attempts to put his precious daughter into lederhosen, I wasn't going to let him. I think he really had wanted a son, but my mother thwarted any chance of that by eloping with our chambermaid, and we never saw her again. Just postcards from Italy, and a hefty deposit in a bank account she opened for me. So I knew she was thinking of me. Guilt is stronger than love.

'A new romance was out of the question for my father, because his whole conversation pitch revolved around plumbing. Any potential

relationship was doomed from the start, because ladies would simply have a fit of the giggles and that, I guess, is the death of passion. My behaviour was the last straw and my first political protest. He began to detest humanity. As fate would have it, he attended one of Oswald Mosley's meetings in Burnley, when Mosley toured the north looking for unemployed malcontents to enlist and give them a new purpose. It was a chance to cause industrial unrest and bash the bosses. He must have heard what he wanted to hear, because that very night, he joined the Blackshirts and gave Mosley some money; hence his immediate rank status as a lieutenant, and being a boss as well put him in the pure league. In some perverse way he related Fascism to a kind of social sanitation, so he was in his element. I am never surprised by anything people believe in. I believed in running, running from my father, I imagine. So I ran fast and then faster. I hated everything my father stood for and that was my spur. I made the Olympics. I'm proud of that – and knowing Jesse Owens. He hadn't got a political hair in his body. Lovely man, and what an athlete! Through his successes he unconsciously aroused hatred in Hitler and I joined him to augment Hitler's anger and get back at my father. The three-legged race that never was – ended up on the cutting-room floor, along with the loo pan I carried just for the ridicule and as a symbol of shithouse trash, which is the hallmark of all tyrants.'

'You see, now I know where Gavin gets his moral indignation from. Do his brother and sisters share any of this protest?'

'Not if they can help it. Too busy carving out careers for themselves. Paloma comes to see me sometimes, but lives her life dribbling down her mobile. Writes about fashion. Never stops. Well, she keeps the same words and changes the names and a few superlatives. I tried to get her to organise a catwalk show for cripples and mutants and the blind (as long as they were given a dog, fashionably dressed, of course, like us). Dress us all up in feathers and backless slips, impossible shoes and daft hats. Shove us out there and watch us slither and stagger like refugees, into the spotlight, to the music of Elgar at the Last Night of the Proms. She

was horrified and hasn't spoken to me for weeks. The idea fascinated Gavin a lot. He wants to design a whole show as a kind of living installation and put it on at the Albert Hall. It's not as sick as it sounds. He has always considered all life as perfection and, as an artist, inspirational. All infirmity is lamentable, he says, but not without hope and a limitless source of food for thought. His idea is quite ingenious. He wants to create a gigantic orrery, a mechanical solar system, with a single power source. Yes, you guessed it! A paraplegic in a wheelchair, driving the whole universe. Cyclists have driven machinery on the back wheels of bikes. Why not someone using their hands on the wheels? You can generate a lot a power that way. It has nothing to do with pity, you see, just ingenuity. Sketches exist for the idea, but no one has taken him up on it yet. Everything is cyclical. No pun intended! That's my son; I admire him for it, in spite of my bitching.'

Fanny reached for the bottle, but I picked it up and leaned over. She pulled her glass back and said, 'I'll pour. There are some things I'm still good at.'

'How about your other children. Two, aren't there?'

'Oh, Nancy, her twin, got an exchange with someone on the West Coast, met someone from Bolinas in the wine trade, so she stayed on, she's into that, and she seems happy enough, but I think he drinks more than he makes. She has her own private fermentation tank with a lock on the cellar door. She has that in common with Gavin. Attention to detail, and a love of good wine. But Gavin's brother is a whole other ball game. Crispin is forever in and out of rest homes for scarred children of crippled mothers. Has Gavin talked about him? Maybe not. Gavin sometimes gets him to sit for him and not out of pity either. He is fascinated by the way Crispin can't sit for more than half an hour before slumping over and weeping into his hands, like he is carrying the whole world on his shoulders. Gavin is in tears before he can ever finish a drawing of him, so that is how they stay. Unfinished. Well, there are unfinished symphonies for all sorts of reasons, why not drawings? Unfinished watercolours, Gavin calls them, which is the only time Crispin laughs. Not a happy man, not

at all happy. Shit! I don't know – who's happy? Are you happy? Does it make you happy asking all these damn fool questions? It is only a book and it's only my son. This is a wheelchair, and I am in it!' She pounds it with the palm of her right hand.

'Shit! Shit! Shit!' Her sherry shakes and spills in her left hand.

I move to get a cloth and wipe it up. 'Leave it!' she snaps. 'I'll do it later. This time you pour and pass around the tapas. I think I sometimes do it on purpose, just to annoy myself. My head is somewhere else and careers around in space tapping into conversations with dead people. Why should I talk to you when I can chat to Max Planck about his Quantum Theory? It's good to know that, dead as my legs are, they still give off chunks of radiation – I've got atomic legs! Just like they used to be.'

I smile at her quirky humour. 'What are you smiling at? It's not funny, y'know!' I mumble to apologise, but she cuts me dead. 'I am a victim of the Chaos theory – that's right! the Chaos theory. I read about it. If I hadn't defied my father, hadn't gone on some damn idealistic crusade to prove something, hadn't stood next to this sweet blathering hero, who caught a bullet straight through – guess where?'

'Surely not there—?' I pointed with my index finger.

'Nothing so romantic. It went straight through the wallet he kept in a breast pocket next to his heart, deflected through his shoulder as he dived over to save me – a reflex action, I guess – and into my thigh, shattering the ilium, the flat bone at the top of the pelvic girdle that shapes my hip. Otherwise he'd have been a goner, and I wouldn't be a cripple. So, according to Chaos theory, the bullet had not yet reached its destination. The grand design was not complete. I had to be there to prove it. A random event, a linear system at work, the bullet from a gun, predictable until it hit his bloody wallet, God knows what was in his wallet, knocked him across me and became a nonlinear complication, as the angle of deflection was impossible to imagine – and became a sequence that would be impossible to do again, since I wasn't going to see if it could happen twice, though it could, so I'm told, by one of my dead friends, if you were daft enough

to try. Mind you, having four bloody kids all at once didn't help the situation, though that has nothing to do with the Chaos theory. That was just sheer bloody carelessness and the bugger didn't even hang around to find out. He was chaotic: he was chaos all right and weak. The whole lot of them were. The Beats. Chaotic, self-indulgent, weak and strong and feckless enough to push the Chaos theory through anybody's wallet, until something good emerged – which of course it did. Chaotic commitment. But that was years after my mishap – fifteen years. It was a contributing factor, though –'

'Ever heard from him again – the father?'

'Howell? Nah! It was a "pity" relationship. Never have one of those. I had a permanent limp and Howell, who had a small apartment in a run-down part of town, old warehouses, Third Street, I think it was called, railway yards, and cobbles, would help me get my shopping in – with the main chance in mind – and a free meal as well. It became fashionable in the sixties when *Rolling Stone* started there. Anyway, long time ago. I was going to have an abortion at first, until I found out it may be quads. It would have cost a fortune in America. The National Health Service was in full swing by this time in England, so I came back, didn't worry my

father and discovered that my mother had set me up with an income.'

'What happened to your father? Did you see him again?'

'Just about. He slipped on a wet tiled floor, and hit his head on the rim of a toilet. Got concussion and was never the same again. He didn't recognise me, particularly in a wheelchair. Thought it was a motorbike, and I was some kind of biker. I told you: he always wanted a son. He never forgot that bit. When he died, I let bygones be bygones and had the old bugger buried in the churchyard over the road. But I had a last laugh. I had him laid out with his head down a toilet pan and a broken chain in his hand. The bastard wasn't going to get away scot-free. The vicar was a bit miffed at first, until I told him I was burying the business along with him. "It was his whole life," I said, "so it's the least I could do for him in Heaven. You never know. If there is a life after death, he may get taken short. Got to think ahead, vicar!" I got a smile out of him. "Pure logic," he said and put a toilet roll in too. "A gift from God." That did it. It cemented my relationship with the church. My father had left me what was left of the firm, so I bought this place.'

Fanny yawned and I got up to take my leave.

'Before you go,' she said, 'be a darling and get me another bottle of sherry at the garage offie. I'll give you the money.'

'Have it on me. My pleasure!' I nipped around the corner, only to find that someone had put a 'For Sale' notice on the windscreen of my taxi. I went in the garage shop and enquired.

'It was either that or start taking passengers. I'll give you two hundred quid for it, mate.'

'Done!' I said. 'And throw in a bottle of rich tawny sherry. Her Ladyship at Number One is thirsty. I'll get the Tube home.'

# CHAPTER 18

# BEATING THE SYSTEM:
# TITE MODERN INSTALLATION

Gavin has at last found a venue for his monumental plumbing extravaganza, *Beating the System*. The installation requires space: space to incorporate the pipework, probably a mile or more and fittings, i.e. bathtub, washbasin, upstairs toilet, stack pipes, S-traps, guest washbowls – two – main traps, rain leaders, waste pipes, leap bends, downstairs toilet, vanity hand-basin, kitchen sink, central heating radiators, boilers, header tanks, cleanouts, inspection covers and disposal outlets. All this must be installed *in situ*, but minus walls, floors and ceilings. What we take for granted as a very utility, but desperately necessary, part of community life can be viewed through new eyes, naked pipes entwined in space, as it were, describing a sculptural ballet, suspended. The house will be there only in our minds, a phantom dwelling. There must then be surrounding space also, to allow for viewing, including gantry platforms and sensation rails, enabling multi-elevation vantage points to minimise vertigo and other agoraphobic possibilities. Gavin has also suggested mountaineering equipment for those energetic enough to want to scale the outer elevations of the structure, for fresh-angle viewing and also for gymnastic photographic opportunities. Above the whole construction, trapeze artistes will be seen performing triple spins and exchanging somersaults in threes; and through a fine transparent nylon net spectators can experience the sensation of watching figures in a space described and marked out by the whole plumbing system. Gavin suggested baboons as an alternative and fundamental substitute, but was discouraged by an animal rights group.

The appearance will be one of weightlessness. As Gavin himself has remarked, all ideas are weightless in the mind. The most

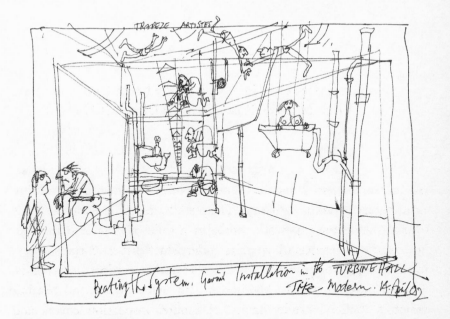

monumental edifices that were ever created by man begin as weightless dreams in the mind. Some are never realised. Frank Lloyd Wright's Mile High Building is still only a dream and a drawing. Maybe one day someone will find the finance to realise such a scheme, maybe in space, where it will remain weightless, and maybe a thousand miles high. A city for giants.

Everything is ordered. Everything is in place. Pipes, compression joints, angle swerves, quarter bends, Y-joints, running traps with handholds, hub-vents, trap screws, S-traps and hopper locks. The Tite Modern Turbine Hall is big, but is it big enough?

I turned up early for the plumb-in of Gavin's most ambitious work to date, *Beating the System: the Pipes of Salvation*. It is an outrageous challenge to the magnitude of a seventy-year-old 300,000,000-brick building that has seen it all come and go. The problem is the site. The massive entrance has a sloping floor. Gavin's installation MUST be absolutely plumb. Plumbing systems, as it is, work at minimum tolerance on level sites. Bureaucracy cannot solve such ordinance discrepancy. There can be no compromises. Gavin suggested to me that perhaps administration has been the problem all along. Not

with art, but with an institution that contains it. Planning exhibitions has been based on cockeyed inclines in odd situations, with no compromise, for nigh on one hundred and fifty years. Nobody liked to say, 'Excuse me but can you tilt that armature a tad to the left?', because, as a rule, most artists are only too flattered to be offered a site at all, and the last thing they want to do is offend someone who has the ear of someone who can drag the whole thing crashing to the floor. Which is why most installations look wrong. This is the easiest part, too, and the part that most people in positions of power relish and embrace. They absorb weaknesses as faults and mistake wrongness for imagination, instead of looking at them as virtues, conceived by the artist. They don't have their job because they LOVE art. They LOVE the job because they have the power to destroy art.

Committees thrive on the realisation that they are all sitting around a table, with nothing better to do than destroy a perfectly nice person, along with their work, and anything else on the agenda for that day. Their obscene sense of power is absolute and their point is malevolently taken. Corporate sport is now a respected way to spend one's time, accepted by those who carp about art as a money-wasting conceit. They grovel in their feedbags to support any new sports stadium that might have a hope in Hell of giving them something to do for the next ten years.

Gavin knew this only too well. He had devised a sculptural system of communal necessity, not as art but as a vital statement of something that we must all acknowledge: sanitation. Without an effective, efficient apparatus for disposing of our worst nightmares, we sit helpless before the might of contagion. Without art we also sit naked before the contagion of banality. We sit, and we shit our worst fears – as the perpetrators of natural mistakes and the receivers of their consequences. We sit and trust that everything works. The Philosophy of French Plumbing is a euphemism for what we have created. Art is an inoffensive sidestep to somewhere we would like to go, if only we would let it by helping it on its way. But that is too easy, and as a rule puts others out of a meaningless job.

Gavin's present quixotic assemblage owes everything to the past,

the awe-inspiring necessity of what he was constructing in a place that owed its very existence to the clamour for efficiency and thrust. A defunct power station. This was his moment to download all the frustrations of life into what had been an architectural tip but had been renovated for Gavin's very purpose. He could not let them down because there was no alternative. This was the ultimate dump. This place would live in infamy as the place where they allowed the fibrillations of a fevered mind full rein to remind us that we are what we eat and this is what we are. 'I am, therefore we are' is the Philosophy of French Plumbing, a system of undeniable rectitude. We all belong to this system and there is no escape. Gavin challenges us to confront our own reality and the dangerous liaison we acquiesce to for the sake of a quiet life.

'Where do you want this, guv?' It was an honest working man. A-more-than-my-job's-worth, salt-of-the-earth kind of a man. Someone who will put whatever he has brought for you anywhere you want – but don't change your mind. You are expected to know the exact location of everything in life, to the nearest inch. There is no other conceivable movement after delivery. The job is done and second thoughts are no job at all. 'There's free fousand, free 'undred an' firty-free yards of copper pipe, mate.'

'Ah! The Pipes! The Pipes! I hear you calling me.' Gavin bowed extravagantly towards the truck and the man looked at his mate in a 'right-one-'ere' kind of way.

'See that big door there? Straight through there – and – and lay them – er – exactly one metre away from the wall.'

'What's a metre, mate?'

'A yard.'

'Right, mate. No problem. A yard it is – and two yard ends?'

'Ends?'

'Two yards in from the end of the door.'

'Oh, yeah, right, see what you mean!'

'Where d'yer want the compression joints? There's free ton of 'em.'

'Just over there, but don't obstruct the fire hydrant.'

'What abart the barfs?'

'Barfs?'

'Yeah. There's free of 'em.'

'Oh, BARFS! Of course. Right next to the compression joints. Line 'em up. Thanks.'

'And the free bisons? Same place, mate?'

'Same place.'

'Free toylits. Same place?'

'Sure. Same place. Is that it?'

'Nah, mate. There's firteen radiators, free boilers, free expansion tanks and free 'undred an' firty-free fermal couplings, darn pipes, risers, waste mains, soils, stacks, stench pipes, traps an' rubber gaskits.'

'Fantastic!' said Gavin. 'Looks like it's all here.'

'Sign 'ere, mate. Oh, fanks!' Gavin handed the man a fiver and handed his mate another one. 'My ole man used ta work 'ere for the Electrici'y Board. Changed a bit. Wa's it gonna be nah? Another fuckin' 'otel?'

'Something like that,' said Gavin. 'The plumbers will be here any minute. See ya!'

The plumbers, Barry and Eric, turned up like extra parts on the same conveyor belt, with tool boxes as big as dump trucks.

Gavin greeted them warmly as vital elements in his plan.

'Barry er –?'

'Barry! Barry Eric.'

'Oh, yes, of course. And Eric er –?'

'Eric! Eric Barry.'

'Of course. Welcome!'

These were the men who really mattered and capable of plumbing in a free-storey block of flats in free days. Fermal couplings, no problem, up an' runnin' in free 'undred 'n' firty-free flippin' hours, an' always firsty. Gavin knew the score and made sure that these men were treated like gods of creation, for right now that was exactly what they were, or there would be no creation.

'I've bought wood to build a platform for the base drains. Work from the bottom up, I should think. No digging either! Ha, ha! They have in-house prop builders, unless you'd like to do your own carpentry.' The in-house crowd were there in free minutes and, since the only thing required was a perfectly plumb platform, it was up in free hours flat, according to Gavin's accurate plan. And a 'membrane' was laid across the flat surface.

Barry and Eric set to work. They took a look at Gavin's intricate plumbing diagram, said, 'That ain't gonna work, Rembrandt. Leave it to us' and set about their task as though some magic button had been pressed. I watched stunned, overawed, piped and pooped, as two virtual pipe dreamers clung, wrenched and swung around the growing spatial quota of Gavin's provocative linear poetry. Quite suddenly, Barry stopped in mid-wrench.

'When's your brickie turning up, and the flooring? You're gonna need floorin'! You specify free barfs, not to mention free boilers, free bisons and header tanks. How you gonna support them?'

'Oh! Sorry,' said Gavin. 'Didn't I tell you? We're not having walls, or floors or roofs, or – anything else really, except a safety net –'

'A safety net? You're gonna bloody need one, old sport!'

'For the trapeze artistes, definitely. When you need support, fliers

will be lowered from the ceiling and all will be hoisted up in place, including yourselves, for you to apply your skills as the need arises, like fairies, flying through the air. Tinker Bells, wrenching here and wrenching there, on a mission of monumental madness. You will be paid for indulging my madness. What more can you ask? A pension scheme?'

'Wotch it! You takin' the piss?'

'Never! Imagine it! Flying through the air like bumble-bees collecting pollen from flower to flower, only you will be jointing and wrenching, suspended exactly where you need to be. Imagine plumbing in a whole block of flats but having no block of flats to get in the way. That is more or less it in a nutshell. I thought you picked that up from the plan. You usually complain about difficult corners, obstructive partitions and walls and lifting floorboards. Well, here, my friend, all you have is thin air, so that all your fine work will be visible for all to see and admire.'

'An' what do you do in all this?'

'Simple,' said Gavin. 'I devised the concept. I articulated its devising and realised it as a possibility. Like it? No awkward corners, no tearing or hacking out of existing obstructions, no cursing in the dark. Nothing! Nothing but thin air between you and the construction of your own masterpiece. It should be as easy as looking at my drawing. Your art will be my art. We will share the glory. The Three Plumbeteers! All for one and one for all.'

'That's different then. Why didn't you say it was an installation, plain and simple? I do watercolours myself.'

'Then you of all people will appreciate the situation. We are brothers.'

'Gotcha! No problem. We'll have this up and workin' in no time at all. As long as the man on the mechanical hoists is a professional, it'll be a doddle. Pass me me blowlamp!'

Three days later, what Gavin was looking at surpassed even *his* wildest dreams. The delicacy of pipes articulating spatial volume brought a lump to his throat, and a tingle of fulfilment through his

whole physiological being. It wasn't so much to do with his floating feet, or levitating extremities, Gavin felt a surge of alimentary pride, as his inner, upper and lower intestines hummed with well-regulated rudeness. His inner self was in harmony with his externalised spirit. He, his art and his team of helpers had reached up and touched the swirling parameters of Heaven. Together they had beaten the system and put it firmly in place for all to see. Suddenly, there was no difference between work and play, art and commerce, pipes and lines of poetry. There never was any difference between art and work, work and fun, music and sound, fish and chips. All is life, all is poetry, all is art and everything is music. Gavin, at that moment, touched the prick of Heaven with his index finger and drew blood.

'Ahem! Excuse me, sir. Are you responsible for this edifice?'

Standing like Cleopatra's obelisk, slightly askew, with his weight on his right foot, was a stern gentleman in a long black astrakhan coat, holding a beige folder under his right arm and a Parker de luxe ballpoint in his left hand, at the ready.

'If you wouldn't mind showing me your D45 specification forms, planning permission ordnance survey particulars, plumbing licence authority exigency clearance, terse and concise elevation plans for the erection of perpendicular projections. I will need a "relevant use" permit which specifies use as a workplace of a kind to which Part 2 of the Fire Precautions (Workplace) Regulations 1997 (clause 6) applies, or a use designated under section 1 of the Fire Precautions Act 1971 (clause 7), whereby a "relevant building" is a building where it is intended that, after completion of building work, the building or any part of it will be put or continue to be put to a relevant use, sir.'

'Of course!' replied Gavin, 'in triplicate, of course. What we all say three times is true. Yes?'

'Naturally, sir. I take it you have those forms at your disposal. We shall need to see evidence of such documentation within three days from the issuance of this notice, otherwise such demonstrations of active elevation without such permission deem it necessary that the – er – articulated edifice before me be dismantled, and completely demolished.'

'I see.' Gavin's face became a picture of utter confusion, of perplexed resignation and a face like anyone else's in a firestorm.

'Tell me more, Mr er –?'

'Mr Lemley, sir. Avis Lemley, approved Inspector to the Secretary of State for Regulatory Bodies concerning Designated Scheme Approval with or without approved regulatory permission and in accordance with public declaration that such work is in an approved category, or deemed a denigration of the site specified as an offence against public taste and/or decency within the bounds set forth and in contravention of a law, thus causing a breach and henceforth, unless proved otherwise, against the law, sir.'

'What if it is art, Mr Lemley? What if it is art?'

'Well, sir. There are certain grounds upon which a local authority can process your application, excluding art, which has no bearing in any court of law, as per today. The grounds on which a local authority shall reject a plans certificate which is not combined with an initial notice are those prescribed in Schedule 4. The grounds on which a

Portrait of a Man Surrounded by His Bride (letterpress block printing)

*clockwise from right:* 3 plus 2
(woodblock print); Cargo
(fragmented zinc plate print)
Absolute Pressure (print, intaglio)
Mirror Image (etching)

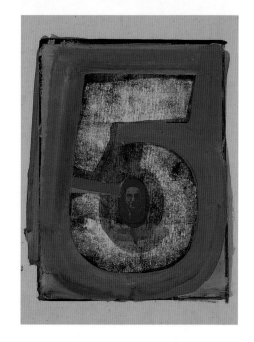

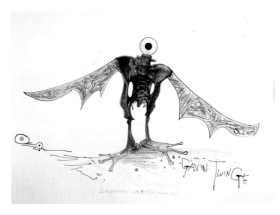

Extinct (ink and wash)

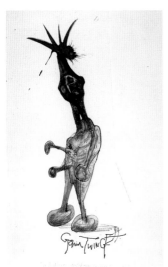

Unknown (ink
and wash)

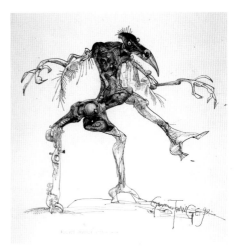

Unloved (ink and wash)

Extinct, Unknown and Unloved (etchings)

Survivor (driftwood
assemblage and sunlight);
Millionaire's Soul (found
objects); Source 2 (found
objects); Restored Pot
(hand coloured photo print)

Immobile Sculpture
Conversation Piece; Restored
Plate with Bullet-Pierced
Wallet; Seated Nude with
Grecian urn (found objects)

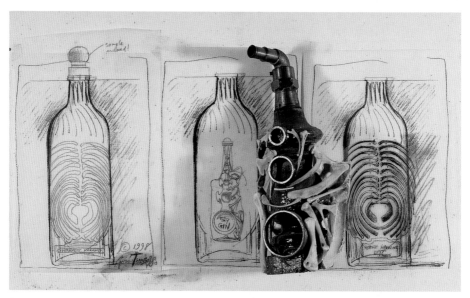

Bone Dry Gin Bottle (working drawings with table leg and chicken bones)

Gavin Twinge at work on his Shredded Literature installation, Exeter Town Hall

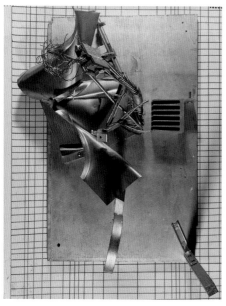

Maquette for Christ's Bride Stripped Bare by Her Religious Mechanics (already)

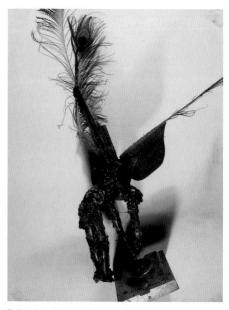

Fallen Angel (assemblage with peacock feathers)

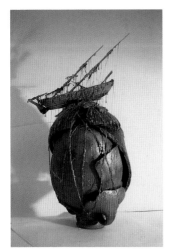

left: Restored Pot
(sculpture as Ancient
Mariner)
right: Homage to
Francis Bacon
(silkscreen)

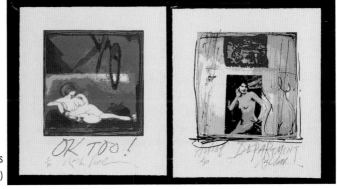

Intimate Art, Nudes
(silkscreen)

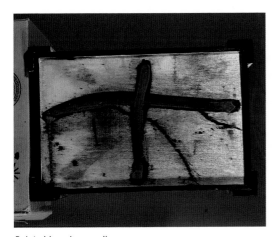

Painted Icon (on wood)

Downtown Denver (acrylic and ink on linen)

Aerial Views – Nazca Lines, Peru (acrylic paint on linen paper)

*above:* Blue Accident from 2000-1000 Feet  *below:* 'And Something New Has Been Added' (title by William Burroughs) (silk screen print with bullet holes)

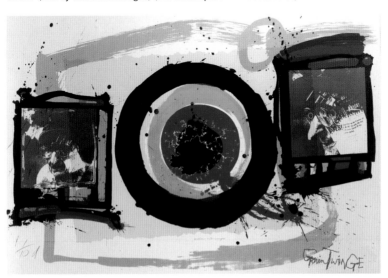

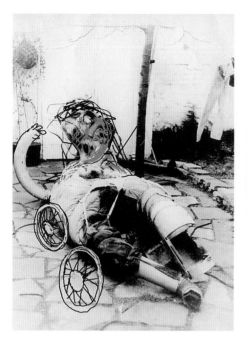

*Clockwise from right:* Skid Row Bums, NY (from Cracked Mirror, Fragments of a Broken Life); The Devil's own (collage and watercolour); Upturned Tree on the Run (organic sculpture); Refugee Pram (found junk)

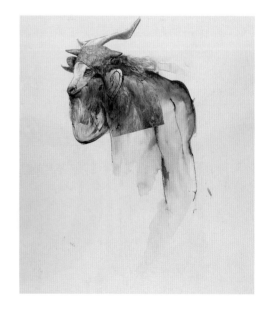

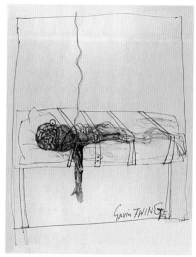

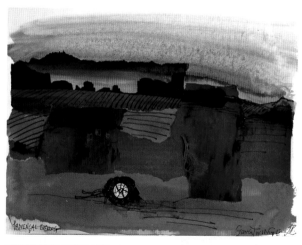

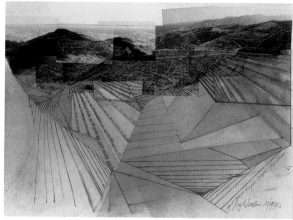

*clockwise from right:* French Landscape (watercolour and collage); French Landscape with Geometry (collage); Nude in French Landscape – Homage to Maillol (collage); Iron Christ – Tears of Rust (monument); Imprisoned Christ Reclining, after Mantegna (collage, pen and ink)

*left:* Spanish Pig Woman of Cadiz
*above:* Digital Nude

Variation on a Theme of Homage to Vera Steadman (installation at Tricycle Theatre, London)

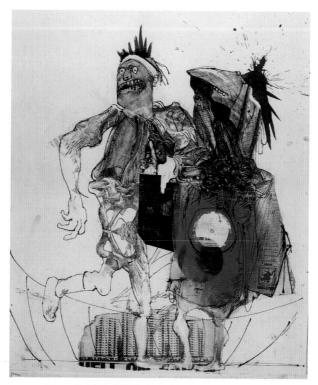

Tribute to Benchley Craig, Sudden Death Football Painter
(with fan, ink and collage)

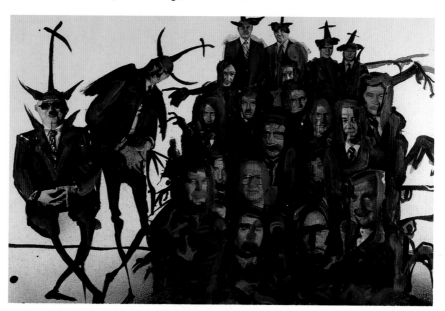

The Carnivalists – Group Portrait (acrylic and photomontage)

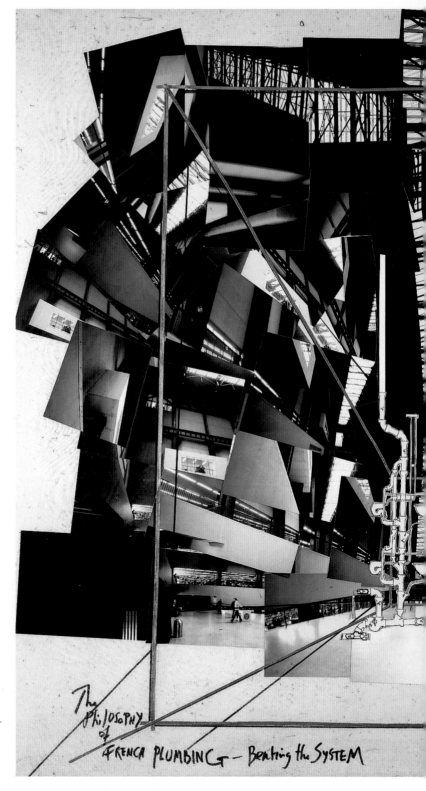

The Philosophy of
French Plumbing —
Beating the System
(installation, Tite
Modern)

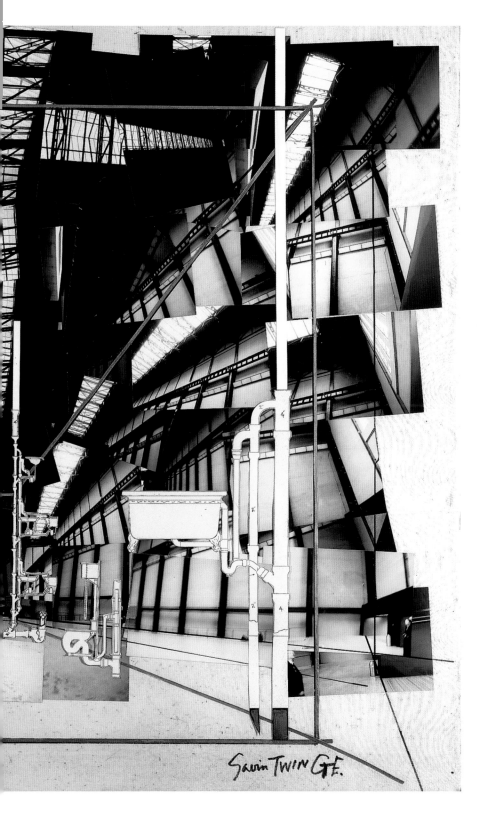

Gavin TWIN GE.

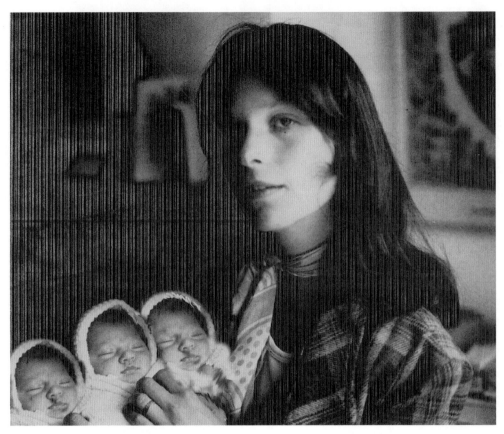

Anya with the Triplets — Andy 1/3, Andy 2/3, Andy 3/3 (real photo)

local authority shall reject a plans certificate combined with an initial notice are those prescribed in Schedule 3 and Schedule 4. The period within which a local authority may give notice of rejection of a plans certificate (whether or not combined with an initial notice), for your information, is five days, beginning on the day on which the certificate is given.'

'So, there are no exceptions then?'

'If the certificate is not in the prescribed form, if the certificate does not describe the work to which it relates and if there is an absence of power to give a certificate, none shall be given. It appears, sir, that you have constructed an elevation which appears to be incomplete, does not conform to any known and acknowledged configuration, i.e. a fully working plumbing system, but not within the confines of an operational place of dwelling, domestic or otherwise. It contravenes all known by-laws concerning the erection and rude display of such facilities in a public place, not to mention in broad daylight. You may well be contravening Obscenity Laws covered by a Regulatory Impact Assessment brought into effect only last year.'

'You mean that naked pipes are obscene unless I get a planning permission permit to display them?' Gavin was nonplussed.

'In a manner of speaking, sir, yes. If pipes are erected with the express purpose of displaying them for themselves alone, not to mention those pendulous toilet items – the naked baths, the brazen washbasins, and the unfamiliar underside of reclining washdown water-closets, with their beautifully formed buttock-like S-bends – you are creating an incitement to sexual arousal on unlicensed premises, under the guise of a spurious claim to be displaying art. You could get five years for such contravention of our decency laws. Am I right, gentlemen?' said Mr Lemley addressing Barry and Eric, whose mouths at this point resembled the ever-open splash cupulas of urinals found in the finest hotels in the land. They had never had their work taken so seriously before.

'Three years, Mr Lemley.'

'Three?'

'Yes, three, Mr Lemley. Three years with good behaviour.'

Just at that moment the mobile phone in Gavin's pocket rang and he whipped it out and answered. His face lit up with obvious delight.

'*What!* I can't believe it! Pregnant. With triplets! Anya, you doll. Mr Lemley will be thrilled. Have you got planning permission? Oh, never mind. I'll tell you later. I'll just photograph this lot to prove it happened. It was worth it just to get the official recognition. I'll bring Ralphael home with me too. If you can squeeze in two more, there's Barry and Eric. My fellow Doodaaa Plumbeteers. Mr Lemley is on his way out.'

I was glad I'd brought along a camera. Gavin had already forgotten what the Hell had been going on for the last three days. He was going to be a father . . . to a set of repros, all called Andy, boys or girls, they will be a limited edition. *Andy* 1/3, *Andy* 2/3 and *Andy* 3/3. Gavin's life and work are inseparable. Life is art.

# APRÈS MOI: THE PHILISTINES

Who hurt Gavin Twinge so much that he wanted to become an artist? His life work is a constant reiteration of the themes within it. A deep sense of wrong, both his own and the insensitive actions of others, fuels his subject matter with the conviction in which fashion plays no part. He never wanted to be a flavour for a period of time and then be irrelevant. Surely, he figured, art is produced by those who believe that what they do and what they achieve is, to a greater or lesser extent, the result of a fierce faith in the act of creation.

'What did not exist before now does because I made it,' Gavin says, 'and therefore a vacuum has been filled, not because it was advertised but because no one, except me, was aware of the vacuum being there in the first place.' That to Gavin IS art. Art is more of a compulsion, a driving force, which has no rules but lives independently of the minor preoccupations regarded by most as central to their existence.

But what caused such a deep hatred in Gavin of those we all refer to as Philistines? All people have to do something, or nothing, by choice and often by force of circumstance, so he was never embittered by a lack of interest in art of any kind. People have other enthusiasms which also engage irrational appetites and he understands this. In their way such people are to him artists in their own right and their own territory. What stirs his wrath are those who speak in hushed reverent tones about things on which they pretend to be authorities, or just as unforgivably vilify that which they do not understand. They do not understand so therefore it is bullshit. They do not understand so therefore it scares them and must be excluded from society like a leper from a society of other lepers. An uncontrollable rage envelops Twinge in a daily rapport with his internal contra-

dictions. There was nothing in his family background that might suggest he would be an artist. On the contrary, everyone else in his family trained for jobs in insurance, dentistry, clerking at a cement factory, sheep farming or, like Beryl, who liked to be called Paloma, staying home to look after his schizophrenic mother who was Cleopatra one day and Orpheus the next. Who were the Philistines? What insidious acts and despicable practices did they visit upon the world that a whole people's name became a symbol for an unpleasant attitude towards the finer things in life? We shovel opprobrium on types, groups and individuals who somehow appear to lack a certain appreciation for what others, the rest of us, are privy to and worship as fine and pure. Contemptuous judgments, pack-howling, as Gavin calls it, are dished out with an air of superiority.

Those who eat junk food are called Philistines, and taste in all things is very much a part of this practice. If your sofa is purple with leopardskin cushion panels and puce-green plastic armrests you are a goddamn Philistine. Your taste in furniture is faulty. Is that a racist remark? Aren't these Philistines a people? A nation? Didn't they smite the Pharisees or did the Pharisees smite them? Nobody says, 'Yurch! So you don't like Philistines, eh? You goddamn Hebrew!' because the Philistines happened to take advantage of the declining vigour of the Hebrew commonwealth. And the inability of the Israelites to defend themselves against the numerous hostile nations who surrounded them made them easy prey.

'My God! You're right!' said Gavin when I put this to him. 'And what's more, the country of Palestine was named after them. Yet the name is commonly understood to mean wanderers or emigrants, or used to be, before they occupied and settled much of the low country along the coast from the Nile up to Ekron,' he said knowledgably. 'They formed some kind of confederacy incorporating Gaza, Askelon, Ashdod and Gath. I guess they were hated because they won, but they had no culture except their power and commercialism. They were better businessmen than the Jews, and damn it! – that is a racist remark – but they had no culture – and that is the point. A superiority so manifested could not fail to kindle personal resent-

ments when public spirit was so low that resistance is feeble and futile. The oppressed crowd look for some weakness to attack, which happened to be the lack of a virile aesthetic like the Egyptians, so murmurings of disapproval spread like cholera, and bingo! Before you know it the Philistines are dummies. They had no sacred art – but what if they did?'

I didn't interrupt him. When Gavin gets a wasp in his jockstrap it is best to let him gabble on, in the hope that he winkles out a nugget of truth that would otherwise get stuck in the vinous lacuna of his brain on its turbulent way around the splenic flexure of his vitals.

'That sofa –'

'What sofa?' I replied.

A PHILISTINE ALTAR.

'Y'know, that purple job with the leopardskin cushion panels – the kind you find dumped on any council estate skip like the one I've got in my studio. Maybe that WAS taste to a Philistine, and maybe they're right. Maybe they had a religion, too. Most tribes did, and for them a sacred shrine was an altar, like the purple sofa, and behind it going to Heaven were three ducks on a wall ascending. That was their aesthetic. Maybe they had other art too. A Philistine ascendancy would have been expressed in all those objects that we now poo-poo

but used to own with pride. In the time of Saul, the biblical turncoat who persuaded his lot to turn the other cheek after he'd had his fill of killing, the ascendancy of the Philistines became established and opposition was carried out only by those Hebrews who couldn't stomach this dreadful vulgar crowd. So they practised guerrilla warfare, like any oppressed minority does today. Overthrowing the Philistines became a crusade and they found Samson. Samson's vindictive policies were at once the natural result of the situation and the best means of exciting the patriotic emulation of his depressed countrymen. Some smiting needed doing and Samson was their man. 'Where did Samson come from?' I ventured. 'God sent him. He knew his chosen people were in trouble when he saw the Philistines' taste in art – when God saw that He knew that the whole of Western culture was under threat from what He saw as rank bad taste. Any God who had created the humming bird *and* the aurora borealis *and* then saw some money-grabbing upstarts worshipping him through some crummy purple sofa, would be driven insane. "Watch it!" boomed God, "you are messing with my Holy Land!" But He didn't reckon with Samson's hots for Delilah. I'll bet she was an undercover Philistine, who saw his weakness for the real beauty Philistines only turned to when the sofa didn't work. I have already done a painting of Delilah as a Philistine nude. One of a series. They turned Samson into a skinhead. It all makes sense. Then there was David, Solomon's undercover Israelite, a little guy who smote a Godzilla, a Philistine if ever I saw one, a big slob of a man whose eating habits could be likened to those of an average bestial middle-class family in a hamburger time warp, gorging on leavened bread, stuffed with unminced thighs of Hebrew slave girls. At this point the Philistines were on the run, in the reign of King Solomon, whose people completely subdued them and put them under tribute, so that they could be left undisturbed, to live as peacefully as they could, under their own laws and organisation. Hence Solomon's wisdom. It takes a big man to pull that off, but not a brute. So . . .'

'So you think it is the brute strength which is the problem?' I thought I ought to say something at this point and added my small

contribution to this Gavinesque scenario of how we vilify a race of people, whose only crime is to have no taste.

'So, yes! The Philistines reappear as an independent state, within this new order, after the division of the Kingdom of Israel, but now the Israelities were Goliath. The Philistines' power had been broken, but isn't that the way with history, which to Voltaire is simply "a delightful fantasy" and isn't he right? We cannot know the minutiae of everyday life. We don't know how Joe Bloggs thought, or how his day-to-day way of life was. We are not privy to some vital conversations that took place in some potential political figure's home, or down at his local taverna. He, or she, may never have made it through the next day.'

'But, surely, all the great figures are known whose ideas reverberate through the human story?'

'Wrong!' Gavin drags his filthy paint-spattered sweater up over his bloodshot eyes in desperation and speaks through the woolly stitches of manual labour, which make his clothes what they are. 'How many people died in battle, or in some ghastly massacre, who may have been potential thinkers and even great artists and musicians? How many were not heard whose life was theirs, but which was torn from them in agony?'

'Two or three maybe?' I suggest. 'YES! Two or three trillion would be nearer the mark,' he snapped, 'but stupid megalomaniacs who want war stole it from them! That the Philistines are no longer the bad guys was only a glitch in the movement of humankind and their fortunes. They resumed their predatory habits at the expense of the Israelites, the Hebrews, who could not and never can, contain a disruptive force Hell bent on its own kind of desecration. Malignant cancer is unstoppable and that is what we are, to ourselves. Just when some things are getting better, someone else has been born with a whole new scheme, and the cycle of events is forever busy with an entirely new and personal agenda of its own. Not to mention these new creatures' formative experience and dynastic struggle and the time into which they are born. And we haven't even mentioned Islam and the Caliph Omar from Persia, whose bloodlust for standing

Christians roused the indignation of Europe, which gave rise to the Crusades, and their ostensible defence of Jerusalem, as a "Christian bastion against these infidels". That was just a murky excuse for guys to leave their wives, go to foreign places and act like soccer hooligans. Whither the Philistines then, eh? Gone the way of all flesh, mate – just a name to kick into play and use as a derogatory term, because they no longer existed as a tangible nation of flesh and blood. We always try to insulate one period from another, but the flow of history's course remains unbroken . . .'

Gavin had made his point. He wasn't really against the Philistines at all, or their bad taste. His anger is not against a sad nation called Philistines, or for that matter Hebrews. Both went up and down in fortune like petrol prices. Both nations suffered from the contentions of surrounding Egyptian and Assyrian monarchs, so that their nationalities became merged in a succession of empires, which commanded the Middle East from the time of Nebuchadnezzar. When the Jews recovered their independence under the Maccabees, they went right out and conquered the country of their ancient rivals, which in turn was annexed by Pompey to a province now known as Syria.

'Don't forget,' added Gavin, who had now warmed to the subject of his professed hatred of 'Philistinism', 'as far as I know, there is no known language of the Philistines, and so they may as well have never existed. But, going by names of their cities, their language would probably have been Semitic. And they had their own gods, too, not a Christian God, but Baal-zebub and my particular favourite, Derceto, half-fish, half-woman, a Philistine nude if ever I imagined one. She is the basis of a new aesthetic for the Philistines. Within the ambivalence of my feelings towards a Philistine attitude, as opposed to a Philistine people, there lurks the spirit of my love/hate relationship with all the arts. Art expresses the conscience and finer aspirations of a nation and yet provides the last refuge for the intellectual thug, who wields art as a weapon. I need a drink.'

At this point I left Gavin struggling with a new menace in his ongoing quest to come to terms with his troubling duality – the

nature of bar codes and their relevance to the twenty-first century. How the Cubists embraced the bric-à-brac of early twentieth-century utility, and the pure aesthetic, bestowed upon the mountains of ephemera of mid-century commercialism through the collage work of the German artist and genius Kurt Schwitters.

I turned at his studio door and said, 'Don't you think that all that happened then has been done and is now part of history?'

'Get outta here!' he said. 'What those people discovered, we are still learning to digest. That may be the quest for an artist unfortunate enough to be alive in the twenty-first century. I rest my angst.'

# EXHIBITIONS AND COLLECTIONS

## GAVIN TWINGE

Born in London.
Doodaaaist (for *Manifesto* see Bibliography I.1).
Lives and works in London, Paris and the village of Les Salces, Languedoc.

## SELECTED SOLO EXHIBITIONS

2044     *Gastronomic Tutu 3000.*

1976–84   *Gavinudes* (withdrawn).

1849     *Lingering Backward Glance (Daguerreotypes)*, Niepce Museum, France.

1996     *Who? Me? No!! Why?? Works of Friction by Gavin Twinge*, Tricycle Theatre, London, and Les Arts Marais, Paris.

1904     *The Distillation Art Gallery* (still under construction).

10,994 BC   *Extinct, Unknown and Unloved: Etchings on Evolution by Gavin Twinge*, Hole in the Ground Gallery of Scotland, Aberdeen.

1986     *Vera: Tragic Oblivion*, Aspen Woody Creek Gallery, Colorado.

1988     *Dancing to Paint*, sets and props (including *Lobster Basket* and *Cubist Chair*) for the ballet of the same name, choreographed by Mischa Bergese in the Queen Elizabeth Hall, London, with an exhibition of 400 drawings by Gavin Twinge (homage to Picasso) in the Royal Festival Hall, London (removed by Fraud Squad).

1989     *Shredded Literature*, installation in Exeter town hall at the Exeter Literature Festival, England.

1989     *Fluorescence et Phosphorescence*, musical installation, Galerie Enghien-Montmorency (Malmaison-Bougival), Paris.

1995     *Christ's Bride Stripped Bare by Her Religious Mechanics (already)*, installation Chez Gaston Lupin, poète mécanique, Évreux, France.

1997     *Vineyard*, landscapes, Les Clos de Paulilles, Rousillon, France.

2002     *The Philosophy of French Plumbing*, three-storey toilet-fixture installation extravaganza, Turbine Hall, Tite Modern, London.

## TWO-PERSON EXHIBITIONS

1994     *The Shooting Gallery*, with William Burroughs – savage attack on fellow-writer entitled 'And Something New Has Been Added'.

## SELECTED GROUP EXHIBITIONS

1987     *The Young Contemptibles*, Doodaaaist group show at the Weightchapel Gallery, London (Royston Balls, Moxey Bedvetter, Egley Bupa, Emilio Castelar, Benchley Craig, Aaron Dickley, Ian Moratorium, Phlar Namdeats, Worthington Niff, Brod Norkitt, Rita de Passage, Garton Pimpless, Anton Schmink-Pitloo, Tzoff Pitz, Lily Potsdam, Maurice de Rim, Tim Slunt, Ormond J. Street, Gavin Twinge, Schlemiel Weiss, Carlton Whisp).

## ONE MAN/TWO MINDS EXHIBITIONS

1990     *MAMA Queen: Left for Dead*, floating objects found in the East River, New York; restoration pieces in memory of Bums of New York, Museum of American Modern Art, New York.

1991     *Solid Block*, exhibition of Carrera marble: homage to memory of dead Doodaaaist Trevorangelo, Forti di Marmi, Italy.

1992     *Red Passing Cloud*, sculptures on the theme of red, October Gallery, London.

1995     *Sing Bechod!*, lyrical works set against a backdrop of druids in yellow wellington boots, in a marquee, National Eisteddfod of Wales, Abergele.

1996     *Writers and Leaders: Etchings*, 1/1 Gallery, Denver, Colorado.

1997     *Concrete Memories*, a tribute to the Berlin Wall, 13th International Biennial of Sardonic Humour and Angst in Art, Gabrova, Bulgaria.

1998     *Shafted!*, self-inflicted show of personal suffering in Atomic Shelter Bunker Gallery, Denver, Colorado.

1999     *Cacc*, images in a lift shaft (Plumbing Department), basement, Bazar de l'Hôtel de Ville, Paris.

2000     *Arriva Duce, Baby*, millennium caress of soft woolly toys trapped inside their own century, Bosphor Arts, Istanbul, Turkey.

2001     *Make or Break*, single drawing in a room of strangers, Tite Britain, London.

2002     *Look Out!!*, show under construction planned to coincide with Turner Prize Exhibition, on pavement in front of Tite Britain.

## COLLECTIONS

First Matzoknedl Bank of Scotland
Christeby's New Movements
Palais de Culture, Municipalité de Lodève, Clermont-l'Hérault, France
Pepper Mill, Whalley, Municipality of Burnley, England
Moshe Veshem Diaspora, University Campus Gallery, Tel Aviv
University of Creationism, Dayton, Tennessee
Pristine Chapel Art Tomb and Souvenir Crypt
Tite Gallery, London
Musée des Booze Arts, Paris
Gluggenheim Museum of Modern Movements, New York
Hole in the Ground Gallery of Scotland, Aberdeen

# BIBLIOGRAPHY

This bibliography has been created by Norbert Nance-Montmorency, formerly of Christeby's 'New Movements' department, in consultation with the author and the artist.

The bibliographer is grateful to the artist and his galleries for their help in compiling this text and to the artist and his publishers for permission to reprint extracts from the listed works.

The bibliography is divided into three sections of three:

I   WRITINGS BY GAVIN TWINGE
  1. Prose and poetry
  2. Musical compositions and libretti
  3. Screenplays
II   WRITINGS ABOUT GAVIN TWINGE
  1. Interviews with Gavin Twinge
  2. Books on Gavin Twinge
  3. Writings on Gavin Twinge
III   EXHIBITION CATALOGUES
  1. Solo exhibition catalogues
  2. Two-person exhibition catalogues
  3. Group exhibition catalogues

In each section entries are listed in chronological order. Items marked with an asterisk (*) have not been seen by the compiler and the bibliographical data for these derive from hearsay. Extracts from the works in question are introduced where the title of an item does not necessarily indicate the full nature of the content.

The section of 'Interviews with Gavin Twinge' consists of abbreviated references to articles and other texts incorporating interviews with the artist, but it should be borne in mind that, except to help Ralphael Steed in the preparation of this book, Gavin Twinge has never given interviews if he could help it, but has occasionally dropped his guard over a drink and for this reason this section is necessarily short, although it does contain some material that may be of interest.

In the section of 'Writings on Gavin Twinge' items marked with a dagger (†) are poignant; those marked with a double dagger (‡) are especially vicious.

# I WRITINGS BY GAVIN TWINGE

## 1. Prose and poetry

*Paperbag Haiku*, Steam Press, 1970
*Doodaaa Manifesto* (with Tzoff Pitz), 1978

> Doodaaa was born of a need for dependence, of a total trust in peasant intuition and a complete lack of judgment. Those who are with us have lost their way too. We love theories, the crazier the better. We are all raving mad anyway. If you are a Cubist or a Futurist, or a lavatory attendant, that's OK. We forgive you. Let each man declare:
>
> There is a great futility to be demonstrated. We must vacuum our brains looking for drivel. We must affirm the drivel of each individual and what we find in there, we must jam it in our work. The drivel must be total, unadulterated madness; a reflection of a world controlled by a gang of criminal scum who cheat each other in malevolent struggles for supremacy. We must be as idiotic as they are ruthless, offer up a senseless elegance to adorn their asinine ambitions. We love all things modern, because they are shiny and bad. We embrace it all because it negates any past we ever had. The more rotten we get the more we will confuse the scum – and that will be our motto: CONFUSE THE SCUM FOR THEY WILL INHERIT THE EARTH.

*On Evolution* (unpublished notebook in Cosby Twing's 'box under the bed')*

> My mind is made up. We are brutes who render the animals incapable of being themselves. We repress them in the name of the God we invoke to bless us and slaughter them in the name of our own stupidity. We are the disgrace of the animal kingdom. I make my own distinctions from hereon in.
>     We are doing the ape family a disservice by saying we are descended from them. They ascended from us and descended from the pig and now behave worse than they do. It is an unfortunate phenomenon for the earth that *Homo sapiens* thinks rationally. It is a great pity that we look upon that ability as a virtue in, say, 99.99 per cent of all humans. The remaining 0.1 per cent, with which I have no quarrel, include Shakespeare, Émile Zola, Leonardo da Vinci, John Lennon and Huysmans (*Against Nature*), Aristotle, Galileo, Euclid, Rembrandt, Confucius. Include Nietzsche, Wittgenstein, Hume, Locke, Pater and Twing. Yes! Twing. My great-grandfather realised, in his ignorance, the need for disposal. Getting rid of all the shit among the sublime thoughts of genius. It has got to be dealt with, inside every human aspiration. The waste. The waste nearly destroyed the achievements of man until the Romans said, 'Enough! We can destroy ourselves with overindulgence

but we cannot allow the evidence of our waste to indict us.' Which is more or less how civilisation happened. Man realised the dangers. An ark full of indiscriminate piles of shit. But it took many attempts to get that fact through, mainly because Man was not and still is not prepared to acknowledge that the pile of shit is his.

*A Song Walks Through the Valley of the Incas* (unpublished poem in Cosby Twing's 'box under the bed')*
*Peru Diary* (unpublished notebook in Cosby Twing's 'box under the bed')*

## 2. Musical compositions and libretti
*The Underground Symphony*, (unpublished, 1993).
*God's Drawing Board*, (unpublished libretto, 1994)

> *A near-dark stage. A white sheet falls from above the proscenium arch and comes to rest on the stage to the distant sounds of thunder which resemble the falling action of the sheet which appears to cause it. It is covered in plan-like geometric drawings of straight lines, curves and circles like a plan of the universe.*
>
> *A creator (GODMAN) hangs beneath it like a parachutist and drops awkwardly on to the stage, apparently pissed, staggers and curses his way from under the parachute as it falls on top of him. The thunder and lightning get louder and more dramatic and a broken-up version of 'Mars' from Holst's* The Planets *is attempted with electronic weird musical noises – a synthesised bedlam grows. God is on a bender. There is a mighty sound of wind – a cosmic fart as though God finally emerges from under his plans and views his handiwork.*

> Twice I have tried creation
> And twice the devils multiplied
> But then I had no ground plan
> No point of reference
> Until now –
> Now you don't believe –
> Don't believe until you need me –
> Now – you need me
> I'm back!
> I've come back!
> Lied my way back.
> Cheated you like you cheated me
> Thrown you peddling assholes together
> Like a disbanded zoo of endangered species.
> Earth was a joke!
> I made it up this morning

I pretended I was God too
I drove a stake through a mortal's soul
And declared my act a warning.

*Death of an Orchestra* (unpublished, 1998)*

A Surreal concept for a concert performance by large orchestra or smaller ensemble.

The blast of a full orchestra shakes the air. The sound of bellowing evolves out of this harmonious but far too strident powerhouse. There are scales, atonal passages, counterpoint riffs, thunderous flowing movements, a kind of joyous ragbag of a composer's store of musical ideas. It is the thought-box, the brains of the mind of the composer thinking out loud, declaring its strength and describing its territory.

Phrases, passages of disjointed thoughts, can be heard sung by a tenor through the sound system. The music reflects the general drift of each statement. It is a music/word collage.

As a ten-minute intro, nothing should ease off and full range of abilities is demonstrated. Mood, pathos, drama, excitement, tension and violence are given full rein.

A basso-profundo or tenor voice, whichever is the most suitable, takes the stage at the height of the swell dressed in a stave-patterned white suit, complete with G-clefs, time signatures, crochets, breves, etc. He is big and powerful and expresses the general character of the orchestra, i.e. the interpreter of a composer's idea – he is not the conductor but more the collective hearts and minds of the orchestra, the sum of its parts.

He then sits down in what appears to be a doctor's waiting room. The back wall is back projected with a huge graph upon which a red line provocatively waits to move across the squares, which subtly suggest staves also. He appears in robust good health and in fact he is. He is full of confidence and shows it. He is merely here for his annual check-up. Also on the wall is a human figure, a diagram *à la* Humanus Corpus of Leonardo da Vinci. Except this figure displays all the organs in their respective places, but externally so that they may light up or throb, strobe or pulsate according to the doctor's examination of the bodily parts, and to which instrument is played to represent each one, i.e.:

The CELLO is the heart
TIMPANI the heartbeat
VIOLINS are the muscles
PIANO the bones
GUITAR the sinews/muscles
TRUMPET or trumpets are excited voice sounds/mouth, as is the
SAXOPHONE with broader tonality
TROMBONE is the stomach

WOODWINDS, well, the rumblings and general flatulence of a
well-stocked stomach

CLARINETS are the small intestine

VIOLAS the lower alimentary canal

EUPHONIUM the sphincter (optional)

FRENCH HORNS the private parts (male and female optional too!)

ORGAN or ACCORDION the lungs

FLUTE a voice of reason, and the tiny recorder or even tin whistle is
the spirit of hope that brings the whole orchestra back to life. The
triangle and tubular bells sound a knell. A dancer or dancers
would express symptoms, backache, muscle spasms, general
discomfort or even rude health.

CONDUCTOR/PROBABLE COMPOSER, yes, the brain. Something or some
spirit has to guide the music.

Essentially, it is a comedy in music with a happy end.

*The Blot Symphony* (unpublished, 1999)

## 3. Screenplays
*Beast Bites Back*

In the late 1970s and early 1980s, Twinge began a series of what he
referred to as 'Devant-Garde' films acknowledging always his debt to the
past. Though he was always in debt, his friends and admirers were never
completely averse to a quick whip-round for him, though some did begin
to grumble and murmur at the prices of his pictures on the walls and
their relative elevation compared to the absence of his wallet. Gavin
shrugged off the detractors as 'Philistine unbelievers, pricks and assholes'
and after such an admonishment most shufflers chipped in.

SCENE: *A cold wind-whipped landscape – clouds scudding across a frost-brittle
sky. A single star flickers and buzzes through a million atmospheres to earth.*

*Camera pans down and comes to rest on a lonely figure, blue with cold, miserable
and lost. It is I.*
*The figure looks about aimlessly. Picks up stones. Juggles. Drops them disconso-
lately and looks about again. Skein of geese crosses the sky in low formation. Picks
up stone and hurls it at them muttering darkly about left-wing flypasts. Looks at
his hands – picks his teeth – spits – then looks about again. Shudders and gathers
an old bear rug around himself. The bear rug still has its head, which flops down
over his shoulder with a pathetic stare – it begins to talk . . .*
BEAR: I'm not the mad one, you know.
ARTIST: Shut your hairy face, you are less than human! You miserable rug!
BEAR: Don't talk to me like that! I have been where no bear has been
before but all bears have been here . . .

ARTIST: . . . and I am here now . . . So?

BEAR: If bears decide to make this way their annual trail again you are finished. No high street is an island.

ARTIST: Nobody is finished until a stupid bear like you sings.

BEAR: OK (*sings operatic Puccini, 'Her tiny hands are frozen although they are so cold!'*).

ARTIST: (*adds*) – and waltzes to Strauss – of course!

BEAR: (*falls off artist's shoulder and waltzes to Strauss*).

ARTIST: – er – Schoenberg!

BEAR: (*waltzes to Schoenberg and then to Pierre Boulez's 'Repons' as well – just as an encore*).

ARTIST: SHIT! I hate smart bears.

## II WRITINGS ABOUT GAVIN TWINGE

### 1. Interviews with Gavin Twinge
'Doodaaaism – Gastronomic Tutu 3000: The Balletic Art of Gavin Twinge' by Art Betcha, *Grauniad*, London, 4 April 2002†

### 2. Books on Gavin Twinge
‡

### 3. Writings on Gavin Twinge
'The Tip behind the Skip', Shiraz Crewe, *Sun and Moon* ('your 24-hour paper'), London, 5 November 2002
'Never again – the day I saw blue', Eric Strutt, *Wingspan*, 2001

## III EXHIBITION CATALOGUES

### 1. Solo exhibition catalogues
*Gastronomic Tutu 3000*, 2044
*Gavinudes* (deleted)
*Cracked Mirror, Fragments of a Broken Life*, Skid Row, New York and Galerie Enghien-Montmorency (Malmaison-Bougival), Paris, 1984
*Lingering Backward Glance (Daguerreotypes)*, Musée de Niepce, 1849.
*Extinct, Unloved, Unknown: Etchings on Evolution by Gavin Twinge*, Hole in the Ground Gallery of Scotland, Aberdeen, Scotland, and Galerie Enghien-Montmorency (Malmaison-Bougival), Paris, 1989

*From the introduction by Brendan Suet:* When Gavin wants to print he moves north to Aberdeen, like Dr Frankenstein on his way to the Pole, to seek mythical creatures in the acid baths of chance. He scratches steel plates, to unmask the fleeting nuance of his dreams. He knows that they lie just beneath the surface. The hunt is on and across the surface of a sheet of

steel, subtle structure imperfections lie silently in wait, for the chemical reactions of the acid to erode the metal, liberate the magic, to reveal a chance encounter within the atomic structure of nature's hidden universe . . . 'They are there, they are there, and they never sleep. The creatures that only God dreamed of are their own creators and wait only for artists to set them free! It has to be said that many of them look unfortunate, awkward and downright wretched: some are like exhumations but, once configured, emerge like plasma from a volcano, may even be plasma. Erupted, they may live for just a second, only to become something else. Many a shapeless blob may once have been Venus, for a nano-second, but isn't that mere relativity? The mystery of the fleeting appearance is the orgasm of art's constant challenge. It will never pass this way again.' These are the creatures that Gavin snatches from his dreams. They may have existed but we can only imagine that. The evidence has melted away. But the imagination that created them again lives in our time. He is convinced that these creatures of the imagination never sleep, and neither do they complain. They simply long for reincarnation. Gavin is their man. Gavin is one of their dreams.

*Shredded Literature*, installation in Exeter Town Hall at the Exeter Literature Festival, 1989

*A note by the festival director, R.G.W.:* Gavin wanted to shred every book that he had ever read and some that he hadn't heard of before. And some that he was forced to read in school that had no rhyme or reason. It wasn't about burning books or even scrawling thoughtlessly in the margins. He did that once and got caught. He can still remember the book and the section. It was Dante's *Divine Comedy*, Canto XXX (Gavin's rule of three) from the *Paradiso*. 'As a sudden flash of lightning which so shattereth the visual spirits as to rob the eye of power to realize even the strongest objects; so there shone around me a living light, leaving me swathed in such a web of its glow that naught appeared to me.' He had drawn a blind dog drawing its master over a cliff. Gavin's act is strangely benevolent. It is also specific. He shredded the Complete Works of Shakespeare except for *King Lear*; all of Dickens except for *Great Expectations*; all of Henry James except for *Washington Square*, and all of Trollope's Barsetshire novels, excluding the last chapter of *Doctor Thorne*, which expresses the quintessential Victorian-ism of the family Twing . . . Future plans include a shred-in at the Albert Hall, something like a Bonfire of the Vanities, which will be the first book to go. Gavin will be dressed as Savonarola and he will be accompanied by the Ensemble Intercontemporain, from the Sound Studio of Pierre Boulez in Paris who will perform *Sur Incises*, a labyrinthine work for three pianos, three harps and three percussion instruments, to externalise the inner lives of the shredded books.

*Dental Floss*, Cheltenham Literature Festival, 1994

*A Note by the festival director, H.C.:* In 1994 Gavin Twinge became Artist-in-Residence at the Cheltenham Literature Festival and was given free rein to do whatever he wished. He set up a consulting room called *Dental Floss* and invited all participating authors to sit for him – 150 in all, including Iris Murdoch, Joanna Trollope, Alan Bennett, Stephen Spender, Michael Foot, Beryl Bainbridge, Andrew Motion, Lady Antonia Fraser and the late Archbishop of Canterbury, then Lord Runcie of Lambeth.

'Pain is an essential dimension of true portraiture,' said Gavin but nevertheless all were willing to sit for his *Gavinoid* portrayals, except for Harold Pinter, who wanted to go shopping.

*Fluorescence et Phosphorescence*, Galerie Enghien-Montmorency (Malmaison-Bougival), Paris, 1989.

*A note by R.S.:* The constant theme of nightmare scenarios, or 'fuck ups', as Gavin called them, resulted in a work called *Fluorescence et Phosphorescence* when Gavin Twinge commissioned a chef called Loi de Stokes to create a meal purely from genetically modified crops of Jerusalem artichokes for the guests. The dish caused a violent reaction which lit up the gallery with radioactive flatulence. The effect was likened to strobe lighting in a disco. The musical event was cancelled on account of an immediate exodus into the fresh air by the audience. Loi de Stokes has a small well-ventilated cellar restaurant immediately adjacent to the Quai de Conti in the sixth arrondissement, called Le Vent.

*Who? Me? No!! Why??* *Works of Friction by Gavin Twinge*, Tricycle Theatre, London, and Les Arts Marais, Paris, 1996
*The Distillation Art Gallery*, 1904 (still under construction)
*The Philosophy of French Plumbing*, Tite Modern, 2002.

*From a letter by GT to his mother, Fanny:* Reflections on an attempted bonding to a way of life – my dream to forge an artist's colony within a rocky idyll . . . it all passes through my mind, a fundamental filtration system, for all the feverish thoughts of a man on the run . . .
. . . fear of starting. The moment before cutting the pipe . . . what if I cannot stem the flood when I do? . . . a whole Paris arrondissement . . . including my neighbours down below . . . are flooded . . . and it's ME!
. . . everything must be there . . . at my fingertips . . . to cover all emergencies and every necessity . . . how will I order compression joints in French? . . . the dimension of the actual pipe? . . . is it still metric or has that been changed to new Eurometric? . . . Nobody ever tells you these things because as a rule nobody needs to know that . . . except a

French plumber . . . then I get this ingenious idea . . . one of those adjustable, wobbly French clamps will do the job . . . most people who have tried renovating a second home in Languedoc or the Ardèche and have bought third-rate tools in the local *quincaillerie* know exactly what I mean . . . I have such a clamp, infinitely adjustable . . . which unless it is actually clamped to something solid perpetually adjusts itself on its free-flowing thread . . . I tighten the clamp firmly but gently on to the pipe I wish to connect to another . . . the clamp can then be pulled away . . . gingerly . . . like a micrometer used by engineers to measure diameter to within a ten-thousandth of a centimetre . . . less than a single hair's breadth from an angora rabbit . . .

*An additional note by RS:* The first time Gavin thought about France was back in the early 1970s when he set out to fulfil a dream and found an artists' colony, to own a piece of real estate down in Languedoc, in a rugged god-hewn landscape, which would test his doubtful spirit to the limit. He needed to raise a paltry five hundred quid because that is all it would take, and the energy of Thor. Gavin sold his stamp collection and never looked back.

It was there, too, that he had his first encounter with French plumbing – *plombier rustique* – a hole atop a concrete plinth in half an acre of old vineyard. But it was all his, all his, and he was there to reconstruct paradise for next to nothing.

## 2. Two-person exhibition catalogues
*The Shooting Gallery*, with William Burroughs, Lawrence, Kansas, 1994.

*From the Introduction by RS:* Gavin hadn't wanted to be there for the actual 'Artshoot'. He didn't think he could stand the savagery or the noise and particularly the desecration of his silkscreen portrait of William Burroughs on fine mouldmade paper. But since it was his idea he had to let it happen. He had to let Burroughs blow holes in everyone of the 120 prints in blocks of ten at a time with whatever weapons came to hand. That was Burroughs's contribution to their artistic collaboration and Gavin wanted him to have fun.

Gavin was intimidated by the power of Burroughs's intellect and the frightening range of his experiences that clung to him like burrs on a tweed suit. Those suits and that trilby/fedora, he never knew which, but Burroughs always reminded him of a seedy small town banker who wasn't after your money so much as your soul. His reptilian eyes and ink-line features flicked restlessly looking for signs of life and a place to enter with unfailing courtesy.

Gavin could never pretend to have become an intimate friend of the

writer. Those claims belonged to the shadows of Burroughs's past that speak to *us* now through the words they left behind and the black-and-white photographs of all those buddies together doing whatever they did to ease the pain. But Gavin sensed a certain mutual rapport which paved the way for an eventual invitation to visit him at his home in Lawrence, Kansas. His place was modest; a weatherboard house was the office of William Burroughs Communications Inc., which was and is run by what many would call his acolytes but what Gavin would call his vital maintenance team.

When Gavin arrived several were in attendance. The front living room was sparsely furnished on bare wooden boards. Burroughs was hunched over a swordstick in a low easy chair facing the synthetic model of a Mugwump, a skeletal figure strapped and chained to a director's chair, a character from the film *Naked Lunch*. Burroughs was drinking from a regularly replenished tumbler of what appeared to be straight Coca-Cola but was, in fact, laced with vodka, because, as Burroughs growled, 'I can't stand the taste of raw liquor on my tongue.'

He read Gavin a poem of his called 'Pantapon Rose' and signed a copy for him. He caressed a small handgun, taking it in and out of its leather case and explained the virtues and intricacies of what appeared to Gavin to be a villainous piece of exquisite engineering. Burroughs carried it with him everywhere, talking a lot about cats, guns and lemurs.

The 'shooting range' was a lush area of grassland set below a steep bank beyond the house. A simple wooden frame had been erected upon which their targets were nailed. The targets they had brought with them consisted of various prints of Gavin's, including *Vintage Dr Gonzo*s which commemorated twenty-five years of Gavin's association with Hunter S. Thompson; a silkscreen of *William Shakespeare*; photo-poem prints of Burroughs photographed through a mirror by Allen Ginsberg; and a handsome silkscreen of a younger Hunter S. Thompson based on a photograph taken of him during his campaign for sheriff of Aspen in 1970 on a Freak Power ticket. There were three bullseyes on that print, between the eyes, a sheriff's badge on his jacket, and his Rolex watch.

They blasted the hell out of most of the art and kept the sheriff till last. When Burroughs aimed he stood about six feet from the target and with a burst from a twelve-bore shotgun could burn away the best part of a *Dr Gonzo* image with the heat alone. Throughout the proceedings he wandered about the range waving a selection of guns which had the party of disciples ducking and weaving to avoid the direction in which the barrel was pointing, always apologising and ever the gentleman he was. During a lull in the shoot Gavin decided to make a 360° 'paranoid' portrait of Burroughs seated entirely alone at the side of the range. Gavin moved around him, photographing his head and shoulders at specific points within the circumference. This would become the basis of his

print, the target portrait, which gave Burroughs the opportunity to participate in his own distinctive way.

The moment came to shoot the last print, the sheriff, with its three bullseyes. Gavin took Burroughs close to the target and explained the three areas to aim for. 'No problem,' he growled as he checked the chambers of his .44 Smith and Wesson Special (Limited Edition) revolver. Burroughs was enjoying himself and everyone felt the sense of occasion. They stood back and waited as he took aim. Then in quick succession – bang! bang! bang! bang! bang! bang! bang! BANG! 'Gotcha!' he said in the silence that followed and Gavin moved past him to inspect the result. 'You missed, William,' he said, 'they've all gone through his neck.' With a half-smile and sidelong glance Burroughs growled, 'Well, he's dead, in'e?'

## 3. Group exhibition catalogues

*The Young Comptemptibles* (Royston Balls, Moxey Bedvetter, Egley Bupa, Emilio Castelar, Benchley Craig, Aaron Dickley, Ian Moratorium, Phlar Namdeats, Worthington Niff, Brod Norkitt, Rita de Passage, Garton Pimpless, Anton Schmink-Pitloo, Tzoff Pitz, Lily Potsdam, Maurice de Rim, Tim Slunt, Ormond J. Street, Gavin Twinge, Schlemiel Weiss, Carlton Whisp), Weightchapel Gallery, London, 1987.

*Note by RS:* This was the exhibition in which Tim Slunt's piece *Skip* so lacked the transformative quality of art that Twinge persuaded his fellow Doodaaaists to tip their own work into another skip and then sold the pair of skips to an American businessman, leading to the scandal of 'The Nude Who Sued' but also to the retrieval of London Bridge from the Arizona desert for the Jubilee year.

# INDEX

Illustrations within the text are indicated by page reference in *italic*. For illustrations in the picture sections the reference is to the title of the section.

## A NOTE ON THE AUTHOR

Ralph Steadman, artist, writer, sculptor, political cartoonist and designer of labels for vintage wines, is the author of many illustrated books including *Sigmund Freud*, *I Leonardo*, *The Big I Am*, and *The Scar-Strangled Banger*. He is also the illustrator of *Treasure Island*, *Alice* and *Animal Farm*, and of Hunter S. Thompson's infamous *Fear and Loathing in Las Vegas*. For thirty years he has been Gardening Correspondent for *Rolling Stone*.
This is his first triography.

## A NOTE ON THE TYPE

Linotype Garamond Three – based on seventeenth century copies of Claude Garamond's types, cut by Jean Jannon. This version was designed for American Type Founders in 1917, by Morris Fuller Benton and Thomas Maitland Cleland and adapted for mechanical composition by Linotype in 1936.

**Doodaaaists**

**Triplets**

**Anya**

**Cosby**

**Vera**

**Gavin**

**Crispin**

**Fanny**

**Howell Northern**

**Betty**   **Raphael**

**Gordon**

**Doris D'eau • Elsi**

**Silas Twing**